Complete Guide to French-Canadian Antiques

Text by Michel Lessard
Illustrated by Huguette Marquis

Translated by Elisabeth Abbott

Hart Publishing Company, Inc.
New York City

Contents

Acknowledgments

The acknowledgments of the authors are addressed first to *Paul-Louis Martin*, ethnographer at the National Institute of Civilization, Ministry of Quebec Cultural Affairs. He has shown a great interest in our study, has reread the text and, thanks to his experience, thrown more light on certain aspects of it.

Louis Martin has likewise aided us by indicating the whereabouts of many articles, which enabled us ultimately to photograph them and insert them in the text.

We must also thank all the libraries, music conservatories, antique dealers, and private collectors who have graciously opened their doors to us and put at our disposal their treasures and their vast knowledge. The list would be too long if we had to enumerate them all.

We would also like to thank cordially all those French Canadians who welcomed us and patiently endured our interviews and inquiries when we were carrying out our research.

Finally, it would be unthinkable not to mention the collaboration of Pierre Pelletier and Jean-François Mercier on the photographic plan.

MICHEL LESSARD
HUGUETTE MARQUIS

Preface

There has long been a need for such a guide to French-Canadian antiques. Recent years have seen an unprecedented increase in the number of Quebecois collectors and connoisseurs of antique objects who have begun to investigate the evidence of their ancestors' material culture.

One can argue endlessly about the delay we French-Canadians have been guilty of in investigating our patrimony, but if our Anglo-Saxon and American neighbors have outstripped us, it is due in part to their popular reviews and antique guides which have greatly disseminated the accomplished research on the subject.

Since 1960, studies of great value have been published in Quebec, and especially in Ontario; the only reproach (which is hardly one at all) that can be made against these studies is that they are very specialized or often very expensive, making them ultimately inaccessible to the greater French-speaking public.

Michel Lessard's "Guide" therefore responds to the need for a complete reference tool on all aspects of French-Canadian material life before the 20th century.

The book has been conceived in a modern, visual fashion: a presentation of the types of objects, a short description of the manufacturing techniques and their evolution, some words on the intrinsic value of the works, and finally a descriptive catalogue utilizing many sketches and photographs. Never to my knowledge have the antique objects of Quebec been elucidated in such a precise and useful way. The ability of the author is first-rate, as is the drawing talent of his wife, Huguette Marquis.

Compliments must likewise be given for the incisive selection of photographs. The author rejected, whenever possible, pieces which were too well known, or schemes which were conventional or unenlightening.

Young collectors, and they are numerous, will find in this book a complete guide, easy to use, and accessible. All French Canadians who consider selling, buying, or even destroying some antique object, whatever it may be, will find their interest piqued here. Even longtime devotees will be instructed, and their first reaction will be: "Ah, if we had only had this guide 15 years ago. . . ."

The study and diffusion of French-Canadian material culture has finally left the exclusive realm of the specialists. Popular art again finds the home in which it was born. The government, the universities, the varied educational facilities are undertaking research on the everyday life of yesteryear. Truly, this is a volume that we have been waiting for.

PAUL-LOUIS MARTIN
Ethnographer

Foreword

During the last twenty years, there has been an unprecedented interest in old things in Quebec. Antique stores have sprung up like mushrooms in our large cities and in the countryside; a market has been organized to satisfy a greater and greater demand. The professional gleaners—who formerly sold their merchandise in the United States—have now directed their wares toward local markets.

With time, connoisseurs of French Canadiana have become more and more demanding, and have made the entire craftwork production of their ancestors the object of a veritable treasure hunt, to such a point that certain sectors of the material culture have been nearly exhausted. The countryside is literally being dug up for anything which manifests the taste and skill of former generations. What previously had been relegated to some shed or attic is now being put back in circulation, to bring a little warmth, a little soul to modern interiors.

What was at the beginning of the century a manifestation of some eccentrics has become such a rage that certain articles having an esthetic and sentimental value are sure to be replaced by copies or European imports that will be sold at very high prices.

The infatuation of the beginners, oriented especially toward furniture of regional French inspiration, will very quickly change direction. Every sector of the early artisan's activity will find its connoisseurs. It was therefore necessary to publish a complete guide to French-Canadian antiques: first, to initiate the neophyte; and second, to help the connoisseur.

This general guide to antiques is designed to respond to this first need by presenting the object and the principal fields of interest of the collectors. For better comprehension, we believed it best to show models of objects in several sketches and then to show the evolution of the forms, demonstrating the diverse styles, diverse epochs. The purpose of this information is to give evidence of our forefathers' sense of creativity to the new devotee, to reveal to him the varied sectors of production, and to make him understand a little better what he is offered in antique stores or what he can discover on his own in some nook or cranny.

For the connoisseur or the specialized collector, this volume is designed to be a general synthesis of past works. It is not an exhaustive study of glass, firearms, silver, toys, artworks. . . . Certain areas have been previously explored by specialists who have produced extensive studies, from which the refined collector will take complementary information.

Our objective was to show the areas of early production, to demonstrate the great stages of evolution, and to illustrate the most representative specimens of the genres and the epochs. For certain categories such as tools, pewter, ceramics, arms, and articles of the forge and foundry, the paucity of French studies published in Quebec makes each of these chapters a unique examination.

We have thought of the buyer, but also the seller. Many a rural or urban home still hides treasures of the past, and one often asks the question: "How old is such and such an article, and how much is it worth?" This book thus will aid the uninitiated who is interested in some element of ancestral patrimony.

In the course of our study, we have encouraged the use of the term *French Canadiana* rather than *Canadiana*. All through our study, we have stated that French-Canadian production differed somewhat from that of the rest of Canada. Though all antique finds in the country were previously labeled Canadiana by the majority of amateur collectors or specialists, the term Canadiana takes in much of the English material culture of the post-Conquest era—more particularly, of the 19th century, when Anglo-Saxon influences are more perceptible in the creations of the Quebec artisan.

In spite of this very strong English influence after 1760, the old French flavor continues to appear in the majority of articles of artisan manufacture. Be it in furniture, or ironwork, or tinwork, or tools, or even ceramics, the designs, patterns, and techniques

imported and developed under the French Administration continue autonomously or are mixed with the contributions of the new colonizers.

In effect, despite the defeat, all our French forefathers who settled on the farm or in the village, along the St. Lawrence or near an important river, changed their way of living and working very little. We will have to wait for the industrialization phase of Quebec, in which the investors and administrators will generally be of English origin, to witness the end of our traditional art. French Canadiana takes in, therefore, all the objects of French-Canadian material culture which were made in New France and whose forms persist until the end of traditional local craftsmanship, up to the end of the 19th century.

In observing the articles on the French-Canadian antique market, we have attended to certain questions. How old is this piece of ceramic? What technique did the tinsmiths use to make their steeplecocks? How can one distinguish the original piece of furniture from a copy or a restored piece? To what style does this armchair belong? How can we restore that old copper bed from the Victorian era? To further satisfy our curiosity, we have relied upon some specialized indices, specific studies, old catalogues, papers, public and private archives and, ultimately, the oral tradition.

This guide does not respond to every question and does not constitute an exhaustive treatment of all aspects of French-Canadian material culture. That is well understood when one knows the immensity of the task and the paucity of documents at our disposal. Many sources remain to be examined. This is a work which is above all a synthesis of present knowledge; it is hoped that the lover of old things, the student, the uninitiated, will understand a little better the French-Canadian life of yesterday.

MICHEL LESSARD

Glossary

Acanthus
Sculptured ornamentation resembling acanthus leaves, as in Corinthian columns.

Adze
Cutting tool with a thin arched blade sharpened on the concave side and set at right angles to the handle, used principally for rough shaping of wood.

Antiquities
From the Latin "antiquus"—old; old things.

Anvil
Heavy, usually steel-faced iron block on which metal is shaped, as by hand hammering or forging.

Argand (lamp)
Lamp with a tubular wick that admits a current of air inside as well as outside of the flame.

Armoire
Large cupboard, wardrobe, or clothespress.

Arquebus
Portable but heavy gun with bent stock.

Artisan
One trained to manual dexterity or skill in a trade; a craftsman.

Astral (lamp)
An Argand lamp with flattened ring-shaped oil reservoir.

Bahut
Chest or cabinet having rounded top.

Baluster
Vertical member having a vaselike or turned outline.

Baroque
Style of art prevalent especially in 17th century, marked by dynamic opposition and energy, employing curved and plastic figures, and elaborate and sometimes grotesque ornamentation.

Beakiron
The taper end of an anvil.

Bennington
Pottery made in Bennington, Vermont, glazing similar to Rockingham style.

Buffet
Cupboard or set of shelves either movable or fixed to a wall for the display of tableware; a sideboard, often without a mirror.

Cabriole
Form of furniture leg curving outward from the structure which it supports and then descending in a tapering reverse curve terminating in an ornamental foot.

Camphene (lamp)
Lamp using a mixture of oil of turpentine and alcohol.

Canape
Long sofa for several persons.

Candelabra
Large candlestick or ornamented lamp having several arms or branches.

Cant hook
Wooden lever with blunt end, often with a toe ring and lip instead of a sharp spike.

Cartouche
Scroll-shaped ornament or member sometimes used for inscription, often bearing a design or a coat of arms.

Cartwright
One who makes carts or wagons.

Caryatid
Draped female figure supporting an entablature in the place of a column or, in furniture, a leg.

Chamfer
The surface formed by cutting away the angle of intersection of two faces of a piece of timber, stone, or metal; a beveled edge.

Chevron
An ornamental unit shaped by two diagonal strips meeting at an angle, often used as one of a number of attached identical units forming a continuous zigzag.

Commode
Low chest of drawers or a cabinet on legs.

Cooper
One who makes or repairs wooden casks or barrels.

Cornucopia
Decorative motif in the form of a curved goat's horn overflowing with fruit and grain at the mouth.

Coulter
Knife or other cutting tool attached to the beam of a plow to cut the sward in advance of the plowshare.

Cramp iron
Metal piece attached at the side of a horse-drawn vehicle where a front wheel may rub when cramped.

Crosier
Structure with a curled or coiled end.

Crozer
The groove at the end of a barrel stave in which the barrel head is inserted.

Dentil
Small rectangular block in a series of teeth-like projections.

Dovetail (joint)
Flaring tenon shaped like a dove's tail which fits tightly into a mortise to make an interlocking joint between two pieces of wood.

Dowel
Circular pin fitting into a corresponding hole in an abutting piece of wood, to act as a fastener.

Dropleaf
Table leaf hinged to the side or end of table and folded down when not in use.

Emery
Common dark granular substance used in the form of a powder for grinding and polishing.

Escutcheon
Protective or ornamental shield, flange, or border resembling a coat of arms.

Festoon
Decorative chain (as of flowers or leaves) hanging in a curve between two points, or a carved, molded, or painted ornament thus shaped.

Flail
Instrument for threshing grain from the ear consisting of a wooden handle and a stouter or shorter stick swinging from the end.

Fluting
Series of vertical grooves used to decorate columns in classical architecture, and similar ornamental grooves in furniture or silverware.

Fretwork
Ornamental work often in relief consisting of small, straight bars intersecting one another in right or oblique angles, or often of solid slats intersecting each other.

Gadroon
Fluting or reeding that is usually short in proportion to its width and often approaches an oval form; produced by notching or carving rounded molding.

Glazing
Glassy silica-contained mixture of oxide that is applied and fused to the surface of clayware for decoration or to make it nonporous.

Grandfather clock
Large pendulum clock having a long upright case usually taller than 6½ feet.

Gueridon
Small stand or table usually ornately carved and embellished.

Guilloche
Architectural ornament in the form of two or more bands twisted over each other in a series, leaving circular openings which are filled by round devices.

Hitchcock chair
Turned, usually rush-seated chair with legs and back slightly bent, a top rail and back posts above the seat, and a finish usually of black paint and stenciled decoration.

Incunabula
Work of art of an early epoch.

Joiner
Woodworker who constructs articles by joining pieces of wood, especially for doors or stairs.

Knacker
One who buys up old structures for their constituent materials.

Lozenge
Figure with four equal sides and two acute and two obtuse angles, such as a diamond or rhombus.

Marquetry
Decorative process in which elaborate, usually floral patterns are formed by the insertion of pieces of wood, shell, or ivory into a wood veneer, which is then applied to the surface of a piece of furniture.

Mortise
Rectangular cavity cut into a piece of timber to receive a tenon.

Ogee
Molding with a profile in the form of a letter S.

Palmette
Conventional ornament of ancient origin consisting of radiating pedals that spring from a base; closely related to the Egyptian lotus.

Pastel
Paste composed of a color ground and compounded with gum water, used for making crayons.

Patina
Film formed naturally on copper and bronze by long exposure to the atmosphere, or the finish of any old object.

Peavey
Stout lever with a strong sharp spike at end, used in lumbering.

Pickaroon
Piked pole with a hook used by lumbermen in river drivings.

Planisher
Hammering tool used to toughen, condense, or polish metal.

Polychrome
Decorated in two or more colors.

Porcelain
Hard, fine-grained, usually white ceramic ware that has a hard paste body, used especially for table and ornamental wares.

Rabbet plane
Openside plane with the plane iron extending to the outer edge of the open side to permit planing of sharp corners and grooves.

Rattan
Portion of the stem of rattan palm used for wickerwork, chairs, seats of chairs.

Ripsaw
Coarse-toothed saw for cutting wood in the direction of the grain.

Rocaille
Style of ornamentation developed in the 18th century and characterized by forms derived from the artificial rockwork and pierced shell-work of the period.

Rockingham
White earthenware covered with brown glaze of varying shades.

Rococo
Style of artistic expression characterized by an often fanciful and frivolous use of flowing, reversed, or unsymmetrical curved lines and ornament of pierced shellwork.

Rosette
Ornamental disc consisting of leafage or a floral design, usually in relief, used as a decorative motif.

Roundel
Plain or colored glass disc; circular table or tray.

Sadiron
Flatiron pointed at both ends and having a removable handle.

Scalloped
Series of curves forming an edge or design.

Scythe
Implement used for mowing grass, grain, or other crops, composed of a long curving blade fastened at an angle to a long handle.

Settee
Long seat having a back and made to accommodate several people at once.

Sickle
Agricultural implement consisting of a hook-shaped metal blade with a short handle.

Sideboard
Piece of dining room furniture having compartments and shelves for holding table service.

Staffordshire
Glazed ceramic ware produced in Staffordshire, England, in 18th and 19th centuries.

Stave
Narrow strip of wood or narrow iron plate placed edge to edge to form sides of a structure.

Tenon
Projecting member in a piece of wood which when inserted into a mortise forms a joint.

Tiffany (glass)
American glassware made in late 19th and early 20th centuries often characterized by an iridescent surface.

Tuffet
Low seat, as a stool.

Turnbuckle
Link with a screw head at one end used for tightening a rod or stay.

Veneer
Thin sheet of wood cut from a log and adapted for adherence to a smooth surface; usually of superior grain and quality used to cover inferior wood.

Volute
Spiral or scroll-shaped ornament.

Wicker
Small pliant twig or osier rod for plaiting basketwork.

Wimble
Tool used for boring holes.

Windsor (chair)
Wooden chair of stick construction having a spindle back, turned raked legs, and usually a saddle seat.

Complete Guide to French-Canadian Antiques

Why Take Interest in Old Things?

*Happy the man who still owns
the humble abode of good, grey
stone, built by an ancestor,
among trees, beside water,
near a church, which satisfies
both his heart and his mind.*

ALBERT LOZEAU

*The art of handicraft identifies
us with the object, not
through a mere impulse of sympathy,
but because it is the
prolongation of ourselves,
born of our aspirations, both
physical and psychological.*

KAMALADEVI CHATTOPADHYAY

The Desire to Return to Sources

The professional gleaners scour the French-Canadian countryside to hunt for the booty their clients crave. With wagons filled to overflowing with relics for the antique stores of Quebec, it will no longer be our neighbors to the south who profit from French-Canadian heritage.

If on a beautiful Sunday afternoon, you stroll through the countryside around a large city —old Montreal or old Quebec, for instance —you will be surprised at the number of antique shops there are, and how many of the browsers in them are not just tourists.

More and more people—young couples in particular—are tending to enrich their households with a rare piece of furniture—a brass bed, a chest, a plain pine wardrobe, an old Victorian-style gilded frame, some native pottery, objects that bring a breath of life

into our cement towers and conventional split-levels.

For the past fifteen years, this infatuation for antiques has been increasing. Before the sixties only a few specialized collectors appeared to be interested in the tangible goods of Canada's patrimony, and most of them came from the well-to-do and so-called intellectual circles of society. One has only to check the list of owners of the beautiful antique furniture in Jean Palardy's[1] book to become aware of this. Not only private individuals but commercial organizations as well have used handcrafted objects of the past to decorate their offices or hotels to give them more indigenous character; this, to be sure, rebounds entirely to their honor.

Up until relatively recently, ignorance and lack of interest in their rich heritage led people to destroy or shamefully vandalize whatever old pieces they had not simply relegated to the attic. Not so long ago it was not unusual to find a lozenge-carved wardrobe that had been sawed in half and tucked away in the dairy of some farmhouse, or an old pine cupboard being used as a workbench or for storing tools in the back of some barn.

However, with the "quiet Revolution," Quebec decided to make another pilgrimage to its sources, as happens in every outburst of nationalism. Since 1960, a sudden collective awareness of both their riches and their possibilities has instilled new energy into the society as a whole. Certain developments, especially in cultural and technical fields, have increased our pride, our feeling of being Quebecois for at last we have become aware of the wealth of our heritage and distinctive character.

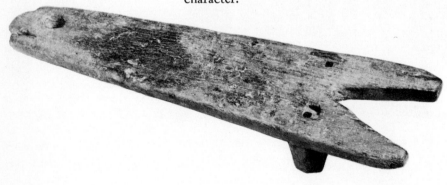

Wood boot jack. 19th century. (Emile Pellerin, Trois-Rivières.)

But that pride must have historical foundations; thus while still deeply interested in the challenges of the future, the people are gradually turning to the past. For many, the handicraft produced by their ancestors, often under harsh conditions, will undoubtedly become the center of their interest in bygone eras.

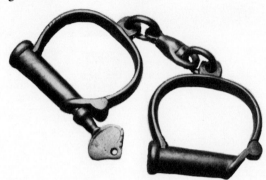

Pair of handcuffs used to subdue criminals. (Private Collection.)

In this revitalization of the past, there is a noticeable reaction, not to say a more or less conscious opposition, on the part of a consumer-oriented society on which has been inflicted for years a certain mode of life, to a type of merchandise based on preconceived arrangements of furniture and articles used in daily life. True, the local emporiums offer "Spanish," "French provincial," "American colonial," "Scandinavian," and other such styles, but these products are more or less foreign to our environment. And more than one lover of French Canadiana will, unconsciously perhaps, evince an interest in local old things, in deliberate reaction against a way of thinking imposed by commercialism and which reveals none of the true spirit of the country, and will opt for the craft products of their forebears with which they can identify.

This return to the sources, this pride, this fondness for things from our past, was in short order perceived by the taste merchants: large department stores promptly began displaying antiques in their windows, using cupboards, church ornaments, wooden wheels rimmed with metal, as decorative backgrounds against which various consumer goods could be more attractively displayed. A shop selling women's shoes uses old chapel benches scraped to the grain, as seats for the customers, and displays its merchandise in old open pine wardrobes; a men's haberdashery looks like a living room in a traditional peasant house.

1. Palardy, Jean. *The Early Furniture of French Canada.* MacMillan of Canada, 1963, 413 pp.

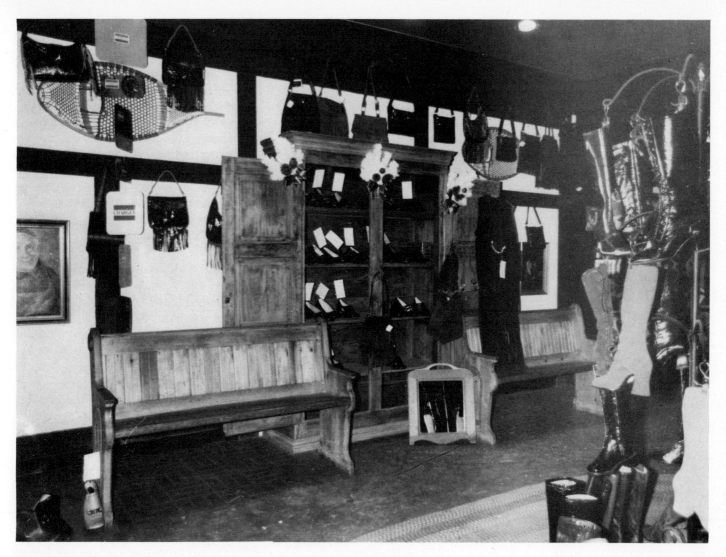

*Store furnished with old
pieces of furniture.*

Not only window-dressers, but architects, too, draw on primal sources for inspiration. Note how many houses sold as Canadian and patterned after the model of the original settlers' homes are built in our suburbs nowadays. Dormer windows, roofs peaked to 50 to 60 degree angles, seeming absence of cellars, windows with twenty-four panes, buildings of natural stone, all seek to give the impression that even if the owner is not the fortunate possessor of an ancient fieldstone dwelling, he is at least living in an old house. Those "Canadian" houses that are in the final analysis only copies of French styles, follow the present fashion by turning to early Quebec provenances.

The interest in old things is not due solely to a fashion born of the aspirations of a people. Esthetic appeal, added to patriotic sentiment, accounts for much of it. Long prior to the recent socio-political changes in Quebec, there were amateur collectors already assembling splendid collections. Life

within our home comprises an important part of the time at our disposal. We need, therefore, an interior that is warm and attractive, restful on long, rainy autumn days or dark winter evenings, particularly since our climate keeps us confined within four walls a good part of the year. For some people, antique furniture will help to break indoor monotony.

Those pieces of furniture that have come down through the ages have earned the approbation of several generations to such an extent that even today, many enterprises specialize in making wardrobes with diamond points, two-tiered cupboards in the style of Louis XIII, pine tables, woven wicker chairs. This victory over time and these reproductions made by the modern craftsman, are tributes to beauty of line and certification of work well done. Ugly objects with awkward shapes have disappeared of their own accord.

The lover of antiques has an almost un-

limited choice, be it in styles, types of furniture, or household articles. There are mementos of past ages to satisfy all tastes, even the most esthetically demanding, and within the reach of even the flattest purse. All one needs is a modicum of good business sense, a little luck, and the courage and patience of the restorer.

Texture and color are two other qualities that attract one to antique furniture: the light reds, soft greens, the blue-greens, or the golden patina that appears on handmade furniture after it has been cleaned or rubbed down, not to mention the chestnuts and natural browns of varnished and lacquered woods of furniture of Anglo-Saxon derivation.

Two other important qualities in articles of the past are balance and harmony. The care the carpenter or cabinet maker has taken will be obvious in Louis XIII style wardrobes or cupboards, where the balance of door and side panels, allied with the symmetry of the decorations, sending a very special grace to the whole. The craftsman, to preserve the symmetry of detail, may have put a false lock on the front of certain wardrobes, though the doors lock from the inside. Or again, in the massive, austere bedroom furniture of the late Victorian era, ornamentations of worked wood repeated symmetrically at the head and foot of beds or on dressing-tables give a pleasing equilibrium to the whole.

And finally, in this classic furniture, one must also speak of simplicity of form and decoration. The lines of the great French-English styles which served as our models were inspired by forms of Greco-Roman antiquity. Sobriety, simplicity, refinement, all these qualities can be attributed to our furniture and to numerous other old objects.

In addition to the esthetic appeal of old furniture, mention must be made of functionalism, whether in the handmade furniture of Quebec or in furniture inherited from Anglo-Americans. And here it takes more than an amateur to know how to buy successfully.

Local handcrafted furniture was built to make the greatest use of interior space. Because of the climate, the *habitant*, or settler, was forced to limit the size of his rooms; however, he also tried to retain the greatest amount of open space possible so as to be able to move about freely. Furniture, in order not to interfere with that freedom, therefore had to be made to accommodate these limitations. Wardrobes and cupboards, shallow, broad and high, and painted in striking colors, were, in addition to being useful hold-alls, a great help in brightening poorly lit rooms. The desire to take maximum advantage of indoor space led them to the copying of the corner-cupboard, with the result that corners, generally considered dead space, were widely used.

The same may be said of furniture of Anglo-Saxon inspiration: Chippendale, Hepplewhite, etc. These pieces of furniture are still practical, useful, take up little room, and are also very decorative. The owner who has to move, or who buys a wardrobe and is obliged to take it apart before he can get it across his threshold will find that it is easily dismantled. A friend of mine moved a suite of bedroom furniture of the late Victorian era from one apartment to another. All the pieces, once taken apart, could be fitted into an elevator eight feet by four.

Moreover, old furniture is strong. Open a drawer of a commode or the door of a cupboard or a wardrobe: see how carefully the mortised or dovetailed joints have been reinforced with wooden dowels, nails, and glue. The carpenter-craftsman did not choose thin plywood planks to make his furniture, as craftsmen of our day so often do. He worked with stout boards of pine, cherry, maple, or oak, solidly assembled. This sturdiness does not necessarily mean that the furniture is immovable or heavy: dry woods are surprisingly light, and a huge wardrobe is often astonishingly easy to move about.

Another quality of old furniture is ease of maintenance, of particular interest to the housekeeper. Once cleaned, the old bed, the grandfather's chest, or the family table need only be polished and dusted now and then. The wood of old furniture has a sheen and a special, inimitable surface texture, the result of frequent usage and the wear and tear of time: this is called a patina. A few extra marks, a few scratches will not alter the beauty of the wood; it might be said that it is inured against further hazards.

The Pleasure of Owning an Unusual Object

Many amateurs will dig into the legacy of durable goods and wares out of a liking for the bizarre, the unusual. I once called on a man who collected old tools, ancestors of the present-day saws, planes and modern chisels. Many pieces were veritable jewels of inventiveness and creativity. Craftsmen had finished to perfection ingenious tools that no longer have a place in the modern world, but which, a hundred years ago, were in regular use. So vast is the number and variety of these tools that the names of several recently discovered ones are not even known nor can they be attributed to any particular profession.

Open cast-iron stoves, tools and instruments, sidearms, primitive firearms, sugarmills, butter molds, are some of the pieces eagerly sought by collectors of curiosities. Other collectors are more interested in the historical origin of an object or in the renown of its owner: the ball from Montcalm's cannon, the medical case that belonged to the king's physician, the bedside book of Philippe-Aubert de Gaspé, a piece of table silver that belonged to Madame de Pean, formerly on overly good terms with Administrator Bigot, as well as antiquities shrouded in mystery.

Some people are attracted to old pieces in the interest of speculation and the monetary rewards such a hobby can bring them. An example would be those wardrobes with lozenges, diamond points, or linen folds. A few years ago they could be bought for $100; today they sell for $2,000 each. The same holds good for silver, provided one is an experienced amateur. The ignorance of the general public on this subject has made the fortune of more than one speculator in this field; and even today it is not unusual to see a farmer sell a rare, ancestral heirloom for a ridiculous sum. The speculator is well aware that it is not only age that makes a piece valuable. Balance, the state of preservation, the number of repairs it has had, its solidity, originality, and scarcity are all more important than the single factor of time. These are the principle criteria that will aid the specialist in fixing the price of an article.

But fluctuations in the value of antiques are relative. To speculate successfully, one must have some idea of the value of the article and a strong intuition as to the future tastes and fashion. Here some antiquarians have the flair of a detective.

Mixing Styles

This love of antiques is explained not only by the warmth, durability, and functional qualities of such articles, but also by the fact that a combination of old with modern is becoming more and more accepted. Old houses may be done in contemporary style, provided certain rules are respected, as witness the article by Jean-Pierre Lenz in *Réalités*,[2] but the reverse is equally valid: the old can be grafted on to the modern, and the two kinds even mixed. Not all devotees choose to do a bedroom or living room completely in antique style down to colors, draperies, fabrics, mirrors, china, lamps, etc.

There is no incompatibility in combining old furniture with a modern interior. We live in a world where contrasts are increasingly numerous and more obvious. Versatility, desire for change, are human characteristics. The many interests and contradictions of everyday life are also reflected in the different types of collectors, the articles they collect, and the way they arrange their acquisitions.

Old furniture, even the most massive, can fit very well into modern architecture. Today we live for the most part in cement skyscrapers, bungalows, or split-level houses with large wall surfaces that are always painted in light colors. Perhaps the idea is to obtain more light or give a greater impression of space, though economy and bad taste undoubtedly play their part, particularly in the clusters of apartment houses that are springing up like mushrooms in the suburbs of our cities. This naked look of interiors is accentuated by the renter's obligation (and the owner's regulations) not to cover the walls with fabrics or ornamental fixtures under pain of having to pay later for damage to the property.

For some time, however, people have become aware that color and accessories add warmth and intimacy to interiors. Antiques are being used with increasing frequency as one of the ways many amateurs vitalize those sterile houses and apartments. What could be more attractive than a hardwood Victorian bedroom suite in different tones of brown, surrounded by four white walls whose mo-

2. See *Réalités*, May 1970, No. 292, pp. 76 to 83. Jean-Pierre Lenz, "Yes, One Can Mix Modern With Antique."

notony is enlivened by a few picture frames of the period; add curtains, a bedcover, a terra-cotta vase overflowing with dried flowers, chamber pot, kerosene lamps—and you have a room that is at once functional, substantial, and very pretty.

It is not necessary to be absolutely strict about conformity to style to obtain a delightfully livable interior that bears the unaffected grace of age. Old furniture that has conquered time will always look well among a few modern pieces or in a setting of diverse styles.

Antiques, therefore, have more than one quality: beauty, durability, functionalism, and easy maintenance, all enhanced by the pride of a people in its heritage and the warmth such articles effuse in chilly interiors. These are some of the factors than explain the fascination for the works of bygone craftsmen. It would now be interesting to define antiquity and to ask what criteria specialists use to label an article "antique."

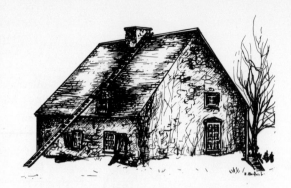

Another early example of Norman influence.

in the Quebec of yesterday. As late as 1860 (and even a little later in some districts), there was a certain continuity in the evolution of our architecture, beginning with French influences. At first, the settler copied models from the mother country as closely as possible: the area around Quebec, with its long and spacious houses came under Norman influences, whereas Montreal, with its square, massive structures favored Brittany-

French-Canadian Houses of Yesterday

Most of the objects that are shown in the following chapters are functional or decorative or both. They were found in different types of domestic, rural, or urban dwellings

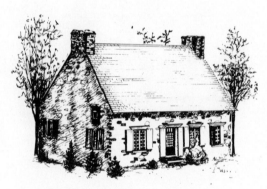

Brittany-type house, Montreal.

type houses. Here, houses and methods of construction reveal various influxes of immigration. But very soon, towards the end of the 17th century, local peculiarities can be observed to have differentiated colonial dwellings from those across the sea, undoubtedly the result of rapid adaptation to the physical environment.

At the end of the 18th century and the beginning of the 19th, the truly French-Canadian house appeared in the countryside and in cities, with all its familiar characteristics. Finally, parallel with this evolution and especially in the 19th century, English and American influences made themselves felt. From Upper Canada, Quebec inherited the house known as "Anglo-Norman." From the United States came the "mansard roof," and towards 1870-1880, there was the English in-

Early Quebec house of Norman influence.

fluence—from Queen Victoria's empire, those spectral "Victorian" mansions made their appearance here and there.

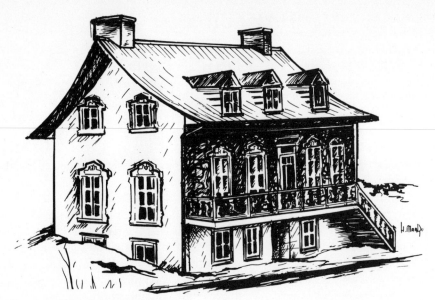

19th-century Québecois house.

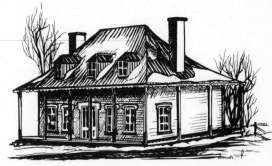

Anglo-Norman house.

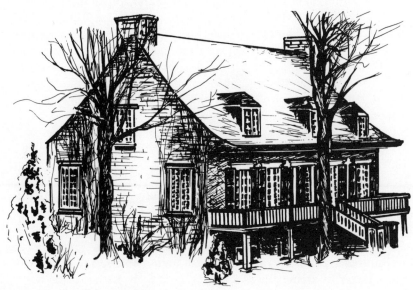

19th-century Québecois house.

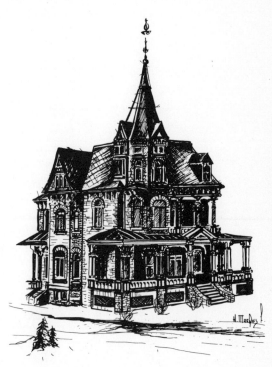

Victorian house.

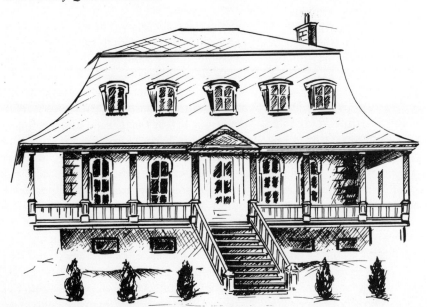

Mansard roof, U.S. influence.

CHAPTER 2

Antiques—in French Canada

During the last war and in the years that followed, the fad for collecting curiosities, often exquisite objects, became widespread. Today it is the fashion to ransack the nooks and crannies of the past and retrieve old furniture. Antique dealers travel through the country, up and down rivers, in search of the booty their clients covet.

MARIUS BARBEAU

The concept of what is past time varies with civilizations, in the world of today, from one continent to another. The Asiatic's origins go far back in the ages, whereas the American's roots lie at most in only four centuries of history, and the European's is part of a continuity that lies midway between these two extremes.

This notion of time influences the idea of what is antique. To an American, his great-grandfather's musket will have considerable importance. It will be the precious object, rare and old, that he hangs above the stone fireplace and exhibits proudly to relatives and friends. In the European, an object of that age would not necessarily arouse the same emotional responses. Heir to more than two thousand years of history, evolution, and creativity, for him antiquities will have a profounder dimension. Thus, to the Frenchman, it is the pre-revolutionary object that will give him a sense of the exceptional, of the value and beauty of the years that haunt it.

For the French Canadian, time leads back through three hundred and fifty years of history marked by the struggle to adapt to a new land, by territorial pursuits, and by efforts to establish a national identity. Early Canadians were compelled to overcome the difficulties of a vast territory and surmount their remoteness from any metropolis or important center. From the very beginning, this gigantic country forced them to depend upon themselves for all their material needs and to rely on their own initiative. Ingenuity and patience, skill, and the will to succeed became the characteristics required of the Canadian pioneer.

Not only did he need to adapt to a life of isolation, but to the climate and physical environment as well. Moreover, he had to accustom himself to foreign, colonial and cultural occupations. Nevertheless, the struggle and the reverses, the unfortunate socio-economic fluctuations, though they may have concealed or dimmed them, have not altered the French Canadian's feeling of pride, his sense of having roots and riches. Today in the '70's, then, every old object is testimony to his adaptation and strivings at every stage in his brief span of history, when confronted with the immensity of the land, with the changes and the new currents of civilization, with progress.

Etymological and Legal Definitions of Antiquity

Etymologically, the word "antiquity" comes from the Latin *antiques* and means old, ancient. According to Larousse, the term "antiquities," when used in the plural, refers to objects whose value is founded on age, but does not specify any limits in time or dates. According to this definition, therefore, everything old is antique. The law and the thinking of antiquarians, however, are more precise: they require that the object or article in question shall have attained a specific minimum age before that title be bestowed upon it. This has been a problem for legislative study, inasmuch as the fixing of a tariff or a customs tax on imports and exports will depend upon knowledge of the age of the object. By the terms of Canadian law, revised in this regard in 1967, an object is classified as *antique* after one hundred years of existence. If the seller or the purchaser can prove that this is so, there is no tariff.

This law, however, varies from country to country. In the United States, Congress established in 1930 that any object anterior to

1830 could be classed as antique. As a result, today the American legal definition covers 140 years. On what criteria, then, can one rely to catalogue an article as being antique? Canadian law has said that one hundred years is sufficient, but, for more than one expert, it is not necessary, in many cases, to go back so far.

The first valid test is relatively subjective. The age an article must be before it can be classified as antique depends upon individual opinion. Some collectors contend that the article must predate 1830; for others, the beginning of the 20th century is a respectable limit. Nevertheless, in the world of antique dealers and collectors, there are certain empirical rules, established several decades ago, that more or less define that limit

In general, an article is considered antique when it has that distinctive air of handiwork that goes back to times that evoke particular sentiments and memories. For many admirers of French Regency, the only articles that can be called antique must have been made during that period. Others are inclined to call any handmade product an "antique." It would therefore appear that any handcrafted article of relatively esthetic value and which, through the passing time, has become a stirring reminder of an epoch different from our own, deserves to qualify as antique.

Just as not all people have the same concept of time and old age, so one can say that things do not age at the same pace in relation to each other. For example: a Victorian piece of furniture is relatively old, since the onset of that era goes back more than one hundred years. On the other hand, a piece of pressed glass from the same period will be even more precious to the experienced collector, for at that time the Canadian glass industry was in its early infancy. An automobile from the beginning of the 20th century is an antique, whereas most pieces of furniture made then are merely old things, not to say old junk. We therefore suggest a few dates that will allow the amateur to label the articles he owns as antiques. These limits are subjective, as will be easily understood when you read the chapter on each particular object.

FURNITURE:	c. 1880 (c. abbreviation for Latin *circa*: about.)
WOODEN OBJECTS:	sugar mills, c. 1900; butter molds, c. 1900;
	clocks, c. 1870, spinning wheels, c. 1870
TOYS:	c. 1915
FIREARMS:	c. 1900
GLASS:	blown, c. 1870; pressed, c. 1900; English importations, c. 1870
SILVER:	Quebecois, c. 1870; American, c. 1850
PEWTER:	c. 1870

Antiques and Old Things

Then what happens to those piles of grandmother's souvenirs one often preserves so carefully and to which, ordinarily, one attaches great importance? It is a mistake to present articles which date back only two or three generations as antiques. Great-aunt's rattan sofa or the bellows camera of the '30's that grandfather brought along on the picnic are merely old things of which numerous duplicates may be found in any second-hand shop and which must wait before they can be officially declared antiques. Sentimental criteria alone are not sufficient, but there is nothing to prevent us from considering these objects as mementos, touching curiosities, or from keeping them in a place of honor in our homes. It all comes down to a matter of taste, and there is nothing more personal than taste.

A common error is assessing the age of an article by adding up the ages of its successive owners. As an example: take that chest of drawers which, let us say, you found in the 30's and which you have just inherited from your mother, aged sixty-two, who had it from her mother on the latter's death at the age of eighty-two. If we take the sum total of those ages, we arrive at 174 years. The chest would then presumably date back to the end of the 18th century or the beginning of the 19th.

In reality, the article in question is between sixty and eighty years old if we take into account the fact that your mother was forty when your grandmother died. The chest of drawers may have great sentimental value, but it is far from being an antique; "old thing" is again the qualification best suited to this object.

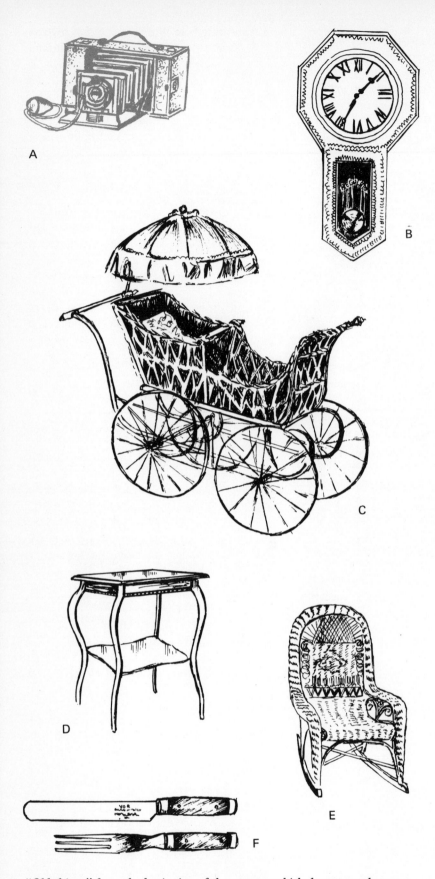

"Old things" from the beginning of the century which do not yet deserve to be called "antiques": (A) Bulb camera; (B) Clock; (C) Baby carriage; (D) Table; (E) Rattan rocking chair; (F) Kitchen utensils.

The Value of Antiques

The value of antiques varies according to the vagaries of fashion. The antique dealer's competence, the rarity of the piece, its condition, the prestige of the material used, the type of object and its "pedigree," all influence price. One need only make the rounds of various shops that sell old furniture to discover these subtle differences. If you are trading with someone who knows the origin of the pieces on display, their rarity, and the working methods of another age, there is a good chance the price will be a fair one. If, on the other hand, your salesman looks like a second-hand shopkeeper, he will fix his price more by instinct or according to what he thinks the customer will pay. In that case the amateur can be taken for an exorbitant sum for an object of little value.

More important than beauty as a criterion is rarity. Philately and numismatics offer any number of examples illustrating this point. An object can be rare, but it must not be too rare, for it must be known. Many French-Canadian pieces of handmade furniture are impossible to find on the market today, and as a result of the demand for them, their value has quintupled and, in some cases, even multiplied by twenty.

The condition of the article will also play a part in determining its worth. Its symmetry and style, easily observable on a general examination, will immediately give one a sense of the beauty of the piece. If, in addition, the quality and style of this handsome piece make it a fine example of its era, its value can only grow. The cabinetmaker's work, his skill and dexterity, his attention to fine detail are further qualities that will affect the initial value of the object. Finally, if time has not too greatly deteriorated or mutilated this product of another age, its price will always increase.

The kind and quality of the material used are also criteria for determining value. Objects made of precious metals, like silver, will always be worth more than those made of glass. There are imported woods that are more sumptuous than the local species used in making furniture. A tool, to mention another example, will never be as attractive as a piece of Dion pottery. The kind of article, therefore, and supply and demand will help the dealer put a price on his wares. And finally, the value of an article is augmented if it has a prestigious "pedigree." Any work that can be traced to a specific craftsman-

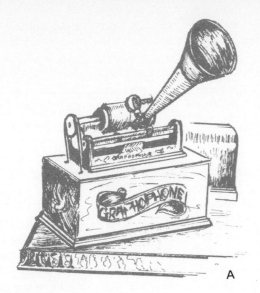

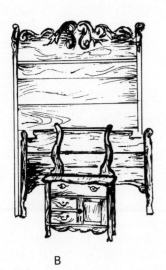

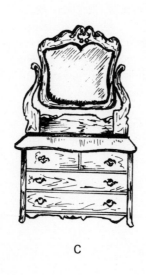

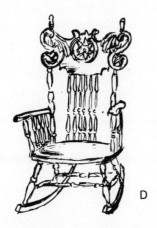

(A) Gramophone; (B & C) Bedroom furniture; (D) Rocking chair with horizontal crosspiece decorated with a plume pattern pressed in by steam.

designer or whose line of successive owners is clear assumes a special importance; and all the more so if one of the early owners is historically famous for some memorable deed.

The Fake and the Semi-Fake

As we have seen, fashion plays an important part in the world of antiques. A concrete example of this is the craze for the past dozen years or so for traditional handcrafted furniture. The demand is so great that all objects of this sort are eagerly sought out at high prices by numbers of amateurs. The resulting scarcity, created by that kind of a demand, can in turn lead some dealers—cavaliers of the industry—to make connections with good carpenters or other skilled artisans to fabricate copies. There are, now and then, French-Canadian wardrobes in Louis XIII style or rustic pine furniture to be found available on the market, that are in fact of very recent make. With modern tools and especially with the aid of the many techniques, both chemical and natural, for aging wood, these counterfeiters succeed in producing fakes that are sold as antiques and are so like the originals that it is almost impossible to tell them apart.

Buyers should always beware the dealer who tries to sell them Louis-Joseph Papineau's bed or the cast-iron stove from Philippe Aubert de Gaspé's manor house. Some antique traders are like automobile salesmen, past masters at the art of pressure-selling their shoddy goods, and they camouflage their subterfuge by glorifying the object with an historical harangue that must be taken with a grain of salt. You may well be looking at a skillfully disguised fake and the article said to be the only one of its kind and to have a glorious past, will often be instead, a good copy, one of several, and will have no historical value at all.

The semi-fake appears in two ways. When a dealer discovers an article that is in poor condition or that has been mutilated by vandals, he has certain parts re-made by an expert craftsman, and with the help of special wood stains, the article is made to look like a genuine museum piece. However, if the prospective buyer examines the texture and grain of the wood closely, he will quickly

23

discover this disguise. Corners, moldings, cornices, and feet of furniture are often the target of these transformations, which are generally hidden from the buyer.

The other form of semi-fake is the combining of old parts. A dealer who has combed the countryside and collected a number of old wardrobes or rustic chests, rebuilds one or two of them with pieces from the others. The handsomest parts are assembled in accordance with old techniques. If it happens that the woods are different in color, the new pieces are allowed to age out of doors, frequently under harsh climatic conditions. The furniture then takes on a uniform coloring and the surface acquires a patina identical on all sides. It takes a very keen eye to detect such transformations.

I knew of a dealer who made cedar flutes in his spare time the way people made our maple sugar-bowls at the end of the last century. He then let them "ripen" in an old barrel under a water-spout; from time to time he laid them out in the sun to bleach and "age." They were then sold to tourists at fifty cents apiece, and clever indeed was he who could distinguish between the fake and the original.

How to Detect Fakes

Even for the most trained eye, it is still a problem to discern the real from the false, and there are few collectors, even experienced ones, who at one time or another have not been victims of an "antiquarian" with a glib tongue. There are, however, certain basic details that can help the amateur to recognize the authenticity and age of an article, be it a piece of furniture or some other object, of French-Canadian origin.

In furniture, the width of the boards is the first sign to check. In pioneer times, the forests abounded with enormous hundred-year old trees. The logs from such trees would yield planks of pine, cedar, and other varieties from 15 to 30 inches wide. Almost all early furniture was made from this wood and so skillfully that a single plank could be used as a side or door panel. In a number of wardrobes with lozenges or diamond points, the door panels have been carved from a single piece of wood.

This test of authenticity, however, is some-what relative. Today, old pine boards from the floors of century-old houses that are being demolished are used in the fabrication of shams. At this point, the exercise of expertise becomes difficult and doubtful.

A second means, almost infallible as regards furniture, is to check the slight superficial grooving of the planks. Years ago, surfaces were aways planed by hand. The result, observable by touch, was a series of almost invisible hills and vales, a slight unevenness, in sharp contrast to the smooth finish on furniture made in our day. This is even more apparent on the inside of the frame where the craftsman took less pains to level or smooth his piece. By merely running the tips of the fingers under the boards of the table or inside the wardrobe, one can, depending upon the smoothness and whether the grooves were made by old tools or modern ones, determine more accurately the age of the piece.

Speaking of tools, let us add that saw marks can also be a great help in unmasking the fake. The slow, vertical motion of the mill-saw used in early days did not have the same effect on wood as do modern rotary saws that make up to 4,000 turns a minute. Thus a plank, cut in the old way, will not be as smooth as one sawed today, and circular saw marks will not appear on recently cut surfaces.

The use of wood bolts or pegs will also attest to the age and quality of a piece of furniture. It is a more efficient method of joining, and until 1860 cabinetmakers used this technique regularly on most traditional furniture. As a rule, handmade bolts are not evenly rounded; moreover, they always project a little beyond the edge of the plank. 1860 did not mark the end of this method, for the same process was still occasionally used in furniture of the late Victorian era.

Another almost infallible means that will help determine the age of a piece is careful examination of screws, nails, hinges, and all trims, whether functional or not. On this point, screws are fairly revealing, for modern, machine-made screws are conical, tapered, or pointed, whereas screws on the market before 1850 have blunt points that are not as elegant. The conical shape is less accentuated and the point is rarely sharp, so that the screw must be made fast by tapping a hole in the wood with a nail or bradawl so that the threads can get a good grip on the wood.

Nails are also very important in verifying

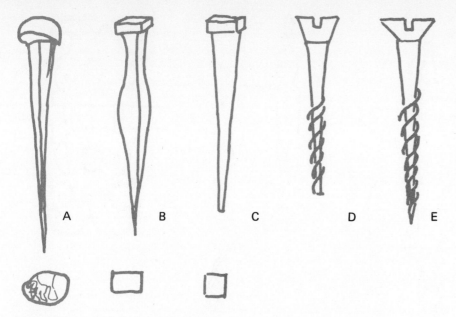

(A) Smith's nail (? to 1830); (B) Square-headed nail and tapered point (1800-1840); (C) Nail with square head and tip (1840 to 1890); (D) Blunt tip screw (before 1840); (E) Ordinary screw, machine-made, with sharp point (after 1840).

teristic of the wardrobe. The rat-tail hinge that supports wardrobe doors of French-inspired cupboards is undoubtedly the best known and the most representative of this type of trim (so well described in the Palardy volume), though it is not the oldest or the one most used. That honor goes to the plain hinge that supports the doors of wardrobes and cupboards of French derivation. This butt-hinge looks like a long leaf, the prolongation of a perpendicuar hinge-pin, that is driven into the frame of the furniture. The second part, the female, nailed or screwed on the door, is in fact only a thin plate of rectangular pierced metal, one end of which has been shorled so as to completely envelope the hinge-pin.

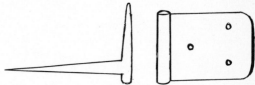

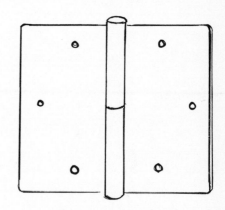

Plain hinge.

Strap hinge of cast iron.

the age of furniture. If you buy a rustic Louis xv style wardrobe and you notice that the nails used to join corners and moldings have a round head and body, you may well question the authenticity of your acquisition, for that type of nail, which is found in hardware stores everywhere, dates back only 70 years at the most.

On the other hand, if the nail heads are uniformly rectangular or square, the piece is undoubtedly not too modern and therefore more interesting. Finally, if the nail heads look thick, heavy, flattened out, and not cut off, if the pin shafts are irregular in size and thickness and tapered on four sides toward the point, you have a genuine collector's piece.

It is easy to find rustic forged nails in furniture made before 1830, although from 1800 to 1830 a new and more refined type was to make its appearance. This cut-off nail is tapered on four sides to a point. From 1830, however, until the turn of the century, it was replaced by the square nail tapered on two sides only and with a blunt point. We find this latter type, with a very blunt point, pyramidal in shape and with a square head, in most of the furniture of the 19th century.

Hinges can also be a valuable help in identifying original furniture. The first hinges were made of wood or leather; few traces of them are found today. One cannot say the same of the first hinges of forged iron. In traditional rural furniture the hinge is a charac-

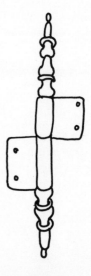

Bead.

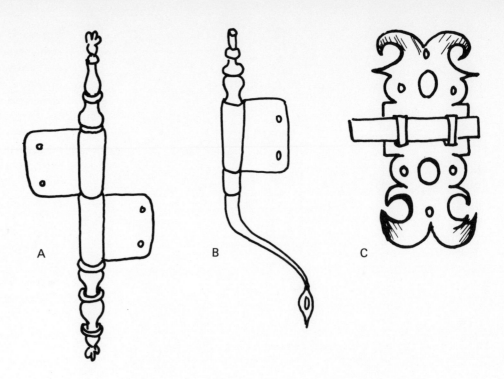

(A) Baluster; (B) Rattail; (C) Both.

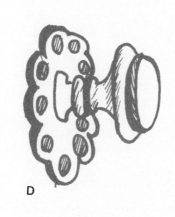

(D & E) Knobs.

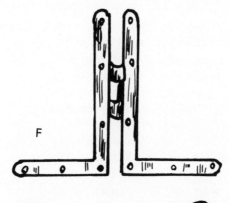

(F) L-shaped strap hinge; (G) Butterfly-wing strap hinge; (H) H & L-shaped strap hinge.

(A) Escutcheon; (B) Knob.

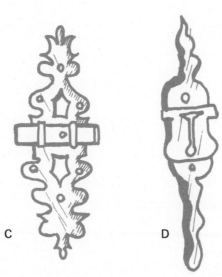

(C) Sash bolt; (D) Escutcheon.

The shaft piece that connects them to the furniture goes completely through the board of the drawer or the door from one side to the other, and is bent back on the inside or held in place by a screw-tap or a metal fastener of the gudgeon (linch-pin) type.

Another good way to verify the age of a piece of furniture is to check the amount of wear and tear it shows. Frequent use of a rocking chair will necessarily thin down the center of the rockers. General rule: all parts exposed to human contacts and friction will suffer this action of time. This will happen to crosspieces of frames and stretchers of chairs where feet have left definite marks. Frequent opening and closing of a drawer or a door will also leave indelible traces. Ordinary usage will wear down corners which originally formed a perfect right angle. Such signs of wear can always be simulated, but if the prospective buyer will examine these particular spots carefully, he will detect the marked regularity of those signs and so discover the subterfuge.

The color of old wood is an additional test of authenticity. All trees, and especially soft woods like pine or cedar, are darkened by the surrounding air and, with the years, turn from white to golden brown on the surface and even in depth. The interiors of wardrobes, cupboards, or commodes have much to tell the expert or alert amateur on this point. The faker of antiques will color the surface, but a slight scratch with a knife will reveal that the wood has been used over and over again.

Dovetailing on antique furniture does not have the regularity and symmetry of modern mortises, which are cut with a special tool. The handwork on antique furniture gives the whole piece an uneven appearance on the surface as well as in depth. The same can be said of wood turnings which, in old pieces, may seem to be regular and uniform. Nevertheless, if you look closely, you will discover that all the patterns in one grouping of furniture are not identical. Thus, in a set of chairs made at the same time and by the same carpenter, each turned part will have its own characteristics.

To tell true from false in furniture may seem relatively easy, since there are numerous criteria to go by, but there again, when you are dealing with a faker who has put his mind to it, it will be impossible to discover the differences and the fraud.

Detecting a copy of an article made of glass, pottery, or metal requires even more

Similarly, bead and baluster hinges will give a touch of elegance to all those pieces of furniture of French provincial influence. Finally, probably towards the middle of the 18th century, the rat-tail hinge was to decorate many a cupboard and wardrobe. H hinges, L hinges, and H-L hinges, more frequently used in architecture than on furniture, are more American in origin. The same can be said of "butterfly-wing" hinges found on furniture of the late 18th and early 19th centuries that reflects Loyalist and Anglo-Canadian influences. Last of all, on furniture where the doors are sharply recessed, we find cast-iron hinges held in place by screws; their handiwork will not have the regularity of modern manufactured products.

As for doorknobs or drawer handles in period furniture or furniture made by hand, such fittings are not screwed or nailed solely to the outer surface, as in modern furniture.

subtle skill. These are items for which the demand is perhaps not as great as for furniture. But for the ever-growing clientele, there are pieces that become increasingly valuable, and from one year to the next, more and more areas of old handicrafts are invaded by counterfeits. At present there are on the market objects of pewter, cast-iron articles such as those stands for flatirons, pierced metal lanterns, and weather vanes that are sold to the innocent buyer as genuine antiques. It is the same with some of the kerosene lamps or heavy glass four-shouldered bottles of recent make.

To be able to authenticate such articles one must know past techniques and processes, so different from those of today, but which have left their traces in spite of the passage of time. Important, too, are signs of wear which can vary in all kinds of ways, depending upon the care these old pieces have been given, the degree of oxidation in metals such as silver, pewter, and copper, and the patina, the true stamp of the value of an old article.

Dealers and Their Sources of Supply

All these objects, all these antiques, originals or copies, are found in antique shops. There are three types of dealers. The first will sell only esthetically beautiful relics of bygone days, first-class, artistic cabinet-work, well preserved and representative of a certain cabinet-maker, a certain style, a certain era. These rare dealers are established in large cities, and the quality, rarity and price of their articles ensures them of a choice clientele. Such dealers are generally great collectors of period furniture, silver and pewter, or of unique and rare pieces, representative of another era or of the bourgeoisie of past centuries.

A second type of dealer is the "big buyer." This individual has his own shop and storehouses which are kept regularly supplied by an army of professional scouts (pickers). He accumulates stock that will then be re-sold to private buyers, put on sale in various little boutiques, or exported by truck to the United States.

The third type, the best known and most frequented by the public, includes all those semi-professionals or even professionals who take advantage of the tourist season or weekend visitors. These dealers are found in historic quarters like Old Quebec, in the suburbs of large cities, or in the country. Supplied by auctions or by professional scouts, they offer a wide range of objects in iron, bronze, glass, ceramics, and wood, from Grandma's sadiron to an armchair in Louis XV style, all of more or less reliable value.

Most of these shops are open only in the summer because their clientele consists mainly of American tourists, but there are a few that keep open all year round to amateurs as well as professionals who are looking for a rare object for some big collector or for some museum. One often comes across very interesting "finds" in those little shops, as no doubt the reader has discovered for himself from personal experience.

Over-enthusiastic collectors, lacking housespace, sometimes will sell very interesting pieces of which they have in duplicate or in surplus. There still are basements or storage rooms in apartment buildings where many an amateur may one day discover that he has a special talent for collecting antiquities.

Objects Still Available

What does one still find at the dealer's shop? Many souvenirs of the pre-war generation (1940), but also a number of articles that have an historical value. Original and authentic pieces of furniture are increasingly scarce, and the same can be said of all the beautiful handcrafted pieces in the field of carpentry, casting, tinware, and in the goldsmith's trade. These things, however, circulate constantly, and scouts still manage to find the *rara avis*. Forays into the country, visits to barns, stables, sheds, cellars, attics, dairies, or even country houses, often lead these insatiable searchers to interesting discoveries. Several layers of paint or rough usage can spoil the original appearance of an article brought to light, but a good job of restoration done by a specialist or a painstaking amateur can produce surprising results.

As for glass and ceramics in general, it is still possible to obtain pieces at a reasonable price. The St.-Jean, the Dion in light leadglazed pottery, the so-called "Portneuf," pieces of blown glass molded by Quebec glassmakers of the 19th century, are among

the many French-Canadian craft pieces which a good antique dealer will be able to offer his regular customers.

Certain areas of indigenous memorabilia have been little touched by the amateur collector. Firearms, sidearms, old toys, equipment belonging to the craft practitioner of the past, plaster knicknacks, all offer more than one specimen that deserves special attention and can be bought in some antique shops at very reasonable prices.

The stock of weather vanes or of original pierced metal lanterns is exhausted, but this form of craftsmanship has led to articles deserving of attention and having decorative value. For the person who wishes to surround himself with old things that are both typical and pretty, the market is still open,

provided he has the patience and the curiosity of the avid collector, two qualities vital to anyone in search of the interesting object.

To collect beautiful pieces, one must visit antique shops regularly and always be on the alert, no matter what sort of object he is looking for. A detailed list of these suppliers of antiques will be found in the Yellow Pages of the telephone book under "Antiquarians" or "Antique Dealers." If he is afraid of spoiling a piece of furniture by rubbing it down or polishing it, or if he wants to repair any major damage, there are cabinetmakers specializing in restorations who will be able to do a proper job; and here again the Yellow Pages, under "Cabinetmakers," will be a great help.

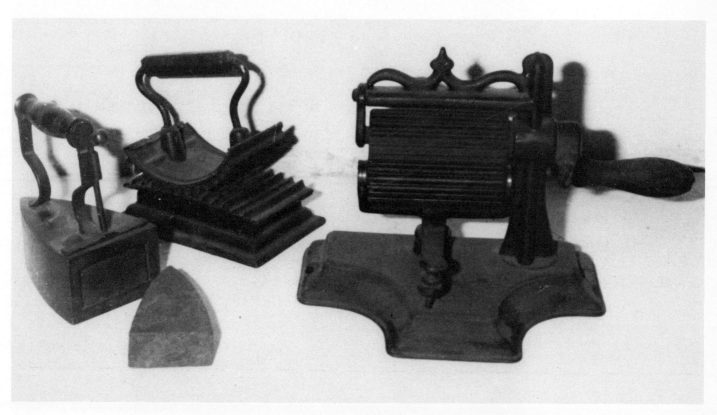

A flatiron was heated by inserting into the iron a block which had been reddened in the fire. Two at right were used for pleating skirts and shirt cuffs. 19th century. (Château de Ramezay, Montreal.)

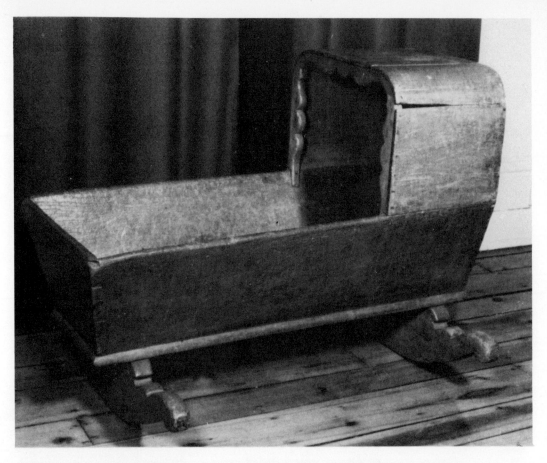

The hood of this pine cradle has a contoured border at the head; rockers were carefully cut out. Late 18th century. (Institut National de la Civilisation—I.N.C.)

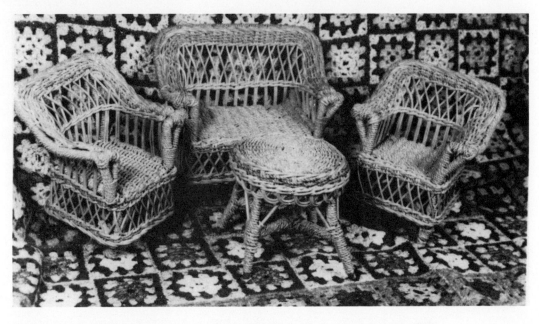

Miniature set of wicker living-room furniture. Height is 6". A toy of the early 20th century. (Jean-Marie Dussault, Deschambault.)

CHAPTER 3

French Styles and Their Influence on French-Canadian Furniture

*"... the evolution of our traditional
furniture has been very slow, and
there has been an enormous number
of styles and variants which appeared
in the Canadian rural communities
after a lapse of as much as a century
after their creation in the mother country."*

JEAN PALARDY

Military conflicts, commerce, and colonization in some way help enrich civilizations. America, Canada, and Quebec in particular, have not only certain conditions in the life of social man, but also a prodigious mixture of ideas.

French Canadians can safely claim to have been present at the confluence of two great currents of thought; there are no events that, once analyzed, do not confirm, in one way or another, the existence of those two cultures. What is true in the fields of politics, law, architecture, is also a reality that can easily be identified in the arts of furniture and decoration and in those numerous occupations relating to crafts that satisfied the needs of previous generations.

France, with its one hundred and fifty years of colonization, England by its military conquest in 1760, and the United States by its proximity, were to make Quebec a meeting place of French and British culture. They were, in addition, at the origin of a special way of seeing and feeling born of this complex heritage. No study and presentation of French-Canadian furniture, however brief, can be made in isolation from this reality.

In the chapters on local furniture, we shall, therefore, consider the principle French styles and the many transformations they have undergone in Quebec as a result of the cabinetmaker's taste and desires. We shall be obliged to linger over the styles of the Louis XIII and Louis XV periods, which had the greatest influence on traditional furniture even up to the middle of the 19th century. After that, we shall review the influence of Anglo-American styles on Canadian craftsmen and on the furniture they produced, as well as the impact of this contribution on the material culture of French Canada, especially after the year 1780. And finally, in another section, we shall discuss the principal types of furniture, their function, and their evolution.

Definition of "Style"

People often talk about style without knowing what the term means. To many, it is a synonym for form; to others, beauty or originality. Some people will rush off to the interior decorator and insist upon having "style" in their furnishings. Before going any further, it is important to define what style is.

Style is the general unity or effect of the original characteristics that distinguish the production of an artist, a group, an era. It is also a manner of composing and executing that is distinctive of a certain artist, a certain school, a certain period.

In furniture, different styles will have their distinguishing form, decorative features, color, and wood. In addition, some furniture styles have even been recently created especially to meet new needs.

Form is one of the salient features that help to distinguish the productions of various centuries. Craftsmen were so marked by the artistic influences of their particular era (painting, sculpture, architecture) that all their work was affected by it. Pure geometric designs, in general favor for a time, were later replaced by the more graceful, curved lines of another era. Instead of the straight, heavy, two-tier wardrobe, the following period preferred furniture with bow-curved fronts.

Decorative designs also follow new styles. One artist, who had set the fashion in the reign of a great king, chose motifs inspired by classical Greece. Another, wishing to please a monarch with the instincts of a conqueror, followed the craze for certain archeological

discovieries and took his designs from the stiff, militaristic ornamentation of ancient Rome. Influenced by the romantic tastes of the age, one school will introduce light, gay colors, whereas another, inspired by the austerity of the times, will stress the grain and color of rare woods in furnishings.

Fashion is also a determining criterion of style. Each period has its preferences in furniture, and princes and commoners alike favor various exotic woods because of the influence of the leading artists who are the taste-makers.

And finally, some styles are characterized by certain types of furniture where the artist-cabinetmaker was not content to work with forms, textures, and decorative elements that merely corresponded to the buyer's latest inclinations but, in answer to the new demands of an advancing civilization, created types of furniture fitted to those new tasks. The commode (or chest of drawers) which

appeared around 1700, the work of André-Charles Boulle, illustrates this point. It can even be said that his commode was characteristic of the Louis XIV style.

And it was the artists—designers of those original features, naturally inspired by the trends of their era—who were to launch this fashion. In England, at the end of the 18th century, Heppelwhite and Sheraton clearly showed that intuition of artists of genius who, at the end of the 18th century, were to influence the style of their contemporaries. Art schools also achieved a similar goal. A prince's approval of those talented visionaries who incorporated their era—the conjunction of middle class and aristocratic desires with those of their monarch—would result in a form, a repertory of decorative elements, colors and woods that would be swiftly and widely diffused. A style would be born: it would mark an era.

Table of French Styles

Styles	Reigns	Period of Influence in Quebec		Dominant Characteristics
Renaissance	Louis XII Henri III Henri IV 1498-1610		Slight Influence	
Louis XIII	Louis XIII 1610-1643	c. 1625 to c. 1800	Strong Influence	Spiral turning, beads, baluster; geometric motifs; lozenge; diamond point.
Louis XIV	Louis XIV 1643-1715	c. 1675 to c. 1750	Weak Influence	Contouring, overly elaborate design; X-shaped stretchers, square feet, baluster feet, ram's feet.
Regency	Regency of Philippe of Orleans 1715-1723	c. 1725 to c. 1760	Weak Influence	Contoured and curved lines; shell acanthus leaf, ram's feet.
Louis XV	Louis XV 1723-1774	c. 1730 to c. 1815	Strong Influence	Curved lines, spiral leg; crossbow shapes, carving, foliated scroll, rococo.
Louis XVI	Louis XVI 1774-1792	c. 1775 to c. 1815	Weak Influence	Fluting, spindle turning, decorations copied from nature.
Directoire*	Directoire 1792-1799	Early XIX century	Weak Influence	Sabre-curved lines; palmettes, acanthus leaves.
Empire	Napoleon I 1799-1815	First half of XIX century	Medium Influence	Straight lines, sharp angles.
Restoration	Louis XVIII Charles X 1815-1830	First half of XIX century	Weak Influence	Claw foot; gondola back, sabre leg, palmettes, lyre.
Louis-Philippe	Louis-Philippe 1830-1848	c. 1840 to c. 1870	?	Everything is possible.
Second Empire	Napoleon III 1851-1870	Second half of XIX century	?	Padding, curved leg on casters.

*After the Louis XVI style, French fashions in furniture reached Canada through the United States.

The Variety of Styles in Quebec: Reflection of a Mingling of Ideas

French-Canadian furniture was largely inspired by French and Anglo-American styles. But inspiration does not necessarily mean copying and servile imitation. Moreover, it would have been difficult to find any furniture of the pure style one finds in the great metropolises during a period said to be characteristic of a reign. For before those great styles reached us, they had to follow a winding path. Furniture made by famous cabinetmakers first spread throughout the many regions of France and England that were, later on, to provide the colonies with artisans and pioneer colonists. And even by then, in those various provinces, their furniture styles underwent a number of large-scale transformations that, in some cases, became alterations. It was this regional furniture that was frequently imported to America or copied by local carpenters.

Court styles were often prohibitive in price, and the French peasant, like his counterpart in the far-off land of America, would never have enough money or time to indulge in the fashion of using imported woods, inlays of metal or mother-of-pearl, those lacquers and oriental glazes, that fine marquetry. Simplicity and sobriety were obligatory. Finally, far from art schools and the academism of European masters, French-Canadian craftsmen, except for a very few, were technically unable to produce such pieces without the aid of simplified sketches.

Quebec came to know a great variety of styles, of which France, England and the United States were the principal purveyors.

Until 1760, French influence was direct. Regular exchanges with the mother country played an important part on all levels, even on furniture. Often, certain styles reached Canada after a delay of several decades and persisted for a hundred years after they had gone out of fashion in Europe. The Conquest, enforced self-dependence, and isolation, undoubtedly explain that phenomenon. Long after the arrival of the British, traces of the *ancien régime* were still visible until the middle of the 19th century.

At the end of the 18th century, English contributions gradually steered the productions of Canadian craftsmen toward new forms. However, the infatuation of Americans with the France of Monsieur de La Fayette's regiment worked against the fashion launched by the new arrivals on Canadian soil; and through emigration and business exchanges, French forms in vogue among our neighbors to the south came back to Canada in the 1800's, until the period of the total degeneration of all handicraft in the last quarter of the 19th century.

All these various currents, all this mingling of ideas and people, only helped to enrich French Canada. But for the amateur collector of today, it becomes extremely difficult to find his way among such a variety of sources and inspiration, to distinguish the stylistic elements that would allow him to estimate the value of a certain piece and to place it correctly. With the aid of this guide, however, the non-professional will be able to pick out characteristic components and make reasonably accurate assessments.

Renaissance Style (1500-1600)

To most people the Renaissance means a return to ancient sources and a renovation of every fashion. Furniture carpentry is no exception; and in technique, structure, and decorative repertoire, furniture was enriched on a large scale in this period.

The Middle Ages knew only simple methods of assembling materials: right angles, the mortise joint, the tongue and groove joint or dovetailing. The Renaissance contributed the mitre joint which is firmer and more stress-resistant. Joining the framing boards and the moldings at a 45-degree angle reinforced the furniture while at the same time giving the appearance of unbroken continuity in its lines.

Another discovery of that period, and one quite as important, was the hidden mitre joint. Who has not noticed on old furniture, especially in the joints of drawers, a series of little trapezoidal projections that sink into corresponding cut-out spaces? (This form of construction takes its name in French—*queue-d'aronde*—from the swallow's tail it closely resembles.) During the Renaissance, the plain mitre joint, which before was in full view, was concealed, thus giving the artisan's work a smoother appearance where conjoining parts met.

It was during the reign of Henri II especially, from 1547 on, that a really new and much more design-oriented spirit spread throughout all France. In the field of con-

struction, carpenters abandoned the traditional use of small panels the width of a plank, separated by stiles of frame posts, a custom that had considerably limited the artist, for generally the artisan was expected to work only with natural dimensions of woods. More and more, however, large panels began to be used in cupboards and wardrobes, sometimes to single ones, made of several boards skillfully put together.

Decoration, however, underwent a complete alteration Arabesque and grotesque ornaments gave way to compositions of varied architectural character, differing according to which region of France they came from. Most of the designs were taken from Italy and the Greco-Roman world: foliated scrolls formed by leafy branches linked in intricate involutions and marked by figurines of naked babes, animals, imaginary beings, human busts rising in relief from a medallion, corbels, candelabra, shells. . . . France enriched this list with themes of her own. To the trophies of arms she added instruments, scientific, artistic, pastoral. Grotesque masks or convex cartouches framed by concave scrolls, festoons, and garlands or branches of oak, laurel, and palms are among the French designs in the decorative repertory of the Renaissance.

The influence of the Renaissance was to persist in regional furniture in France until the emergence of the Louis XIII style. In construction techniques and in the use of wood panels joined to give plainer and less crowded surfaces, Quebec was influenced by French regionalism which had been transplanted to American soil at the beginning of the 17th century. The same thing happened with various types of ornamentation, some remnants of which will be found on an occasional chest or handmade wardrobe. And finally, the Louis XIII style, which was to be especially popular, drew largely on the preceding period.

Louis XIII Style (1610-1643)

Under Louis XIII French furniture entered upon a new era. Before then, craftsmen worked directly on the wood; in other words, the work of ornamentation was done on the planks themselves. But from that time on, they began to experiment with ebony veneers, inlays, and a certain amount of marquetry.

In veneering, the cabinetmaker applies very thin sheets of ebony on an ordinary wood frame. Or else, after incising a gash in the wood, he will insert several lamella, or thin leaves of different colored woods or marble which will then be held in place by glue. Finally, in marquetry, the framework or certain parts of it is covered with thin layers of colored wood previously assembled in a design.

This was a new method in furniture-making, and for a long time it was decried by those who favored treating the material as it had been done in the Middle Ages and during the Renaissance. Craftsmen during the Louis XIII era no longer sought to get the effect of light by clever carving or combining materials, but tried to achieve it solely through the colors of various, often precious, woods. It was the birth of cabinetwork with all its techniques of veneering rare woods. Those techniques, popular at Court and among the great, did not find favor with the artisan in the provinces of France. In the provinces from which our ancestors came, artisans continued to follow the forms and the decorative repertoire of the Louis XIII style and to cling to the custom of massive structures inherited from the Middle Ages.

The decorative repertory of that period was extremely varied. Spiral, bead, or baluster turnings, which we can admire on those chairs and rectangular tables with H-shaped stretchers a few inches from the floor were widely diffused throughout France. Rosettes, gadroons, crossed laurel branches, cornucopias spilling with fruit, swags of draperies fastened to a woman's head and finally, a whole range of geometric motifs—lozenges, squares, rectangles, diamond points—are the decorations that were most common.

Heavy, square chairs, with a stretcher a

LOUIS XIII STYLE: *(A) Swag of drapery, woman's head; (B) Cartouche, elongated shape; borders rounded in raised relief.*

few inches from the floor, have straight backs with turned bars. The turning is intersected by discs linked at a blunt angle, and the seat is usually padded and covered with fabric.

The wardrobe, which was formerly a

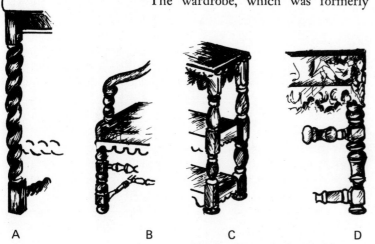

(A) Spiral-turned table leg; (B) Chair leg; (C) Baluster-turned table end; (D) End of massive Louis XIII table; (E) Table with spiral-turned legs; (F) Column leg ending in ball foot; (G) Table leg, stretcher close to floor.

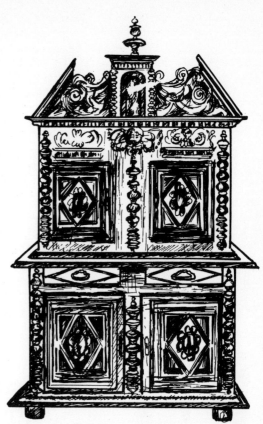

Two-tier wardrobe with wood turning; geometric design on panels, ornamented with oval cartouches in center.

showpiece and reserved for the nobility, came into general use in the 17th century. It is found in the homes of all good middle-class folk and even in peasants' houses. They were either two-tier, four-legged wardrobe-cupboards, or enormous, imposing, two-door armoires ornamented with geometric motifs and with a fixed post where the doors met.

In the two-tier cupboard, the top part is usually recessed and is smaller in scale than its lower part. The handles of the wardrobes were inspired by a motif taken from the Dutch knocker, and represent a lion's nose bearing a metal ring. The cornices are taken from furniture of the Renaissance period, with decoration of gadroons arranged in fan-shape.

Furniture in the style of Louis XIII was very popular in French Canada, if we can rely on death inventories, professional scouts, and dealers who have unearthed more than one discovery in that style.

By the time the early settlers left their homeland, the Louis XIII style had become so widespread in the provinces that local craftsmen were greatly influenced by it. Unfortunately, only a fifth of their production remains, fire having taken its toll of the rest.

Quebec continued to produce massive furniture in which the only ornamentation was made directly on the wood of the structure itself. Geometric designs of lozenges or of motifs known as "galettes" or "discs," derived from furniture from the west coast of France, lightened and lent a harmonious appearance to these ensembles.

And as the traditional settler's house was fairly dark, the climate making it necessary to limit the number of windows, those pieces of furniture painted blue, blue-green, red, mustard yellow or yellowish-white, brought a note of gaiety and brightness into country homes. White pine, cedar, light walnut, woods softer than cherry and maple were the artisan's favorites, and on them he could more easily exercise his talent for carving.

Louis XIV Style (1643-1715)

The impact of the Louis XIV style was much less important, if not wholly negligible, in comparison to the style of its predecessor. That opulence was indeed in keeping with the ostentatious display at Versailles, but its excessive ornamentation and complex carved motifs discouraged the local craftsman, accustomed as he was to far greater simplicity.

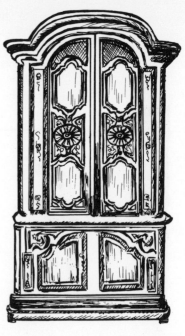

Two-tier, bonnet-type wardrobe, Regency style.

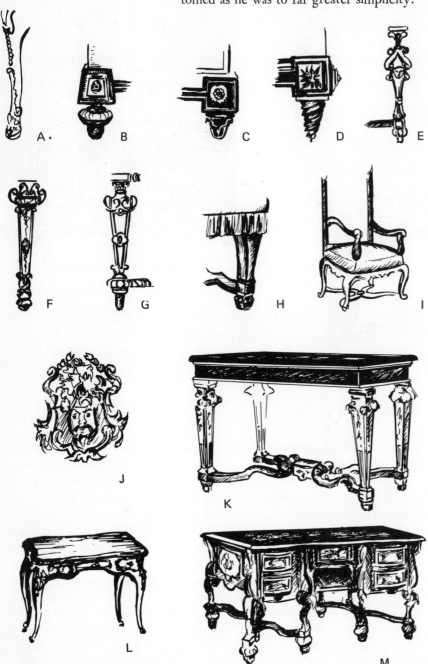

LOUIS XIV STYLE: *(A) Ram's foot; (B) Bun foot; (C) Foot with inverted acanthus leaf; (D) Heavy, spiral-turned peg-top foot; (E) Encased caryatids; (F) Straight leg with acanthus leaf; (G) Tapered leg terminating in spiral foot; (H) Square baluster leg, terminating in fringed foot; (I) X-shaped stretcher; (J) Bacchus head; (K) Table with square, tapered legs, X-shaped stretcher, marble top—all characteristics of Louis XIV style; (L) Table with cabriole legs and carved apron; (M) Kneehole writing-table, with eight matching legs, bracket-shaped.*

The reign of the Sun King saw the unprecedented development of veneering and the triumph of delicate cabinet-work in the use of brass and shells. Gold, silver, marble, allegorical paintings of great frescoes were to heighten the esthetic value of furniture. The mask, surrounded by sunrays, an aureole of a palmette, or framed in acanthus leaves; the sun, the lion, the ram's foot, intertwined shells, baskets of fruits; square, baluster legs, x-shaped stretchers, marble veneering—all are characteristic elements of the furniture of that epoch.

New styles in furniture were created, thanks to the ingenuity of the architect-cabinetmakers of the day: the wall-console, a small, two-legged table usually propped against a wall; the table-desk; and the commode, a kind of chest with drawers.

In New France, craftsmen clung to the forms of the preceding era, and the copying of old, familiar styles continued in full force to the end of the 17th century. Some local open armchairs, a few commodes, and certain consoles took their forms and decorative designs from the Louis XIV style, but they were less elaborate and more modest. The colonial artisan, far from official art schools, preferred to work with a knife on soft wood rather than to veneer, inlay, or carve precious woods. Also, the impact of the Louis XIII style regained strength just as it did during the Louis XV period; and combin-

ing forms and decorative repertoires was common practice among our carpenters who chose those they liked best.

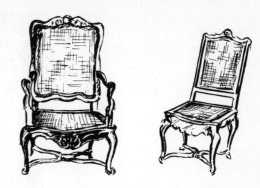

Open caned armchair and matching side chair.

Regency Style (1715-1723)

It is important not to confuse this style with the English "Regency" of the first half of the 19th century; the characteristics are very different. The French Regency or *Regence* style marks a transition between the Louis XIV and the Louis XV periods. The French artist breaks away from the majesty and austere grandeur of the preceding period in favor of softer lines to create a less bulky, less overloaded and more comfortable piece of furniture. Decoration abandons mythological motifs and turns to nature for inspiration

Legs of tables and armchairs are curved in console-shape and terminate in a stag's or ram's foot. Arms and legs of chairs are carved, the latter strengthened by an x-shaped stretcher. The fashion for skirts with paniers was responsible for a definite modification in the construction of chairs, whose supports and arm-rests were now no longer in line with the legs, but recessed several inches to allow room for the wider skirts. Caned armchairs with carved frames are also characteristic of this style. The crossbow outline

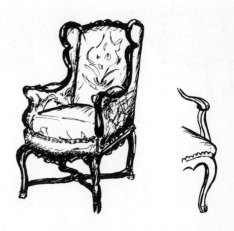

Winged armchair, transition period; cabriole legs terminating in pieds de biche *(deer feet); armrest and cabriole leg.*

of table legs, swell-front commodes and cornices of some wardrobes are representative forms of the furniture of those days. Who has not seen one of those chests of drawers sometimes called *en tombeau*, with short carved legs?

REGENCY STYLE: *(A) Shell motif; (B) Quartered motif with flowerets, symbols of the hunt; (C) Rosette on latticed background, acanthus leaf; (D) Wild animal head* en espagnolette *(surrounded by stiff lace collar or ruff).*

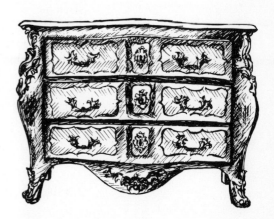

Commode, early 18th century; bronze decorations are lighter in feeling, but overall design is heavy.

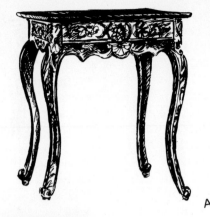

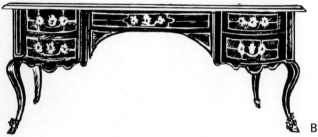

(A) Table carved on all four sides; apron with shells and foliage; motifs inspired by the acanthus leaf; legs slightly curved; scrolled feet; (B) Flat-topped writing desk ornamented with brass inlay; gilded bronze handles and keyholes.

Finally, five-part shells, fabulous animals, rosettes on a latticed background, acanthus leaves, a woman's head surmounted by a five-pronged diadem—these are the main characteristics of the Regency decorative repertoire.

This transition period left definite traces on the furniture of Quebec, notably in wardrobes and open armchairs. The local Regency style commode is convex on front and sides and, in addition to this general curve, the front rail is carved and, as a rule, decorated with a shell. The open armchair, with its cambered legs, its shells and acanthus leaves on the apron and the back stretchers, is upholstered in velours and fastened at the front rail by a multitude of upholstery nails. The stretcher shaped like a double "gendarme's hat," consolidates the whole, as in one of those Regency-type armchairs in the Church of the Hurons de la Jeune-Lorette. In French-Canadian furniture, however, it is difficult to distinguish Regency influence from the influence of the Louis XIV and Louis XV styles.

Louis XV Style (1723-1774)

The reign of Louis XV marked a major step in the history of French cabinetmaking. Experts generally agree that this was the *grand siècle* of French furniture, not only because of the superb workmanship and fine techniques it produced, but also because of the designs it originated.

As for techniques, lacquers, wood striping, veneers, and marquetry—both checkered and mosaic—were in general use. In the 18th century, lacquered furniture, decorated with mountain landscapes or pagodas, was in high fashion, and with the invention of the Martin brothers in 1748, various colors with a hard, shiny finish gave an Oriental appearance to these ensembles.

Wood striping, a process that consists of veneering very thin layers of fine wood of irregular graining, was popular with the wealthy clientele that gravitated around the Court. Diamond-shape wood striping is found in a number of Louis XV tables, commodes, and wardrobes. In veneering, an ordinary wood base is covered with thin layers of precious woods. The importation of exotic woods furnished a rich, and till then undreamed-of, palette. Colors, warm or bright, gave a wholly new appearance to the works of cabinetmakers: mahogany with its reds, sandalwood for yellow, kingwood or violet wood and Brazilian rosewood (or palisander) in a gamut of violet tones.

When figures or geometric designs are inserted in the veneer, the process changes and is called marquetry. This technique, as well as those previously mentioned, was very popular in the reign of Louis XV.

The Louis XV style is often called "rococo." Let us make it clear at once that this was a form used for certain categories of furniture, chiefly the console, that little table fastened against the wall below a mirror. This style substitutes for classic symmetry a system of balanced curves and counter curves which whirl in turbulent spirals. Distorted and jagged lines, motifs of foliage and shells inspired by the Italian baroque, are some of the details that overload the ornamentation of that area. This is also the period when each room in the house was given a special designation: the music salon, the din-

(A) Buckle: woman's head; (B) Cartouche: winged shell, crossed quivers, garlands of flowers.

Winged cartouche.

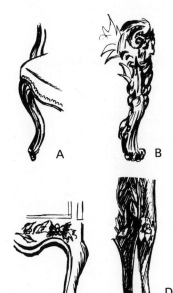

(A) Cabriole leg; (B) Sumptuously carved cabriole leg, stile forming a serpentine curve; (C) Leg terminating in a spiral, the apron carved; (D) Pièds-de-biche *(deer feet); (E) Cabriole leg with gilded and richly chiseled sabot.*

ing room, the study for the amateur collector, the library. . . . Among the decorative repertoire the most characteristic motifs are the asymmetric, indented shell, the winged cartouche, the cabriole leg, the head of a woman wearing a rose framed in rocks and flowers, the rock itself, a veritable cornucopia overflowing with wreaths of flowers.

The two-tier or the three-tier commode is slightly convex. The wardrobe, with serpentine front decorated with gadroons, defines the line of the top of the doors. The center of the panels is ornamented with moldings of garlands of roses whereas at the top a basket of fruit spills over toward the lateral stiles.

Appearance and comfort are also among the leading characteristics of this style. Polychromy and lacquers are there to testify to aesthetic interests. Padded, winded *bergères*, those large armchairs with winged back, are evidence of a desire for greater comfort; the down cushion on the seat is loose and the long, padded back permits one to rest one's head comfortably against it. The metal spring now made its appearance. Stretchers on straight chairs and armchairs disappeared, as can be seen in the *bergère* or in the cabriolet chair. Caned seats were still very popular.

This style had a great impact in French Canada. The wood used was not as precious as that used in Europe, and veneers, ornamentation and marquetry were not popular with Canadian craftsmen. Nevertheless, local pieces of furniture of simple workmanship, but inspired by that style, have a grace and elegance of their own. One has only to think of those rural wardrobes with their lavishly carved panels ornamented with foliated scrolls and with frames and stretchers decorated with leaves and stylized flowers (or with rococo designs like the daisy or bunches of grapes). The two-tier, curved cupboards, with spirally carved doors lightly ornamented with shells, are examples of this type. Finally, handmade chairs with cabriole legs, curved front rails, *pieds-de-biche* or stag's foot, carved stiles and back stretchers, and commodes in the shape of a crossbow, also illustrate the important influence of the Louis XV style on local artisans.

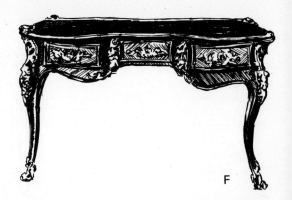

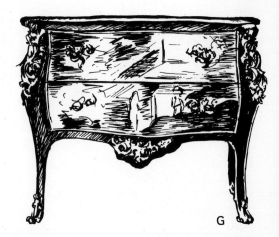

LOUIS XV STYLE: *(F) Large, flat writing table, border of gilded brass around the top; legs surmounted in bronze; (G) French commode, slightly swell-front, with no dividing strip between drawers.*

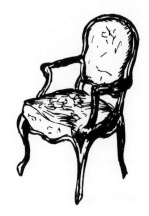

Cabriolet-type open armchair with "fiddle" back.

Louis XVI Style (1774-1792)

The Louis XVI style derives directly from the purity and elegance of Greek art. The

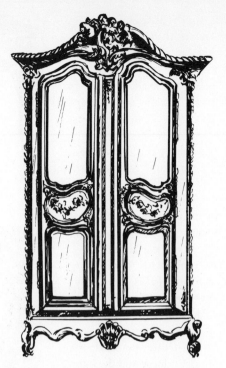

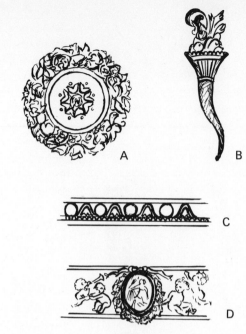

(A) Crown of roses; (B) Cornucopia overflowing with fruit; (C) Ovate stripes; (D) Medallion surrounded by cupids.

Large wardrobe with serpentine pediment ornamented with gadroons; its architectural shape determines the line of the top of the doors; classic Louis XV style.

Bonheur-du-jour *or* escritoire; *drawer with apron, shelf, turned fluted legs.*

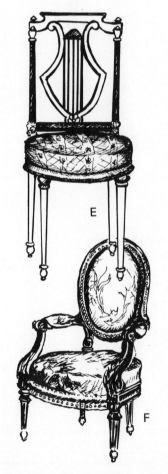

Drawing room table (in marquetry) with geometric designs, sheathed legs, decorated apron.

(E) Lyre-back chair; (F) Open armchair with oval back; medallion-shaped; straight, fluted legs; pearl-bead border.

LOUIS XVI STYLE: *(A) Grooved leg, reversed console-type armrest ornamented with acanthus leaf; (B) Baluster-type bulge terminating in peg-top foot; (C) Straight, grooved leg terminating in a peg top.*

Large commode with curved marble top; pulls in shape of rosettes.

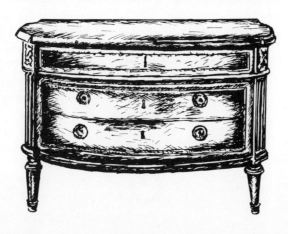

fluting at the base of the Doric column is the true trademark of this style. The sobriety and simplicity of the classic period obviously influenced cabinetmakers to produce delicate creations with graceful lines. Decorations were modeled on Nature: cornucopias overflowing with fruits, laurel wreaths, crowns and garlands of roses, ovate stripes, acanthus leaves and the buckle are found on beech, walnut, mahogany and rosewood.

Peg-top turnings on the legs of tables and chairs were also very popular on the eve of the Revolution. Stretchers were decorated on two sides with a rosette or a marguerite. Legs of open armchairs and other types of furniture were straight and tapered toward the foot, and the curve of the arms and the baluster turning gave a special lightness to these forms. As for the backs, they were generally rectangular or rounded like a medallion; sometimes, following English influences, they were openwork with a tyre, a fire-balloon or a basket in the center.

The straight commode with two or three drawers often replaced the top drawer with a series of smaller drawers. The fall front secretary or writing desk, already popular under Louis XV, became fairly widespread among both a middle class and aristocratic clientele. This style was not widely diffused in Quebec, for the Conquest had already severed the tie between the mother country and its former colony. For a while, the styles of the preceding periods continued to be copied, until through the British colonists and the Loyalists, Anglo-American styles infiltrated. Not until after a quiescence of more than half a century, however, was France to come back to us, this time via the U.S.A. and a number of local artists who went there at the beginning of the 20th century to finish their education.

Directoire Style (1795-1804)

Directoire is a period between Louis XVI and the Empire, between Greek mannered style and Roman forms. The furniture of that revolutionary period, although clearly inspired by Pompeian designs, also reflected the influence of the English brothers Robert and James Adam, then at their apogee in Britain. The fan motif is without doubt a striking example of this latter mimesis. We also find much similarity with the preceding epoch, although certain modifications deserve to be underlined.

Styles in chairs suffered a number of changes: the top of the chair back was curved slightly backward in volutes; this is called scrolled or crosiered. The arms were widened toward the back to give us chairs called

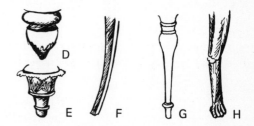

DIRECTOIRE STYLE: *(D & E) Ends of legs; (F) Saber leg; (G) Straight leg; (H) Lion's-paw foot.*

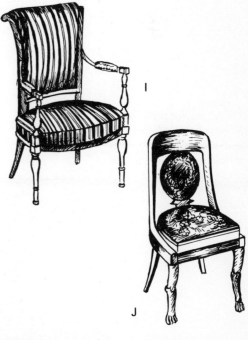

(I) "Scrolled" armchair, so-called because of width of back compared to arms; (J) Gondola chair, back ornamented with medallion, lion's-paw feet.

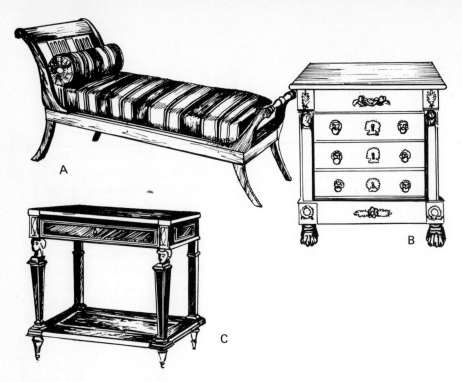

DIRECTOIRE: *(A) Daybed with saber legs; (B) Commode, caryatids on front stiles; (C) Serving table* (console-desserte).

lar effect on French furniture: several emblematic decorations such as bundles of pikes and the Phrygian bonnet, Republican symbols then in fashion, were applied to forms in the Louis XVI style.

Decorations include the lozenge, which is placed in the middle of a panel or on an extension block on the chair frames; caryatids, the winged victory wearing a lyre on her head; the palmette, the vase in the shape of an urn with handles; and coiled snakes. The cheval-glass, a large swinging mirror on a frame held between two posts, first appeared at this time.

There is no doubt that in the first half of the 19th century, Quebec and Anglo-American furniture borrowed certain lines from this style, by way of the U.S.A.; but because of regional variations and the many different influences during this period, it is still difficult for amateur and professional alike to pinpoint the particular contributions of the French Directoire to our handcrafted furniture.

"trapezoid" in the language of art historians. The front legs, straight and vertical, have simple turnings and are joined to the front rail by a disc ornamented with grooves; the rear legs, gently cambered, form part of the back. They are called "sabered" and foreshadow the Empire style. The back, made with a carved wooden crosspiece is open-worked with the splat in the design of a palmette or a fan.

The Revolution did not have any particu-

Empire Style (1803-1814)

Inspired largely by Roman art which marked it with indisputable variety, furniture in the Empire style presents an architecture in which rectilinear shapes predominate. The rounded softness of traditional furniture was sacrificed to geometric severity and jutting edges. The whole range of decorative elements, carving, molding, and even marquetry that highlighted the works of cabinetmakers and carpenters in past centuries now disappeared completely.

During that period of conquest and grandeur, France, which was then a model for all Europe and indeed for the whole world, preferred furniture marked with a sobriety and nobility relieved by some bronze ornamentation, which was engraved, or gilded with a dull burnish. The use of the sheathed caryatid in a great variety of forms became general. A whole range of applied bronze ornaments helped to break the monotony of straight lines: wreaths of oak leaves tied with fluttering ribbons, garlands of vines, bunches of stylized laurels, palms, pine cones, myrtle, trefoil, poppies....

Ornamentation was also inspired by Roman and Egyptian discoveries that archaeologists

(D) Decorative palmettes; (E) Greek spinx bearing fruit basket; (F) Classical medallion; (G) Connecting plinth and reeding in Directoire style; (H and I) Furniture hardware.

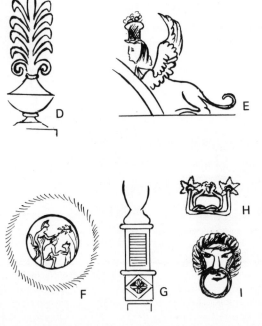

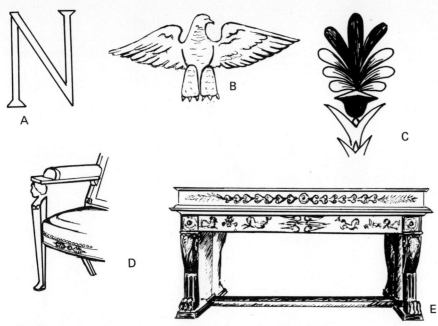

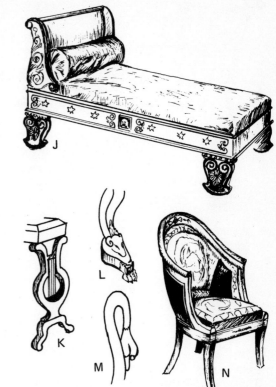

EMPIRE STYLE (FIRST): *(A) Napoleon's initial; (B) Imperial eagle; (C) Egyptian-inspired palmettes on lotus leaves; (D) Straight leg in form of sheathed caryatid; (E) Work desk.*

RESTORATION STYLE: *(J) Daybed of Greco-Roman inspiration; (K) Lyre-shaped framework; (L) Claw feet with ram's head; (M) Swan's neck; (N) Gondola armchair, so named for its enveloping back.*

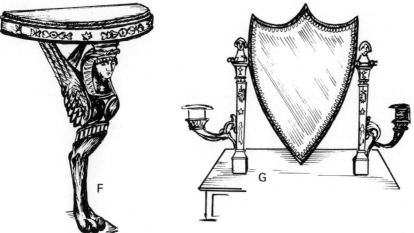

(F) Console in half-moon shape, top and pedestal usually marble; (G) Cheval-glass; this innovation of the Empire period was portable.

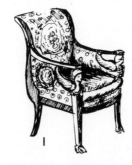

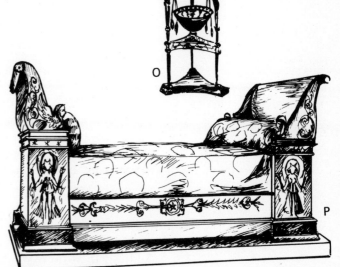

*(H) Open armchair with palmettes, lion's paws at ends of straight legs; (I) Upholstered armchair (*bergère*; front legs surmounted with spinx heads.*

EMPIRE STYLE (FIRST): *(O) "Athenian" tripod used as a work table; (P) Boat bed, direct ancestor of the French-Canadian sleigh bed, shows Egyptian influence in its sphinxes, wreaths, and palmettes.*

had recently unearthed: palmettes, carved flowers, beads, amphorae, tripods, cornucopias, sirens, sea-horses, eagles, swans, bees, butterflies, loins' snouts, goddesses, stars in diadems, winged torches, lyres, winged thunderbolts....

Armchairs, straight chairs, and beds took on special mannerisms, and several kinds of furniture corresponding to new needs were created: dressing-tables, mirrored wardrobes, washstands.... Straight chairs and open frame armchairs were made according to a new technique: the seat was placed between four posts that rose in one unbroken line from bottom to top. The bateau bed, boat-like in profile with its outward curved head and foot equal in height, was positioned with headboard against the wall and decorated only on the facing surface. Among the divan styles, there was sometimes included a short sofa called a *meridienne*. One arm was higher than the other, so that from front view, the top line of its straight or often outwardly curved back slanted upward. It was a style that was copied all over the world throughout the 19th century. Lastly, tables usually had round tops supported by a richly ornamented central leg or by three little columns joined with a triangular base.

Quebec was to borrow a number of decorative elements and some lines from the Empire style. Sleigh-beds and settees were the main types of furniture that were strongly inspired by the Napoleonic period.

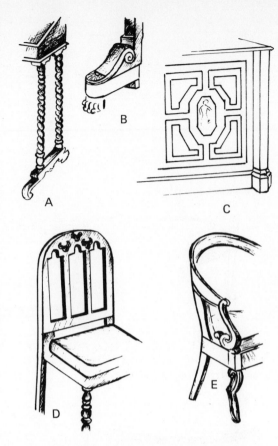

LOUIS-PHILIPPE STYLE: *(A) Secretary-table frame; (B) Lion's-paw foot, palmette at end of bracket; (C) Panel with geometric design and figuring at center; (D) Cathedral-style chair with back cut in Gothic-arch shape; (E) Gondola armchair.*

Restoration Style (1815-1830)

In the fifteen years of its reign, the new regime laid great stress on repudiating the preceding era that was so fond of geometric forms in furniture. Now all lines curved inward, wood was pliable; settees, beds, gondola armchairs with saber legs, tables with curved legs, all those creations in modestly inlaid maple bore witness to this change.

SECOND EMPIRE STYLE: *Upholstered chair; wood disappears beneath silk fabrics and fringes; loose back; converts into a tuffet.*

Louis-Philippe Style (1830-1848)

It is questionable whether those mementos of the past that appeared in the reign of Louis-Philippe merit the designation of "style." Certain economic and social changes forced

the artisan to work faster and produce more cheaply in order to satisfy the urgent demands of a newly rich clientele. New tools, that were constantly being perfected, also accented this movement.

Furniture shapes became heavy and excessively curved, but there was still room for "elaborated" furniture. Arms of chairs were twisted into ram's horns; the table, still round, rested on three heavy, spiraled consoles with feet carved to represent lion's paws. The boat bed became a veritable monument. Decorative motifs were painted: flowers, animals, landscapes of all sorts, overloaded those already massive pieces of furniture. One wonders whether numerous pieces of Canadian rococo, like dressing tables and spindle beds, did not borrow something from the Louis-Philippe style.

Second Empire Style (1852-1870)

Under Napolean III, as in the preceding period, all furniture forms bent, curved, and twisted. Craftsmen, though still influenced by the styles of Louis XV and Louis XIV, were giving more thought to comfort than to esthetics alone. Open armchairs, straight chairs, many settees, and the truffet were now padded, upholstered and fringed; cornices of wardrobe, sideboard, or headboard were decorated with geometric motifs of a Renaissance flavor; legs of tables, chairs, and armchairs were extremely curved, grooved, and mounted on casters. The most important decorative element was without doubt the medallion adorned with a bouquet of flowers. As in the Victorian style, symmetrical panels, with delicately balustered or onion-turned colonnades at their base, were found almost everywhere.

(A) Cornice with geometric motif; lavishly ornamented in Renaissance and Baroque taste; Victorian furniture chose the same form; (B) Curved leg mounted on casters, an interpretation of Louis XV style; (C) Romantic-style medallion with floral bouquet; (D) Corner whatnot from mid-19th century.

CHAPTER 4
Anglo-American Styles and Their Influences

*French-inspired furniture was
quickly replaced by "art nouveau,"
in spite of a few rare inroads by
Directoire and Empire styles.*

JEAN PALARDY

Until the 19th century, French-Canadian furniture was inspired chiefly by French designs, but around 1775 and during the last century, cabinetmakers' shops began showing furniture made in the Anglo-Saxon styles.

This influence appeared with the Conquest and the gradual installation of British officials in the 18th century. Military men and middle-class immigrants surrounded themselves with furniture then in vogue by importing from their native land furniture that borrowed elements of Queen Anne style or of the "Georgian" period.

The Loyalists, those pioneers of the Thirteen Colonies who chose to remain faithful to the English crown and refused to sanction the Independence of 1776, were another source of English contribution to Canadian furniture. They moved their household effects to a colony more respectful of tradition, to Canada, where they settled in Quebec, in the provinces of the East and in other parts. Once in their homes, the furniture they brought with them and their recollections of old pieces used in their houses in the old country, became models for the Queen Anne or "Georgian" styles (Chippendale, Hepplewhite, Adam) that would be used. With the Conquest, a number of those sons of proud Albion gradually took control throughout the colony, and commerce, as well as a burgeoning industry, became their important sources of revenue. The sumptuous mansions they built in Quebec, in Montreal and the countryside, are still there as proof of their success. Those wealthy gentlemen furnished their houses to fit their own tastes in English styles or styles inspired by the English. And it was not long before the country folk and craftsmen employed by the businessmen copied the furniture styles of the ruling class. A prominent man would give the local carpenter an order for a table like the one he had seen in an English merchant's house and in this way the design would become widespread. If a country man needed a chest of drawers, the carpenter would copy the English style piece of furniture he had made for the rich man. In this way traditional French furniture was enriched—or debased—by the elements of another culture.

In short, all those people who emigrated to the United States in the 19th century and who eventually returned, added to the craze for English-inspired styles. It was for this reason that a number of prominent men from the Province of Quebec, because of their connection with the Anglo-Saxon world, preferred the austere furniture of Upper Canada. More than one Ontarian politician, more than one with English accent in the federal capital, had a rich *pied à terre* in some Quebec countryside vacation spot like La Malbaie or Notre-Dame-du-Portage, and it is interesting to note that foreign contributions to the furniture in those regions are plainly visible to this day.

Furniture from the End of the 18th and the 19th Centuries

Not all English styles had the same impact in Quebec. Jacobean styles and William and Mary modes played practically no role, except for a few decorations found on occasional pieces of local furniture at the end of the 18th century. Chippendale and all the styles of the Georgian period, Adam, Hepplewhite, Sheraton, were copied line for line by a throng of lesser English "masters." Immediately after the Conquest, but more especially in the last quarter of the 18th century, these craftsmen opened shops in the great centers of the time, Quebec and Montreal, to fill the needs of a middle-class clientele of officials, military men, and merchants.

It will suffice to mention here only a few carpenters of English or Scottish origin in

Quebec: James Black (c. 1805), William Dow (c. 1790), James Edie (c. 1790), William Fraser (c. 1790), Benjamin Gall (c. 1805), Hugh Wilson (c. 1805). In Montreal, we find the same phenomenon: Thomas Ferguson (c. 1800), William Griffin (c. 1810), David Hunter (c. 1800), Samuel Park (c. 1800), Antoine Rhode.

Though little is known of the history of these 19th century cabinetmakers, we still have enough furniture, written documents, and oral tradition to suggest that many a local craftsman, influenced by the fashions of the day, copied English styles. Thanks to new tools that had become available, clever cabinetmakers were able to produce, from native or exotic woods imported from the Antilles, furniture styles of the late "Georgian" period, the Regency, and especially the Victorian period, with its profusion of carving, often in high relief, and its overly lavish ornamentations. Some of these pieces are unique.

Georges Bigaouette (c. 1845), François-Xavier Drolet (c. 1840), François and Pierre Drouin (c. 1840), Magloire Caron (c. 1835), Jean-Baptiste Lépine (c. 1818), the first Pierre Roy (c. 1865) who even used Canadian elk horns to make Victorian pieces that were true works of French-Canadian rococo, and Jean-Baptiste Côté (c. 1860)—all had shops in the city of Quebec and, in brief advertisements in the press, offered their merchandise for sale. Also registered in this list of carpenters of the past century from the Province of Quebec are Pierre Fournier (c. 1845), the Falardeau's (Wilbrod, François-Xavier, and Joseph (circa 1850), Pierre Ferdinand Arel (c. 1850), François and Elzéar Gourdeau (c. 1840).

In Montreal, T. M. Poulin (c. 1850), A. J. Pigeon (c. 1860), Azarie Lavigne, with his advertising of Molinelli and Canterbury style furniture (probably "cathedral" style, late Victorian), and Adolphe Bélanger (c. 1865), produced suites of furniture and single pieces in an excessively ornate Victorian style. This was also true of that "son of liberty," Thomas Barbe (c. 1840).

Groups of craftsmen in villages like Saint-Charles-de-Bellechasse or Saint-Romuald d'Etchemin, on the south bank opposite Quebec, enjoyed certain fame and their products were widely sold beyond their locales. Not only artisans in their simple workshops, but manufacturers of furniture as well flourished in Quebec and Montreal, the two great centers of the day.

In Quebec, William Drum (1808-76) had six showrooms 40'x36' and a workshop with 96 employees, divided between the factory on the rue Saint-Paul and the one at Château-Richer (perhaps also passing by Levis'), who assembled, varnished, polished, glued, nailed, veneered, and upholstered. This workshop distributed furniture galore, all of it decorated with pine cones, garlands of roses or creations in the Louis xv style, some of them stamped with the name of the maker.

The appearance of the signature at this point indicates a new tendency. Hitherto, the workman had maintained a certain anonymity, which explains how difficult it is to trace the origin of 17th and 18th century furniture of Quebec make if the maker's account books cannot be found. That anonymity, so contrary to the present day eagerness for publicity and adulation of personalities, is undoubtedly explained by the fact that cabinetmakers depended more on personal connections than on business contacts or on relations with competitors. In such a society, the signature did not particularly add to the value of the object: the beauty was an end in itself and social utility a source of complete satisfaction. The artisan was content with his position and the security he enjoyed. The maker's mark, stamped or burnt on the piece of furniture, reveals a commercial outlook that was new.

This was all the more true in the city of Quebec, where even Drum had to vie with the Lafleurs (François and François-Simon, from la Côté d'Abraham, c. 1820-1850), the Vallieres (Joseph and Philippe), and several other competitors previously mentioned.

The same situation existed in Montreal with the J.A.I. Craig factory (c. 1875), whose 175 workers produced for the local market as well as for exportation, and Hilton and Baird (c. 1865), with about 150 workers, half of them with French names who made furniture from imported wood as well as from the local lumber of the country. These enterprises made furniture in suites (bedroom suites, drawing room suites), and, a fact to be noted, from 1840 on, furniture makers guaranteed their products.

Competition was so heavy that these products had to be consigned to other provincial or international markets. The World Exposition in Paris in 1855 saw many works from Quebec furniture makers. Pierre Roy sent some of his pieces to the Dublin Exposition in 1865, and furniture from the firm of McGavey, Owen and Sons of Montreal was

Table of Anglo-American Styles

Styles	Reigns	Influence in Quebec		Characteristics
Jacobean	The Stuarts and Cromwell 1603-1688	U.S. 1600-1700	None	None
William and Mary	William and Mary 1689-1702	U.S. 1690-1730	Weak	Ball turning; arched panels.
Queen Anne	Anne 1702-1714	1760-1780	Weak	Arched door panels; curved legs; carving.
Chippendale 1749-1779	George II George III	1770-1800	Medium	Claw and ball foot; shell-shaped, broken pediment; crossbow-shape outline.
Adam 1765-1785	George III	1775-1825	Medium	Reeding and garlands, beads, ram's head, straight lines.
Hepplewhite 1785-1795	George III	1790-1825	Medium	Straight form with legs tapered and round; *pied de biche,* crossbow-shaped front.
Sheraton 1785-1805	George III	1800-1830	Medium	Block foot; lyre, urn, acanthus leaf; bed posts.
Regency* 1800-1840	Regency George IV William IV	1825-1850	Weak	Often confused with French Empire style; curved line, Greek and Egyptian ornamentation.
Victorian 1840-1910 (Early 1837-1860) (Late 1860-1910)	Victoria 1837-1901	1850-1910	Strong	Casters; use of laminating; machine-work even for decoration on wood; motifs taken from Gothic, Renaissance; excessive ornamentation; garlands of roses.

*French influences reached Anglo-Saxon America after 1775. France's aid to the Thirteen Colonies led to a craze for French styles. These influences persisted in the United States until the end of the Second Empire and touched Quebec indirectly. Among our neighbors to the south there was more talk of Directoire and Empire styles than Regency.

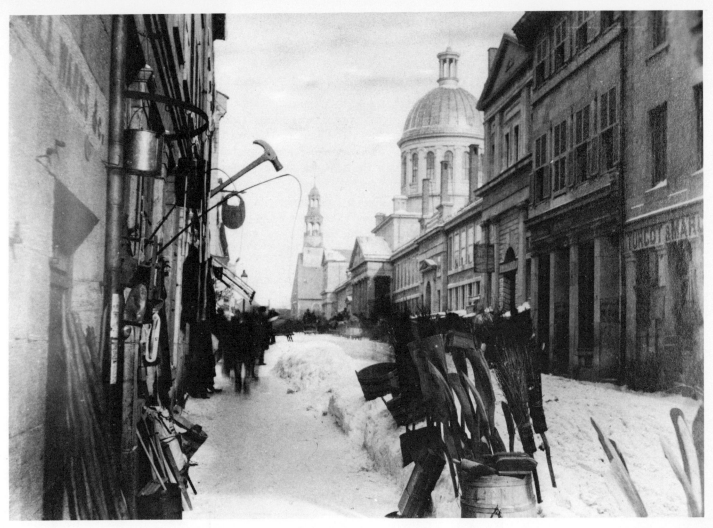

Montreal in 1884, looking down the rue Saint-Paul; the Bonsecours market in the center, the Hotel Rasco on the left.

exhibited at the Antwerp Exposition in 1885. The prizes received, and there were many, proved to be good publicity for these firms in their own locales.

Jacobean Style (1603-1688)

Jacobean was the first Anglo-Saxon style to be brought to America in the 17th century and cultivated by the pioneers. Not only did the first inhabitants of the Thirteen Colonies bring furniture of this style from their mother country, but once settled in the New World, their artisans began to copy it. By Jacobean, we mean all the English or English-inspired furniture in the period from James I to James II, whether from 1603 to 1688 or, *in extenso*, all the Anglo-Saxon and American furniture of the 17th century.

Most of the American furniture of that period was made of oak, sometimes of pine, and the few pieces that time has spared and which one can still admire in certain great museums of the U. S. (this style did not touch New France) are strong and carefully made, but rigid in form and uncomfortable, particularly the chairs. These latter, commonly called "panel chairs," have a heavy wood back and seat, the posts and apron are sometimes carved. The back is made of planks covered with leather, as the seat is, which is often made of rush. Tables with four turned legs held together by a quadrilateral stretcher a few inches from the floor or by a trestle, and chests and wardrobes with carved panels and onion-ball feet are characteristic of those early creations.

Bulbous forms taken from the Flemish, simple spiral turnings, make certain pieces look very much like the Louis XIII style. The use of small panels decorated with lozenges surrounded by scrolls and checkered patterns lessens the heaviness of these pieces and makes them more pleasing to the eye.

49

William and Mary Style
(1689-1702)

During the William and Mary period, Anglo-Saxon furniture changed radically. Longer forms generally made lines more graceful and elegant; particular care was taken to make beds and sofas more comfortable. This was a definite break with the stiff, heavy furniture of the Jacobean period. There is also a very evident contribution from Holland, where William and Mary had lived until, after James II was deposed, they were called to reign over England. From that day on, English furniture was more refined, and in this the Dutch cabinet makers, brought over by William, certainly played a large part. Furniture of this style—whether clocks, beds, highboys, and even backs of chairs—is all tall, elongated.

One of the innovations of this period is the "highboy." This is a two-tier piece: the lower tier is a table with drawers supported by four fairly high turned legs and reinforced at the base by quadrilateral stretchers a few inches from the ground. On this base is placed a straight chest containing three or four drawers. This forms the second tier. The base is called a "lowboy," and piling the two structures one on top of the other gives us the "highboy." Bun, turnip or even scroll feet, serpentine crosspieces, turned feet with inverted cup—all these decorative elements lend an additional touch of elegance to this furniture. Caned chairs, lacquer, and veneering are still the principal characteristics. The use of varnish and lacquers gave a very rich and shiny finish that contrasted and brightened the dull, somber interiors of that period.

We cannot end our report on this style without mentioning the graceful chairs, with backs ornamented with split vertical uprights. This type of chair is easily recognized by its back of turned vertical posts like banisters on a staircase. Those small round bars were split in two and the flat side was placed in front, while the turned vertical section embellished the back of the chair. There is also the straight chair without arms, with X-shaped stretchers and the winged armchair with cabriole legs and stretcher.

Highboy.

Lowboy.

WILLIAM AND MARY STYLE: *(A) Fall-top secretary desk; (B) Pendant.*

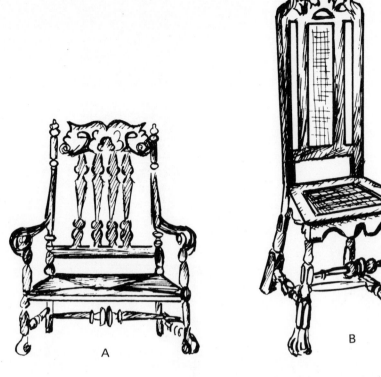

*(A) Open armchair; (B) Caned chair; (C)
Straight chair. William and Mary Style.*

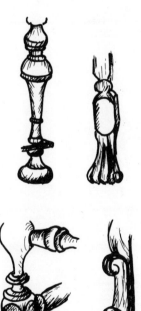

*Examples of legs in the
William and Mary style.*

Queen Anne Style (1702-1714)

Though Queen Anne reigned over England only from 1702 to 1714, furniture of this designation spanned the period from 1710 to 1760. Transplanted to the United States around 1720, after the Conquest, it had a certain popularity in Canada. There are few traces of this type of furniture in Quebec today, though I have discovered a table with rounded corners decorated with a fan-shaped shell and carved apron and ending in ball and claw feet. It was standing in the corner of an open shed belonging to a second-hand antique dealer in the Eastern Cantons. It was in the reign of Queen Anne that the celebrated Windsor chair appeared and spread like wildfire throughout all Anglo-Saxon America. We shall have more to say on this subject in the chapter on types of furniture under the section on chairs.

The lines of furniture in that first half of the 18th century were even more graceful than those of the preceding style. The double curve, strangely reminiscent of the axis of a flower's growth and decline, is found in all the cabinetwork of that period. William

Hogarth, the artist (1697-1764), did not speak of the double curve but of a "line of beauty," so graceful, so elegant is this form. It is also called a cyma curve. Flower lovers or specialists in floral arrangements are familiar with the term.

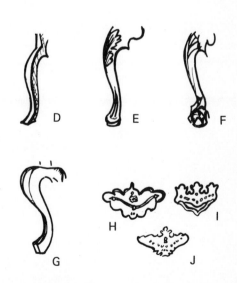

QUEEN ANNE STYLE: *(D,E,F,G) Legs; (H,I,J)
Furniture hardware.*

Queen Anne chairs have removable cushions, carved or plain cabriole legs ending in a ball and claw foot. The backs are straight or spoon-shaped and decorated in the center with a wide, vertical splat shaped like a flower vase or a violin. We may add that all these

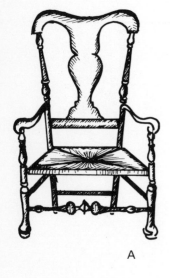

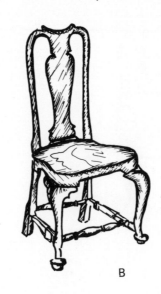

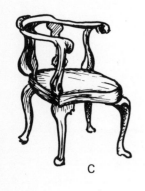

(A) Open armchair; (B) Straight chair; (C) Corner chair.

chairs display a concern for greater comfort, a concern that extends to the well-padded armchair, covered with fabric. This is the wing chair or bergere.

The highboy becomes more refined, elongated in height and more elegant in appearance. The upper part consists of a series of three or four large drawers on which are superimposed two rows of smaller drawers topped with a broken pediment which is even closer to the characteristic curve of this style. The lowboy is embellished with a row of additional drawers.

Fan-shaped shell work is still the decoration most used. It is carved in the center of an ensemble, on the knee of a cabriole leg, on the aprons of chairs and tables. Carving is not used excessively in this style, but cabinetmakers insisted upon graceful lines and elegance of shape. Inlay and delicate marquetry were again in favor, but this fashion died, and thereafter, cabinetmakers applied themselves to bringing out the quality of the wood. Lacquered or varnished furniture seemed more in keeping with a heterogeneous ensemble: Chinese or white porcelain, Venetian glass, Oriental rugs. Walnut and curly maple were still the woods Anglo-American craftsmen preferred.

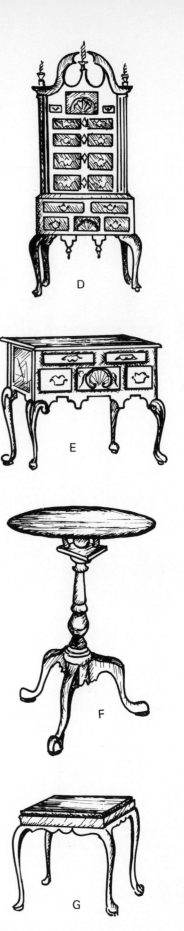

(D) Highboy; (E) Lowboy ; (F) Three-legged round table; (G) Tea table.

CHIPPENDALE STYLE:
Furniture hardware.

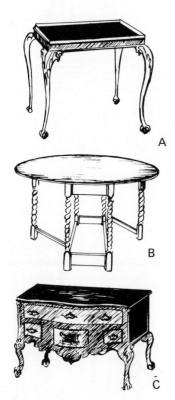

(A) Tea table; (B) Kitchen table with turned ladder-type legs; (C) Lowboy.

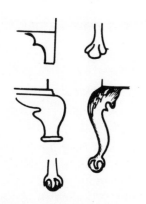

Various types of feet in which the claw and ball predominate.

Chippendale (1749-1779)

The "Georgian" period began in 1715 and, until 1815, a series of artists set the trend and put their mark on Great Britain. Specialists in the history of art divide this period into two sections: Early Georgian (1715-1750) and Late Georgian (1750-1815). The first part of this long period saw the works of Thomas Chippendale, whereas Adam, Hepplewhite, and Sheraton found favor with the public at the end of the 18th and the beginning of the 19th century.

Thomas Chippendale was the most famous of English cabinetmakers. Son of a carpenter-wood carver, he made his debut in the profession as a carver of chairs, but quickly attained a reputation that increased with the publication in 1754 of his *The Gentleman and Cabinet Maker's Directory*, the first volume of its kind.

Chippendale was above all a remarkable designer. Inspired by the English tradition, influenced by Holland, drawing on a Gothic art that was mixed with Chinese exoticism, the master created beautiful, graceful, perfectly balanced furniture.

One of the most usual motifs in the decorative repertoire that is directly associated with Chippendale is the ball and claw foot at the end of a cabriole leg. Gadrooning, the drake (three-lobed) foot, and short, wide bracket feet are also forms this artist favored.

Chippendale was inspired by Chinese styles which were in general favor in the last half of the 18th century (1750-1775). One has only to look at his chairs with straight, square, untapered legs, the ladder back or the openwork back, to note this influence. Chairs are the most beautiful pieces of his *oeuvre*.

In addition, this great English master was the first to use laminating to reinforce the openwork slats of chair backs. Instead of a single thickness of wood, he laid together three little boards with the grain in each piece running in a different direction. The process of laminating, as we know it today, was patented in the United States in 1854 by an American of German origin, John Henry Belter. Though Chippendale did not slice the layers of wood thin and glue them together across the grain, nevertheless his technique proved to be definitely ahead of his time.

Chippendale furniture was usually made of mahogany and so solidly built that it has withstood the ages. Carving and oriental lac-

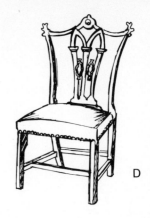

D

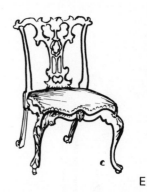

E

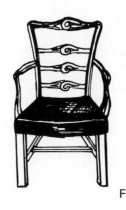

F

(D) Straight chair, Chinese inspired; (E) Straight chair; (F) Ladderback open armchair.

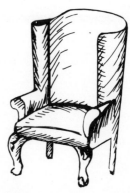

Wing armchair.

quers added to its richness. In the United States, curly maple and cherry-wood were popular with craftsmen who copied the creations of the great English cabinetmaker.

Wing armchairs, padded and upholstered in fabric, look very comfortable with their horizontally rolled armrests. This armchair is frequently confused with the Queen Anne armchair where the curve of the arm is vertical. Claw and ball feet are another difference, although they are not found in all Chippendale-style wing chairs. Among the decorative motifs the artist preferred we shall mention only the acanthus leaf, shells, arabesques, garlands, rocks, drake feet, slippered feet, and ball and claw feet.

ADAM STYLE: (C) Drawing-room table; (D) Gaming table; (E) Commode.

(A) Mirror; (B) Three-legged table or occasional table.

And finally we must add that the furniture of this half of the 18th century was enhanced by a complete collection of curios and knick-knacks, in particular Chinese. In the Province of Quebec, we find furniture of this style in the counties southwest of the St. Lawrence, from Levis to Rivière-du-Loup. Professional pickers, scouting these areas have occasionally discovered rare pieces for their wealthy clientele in the big centers. There have been, as well, numerous pieces of handmade furniture copied from the decorative repertoire of the Chippendale style.

(F) Open armchair; (G) Ladderback chair.

Adam Style (1765-1785)

Robert Adam was first and foremost an architect, but in addition to drawing up plans for houses, he designed furniture down to the slightest detail. The fact that he had collaborated in certain archeological excavations in Italy had given him a taste for Roman forms; but he was not satisfied to slavishly imitate the models of antiquity. Instead he created furniture in a style known as neoclassic. We are therefore no longer in the Chippendale vein.

All that furniture has a very special place

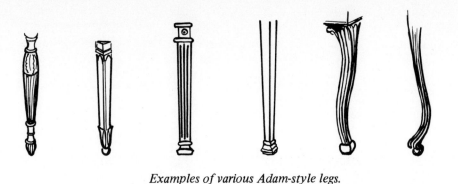

Examples of various Adam-style legs.

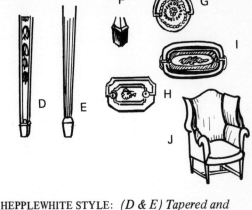

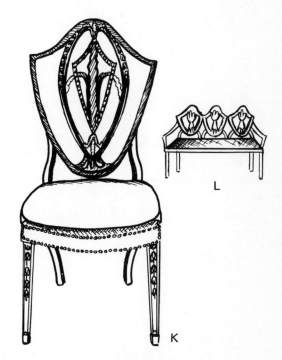

HEPPLEWHITE STYLE: *(D & E) Tapered and straight legs, often fluted and decorated; (F) End of spade-shaped foot; (G H I) Furniture hardware; (J) Wing* bergère.

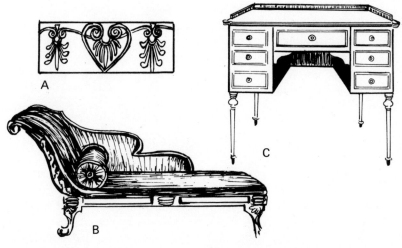

(A) Decorative palmettes; (B)Daybed; (C)Secretary desk.

in the architectural portions of Adam's designs. Chairs, lighter in weight than Chippendale's, sometimes have the back, with an oval motif curved inward and padded, or a straight, pierced back decorated with a lyre. The legs taper downward to a pedestal, like a column. Without any doubt our architect was influenced by the Louis xvi style when he created those chairs with carved back crosspieces and scrolled feet.

Grooving, flutings and dentils with beading, ram's heads, urns, medallions and especially the classic honeysuckle, are the important accents in his decorative repertoire. Adam's influence on Quebec furniture is especially noticeable in the decorative components. Flutings, grooving on the posts of wardrobes and cupboards, or even cornice dentils, bear witness to that influence, though dentils on cornices were common long before Adam.

Hepplewhite Style (1785-1795)

Another English artist, outstanding in furniture making, whose influence is visible even in our day, was Thomas Hepplewhite. Hepplewhite's designs were popular in England

(K) Straight chair; (L) Settee for two; (M) Plume motif called "Prince of Wales," which often ornaments the backs of Hepplewhite chairs.

Dropleaf table and drawers.

Half-moon armoirette.

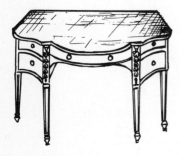

Secretary table.

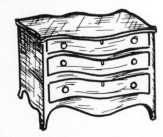

Chest of drawers.

at the end of the 18th century and in the U.S.A. at the beginning of the 19th. In 1788, the posthumous publication by his widow of *The Cabinet Maker and Upholsterer's Guide* was so well received by devotees of fine furniture that several subsequent editions had to be issued.

Hepplewhite's style was greatly influenced by the work of the four Adam brothers, the most famous of which was Robert. This is easily understood when we realize that the architect Adam had his furniture made in the Hepplewhite workrooms. And we may add that Thomas Hepplewhite was above all a popularizer of the Adam creations.

Hepplewhite furniture is distinguished particularly by straight, stiff forms, light in appearance, as we can see in the square legs of chairs and tables; serpentine fronts, delicate curves, exquisite inlays, backs of chairs with medallion and shield motifs. These are all characteristic elements of this style.

The chairs have a special characteristic: the legs are usually straight and tapered, ending in a spade-shaped foot, whereas the backs, decorated with an oval shield, show intermingled hearts and fleurs de lis. Moreover, even though these chairs each have a reinforcement of horizontal stretchers a few inches from the floor, they are not very strong—if we may judge by their condition after several decades of use. The entire chair seat is covered with fabric, even the edges which are lightly padded. Notice that the square legs are tapered toward the foot on the inside of the frame before it narrows down toward the bottom. The effect is to give the chair or the table a very graceful appearance.

Hepplewhite, a truly great cabinetmaker, launched new types of furniture. The sideboard is generally attributed to him. This piece of dining room furniture, which stands high on feet, is somewhat like a tomb in shape, with drawers below the top and several panels. The sideboard was to spread from the English workshop of the master cabinetmaker. A bowed front and tapered legs are other details that help date this article.

To decorate his work, Hepplewhite used many inlays and veneers as well as a series of classical motifs ranging from the sheaf of wheat, necklace of shells, and Canterbury bells to round or oval medallions. Prince of Whales plumes, in hone of his protector and admirer, were also part of this range of motifs. Woods like mahogany and a variety of precious woods—Brazilian rosewood, Indian snakewood—were often completely camouflaged by varnish or paint. Wedgewood is the most representative accessory and it enlivens these creations together with a wide collection of Chinese knickknacks.

Sheraton Style (1785-1805)

The Sheraton style is often confusd with Hepplewhite. In fact, the lines, forms and decorative elements are so similar that many amateur collectors often have difficulty in distinguishing the two styles, though each style has certain characteristics of its own. Imitation, however, explains the resemblance of some details.

Thomas Sheraton (1750-1806) had a most eventful life, if one considers his many interests and the range of professions he practiced. He was by turns a carpenter, cabinetmaker, designer, editor and preacher. At the age of forty, he gained a measure of renown from his books on popularizing art: *Designs for Furniture* (1790); the following year, *Cabinet Maker's and Upholsterer's Drawing Book*, then a dictionary of cabinetmaking, and, in 1804, his major work, *Cabinet Maker's and Upholsterer's and Artist's Encyclopedia*, the latter work being interrupted by his death. Those, in brief, are the principal achievements of this man of multiple talents.

Inspired by the forms of the Louis XVI era, the Sheraton style, which was almost contemporary with the Hepplewhite style, developed at the end of the 18th century and continued in fashion until 1830. The last of the great English cabinetmakers had a tremendous influence on United States and Canadian furniture makers.

A straight, square, solidly built piece of furniture is a good example of the Sheraton line. The posts are thin and taper toward the bottom; feet are turned or square, spade or block shaped. Chairs are plain, their straight backs reinforced by an arched, openwork, or carved splat. The arms of arm-rests are high at the back and glide gently in an S-shape to the side supports which are the continuation of the front posts.

The chair frame is frequently reinforced. The upholstery padding on the front rail distinguishes the Sheraton armchair from the Hepplewhite which covers the edge of the material with a band or cord. Sheraton makes

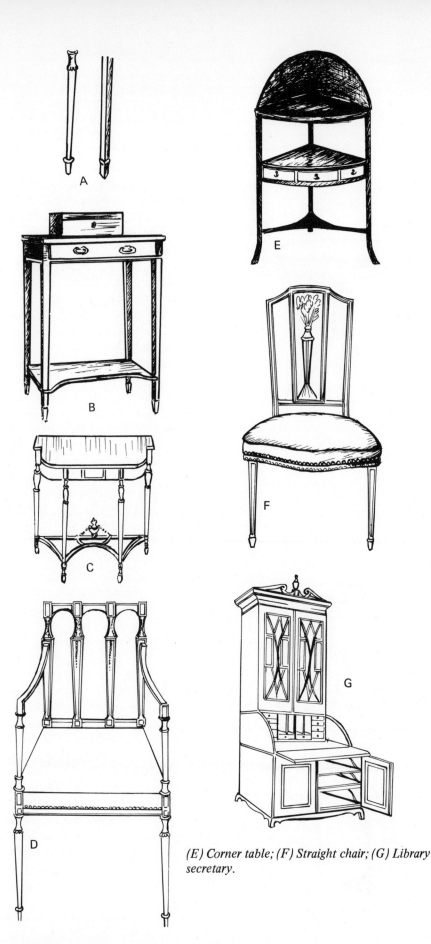

full use of every means to·embellish the whole. Carving, inlay, and even painting soften the austere aspect of all its lines, as on the luxurious painted daybed, which became very popular at that time.

Mahogany was still the wood most used, and inlays of precious woods, tinted to add to their beauty, gave new life to Sheraton's creations. Spiral turnings were combined with motifs in the form of lyres, urns or little fan-shaped discs, acanthus leaves, garlands and stars. Round or hexagonal hardware and round glass knobs served as additional ornamentational touches.

One of the great innovations of the Sheraton style was undoubtedly the large sofa with eight turned, fluted feet. In the Province of Quebec this type of furniture is found chiefly in the west and southeast of the St. Lawrence. However, studies on the dispersion of Anglo-Saxon furniture in Quebec are still to be made.

At the end of this period, it became almost impossible to tell the difference between Directoire, Empire, and Sheraton styles. This was especially true in the United States where furniture was subjected to all those different influences at the same time. One can speak of inspiration, of borrowing from certain styles, but preciseness is relative and open to question. We must therefore be satisfied to present those handcrafted creations as works from the early 19th century.

(E) Corner table; (F) Straight chair; (G) Library secretary.

SHERATON STYLE: *(A) Legs; (B) Table; (C) Wall table or console; (D) Armchair.*

Examples of Sheraton-style hardware.

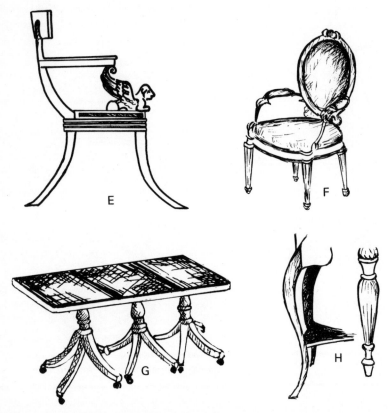

REGENCY STYLE: *(A) Dining room table; (B) Decorative palmettes; (C) Glassed cupboard; (D) Round table.*

(E) Klismos, *a Greek-inspired armchair, popularized under Adam; (F) Armchair; (G) Dining room table; (H) Legs.*

Regency Style (1800-1840)

Regency, the English style in vogue between 1800 and 1840, marked a return to classic forms. Largely as a reaction to Adam's neo-classicism, cabinetmakers began to reproduce antique forms and to adapt them to the needs of the day. Because of the striking resemblance of this style to the works of those two great French artists of the early 19th century, C. Percier and P. Fontaine, who set the fashion in Europe, Regency is often called "the English Empire style."

Ancient Greece was the inspiration for great cabinetmakers like Henri Holland (1745-1806) and Thomas Hope (1768-1831), when they were not influenced by the Roman or Egyptian models unearthed by archeological excavations. But the man who made those lines popular was the cabinetmaker-wood-carver George Smith, with his two publications: *Collection of Designs for Household Furniture and Interior Decoration* in 1808, and *Cabinet Makers and Upholsterers,* in 1826.

The chief characteristic of household furniture in that era was the simplicity of straight surfaces accentuated by vertical and horizontal lines. The chair, the table, and the sofa, were directly inspired by classical Greece. Decorations from the age of Pericles or from the Hellenistic period, such as the lion's paw, the claw, or the lyre, were used with restraint to ornament facades. Other motifs were taken from Egyptian antiquity: the Sphinx, the lotus leaf, or the crushed paw of a wounded lion. Most of these pieces of furniture were made of mahogany or of rare woods like rosewood. Columns, trellises, heads of lions or beavers, are among the inlaid brass fittings that embellish this furniture. Bamboo turnings, following the Chinese influence, were also very popular. The backs of chairs and their rear and front supports curved inward like a sabre at an opposite angle to the curve of the back. The back had a wide, semi-circular crosspiece at shoulder height, which sometimes did or sometimes did not extend beyond the supports of the arm rests. The bergere, a comfortable armchair, was entirely caned. Tables had their X-shaped stretchers and ended in massive animal feet.

The daybed came into general use during this period. The arms scrolled inward and the leg curved outward to end in the paw of a wounded lion. The dining room suite with an extendable table mounted on a heavy,

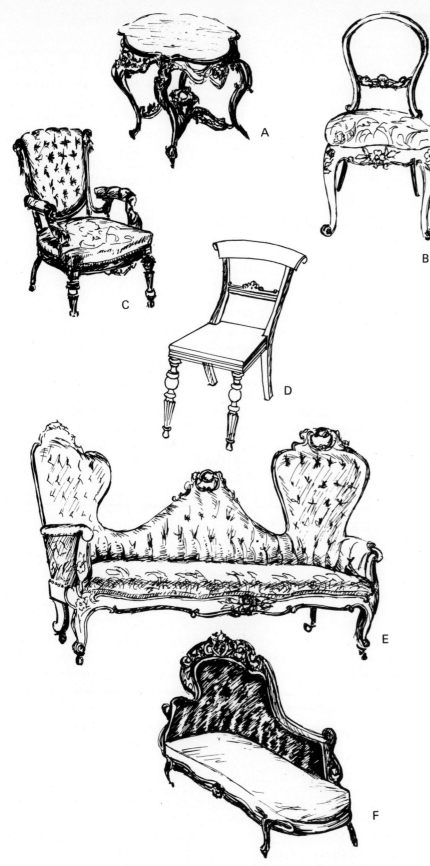

richly ornamented pedestal, supported by four curved feet, was also characteristic of this style. Commodes did not change; brass handles representing a lion's snout and fluted columns at the corners were the essential differences in decoration.

Victorian Style (1837-1910)

The Victorian Style takes its name from Queen Victoria who reigned over that British Empire "on which the sun never sets" from 1837 to 1901. It was one of the longest reigns in the history of mankind. This period is divided into Early Victorian (1837-1860), Middle Victorian (1860-1880) and Late Victorian (1880-1901). Certain changes and various influences along the way were to modify the natural evolution of all the arts in general.

Victorian furniture is characterized by marble tops on tables and writing desks, and by round or painted knobs of different sizes that were attached almost everywhere. All these creations are familiar to us for we are seeing them again in the "westerns" on television and in motion pictures. Do you remember those chairs covered in red plush, or those beds with high headboards, veneered, turned, ornamented with little columns? For many people (especially for Anglo-Saxons) this is the period the word "antiques" brings to mind. Taking into account the growth of population and cities in the course of that half century, and the general increase in purchasing power, it must be noted that factories produced as many pieces of furniture during that period as had been made up to that time. The machine, born of the industrial era, was to supply an ever-increasing clientele.

During that period, man obtained a working knowledge of new inventions of finely perfected tools. Carving and inlay were still in use, but the work was no longer done with old tools. Like a child who has just been given a new toy, the artisan racked his brains to find a thousand and one ways to use those innovations. Thus the most fantastic groovings, flutings, and turnings (regular dust-catchers) appeared practically everywhere on this furniture. The machine-age was beginning, and it was to come into its own when production needs became pressing.

Padded and fabric upholstery were con-

VICTORIAN STYLE: *(A) Table richly ornamented with carved floral motifs, marble top; (B) Chair with rounded or balloon silhouette back, often ornamented with garlands of roses or other motifs taken from Anglo-French styles; (C) Open armchair, padded and upholstered, Renaissance-inspired; (D) Grecian chair, early Victorian; (E) Victorian rococo sofa; (F) Daybed.*

Sofa, American Empire style.

A

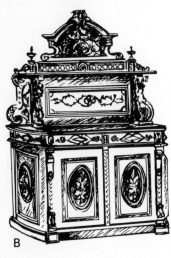

B

(A) Etagère *or "whatnot"
with twisted or turned
uprights and two-drawer table
top; (B) Dining room buffet
inspired by the Renaissance;
Popular shape in the late
Victorian period (English).*

sidered smart and used so lavishly that only
the heavy feet revealed the wooden structure
beneath. Casters and springs were found on
all chairs. Comfort and ease in handling were
factors every furniture maker learned to
respect.

Furniture produced during the early years
of that period was rather Gothic in style,
with straight lines and very square shapes.
But French influence soon added some ele-
gance with corners and surfaces curved in-
ward or rounded. Dark walnut became the
favorite wood of cabinetmakers, who even
went so far as to apply thin layers of that
wood on pine frames. Mahogany, maple,
cherry, and wild-cherry were also the car-
penter's favorites.

Confronted with new demands, the in-
ventive minds of those cabinetmakers pro-
duced a series of new types of furniture:
kitchen sinks, wash stands, umbrella stands,
clothes racks shaped like straight high chairs
with backs ornamented with beveled mir-
rors, small all-purpose armoires, tables with
several shelves on spiral-turned supports, dec-
orative little tables in the most surprising
shapes

It was also during this period that metal
beds and chairs came into general use. Iron
beds covered with thin layers of brass (fre-
quently mistaken for solid brass), with their
tubes or their assemblage of thin, straight
bars, are fairly representative of that craze
for metal objects. Cast-iron beds also date
from this period. It was chiefly in the Vic-
torian age that dining room, drawing room,
and bedroom furniture was sold in suites, a
procedure seldom used before when every
piece was made by hand.

The Victorian style had an extraordinary
impact on the life of Canadians: and it is safe

to say that throughout the second half of the
19th century, this was the only style in vogue
—as a stroll through a few antique shops or a
visit to the homes of the wealthy bourgeoisie
or even to country houses of the past century
will confirm.

Glass was one of the most important ac-
cessories in the decor of a Victorian room.
Kerosene hurricane lamps, those lamps with
two large globes one on top of the other and
decorated with handpainted flowers, bracket
lights with reflectors cast their glow on pur-
ple, lilac, rose, dark green, or brown walls.

American Directoire Style
(1805-1825)

So far we have seen the French and English
influences on French-Canadian furniture, but
we must not forget the American contribu-
tion. The United States assimilated certain
styles and exported them to Canada in new
forms.

It has already been mentioned that after
the War of Independence of 1776, the United
States developed a manifest enthusiasm for
their French ally, fervor which the arrival
of LaFayette's regiment only served to in-
crease. Between 1805 and 1825, the Direc-
toire style, decried by Paris newspapers, was
to have far-reaching effects on American
furniture.

That period, as we recall, was famous for
its Greek-style beds, its sofas with sabre feet,
backs of chairs with lyre motifs. Laurel
branches, stars, rosettes, aphorae, and palm-
ettes go hand in hand with such military mo-
tifs as battle-axes, torches, shields.

In its American version the Directoire style
is less ornate and carved than the French
Directoire. The bald eagle is a customary
decoration. The blue, white and red of the
tricolor and beige and gray tones decorated
the American-style furniture.

American Empire Style (1815-1850)

The American Empire, that adaptation of
the French Empire, also had its influence on
Canada. Here again, Americans greatly sim-
plified ornamentation. Most of the chairs
were painted, and an American carpenter
turned out more than 15,000 of them annu-
ally. A number of Canadian rustic chairs
were inspired by the luxurious and whimsical

Table of the Directoire style.

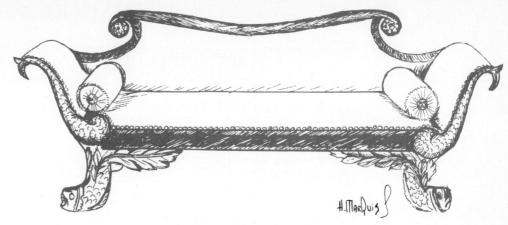

"Dauphin" sofa of the Empire style.

Settee and tripod table, both Directoire.

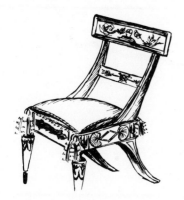

Roman version of Greek Klismos *chair (Empire).*

chairs of Lambert Hitchcock.

In the United States, the principal motifs used for decoration were the acanthus leaf, the pineapple, animals' paws, and lion's snout. Mahogany and curly maple were still the popular woods, which the artist delicately carved. Maple veneer on a mahogany frame was a process used by more than one manufacturer. Types of furniture dominating this period (as we saw previously in the presentation of French styles) were "sleigh" beds, sofas with flared, slightly rolled arms, and either scroll or animal paw feet.

Duncan Phyfe (1800-1820)

A number of pieces of furniture found in Quebec are often attributed to that great furniture maker, Duncan Phyfe (1795-1856). His creations are a mixture of Sheraton and Directoire, as one would expect in a period in which those two styles were simultaneously in fashion in the United States.

Newspapers are an important source for anyone who wishes to study the furniture of the 19th century. The *Journal de Québec* (Sept. 1871) reports the events of the latest regional exhibition and lists the names of the exhibitors of furniture and the winners. Furniture makers' advertisements in the newspapers of the 19th century tell us much about this industry in Quebec during that century. The following announcement by Drouin & Roy appeared in the *Journal de Québec* (May, 1871).

"Leaders among our Quebec industrialists, both in merit as well as in enterprise, are Messrs. Vallière and Drum, who own two of the largest cabinetmaking establishments in Canada and can uphold the honor of our city against all-comers.

"M. Vallière has won seven first prizes, and we think it would be difficult to find anyone more deserving. His set of drawing room furniture in dark walnut, Louis xv style, certainly deserved this distinction. There is nothing to equal the beauty and finish of the carving on this furniture of exquisite taste and elegance. Everyone eager to have his own home will wish to own it.

"M. Vallière has also received the prize for carving: a magnificent walnut etagere and a sideboard in the same wood have also been given prizes, as well as a suite of bedroom furniture in dark walnut and ash, whose simplicity and elegance we found equally striking. His chairs for export and cradles with springs have also received first prizes. Bravo, M. Vallière!

"M. Drum has five prizes to his credit. His large sideboard in dark walnut is magnificent and attracts much attention. It is a very handsome piece of furniture and it would be difficult to find anything finer of its kind.

"M. Drum also received first prize for a magnificent wardrobe and the same honor for a drawing room suite in dark walnut and also for a dining room suite. These two cabinetmakers, Messrs. Drum and Vallière, know how to make the most of our Canadian woods, and their furniture in polished dark walnut certainly shows to advantage beside furniture made of mahogany and other woods. These two rivals deserve our praise on another score. In striving to outdo one another, they give employment to hundreds of people while at the same time they are working to assure for our city the furniture trade of the Maritime Provinces. If we had many industrialists like Messrs. Vallière and Drum, Quebec would soon emerge from the distressing stagnation in which we now see her."

Types of French-Canadian Furniture

It is a large, carved buffet;
the oak, dark and very old, has
taken on that delightful air of
old people. This buffet is open
and its shadows pour forth inviting
perfumes like a flood of old wine.

RIMBAUD

When it comes to the traditional furniture, one must not always try to connect this article or that with a particular style. Local artisans did not always have a model at hand and though imitation has been an important factor in the evolution of our art, necessity and the taste of the buyer were restraining priorities for the maker.

The general shape of the piece or the decorative details will always point to certain affinities with one or another epoque; but even the specialist will go astray at times in trying to pin a definite date on a piece; the touchstones are often infinitesimal and the influences too numerous. One could suggest a century, a style, but there will always be room for greater precision. If there is no documentation and if the signature of the cabinetmaker is missing, only the outward appearance of the work and oral tradition can help in this process of evaluation, except, of course, in cases of purchases from factories where the account books have been preserved.

This history of a family that has handed down furniture from generation to generation will throw a little light on the date of purchase and the origin of a handmade piece. This is true with some of the wardrobes or inlaid commodes bearing a date and a name on their facades: the bride, especially in the 19th century, immortalized the blessed day of her marriage in this obvious manner. Unfortunately, there are exceptions to this custom.

In spite of the difficulty of labeling most traditional rural furniture, much of it can be said to have been inspired by French or Anglo-American styles. Its various details, and a knowledge of the techniques of cabinetmaking of various periods will help to

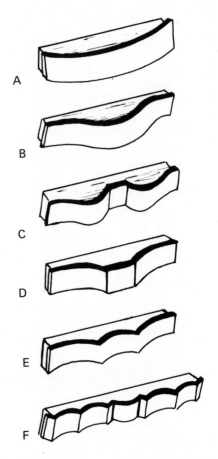

Fronts of commodes and other furniture: (A) Bow front; (B) Curved; (C) Crossbow; (D) Projecting or à ressaut; *(E) Concave* ressaut; *(F) Serpentine.*

Chest.

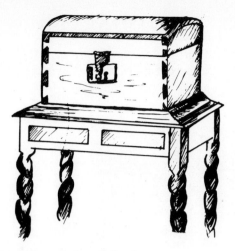

Dome-topped chest (bahut).

place these pieces in time, and often in space—that is, region.

But here again, one must be very cautious, for certain forms that have long since ceased to exist in Europe still persist here. This was true of Louis XIII and Louis XV styles, which, at the beginning of the last century, served as an inspiration to more than one local artisan.

Types of Furniture

Our ancestors were not rich, but they were better off than the peasant across the sea. Moreover, they liked beautiful things, as witness their furniture of solid wood, delicately carved, well balanced, and congenial. There is no question of servile imitation or copying,

for the works of most artisans—works are original creations, both in form and in decorative detail.

Veneering, collage, and inlay were used very little, but the colors of painted furniture or of natural woods lent a necessary warmth to those dark houses of wood or stone. Nor were Canadian artisans satisfied to build straight, ungraceful furniture. More than one apron of a table or foot rail of a chair will have a bow front, curved, crossbowed, concave, or serpentine, following French or Anglo-American influences. The legs will often be chamfered when they are not spindle-shaped, turned or curved.

Since what the rural dweller required basically, were, above all, the necessities of life, the range of furniture in daily use here was not as wide as it was in the mansions in the capitals of Europe. The refinement of the Court and the fact that furniture was made to suit various activities had led master cabinetmakers of the homeland to create a large number of elaborate pieces, as much for the private studies of collectors as for luxurious drawing rooms or bedrooms.

In America needs were different, and there was no time for the leisure that only wealth permits. The settler was therefore obliged to surround himself with only the strict essentials. Here a man was satisfied to furnish his common room, which served both as kitchen and living room, and the bedrooms. In the richest houses, especially during the second half of the 17th century and until the 19th, they managed to establish distinctions between the various rooms, and they added a study, perhaps, or a kind of office. On the whole, however, kitchen, living room,

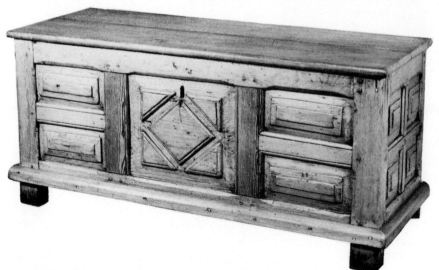

Chest with 11 panels in graduated relief; the one in the center is lozenged. Louis XIII style. Cover and lower moulding were remade. 18th century. (Musée de l'Hôtel-Dieu, Quebec.)

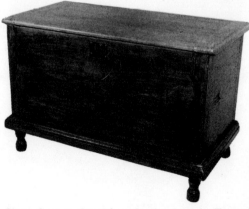

Plain chest made with wide pine boards. Turned feet. Interior includes an equipette, a small coffer or box that is inserted at one end and holds papers or jewels. Base molding is very decorative. Late 18th century. (Louis Martin, Quebec.)

63

and bedrooms remained the only rooms to be furnished in the traditional household.

At this point, we shall present the various types of furniture in use according to their functions. First, there are flat-topped chests or the domed top trunk, bahuts. Wardrobes with one or two doors were used for storing linen and clothes as well as precious objects. Next, there were the pieces used as larders and sometimes to store dishes and glasses. Thus, there were low buffets and two-tiered cupboards, dressers with shelves, glazed buffets and corner-cupboards from the beginning of the 19th century.

Bread bins or kneading troughs, as well as dressers with fretwork doors, were found in every house in the past, for the commercial bakery had not yet supplanted the domestic stove of stone imbedded in the kitchen wall or outside the house. Every householder had to take care of his own needs, to make the essentials, and put up provisions for the cold season.

The bedroom, the sole center of repose, was an important section of every country house. Beds were the dominant piece of furniture in that room. The enclosed box-bed, the canopy bed, beds with turned post and bedroom suites of the Victorian era in particular claim our attention. Cradles and commodes also belong in the category of bedroom furniture.

In those days, work was interrupted by moments of respite and time to chat quietly by the hearth in winter or in the cool of the living room in summer. And to accommodate these interims, benches, straight-chairs, open armchairs, and cradles were to be found in a number of variants in the traditional dwellings, depending upon the era and the region.

Kitchen tables, a number of decorative and useful little tables, consoles, secretaries, and desks complete this survey of the production of our carpenter-artisans.

In this chapter we shall, therefore, review the principal types of furniture, their function, and methods that were used to assemble them. By presenting their chief stylistic characteristics, we shall be able to discover the dominant influences.

Chest with four plain panels, straight base, intricate lower molding. Wide pine planks. 18th century. (M. and Mme. G.E. Gagné, Neuville.)

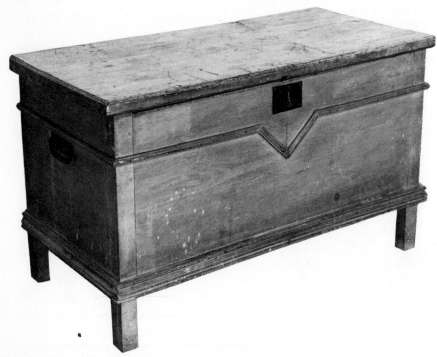

Chest decorated with applied rope trim forming a decorative V at the front. Side handles. Plain base. 18th century. (Musée de l'Hôtel-Dieu, Quebec.)

Chests and Bahuts

The coffer or chest is the ancestor of all our furniture. In the Middle Ages, European townspeople and peasants put everything they owned into those wooden boxes with locks and strap hinges. Clothing, laces, precious objects were placed in that one piece of furniture, to which a table and some

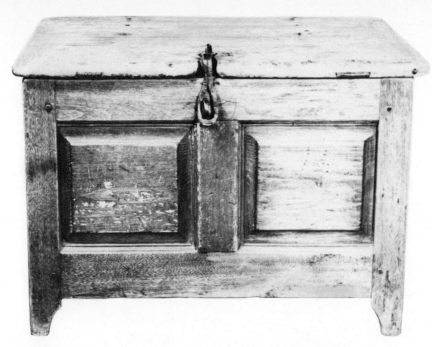

Small paneled chest with wide hasp of wrought iron. Typical of many old pieces of this style, two rings take the place of hinges. 18th century. (I.N.C.)

Panel motifs of traditional Quebec furniture: (A) Diamond points; (B) Lozenge; (C) Multiple diamond points.

benches were often added.

Canadian "settlers" attached great importance to the chest, and this sentiment was to persist. Only a few years ago the cedar chest was the indispensable article that every young girl from the country or the city had to have before she prepared her trousseau.

In the 16th century this piece of furniture was generally a rectangular box with a flat hasp. This massive, fairly plain hold-all, with straight and simple rectangular frame, was used for climbing into the high beds or as a bench. It was usually placed at the foot of the bed in the bedroom or in the large common room.

Carpenter-artisans also made chest-bahuts, so named because the cover was rounded, like those old traveling dome-topped trunks at the beginning of the century, of which it is undoubtedly the ancestor. The bahut was at first that two-door piece of furniture which, when surmounted by two drawers, was then called an armoire or wardrobe.

The popularity of this type of furniture explains the number and variety of coffers and bahuts shown in antique shops. They are plain, solid articles, made of broad pine planks with tongue-and-groove joints, the butt-joint dovetailed or even pegged into the grooved stiles.

Several rarer specimens are ornamented with geometric motifs taken from the Louis XIII decorative repertoire. Others, drawing from the Louis XV style, have curved panels or console legs of Anglo-American inspira-

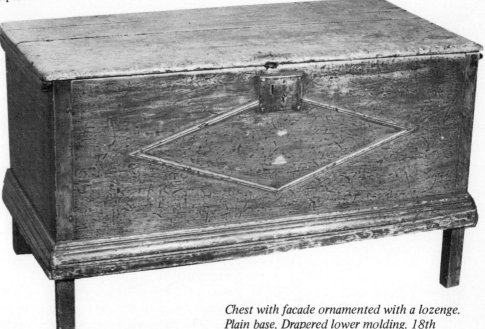

Chest with facade ornamented with a lozenge. Plain base. Drapered lower molding. 18th century. (Private Collection.)

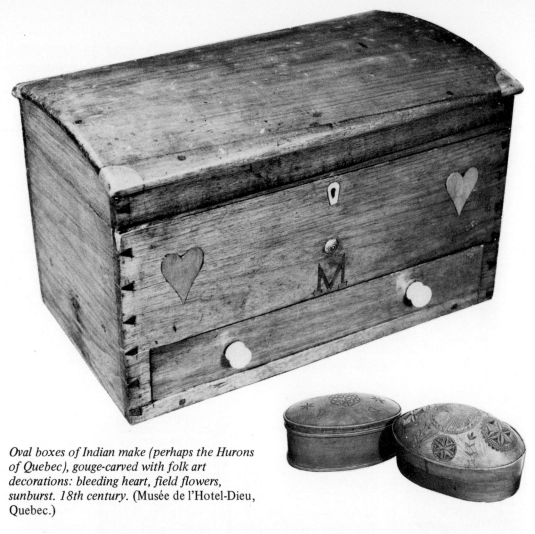

Small chest with domed lid; drawer at base ornamented with two ceramic buttons. Dovetailed joining. Corners of lid reinforced with metal; inlays of wood in the folk-art tradition of the 19th century. (Musée de l'Hôtel Dieu, Quebec.)

Oval boxes of Indian make (perhaps the Hurons of Quebec), gouge-carved with folk art decorations: bleeding heart, field flowers, sunburst. 18th century. (Musée de l'Hotel-Dieu, Quebec.)

Chest with convex lid, with handles at the ends. Dovetailed joining. 18th century. (Musée de l'Hôtel Dieu, Quebec.)

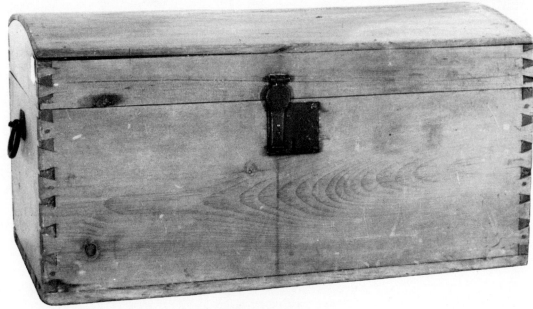

tion. Finally, some of those pieces of furniture are forerunners of the commode, or chest of drawers, for it will have a drawer in the lower part, close to the floor. Most of them are made by hand and date from the end of the 18th and 19th centuries.

Armoires

The armoire is without doubt the best known, most representative, and most elegant article of French-inspired furniture. Several examples of this quality furniture

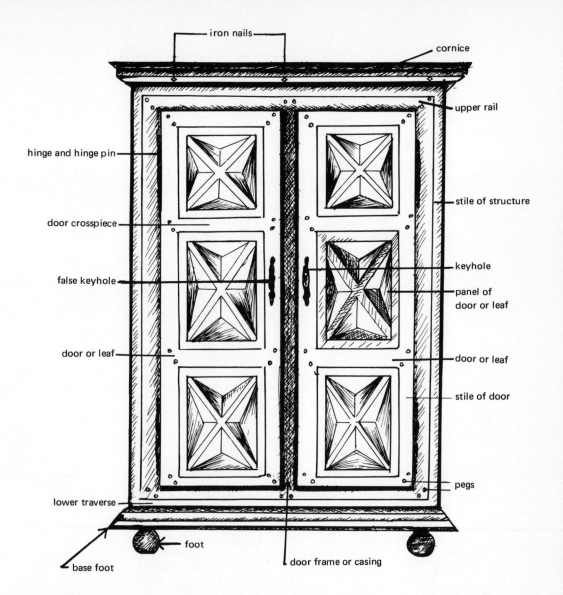

iron nails

cornice

hinge and hinge pin

upper rail

door crosspiece

stile of structure

false keyhole

keyhole

panel of
door or leaf

door or leaf

door or leaf

stile of door

pegs

lower traverse

foot

base foot

door frame or casing

Disc or pancake.

The Wardrobe and Its Different Parts: A wooden latch could be added above the keyhole; if the keys were lost, this could be used to hold the doors shut. It is still unusual to find a wardrobe or a cupboard made with only a latch. The cornice on this wardrobe is a hood cornice made from one solid piece of wood. One can also find a cornice with a molded support when the top of the wardrobe is a different part of this upper molding.

have managed to survive through the ages, and all true amateur collectors are proud to own one of those pieces. So great is the interest in them that forgers and rebuilders devote themselves entirely to imitating those artistic creations.

The armoire, or wardrobe, is a piece of furniture in one single body, that is to say, it is only one single piece with one or two doors and frequently surmounted by an elaborate cornice made of several moldings cut from a single piece of wood. The lower part, made with a very decoratively carved crosspiece, serves as a base. The elongated stiles also sometimes function as feet. Today, the pieces most frequently found on the market have

a straight base, with or without molding. The panels are joined to the stiles by hand-made hinges and close on a vertical plank called a casing fixed frame.

The cornice, the upper part of the panels, the doors, and the lower crosspiece are cut from one broad plank of wood and carved with geometric motifs (diamond points, lozenges, discs, pancake) or scrolled in the Louis xv style and reeded to imitate Adam.

The side panels are often symmetrical repetitions of the doors. That symmetry, the apt proportions of the whole piece, together with the arrangement of the panels, the cornices with plain moldings but balanced by the arrangement of grooves, beads, and slots, give

Panel motifs: (A) Linen fold; (B) Curved panel; (C) Panel carved with rococo motif; (D) Relief ornament with reeding.

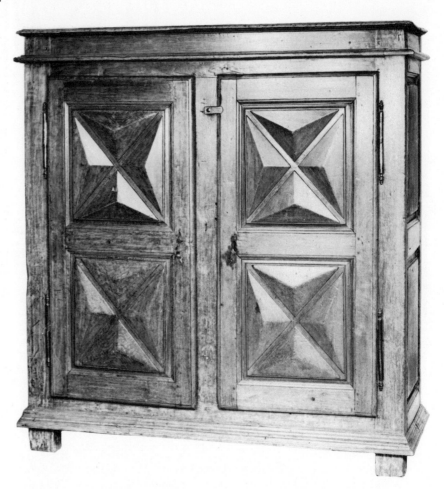

Armoire with two doors ornamented with diamond points. Upper crosspiece heightened by a rail. Carved molding on the lower crosspiece. Bannister hinge; latch added later. Late 18th century. (M. and Mme. G.E. Gagné, Neuville.)

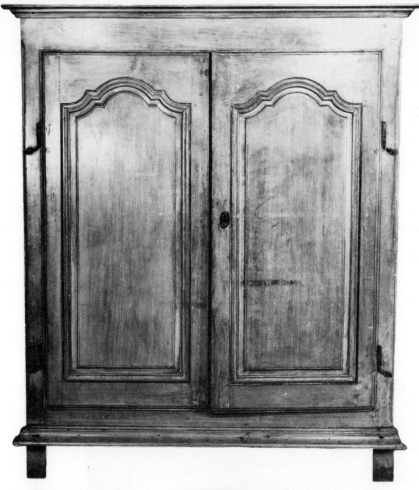

Two-doored armoire chest with plain panels. Notice the absence of a frame. Lower rail carved. (I.N.C.)

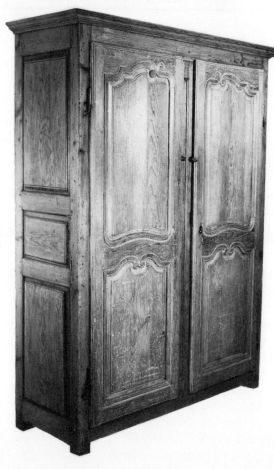

the Quebecois armoire a very special charm.

This furniture, the result of vertical elongation of the chest, serves as a linen closet, or a hold-all. The interior is equipped with wide shelves which were in use until the end of the last century.

The first armoires were inspired by Renaissance and Louis XIII styles. For more than one hundred and fifty years local artisans were to make pieces like these, taking their forms and decorative elements from French regional joinery but introducing numerous personal changes. The armoires inspired by the Louis XIII era are gigantic pieces in pine, with geometric ornamentation. The inset lozenge, the diamond point in relief, the simplified linen fold of the medieval period, the disk or pancake (*galette*) from the west of France are some of the details wood-carvers used on panels throughout the 17th and 18th centuries.

A fact worth noting: symmetry and harmony of forms, down to the smallest detail, were so much the constant concern of the craftsman that at times they even went so far as to add a false keyhole to the door that was locked from inside.

After the War of 1760, prosperity, then enjoying a brief revival, brought a certain ease to country man and city dweller alike. That economic change was to have repercussions in the furniture field. People could afford to buy furniture with elaborate decorations in the Louis XV style. Inspired by this style, the artisan carved foliated scrolls, spirals, shells, rosettes, seaweed, hearts, ribbons, and flutings—the many motifs that were to decorate crosspieces, stiles, and door panels. Pediments were arched and set the upper line of the door. Carved panels and turned bases completed these local productions.

A little later the armoire was influenced by both Louis XVI and Adam styles. The return to the antique in geometric forms, as is shown in the numbers of little panels on doors, and borrowings from Louis XVI style decorations, are characteristic of armoires of this type.

Finally, industrialization, mechanized equipment, and mass production (all resulting from an increase in population) are some of the elements that gradually put an end to

Armoire with two doors, carved panels ornamented with spirals. Structure is rectilinear: base, cornice, side paneling, with the exception of the door panels. Rattail hinges of wrought iron, bracket added. Late 18th century. (Private Collection.)

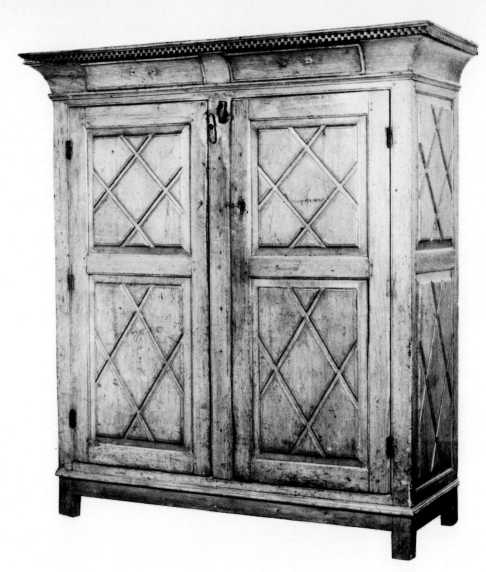

Two-door armoire with lozenges. The deep, concave cornice, ornamented with dentils, has two drawers. Cast-iron strap hinge. Wooden latch added later. Early 19th century. (I.N.C.)

the artisanry of taste, starting from the year 1840. The armoire degenerated, and carved ornamentation yielded to hollow panels almost always decorated with applied moldings. We find any number of armoires of this latter type in the yards of many junk shop antique dealers.

The Anglo-Saxon furniture of Upper Canada does not have as much warmth as the furniture of Quebec. There the armoire is a massive piece of furniture, with straight, austere lines. Doors and panels are made of several planks fitted together, with carved work practically non-existent. Several armoires of this make are found in the Province of Quebec, especially in the area around Montreal. Our rustic armoires, and much other furniture, for that matter, were meant to bring a little gaiety into somber dwellings. The majority were painted green, reddish-yellow, very dark blue-green, or white tinted with

yellow ochre. One sees this especially in furniture from 1750 on. Many amateur collectors and several museums have taken care to respect that initial color in the course of restoration, and thus did not fall prey to that frenzy for deep cleaning and exposing the golden and orangey tones of old woods. The knobs and hinges of those old wardrobes tell us much about the age of the piece. The pearl hinge, plain hinge, bannister hinge, and famous rat-tail hinge, while they all served a utilitarian purpose, also decorated the posts of pieces of the 18th and the beginning of the 19th centuries. Stylized keyholes with motifs of sea horses, dragons, or flames, made of wrought iron, or sometimes of brass—all of them handmade—are also from that same era. Finally, the L, H and butterfly hinges, all made in the blacksmith's shop, were especially popular during the 19th century. They are of Anglo-American inspiration.

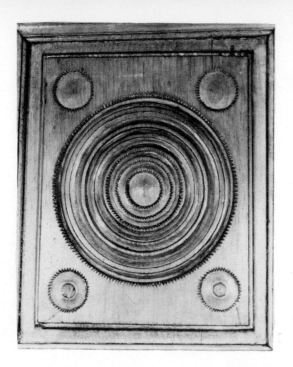
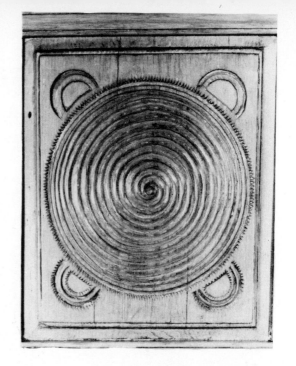

Dentiled discs.

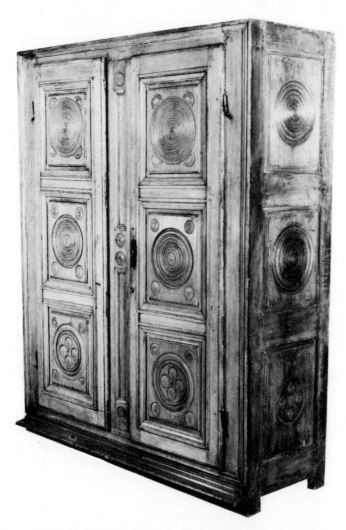

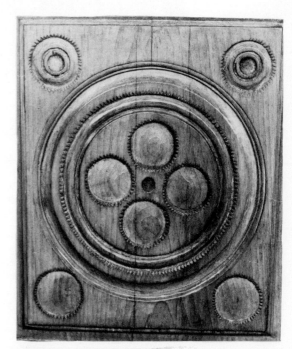

Pancake motif of armoire.

Armoire with multiple decorations of discs or galettes, traditional to Brittany. Heavy, massive furniture, made heavier-looking by the absence of the cornice, which has been sawed off. Molding on lower crosspiece, in the shape of a set of steps, gives the whole piece an architectural dimension. 18th century. (I.N.C.)

Buffets or Sideboards

Buffets are an article of furniture still found in the "common" or living room of most ancestral homes. Very few of them left on the market are worthy of much notice save for a few dating from the end of the 19th century; and they are without great interest esthetically or as specimens of fine handicraft.

In most furniture of this type that has come down to us and which is especially attractive to a collector, we find paneled doors ornamented with geometric designs borrowed

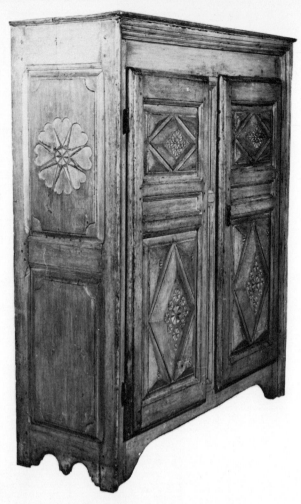

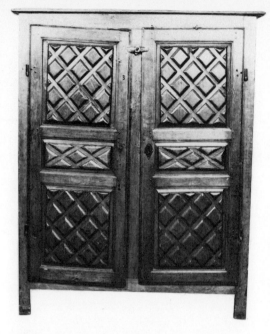

Wardrobe or armoire with two doors, their panels decorated with multiple lozenges forming crosshatching. The finished top makes it a logical link between the chest and the armoire. Wooden latch added. Plain hinges of wrought iron. Early 18th century. (I.N.C.)

Armoire with diamond points à la Louis XIII. The side panels are simplified linen folds. Doors and panels are decorated with geometric motifs. Base carved at sides, front rail cut out. (I.N.C.)

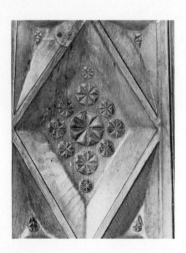 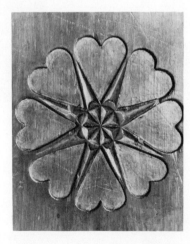

(A) Detail of diamond point of armoire above. Rounds or compass dials in traditional folk art design of Quebec; (B) Detail of side panel; flowers made of hearts, another traditional folk motif.

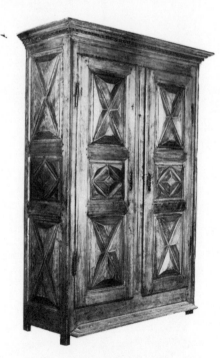

Fine wardrobe with diamond points. Generous proportions and perfect balance of panels. Baluster-shaped hinges; cornice denticulated and serrated; molding on lower rail in the form of steps; sea horse escutcheon. True diamond point found on the center panel is a lozenge in relief; other panels are most like St. Andrew's crosses outlining four triangles in relief. 18th century. (I.N.C.)

from the Louis XIII period or nail heads, lozenges, and simplified linen folds from the Middle Ages. Other buffets, taking their inspiration from the Louis XV style, show decorations in which the curved pattern predominates. Projecting cornices made of several moldings cut from a single block of wood, such as we see in handsome wardrobes, are sometimes replaced by a broken pediment in imitation of the Renaissance. Here again, as in the wardrobe, the sides of the cupboard are in keeping with the symmetry of the decoration on the front.

The low sideboard, a type like the two-tier buffet cut off from the top part, was in general use among the settlers (the *habitants*) from the beginning of the 17th century, if one may rely on the property inventories of deceased persons. These particular pieces of furniture, used for storing linen and dishes as well as food, turn up in several variations. First, there is the two-tier cupboard in cherry, pine, or light walnut. This is an architectural assembly of two parts placed one on top of the other, with the upper tier set slightly back at front and sides. Each section has two doors that open, and just under where the two sections meet, the lower por-

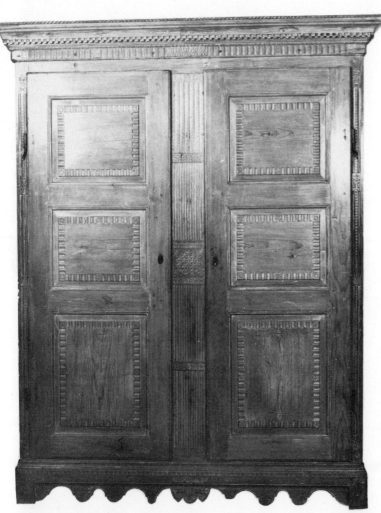

Armoire with two doors, each ornamented with three panels. One can see groovings, wolf's teeth, flowers, rounds, geometric motifs, chisel marks. Stiles are ornamented with little flower pots with a network of foliage emerging from them. Console base pleasantly contoured, reflecting the various influences current in Quebec at the end of the 18th century. (I.N.C.)

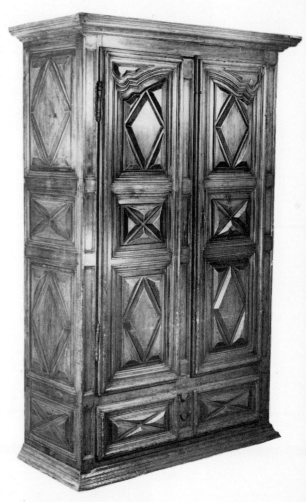

Armoire is a fine example of furniture of the transition period between Louis XV and Louis XVI – the molding of upper panel is Louis XVI, but the whole piece is more in the character of Louis XV. Notice that the center post is false – it is actually one of the doors. Mid-18th century. (I.N.C.)

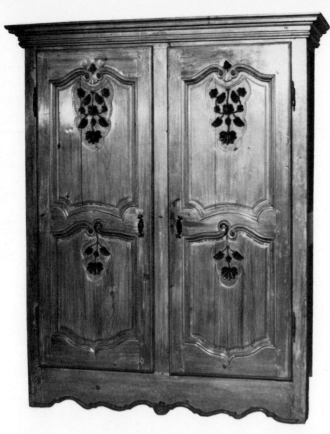

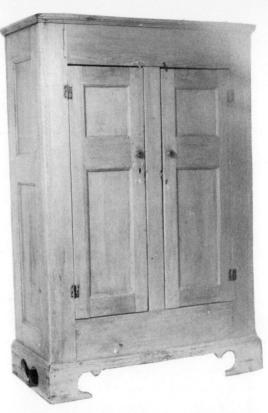

Armoire with doors decorated with foliated scrolls; massive lower rail carved. Cartouche on the panels is decorated with foliage and flowers in the rococo style of Louis XV. Unfortunately, the base is short, making the general appearance heavy. (I.N.C.)

Small armoire with double doors. Dating from the end of the handcraft period, this kind of armoire is still frequently found in antique shops. Second half of the 19th century. (Private Collection.)

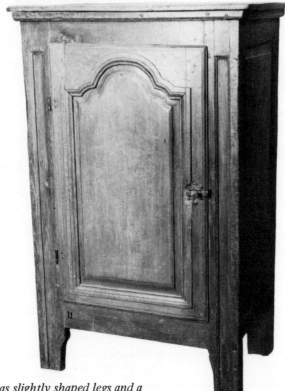

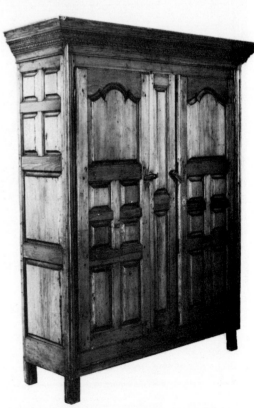

Small armoire has slightly shaped legs and a contoured door panel. Front posts ornamented with narrow vertical panels. Plain hinges and latch of the period. Late 18th century. (I.N.C.)

The general appearance of this armoire is very geometric, accentuated by the framing. A transition piece, it manifests the styles of Louis XIV and Louis XV. Late 18th century. (I.N.C.)

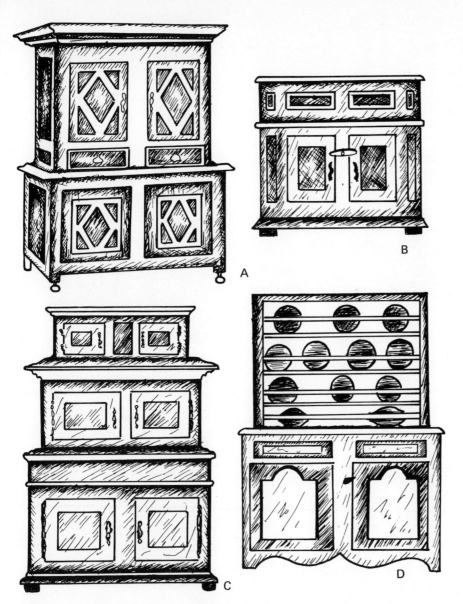

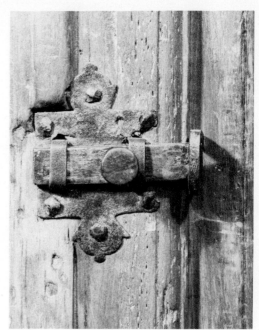

Detail of bolt of armoire at bottom left, page 74.

(A) Two-tier buffet (or sideboard); (B) Chest, two doors, two drawers; (C) Three-tier buffet; (D) Open glass dresser (or cupboard) with shelves.

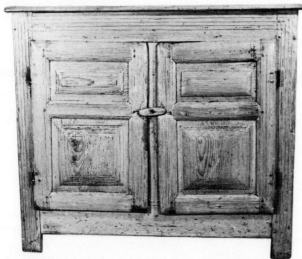

Low sideboard. Doors ornamented with square or rectangular panels in relief. Stiles and upper rail grooved after Anglo-American influences. Plain hinges. Late 18th-early 19th centuries. (I.N.C.)

tion has two drawers. In some buffets, those drawers will be found at the bottom of the upper portion.

Craftsmen will have lavished special care on this piece of furniture and it can be stated positively that these creations of the 17th and 18th centuries are among the finest specimens of French-Canadian handicraft. The projecting cornice and the paneled doors with their simple ornamentation are taken from styles then in vogue as well as from changes made in those styles in the provinces of France. This piece of furniture, with or without drawers at the top (when there are drawers below the top it is called a chest or bahut), was given as much care and ornamentation as the two-tier cupboard. After 1775, the belated influence of the Louis xv style led the Quebec carpenter to shape the front and side panels as well as the lower rail when his inspiration or his genius for imitation did not produce the design of the crossbow or the arched panel.

We find the same type of furniture again throughout the 19th century, as can be verified by examining keyhole escutcheons and hinges. Concave door panels, straight, unornamented shapes make for historically interesting pieces, but they are far from having the charm of the furniture of the preceding centuries. By the end of the 19th century, degeneration and stark simplification had set in.

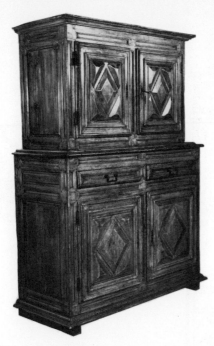

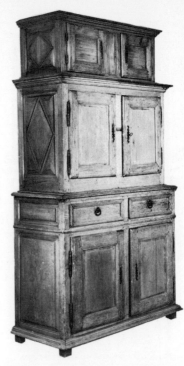

Two-tier cupboard with unfinished diamond points. Drawers are part of lower tier, but this type may have drawers on second tier. Door moldings are in one piece. Small rectangular panels ornament facade and sides. Carved molding and cornices. Magnificent collection piece. Late 18th century. (I.N.C.)

An uncommon type of furniture in Quebec, the facade of this three-tier buffet is ornamented with plain panels whereas the sides are decorated with lozenges. The top tier, though old, is obviously of a later period. Mid-18th century. (I.N.C.)

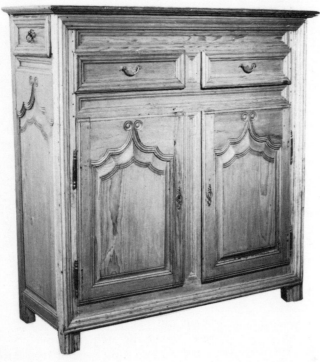

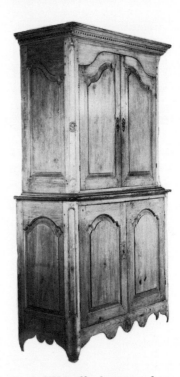

The work of a local artisan, this low sideboard shows the kind of originality that is far from any academicism. Assembled in an uncommon fashion, with very thin wooden pegs, there is a long side drawer which slides in under the top. It is ornamented fancifully with unusual contoured panels; the facade is ornamented with a frame of molding. Handles of front drawers are of a later date. 19th century. (Private Collection.)

Two-tier Louis XV buffet has curved top doors and carved panels. There is no post between the doors. Stiles are rounded and paneled; lower rail is carved. Cornice is ornamented with dentils. Early 19th century. (I.N.C.)

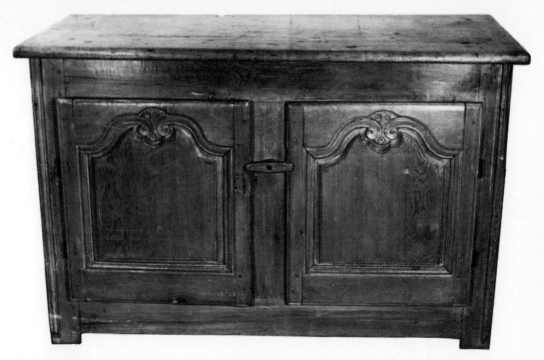

Lower part of armoire or chest. Two doors ornamented with contoured carving on panels. Notice the front facing on lateral stiles. Late 18th century. (I.N.C.)

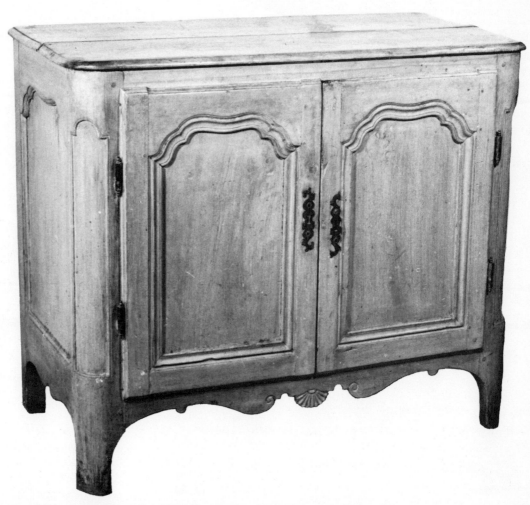

Low cupboard, its curved panels of Louis XV influence. Lower rail gracefully curved and ornamented with fanlike shell, clearly in the manner of Dunlap of New England. Late 18th century. (I.N.C.)

Dressers

Quite a few amateur collectors today are hunting for dressers. Aside from often being a remarkable piece of carpentry, this furniture is useful for displaying a collection of china, glass, or pewter which is what it was used for in middle class houses in the 18th and 19th centuries.

This traditional piece of furniture is usually

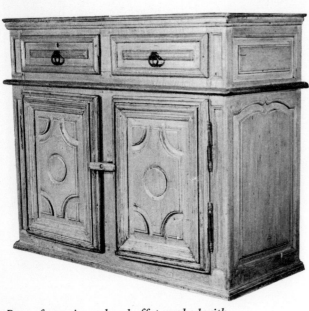

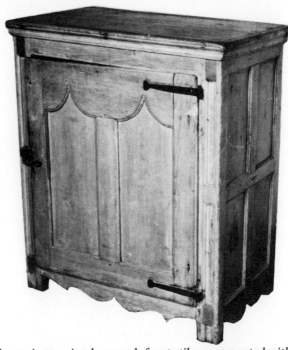

Base of armoire or low buffet marked with panels called "linen folds." Base has probably been cut down and top tier relegated to the attic. By general appearance, heaviness, and ornamentation, one can assume that the inspiration was Louis XIII style. 18th century. (I.N.C.)

Small paneled armoirette, simply carved; front stiles ornamented with rectangular hollow panels. Hinges were probably added later. Early 19th century. (I.N.C.)

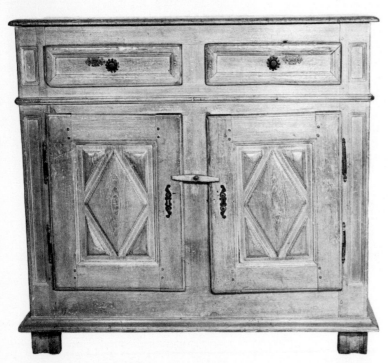

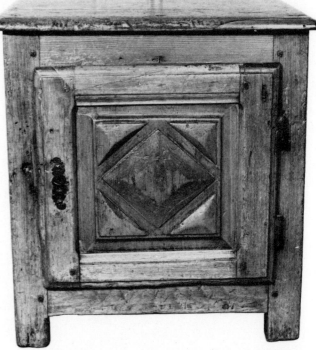

In the interests of symmetry, the artisan applied a false keyhole on left door of this low cupboard. Baluster hinges, diamond points, paneled stiles. Late 18th century. (I.N.C.)

Small wardrobe with diamond points, Louis XIII influence. The right corner of the top and left edge of door were intelligently repaired: one scarcely can distinguish the mortise wedge, though the color and grain of wood are slightly different. 18th century. (M. and Mme. G.E. Gagné, Neuville.)

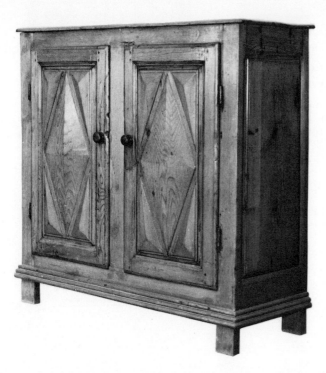

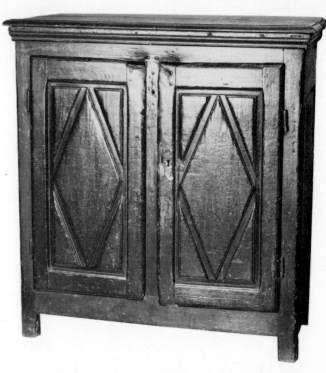

The round knobs on this low sideboard have undoubtedly been repaired.
(Musée de l'Hôtel-Dieu, Quebec.)

Chest with doors ornamented with lozenges.
18th century. (I.N.C.)

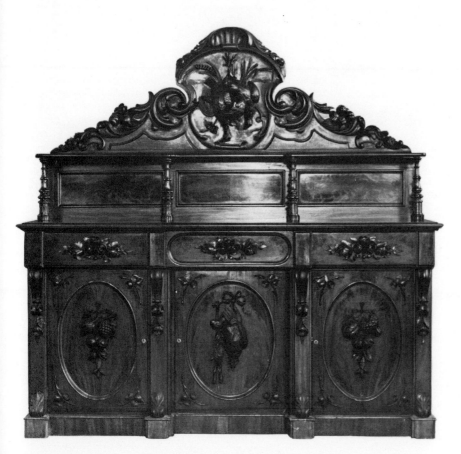

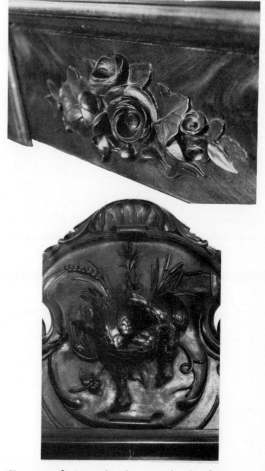

Massive Victorian-style sideboard in walnut, without doubt from the old
Quebec furniture studios of the mid-19th century. Richly carved pediment
is ornamented with medallion representing a pair of dead partridges
surrounded by frogs and marsh flowers. (Séminaire de Québec.)

Close-up of cartouche shows garlands of roses.
(Séminaire de Québec.)

Bucket bench.

Corner cabinet.

Two-tiered glazed china cabinet.

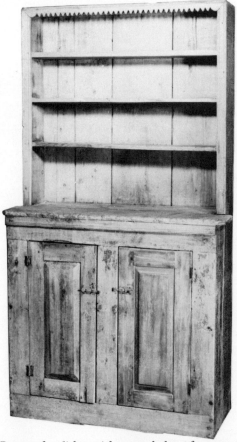

Dresser for dishes with open shelves, festooned cornice. Two doors in the base have plain panels in relief. (I.N.C.)

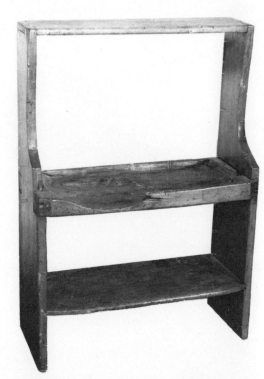

The middle shelf of this bucket bench has been worn away by water and washing. Such a piece was part of the common room in many settlers' dwellings in the 18th and 19th centuries. Wide dovetailing. Late 18th century. (I.N.C.)

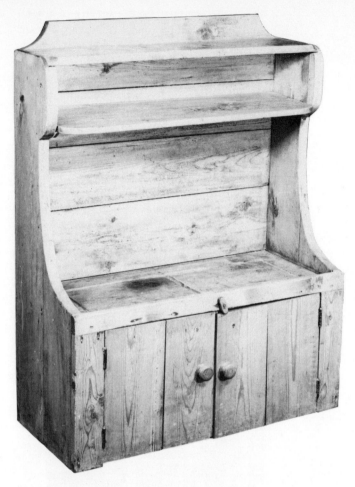

Quebec bucket bench with two doors. Late 19th century. (I.N.C.)

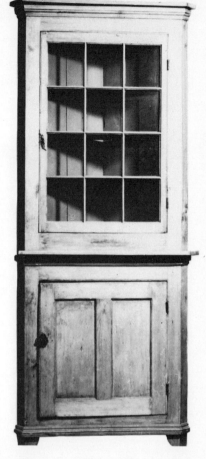

Corner cabinet, two-tiered with two panels. Cornice and base marked by elaborate molding. Mid-19th century. (I.N.C.)

two-tiered, having a two-door cupboard below, supplied with drawers for cutlery, and a set of shelves on top, with or without a glass door, slightly recessed from the lower tier. Some of these pieces were used for varied purposes, as, for instance, storing the buckets and pots of the kitchen-living room. Such examples are smaller and less lavishly ornamented, and the junction between the two parts looks like a counter, so greatly recessed is the set of shelves. They are then called bucket-benches, and are generally placed near the service door, or *porte de semaine*.

It seems that Anglo-American influence has been fairly strong in this type of furniture, judging from certain forms and decorations like cornice denticles and console feet of bases.

Cabinets

The corner cabinet is a one- or two-tiered buffet, usually glazed, triangular in shape, and occupies one of the corners in the common room. It is a functional piece that fills the empty space of corners and which is both useful and decorative. Early corner cabinets go back to the second half of the 18th century (c. 1750), and even at the end of the last century, it was still a very popular article of handmade furniture.

The oldest cabinets fitted into the wall which served as their back. They were built at the same time as the house. Toward 1775, the corner cupboard became a separate piece of furniture and from then on was in general use in middle-class and country houses. This undoubtedly explains why many of them are still found on the present antique market.

The lower tier of these corner cupboards has two doors, sometimes surmounted by drawers. The shelves in the upper part are usually closed by one or two glass doors with small square panes, though some of them have tiers of open shelves.

Carpenter-wood-carvers often preferred uniform fronts, artistically paneled and arched; that is, the furniture was concave

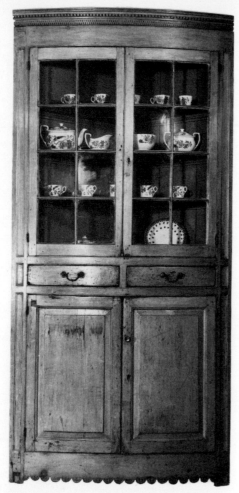

Corner cabinet, slightly curved, with four panels. Two drawers separate glazed shelves from closed base. Stiles have vertical panels. 19th century. (I.N.C.)

and then continued on the surface in a horizontal plane. This curve gives an elegant appearance to the whole and greatly embellishes the corner of the room.

It would seem that in this type of furniture, English influence has been predominant and that the cabinetmakers of the Georgian and Regency periods may have set the fashion for Canadian carpenters from the beginning of the 19th century. In fact, most corner cupboards were inspired by Adam, Hepplewhite, Chippendale, Sheraton, and Regency styles, both in form as well as in decoration. Doors without post, denticles, fans, geometric reedings, and rosettes are some of the details that attest to this contribution.

The Louis xv style was to serve as a model

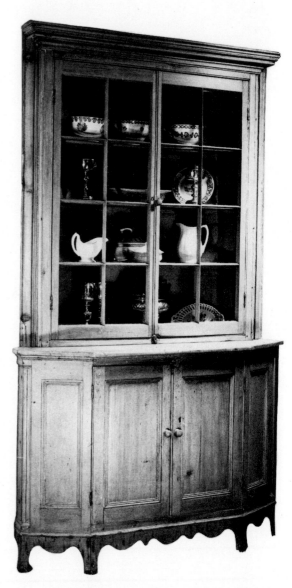

Two-tier corner cupboard. Lower tier is shaped like a folding screen, heightened by plain panels. (Private Collection.)

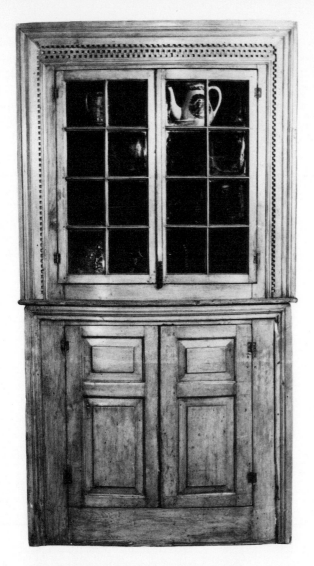

for more than one artisan of the day for this specific type of furniture; and more than one corner-cabinet is made with panels and a carved upper rail, while the doors are framed by complicated projecting moldings.

Hutches and Food Lockers

Since we are talking about cupboards and furniture used for storing dishes and food, we might as well speak here of hutches and food lockers. The settlers, who had to be self-sufficient in every way, made their bread at home. This meant that each family had to

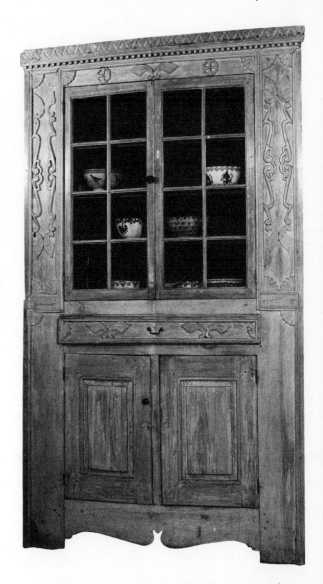

Glazed corner cupboard with four panels; English influence. Top tier is framed with moldings and dentils. Lower doors have plain panels in relief. Doors are without center post. (I.N.C.)

Large corner cupboard richly decorated with elements adopted from late Georgian, Adam, and Chippendale styles. Cornice ornamented with dentils and lower rail cut out in shape of a bat. Drawer separates the two sections. (I.N.C.)

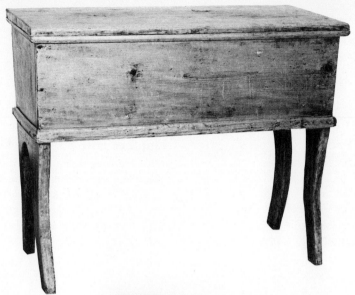

Hutch with curved legs, American-inspired style. 19th century. (Musée de l'Hôtel-Dieu, Quebec.)

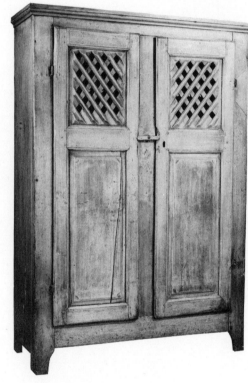

Superb larder of the 18th century with two paneled doors. Latticework on the upper part of doors, permitting saration, was cut from a single plank of wood. Origin: Saint-Alban, Portneuf. Late 18th century. (I.N.C.)

Hanging or suspension cradle.

have its kneading butch (or trough) which, once the bread was baked, would be used to store it and keep it fresh.

Most of the troughs or hutches we find today on the market look like tall pine chests on legs, with or without stretchers, and generally with a cover. Very few of them have been made by a master carpenter. Broad planks hewn out of a single block, dovetailed for tightness, and there you have the hutch! Some that are very primitive in appearance have been dug out with an adze, exactly like a trough, from a tree trunk of soft wood. The disappearance of the bake oven with the arrival of village bakeries led to the shunting of this piece of furniture to the attic.

Notice that the hutches seen on the market frequently have wormholes on the inside. It must be made clear here that it is rare to find old wood furniture that has been "riddled by worms." The local soft walnut, and infrequently pine, may be victims of these parasites, but in hutch interiors the wormholes are very numerous. The explanation is simple: the larvae burrowed into the dried dough and ate the surface of the wood while feeding on the moldy flour.

The larder, or meat safe, was once a very popular functional piece of furniture, but few traces of them are found today. It is a cabinet with one or two doors generally fretted at the upper part. The air being better able to circulate in these pieces, which look like confessionals, food was well preserved.

Beds and Cradles

In addition to foreign influences, the Canadian climate was to have a strong impact on the local evolution of the bed. The first houses of wood or stone were very poorly heated by those huge hearths of fieldstone which "warmed the weather" or "heated the outdoors," as our ancestors said. Because of the rigors of winter and the indoor drafts, the first beds used in New France were veritable apartments, bed-cabins, as they were called. There was a raised straw mattress or pallet surrounded by four walls, the whole thing topped by a roof built of planks of pine, fir, or spruce. Access was through two doors. Those closed beds and early cots were not as long as beds today, perhaps because people were not as tall, or because they slept curled

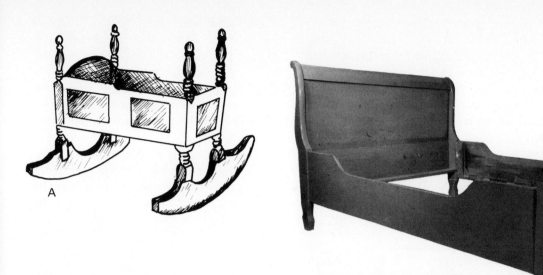

A

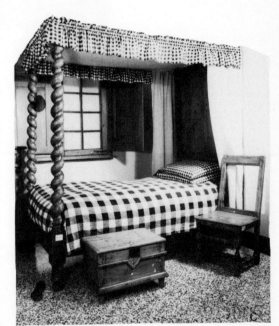

B

(A) Cradle with rockers and four posts; (B) Sleigh bed, Empire influence. Head and foot curve inward slightly, terminating in a spiral. Foot ornamented with wide panel, floral motif, and horizontal cartouche. (Private Collection.); *(C) Bed with twisted columns, Louis XIII style. One of the oldest pieces known; in remarkably good condition. Headboard is a plain, broad panel. Late 17th century; very rare.* (Musée de l'Hôtel Dieu, Quebec.)

up to keep warm. The couch, also of planks, was built flush with the cabin, or else, sometimes, they even put a four poster bed inside the four walls. Today, no trace of this sort of bed can be found. This type of construction was discontinued at the beginning of the 18th century when experience had taught the colonist to protect himself better from the outside elements.

The four-poster bed was to take over. That piece of furniture, has four tall corner posts, turned, twisted, or chamfered. Chamfering is that oblique surface obtained by rounding or bevelling the sharp corner edges of wooden posts.

Most of those high four-posters become narrower toward the top, and support the frame or the hoops that hold the fabric of the bed-canopy in place. In others, the post at the head is replaced by a wood panel hung with tapestry for greater warmth.

Another type of bed popular in the 18th century had a different shape from its predecessors. The pallet, standing high on legs and enclosed in plain wood planks, was surmounted by a tester attached to the ceiling from which curtains hung down on all four sides.

Constant improvement in the heating system with the arrival of closed stoves in the middle of the century of the Conquest and the experience of living in a climate that was hostile a good deal of the time led to the evolution of the bed. At the end of the 18th century, in fact, beds were to lose their traditional trappings.

The high posts were still preserved and, following the English fashion, the ball and claw foot was borrowed from the Chippendale style, the spade foot from the Hepplewhite, and the elegant turning from the Sheraton.

At the beginning of the 19th century the

four corner posts lost their height, for the canopy bed was no longer in use and, gradually, the feet and the head were constructed of horizontal planks put together in sparsely ornamented panels. It was also at this time that sleigh beds or carrioles appeared, inspired by the boat-bed of the Empire style, itself an imitation of antiquity.

In its early period, the Victorian era modified beds perceptibly, and spindle beds or beds with bead turning spread like wildfire.

Finally, around 1870, the late Victorian bed with the high walnut headboard, with its veneerings, elaborate machine-made moldings, and panels decorated with bunches of grapes (they too were machine made), became very popular. The brass bed and the cast-iron bed also date from this period (c. 1870 to c. 1920).

Most people born in Quebec in years past spent their early infancy in the *"ber"* (cradle) which their parents set in motion by giving the corner posts a hard push or by

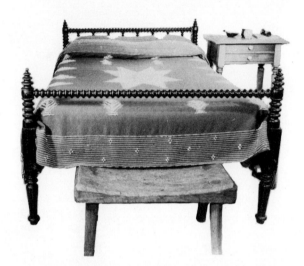

Bed with turned uprights and crosspiece. Head decorated with vertical spindles. Late 19th century. (M. and Mme. G.E. Gagné, Neuville.)

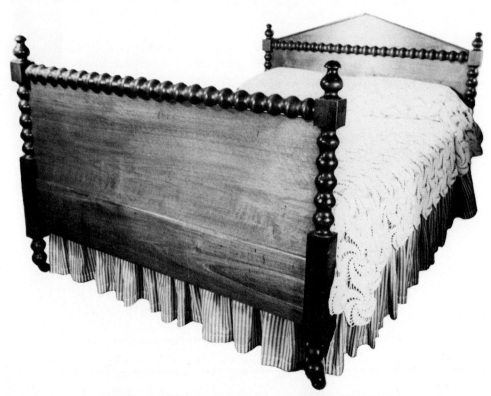

Bead-turned bed, head topped by a pediment in Renaissance-Victorian style. Late 19th century. (M. and Mme. G.E. Gagné, Neuville.)

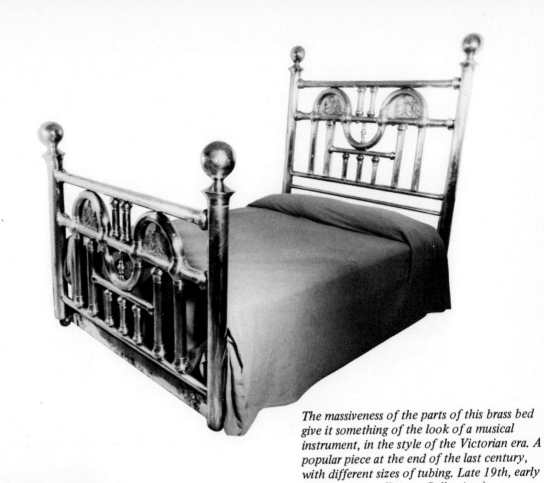

The massiveness of the parts of this brass bed give it something of the look of a musical instrument, in the style of the Victorian era. A popular piece at the end of the last century, with different sizes of tubing. Late 19th, early 20th centuries. (Private Collection.)

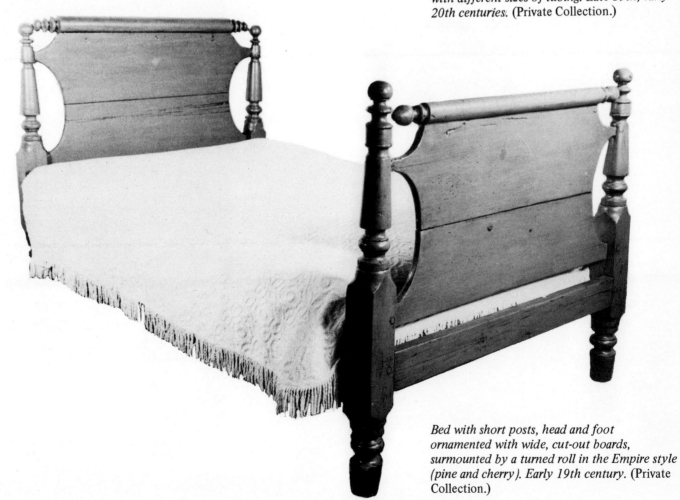

Bed with short posts, head and foot ornamented with wide, cut-out boards, surmounted by a turned roll in the Empire style (pine and cherry). Early 19th century. (Private Collection.)

87

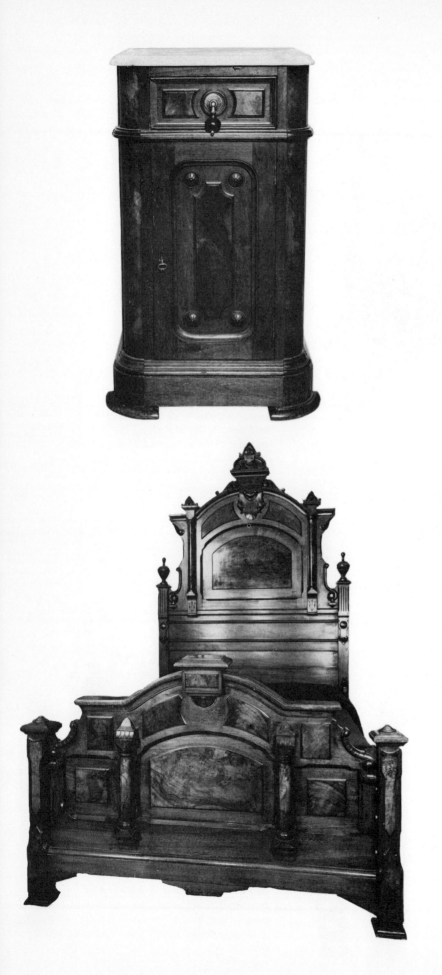

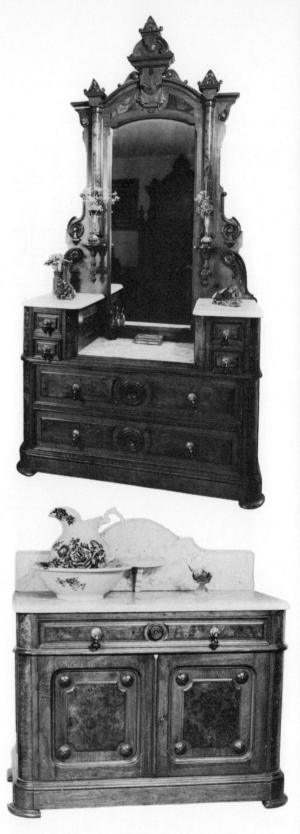

Late Victorian bedroom suite of four pieces in tinted walnut. Veneering in walnut burl; pediments with shaped finials, small columns, marble tops, lavish ornamentation. Severity of elements is characteristic of Victorian furniture. Probably Quebecois manufacture. Late 19th century. (Private Collection.)

pressing a foot on the rockers.

We find two types of cradles among us, but their styles are no criteria of their era: the first type, known as "suspension," looks like a little pine chest of the 18th century or a little bed with turned rungs held in place by two stiles reinforced by dowelled stretchers of the 19th century. The second cradle, much less rare, is a rectangular box with turned posts at the four corners. The box is mounted on two curved rockers. The oldest beds apparently go back to the second half of the 18th century (c. 1775).

At the beginning of the 19th century, again as the result of American influence, many rocking cradles were embellishd with a curved hood, a kind of finely carved half-roof arched over the head of the cradle.

Most of these handcrafted pieces are made of rabbeted planks connected with the four poster corners by tongue and groove joints. Others are made of small panels, inspired by the Georgian and Regency styles. Some will be miniatures of the sleigh bed of Empire inspiration, or the spindle bed of the Victorian era, with their bead-turned vertical bars.

Commodes or Chests of Drawers

Along with the wardrobe, the commode is the article of French-Canadian furniture for which the artisan wood-carver showed the most talent and originality. Not content to imitate or to be inspired directly by the creations of master cabinet makers from overseas, he displayed an evident fantasy born of the requirements of his clientele, of acquaintances, and of the carpenter's own taste. Moreover, Franco-English contributions were to characterize the greater part of those local creations.

In his *Dictionnaire de l'ameublement*, published in Paris in 1887, Henry Havard says that the commode, like the wardrobe, stemmed from a development of the traditional coffer to which was added a series of drawers, in preference to a hinged cover. In addition, we find, at the end of the 17th century, those chest-bahuts with one or two drawers a few inches from the floor that have evolved from that article so indispensable to any young girl's marriage. The small commode of Madame d'Alleboust, with a Louis

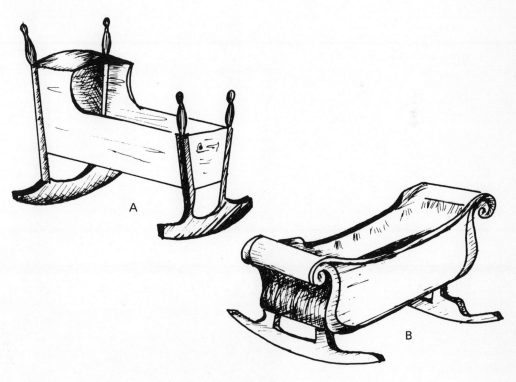

(A) Cradle with rockers, posts, and headboard; (B) "Sleigh" cradle, Empire style.

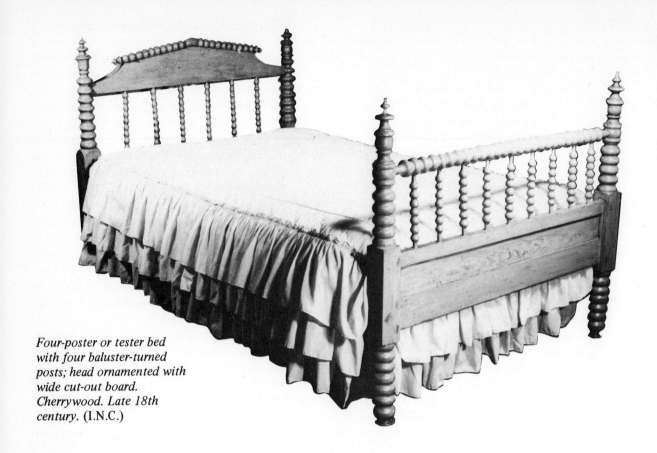

*Four-poster or tester bed
with four baluster-turned
posts; head ornamented with
wide cut-out board.
Cherrywood. Late 18th
century. (I.N.C.)*

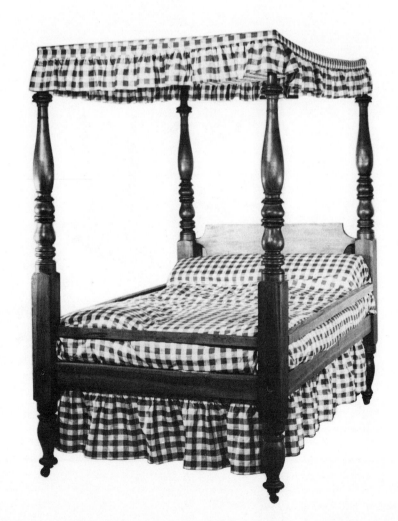

*Bed with four spindle-turned
supports; foot and head
marked by crosspieces and
bead-turned spindles.
Victorian. Late 19th century.
(Private Collection.)*

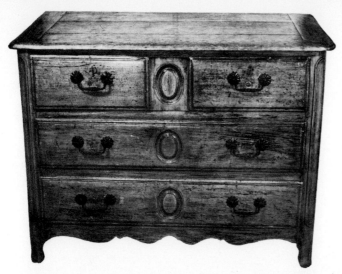

Commode with medallion, flat front and four drawers. The way the top is assembled shows clearly how the commode derived from the chest. Late 18th century. (Private Collection.)

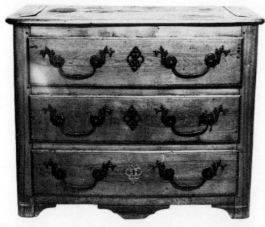

Commode with flat front — three drawers have rounded stiles, lower crosspiece is ornamented with brackets and a central applied motif. Top assembled in old style. Late 18th century. Handles and keyholes recent; original pieces in brass and copper would be more suitable. (Séminaire de Québec.)

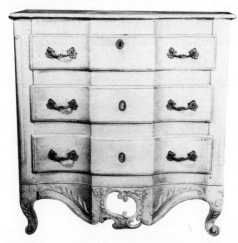

Several of these small commodes are extant, and attributed to the school of Louis Quévillon, Montreal woodcarver in the first half of the 19th century. Ornamentation is concentrated in the lower rail, which is broad, open-worked, and carved with palmettes; cabriole legs. (I.N.C.)

xiii base that dates from the end of the 17th century, still has its side handles. In any case the invention of this piece of furniture is attributed to the great cabinetmaker, Charles André Boulle (1648-1732).

According to death inventories it seems that the first French-Canadian commodes date from the middle of the 18th century (c. 1745). In the 19th century they became indispensable to the trousseau of every young girl of good family, and toward the middle of the last century more than one of those articles bear the wedding date of its young owner inscribed in marquetry on the front of one of the drawers. This piece of furniture stands in the bedroom and is used for storing linen, bedding, clothing. Many of those commodes were used to hold chasubles in sacristies or in presbyteries.

Commodes with three or four drawers have a very heavy front. Their sides are dovetailed, usually with three mortises: one very broad, one in the center, and two little ones at the ends. This joint is firmly held by a wrought-iron or cut-off nail inserted in the center tenon. The openwork or solid hardware, handmade, goes through the wood of the drawer front and is held from inside by a fastening or a nut. The stiles are cut out of a single piece of wood and the back is made of wide boards with tongue and groove and slid into the rear stiles.

The fronts of commodes, more than the fronts of wardrobes or any other piece of furniture, have a wide variety of shapes depending upon foreign influences; arched, contoured, crossbow, concave, serpentine, and straight, depending upon the outer shape of the drawer and the line of the front of the structure. They are not, however, characteristics to be used as criteria for determining age, for in the 19th century all those variations emerged from the workshops of local artisans.

Certain commodes of very simple make have a straight front ornamented or not, with the lower rails with modestly curved silhouette. The feet are at sharp angles, and sometimes a slender molding frames the drawer. The sides are ornamented with straight panels. Still others with flat fronts, will have the edge of the top and the corner stiles rounded and carved.

At the beginning of the 19th century, the artisan, influenced by Louis xv and English-American styles, varied the shapes of commodes endlessly, and crossbow patterns and concave projections enjoyed great popular-

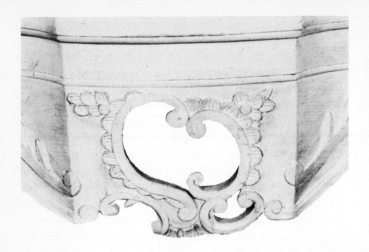

Detail of Querillon's commode, preceeding page. The massiveness of the lower traverse and the naiveté of the floral decoration are, according to experts, typical Quebecois characteristics.

Crossbow-front commode with motif of ball and hand on base (see detail), undoubtedly inspired by Chippendale style. The three drawers, the top, and base follow serpentine line in the shape of a crossbow; corners are rounded and embellished with a cartouche with flowers added. Late 18th century. (I.N.C.)

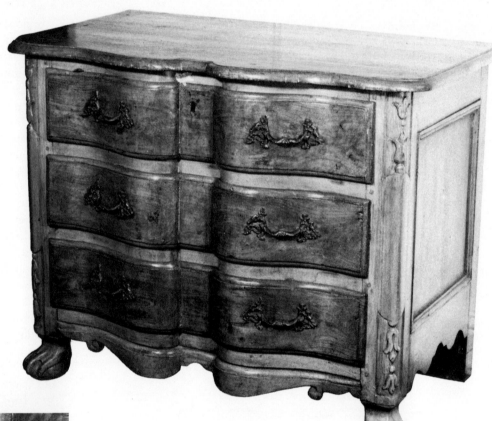

Detail of ball-and-hand motif.

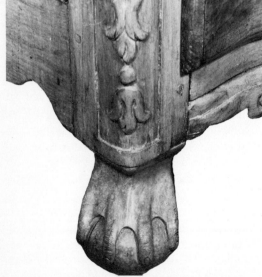

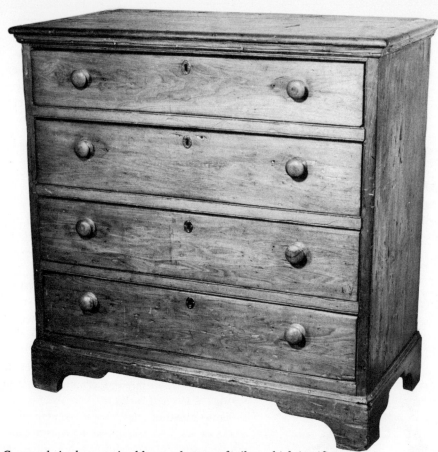

Commode is characterized by an absence of stiles, which justifies a separate bracket base. Mid-19th century. (Private Collection.)

ity. Legs were curved; feet were ornamented with claws grasping a ball, with eagles' talons, lions' paws, or even those knotty fingers clutching a ball, a motif known as Chippendale Rococo, borrowed by England from Asiatic (Chinese) art.

From shell and rock designs in the manner of Louis XV came a great variety of decorative details that would later embellish the commode. Church artisans decorated carved rails with openwork floral motifs, and festooned corners and legs with spirals and acanthus leaves. Even the feet were lavishly decorated by the wood-carvers' chisels. Side panels and rails were carved in the Louis XV style.

And finally, we can still find some of those swell front commodes, also called "tombeau," which take their bulging shape from the commodes in the Dauphine. However, one can find very definite characteristics of our own French-Canadian origin, chiefly in the ornamentation and arrangement of cutouts on crosspieces, the width and thickness of the wood, the motifs carved with a little less finesse and virtuosity, a little less careful finish of those parts not usually visible (back, bottom, interior), and all made from native woods such as light walnut and cherry.

Later on, altered by American influences, legs were shaped like those of the great English styles: cabriole legs in the style of Queen Anne and Chippendale. Many carved aprons ornamented with a fan-shaped shell borrowed this style from Dunlap of New England.

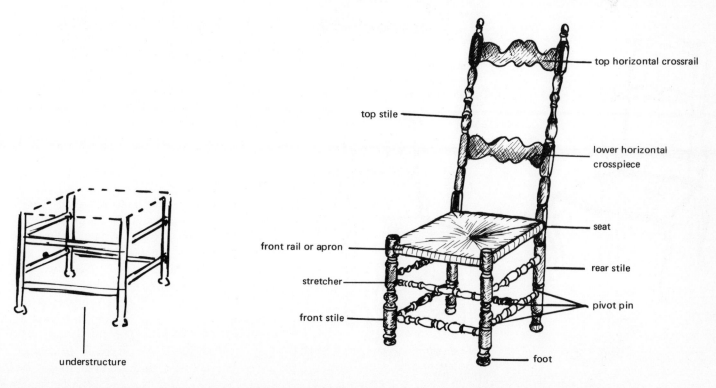

understructure

top horizontal crossrail

top stile

lower horizontal crosspiece

seat

front rail or apron

rear stile

stretcher

pivot pin

front stile

foot

"Banc de Quêteux" or bench bed.

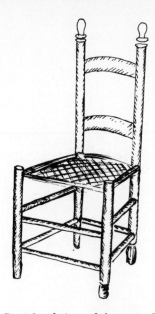

Straight chair, rush-bottomed seat.

"Boston" Rocker (armchair).

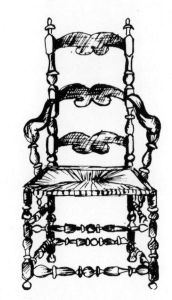

Armchair, characterized by armrests and large dimensions à la Capucine.

Louis XV style chair.

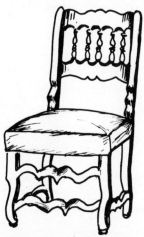

Chair with "sheepbone" understructure.

At the end of the 19th century the commode lost its importance, for in these Victorian sets it was replaced by other types of furniture. What was now produced was decorated with little recessed columns or even so excessively simplified in form and decoration that it became a solid box with drawers, in maple or light walnut.

Chairs

French-Canadian chairs are subdivided into four types which we shall study briefly in this order: straight chairs, armchairs, rocking chairs, and finally benches.

There are two kinds of straight chairs: those inspired directly by the grand style, in which one finds extensive borrowings from French or English creations, and others, which were the result of the early colonists' ingenious handicraft, like that chair *à la Capucine*, so popular around Montreal during the past centuries.

Many amateur collectors wonder how works of such fragile appearance have been able to withstand time without showing more evidence of wear and tear. Their strength and solidity are the result of a thorough knowledge of various woods and the techniques of assembling them. Old chairs, whether rustic or not, were only pegged (or bolted) together. The trick of choosing green wood for the stiles and dry wood for the stretchers and rails kept the chair from falling to pieces despite frequent usage, for green wood, in drying, compressed the stretchers and rails and held them as if in a vise.

Chairs in Louis XIII style have an understructure with an H-stretcher a few inches from the floor. The backs have chamfered or turned stiles and their crossrails are connected by vertical turned spindles. Some of the chairs have completely open backs or have three contoured cross rails.

The influence of the Louis XIV style is found again in those chairs called "sheep bone," *os de mouton*. This is a motif shaped like a wave or a crossbow, bony in appearance, which is obtained by rounding and polishing the piece all over. Such work is noticeable especially in the understructure.

The Louis XV style chair is characterized by curved front stiles ending in a *pied de biche*, or stag's foot. The apron, the stiles, and the crossrails are carved in an original fashion. The seat, too, is carved around the

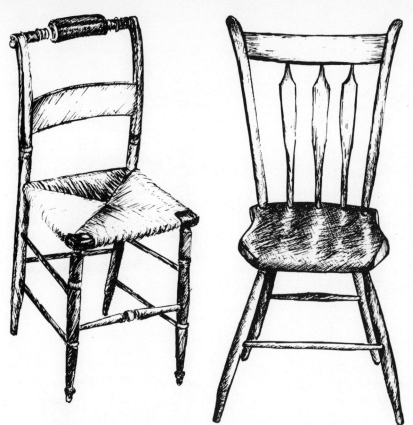

Two American chairs which were widely reproduced in Quebec in the Victorian era. Right: a small, straight, Anglo-American chair with seat cut from a single pine plank and back decorated with vertical arrow slate. "Arrowback" model which is found in armchairs and rocking chairs. Left: a straight chair with the Empire look somewhat simplified, it has a back with a scroll top and slightly turned base. Called "Hitchcock," this chair was made by the thousands in Canada and in the U.S. in the middle of the 19th century.

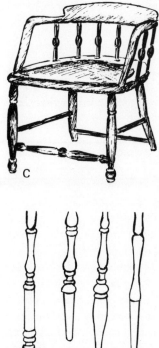

Different turnings found in Windsor chairs.

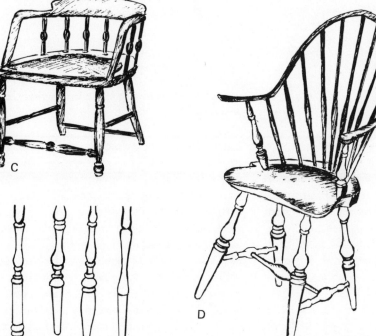

(A) Straight chair with arched back; (B) Desk chair (rare); (C) Captain's chair; (D) Armchair with arched back in one section; (E) Windsor armchair of English make with vertical splat in middle of back.

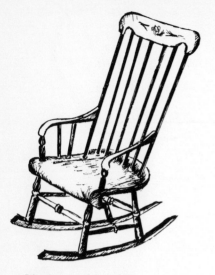

Windsor rocking chair.

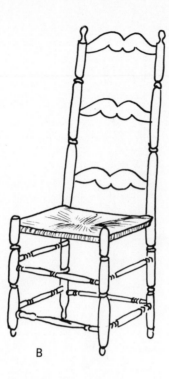

(A) Chair of the "Ile d'Orléans" type, Quebec countryside; (B) Settler's chair, known as "à la Capucine" or "ladderback," from the region west of Quebec.

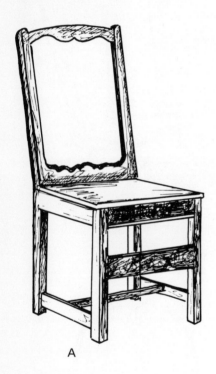

A

B

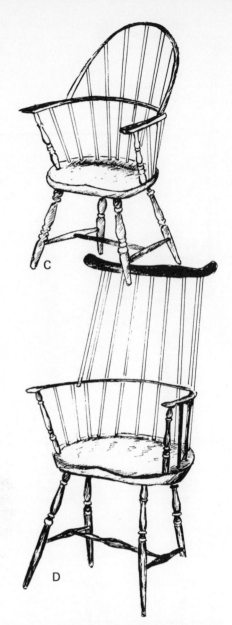

C

D

(C) Windsor armchair with arched back in two sections; (D) Windsor armchair with back in two sections; lower one extended by shoulder-rest called a "comb."

edge and cut out of one piece.

The Windsor chair was very popular during the 19th century, especially in cities, as a result of stronger and stronger English and American influences. This type of chair, which dates from the 16th century, originated in Great Britain. Thanks to its comfort and its agreeable appearance, it gained great popularity in the United States around 1725 and in Canada around 1800. One finds a great variety of them. The most common ones have a seat cut from a single plank and slightly hollowed in the shape of a saddle. Later, these same seats were made of small boards fitted together and glued.

The seat is either circular or square, the backs straight or rounded, deep set understructure, the H-shaped stretcher, and the stiles are turned in various fashions. Most of these chairs have armrests, and the most sought after by the collector are the chairs with desk arms for writing and those with the three-section bent back.

A fact worth remembering: In the 19th and 20th century, public establishments in particular chose this type of chair in hard wood. More than one tavern could thus avoid having to replace chairs or tables too frequently, for sturdiness and solidity are two characteristics of the Windsor chair. The Boston rocker is a variation of this type.

At the begnning of the last century, Chip-

pendale, Hepplewhite, Sheraton, and Regency as well as American Empire and Victorian styles had very definite influences on the Windsor chair. A brief glance at the chapter on English styles and their contribution to French-Canadian furniture will illustrate this point.

In the more rustic and widely used carpenter-assembled chair we distinguish two great styles: the chair called *l'Ile d'Or-*

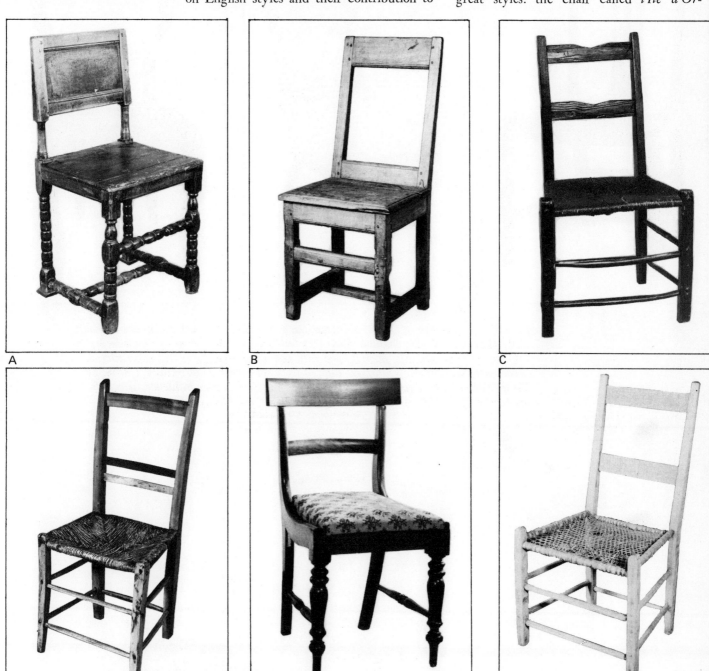

(A) Small chair, Louis XIII style, with turned understructure and metal fittings; straight back, paneled; H-shaped stretcher; apron around seat. 17th century. (I.N.C.); (B) "L'Ile d'Orléans" chair with chamfered (beveled) understructure and molding. Straight back; vertical stiles extend from rear legs. (I.N.C.); (C) Straight rush-bottom chair. Horizontal crosspieces slightly shaped. 18th century. (Musée des Ursulines, Quebec.); (D) Rush-bottom chair with tapered legs; three horizontal crosspieces on back. Early 19th century. (I.N.C.); (E) Chair of Adam or Directoire influence, Quebecois make. Saber legs at rear; turned legs in front. Early 19th century. (Séminaire de Québec.); (F) Small chair with seat woven with leather thongs. Vertical back stiles are slightly recessed; two horizontal crosspieces ornament the back. Found frequently and chiefly in the region near Montreal. 19th century. (Private Collection.)

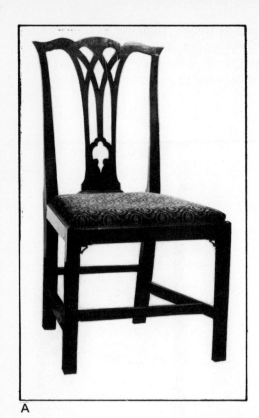
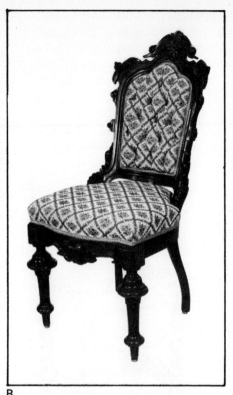
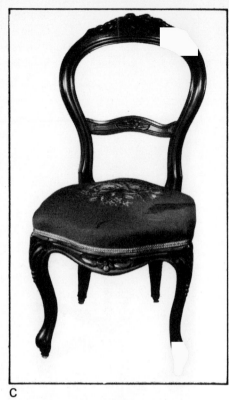

A B C

(A) Chippendale chair of Quebecois make. Back is ornamented with an openwork motif. Early 19th century. (Séminaire de Québec.); *(B) Drawing room chair of Victorian styling, inspired by Empire motifs. Back topped with policeman's hat; front of understructure ornamented with spin-top turnings. Sides of back are carved. 19th century.* (Musée de l'Hôtel-Dieu, Quebec.); *(C) Small dining room chair of Victorian influence, after the manner of Louis XV. Latter 19th century.* (Private Collection.)

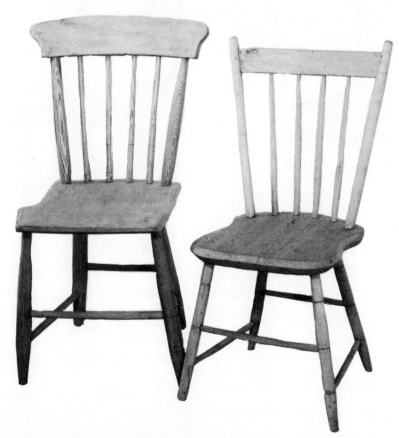

Two late 19th century chairs. (Private Collection.)

léans and the chair *à la Capucine.*

The chair *Ile d'Orléans* (or *St. Anne de Beaupré*) is sturdy and massive like the chair inspired by the Louis XIII style. Its broad, heavy base is chamfered, the stretchers and the two stiles of a straight, openwork back are sometimes curved and contoured.

The chair *à la Capucine*, or rush-bottomed chair which is also one of the oldest, was still found in some areas as late as the 20th century. Their variety is equalled only by the artisans who made them and the regions in which they appeared.

The seat of the *à la Capucine* chair is of rush, cane or woven "*babiche*" (thongs of steer leather or sinews of some animal). The back stiles, which are of one piece with the legs, are straight but slightly slanted to the rear. The front stiles, which are very plain, are straight and reinforced with turned rails. Some of them have artfully turned legs and stiles, others are chamfered, and the stiles taper vertically. The crosspieces of the back are straight or contoured. Several chairs of this type combine decorative elements borrowed from the great styles or from local folk art. They often reflect obvious American influences.

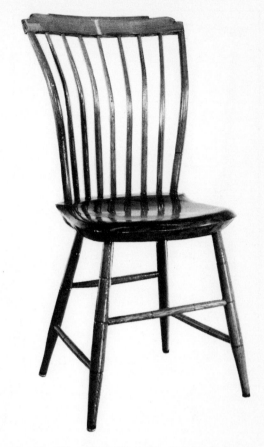

Windsor chair with hollowed seat. Late 19th century. (Musée de l'Hôtel-Dieu, Quebec.)

Armchairs

Armchairs have never been as abundantly produced as have straight chairs. The armchair was a luxury article reserved for well-to-do persons. Here again, French influences were preponderant up to 1800, but after that date Anglo-American contributions were to gradually supplant the French style. At the beginning of the 20th century there was a complete degeneration on all levels: handicraft, technique, esthetics. The "late Victorian" style was to bring to a close three hundred years of handicraft production.

The 16th and the beginning of the 17th centuries knew armchairs inspired by Louis XIII, with their beaded understructures, their connecting cubes chamfered, and their long armrests carved and terminating in spirals. Some of these rustic armchairs, no doubt imitations of earlier ones seen in the house of some squire, had chamfered legs and stiles, carved crosspieces, and preserved the massive appearance of the era and of the original style.

In the next phase of its evolution, the arm-

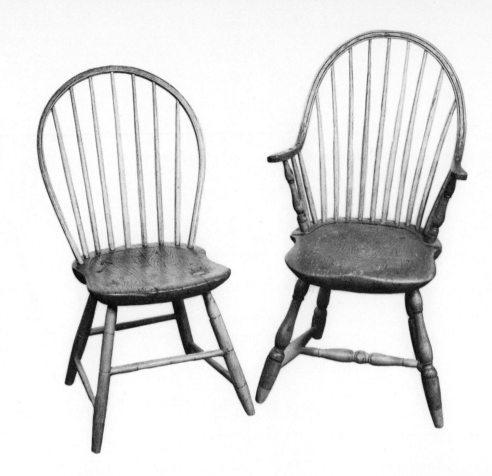

Windsor chair and armchair, Quebecois make. 19th century. (Private Collection.)

Two high chairs of the 19th century; one at right has a hollowed seat. (I.N.C.)

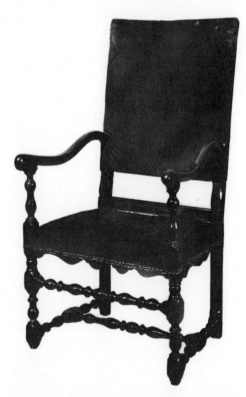

Open armchair with turned base, Louis XIII style. Notice the geometric form of the back; compare the total effect of this chair with that created by the supple lines of the "sheep's bone" armchair opposite. Late 17th, early 18th centuries. (Musée des Ursulines, Quebec.)

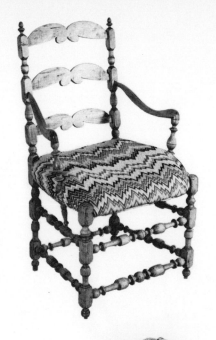

"A la Capucine" armchair, with turned stiles and understructure and three cut-out crosspieces at the back. Note the delicacy of the turnings. Armrests recessed to accommodate the fashion for hooped skirts. Seat upholstered in Hungarian, or flame, point (Bargello). (Musée de l'Hôtel-Dieu, Quebec.)

Armchair of Regency influence, with X-shaped stretchers and "double gendarme hat." Legs are curved and decorated with acanthus leaves. Fan-shaped shell ornaments sides of front rail and top of back. Recessed armrests. Late 18th century. (Musée de l'Hôtel-Dieu, Quebec.)

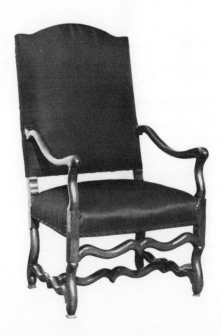

"Sheep's bone" armchair. Back has cyma curve ending in gendarme hat. Arms are a continuation of front stiles. (Séminaire de Québec.)

chair rejected rectilinear forms in favor of scrolls and systematic carving of various parts. The piece most characteristic of this genre is the one called "sheep's bones," which borrows from both Louis XIII and Louis XV styles. Just as in France under Louis XV, the fashion of paniers on gowns obliged craftsmen to recess armrests in relation to the front stiles in order to give the ladies room to sit down. However, first pieces of furniture of this style had the front base of the armrest and the stiles made in one unbroken piece. The crossbow shape of the front rail and the console leg gave this padded and upholstered chair a very special grace.

The armchair *à la Capucine*, exactly like the straight chair of the same style, is undoubtedly the most interesting, most elegant, and most original creation in this type. Very popular around Montreal, this rush-bottom armchair is unique in the furniture of the world. It is characterized by its turned slats and the numerous connecting cubes in the understructure; the armrests, sometimes recessed, and the shaping of the many crosspieces of a high, straight back, are details that emphasize the gracefulness of this chair.

The armchair of Regency influence, with curved legs, ornamented with acanthus leaves and shells on the front rail and the crosspiece of the back, without doubt made by a professional wood-carver remains a rare object. The crosspiece, spiral turned leg, carved, recessed armrests, the padding of seats and backs—all show influences of this great transition style.

As we have already mentioned, the reign of the Sun King, with its elegant furniture, had little repercussion in Quebec. A few rare armchairs borrowed some elements which were mixed with English influences, like that armchair with curved front stiles and *pied de biche*, with front rail, crosspieces and stiles.

Our skilled craftsmen produced a wide range of rustic armchairs in the 18th and 19th centuries. Some of them, with wooden wings at the sides of the back and armrests decorated with spindles, remind us of the more comfortable and completely padded European *bergère*. Others, with their three carved and openworked crosspieces are strangely reminiscent of the Chippendale style. And these are only a few examples of the numerous handicrafted pieces with caned or rush-bottom seats, or woven with cowhide thongs, thin strips of elmwood, or rope.

Finally, the Victorian era which made its

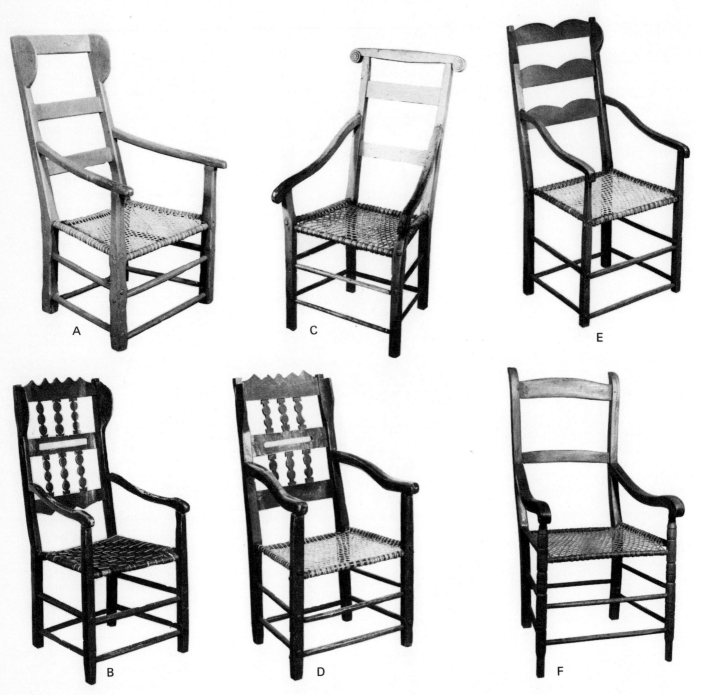

(A) Armchair with chamfered stiles and very plain armrests. Late 18th century. (I.N.C.); (B) Armchair with wings, denticulated upper crosspiece and openwork middle crosspiece. Seat woven with thin strips of elmwood. Vertical splats cut out in bead motif. Early 19th century. (I.N.C.)

(C) Armchair with spiral back crosspiece, American influence. Seat of cowhide thongs, re-made. Early 19th century. (I.N.C.); (D) Armchair with wings, probably made by the same artisan as chair at left. Armrests better finished however, and middle openwork crosspieces more rounded, making it easier to move the chair; also wings more refined. Early 19th century. (I.N.C.)

(E) Armchair with wings and three contoured crosspieces. (I.N.C.); (F) Armchair with turned front stile and lowered armrests ending in an outline of scrolls. Rear stiles are curved back and tapered in American manner. Early 19th century. (I.N.C.)

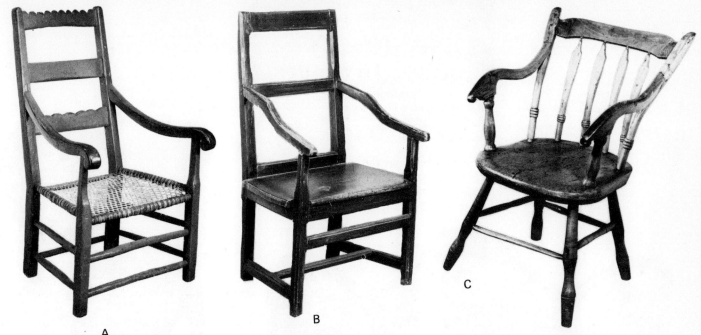

(A) Armchair with three horizontal crosspieces, two of them cut out and denticulated. Serpentine arms end in spiral; understructure is reinforced by wide, clumsily turned crosspieces. Front and back stiles slightly chamfered. Early 19th century. (I.N.C.); (B) This massive armchair, of Louis XIII influence, belongs with the chairs from the Côte de Beaupré. Inner sides of rear stiles are chamfered; front stiles are delicately fluted. 18th century. (I.N.C.); (C) "Arrowback" armchair with turned and ringed stiles, vertical splats ending in arrow tips. Notice the massive ends of the armrests. Early 19th century. (I.N.C.)

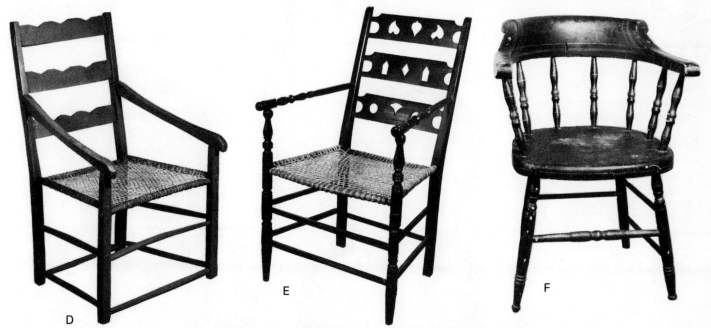

(D) Armchair with three cut-out crosspieces. Early 19th century. (I.N.C.); (E) Armchair with openwork back, varied motifs. Notice that the front stiles and arms are turned, Anglo-American style. Early 19th century. (I.N.C.); (F) Captain's armchair with turned stretchers and stiles; strongly rounded back was cut from a single piece of wood, a popular practice in the 19th century; ornamented with stencil painting. The mark of William Drum, the manufacturer, is stamped on the underpart of the seat (see detail next page). Mid-19th century. (Manoir Couillard-Dupuis, Montmagny.)

Stamp of Drum under the seat of the captain's chair on preceding page. (Manoir Couillard-Dupuis, Montmagny.)

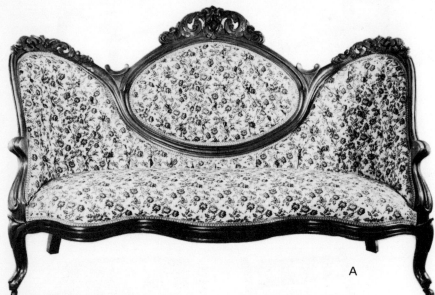

A

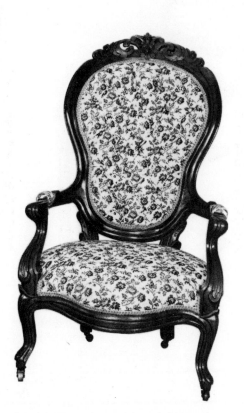

B

(A) Victorian sofa with medallion back. Upper crosspiece is carved with openwork palmettes. Legs strongly curved; lower apron serpentine. Attributed to furniture makers in Quebec area. 19th century. (Séminaire de Québec.)*; (B) Small drawing-room chair, Victorian influence.* (Séminaire de Québec.)

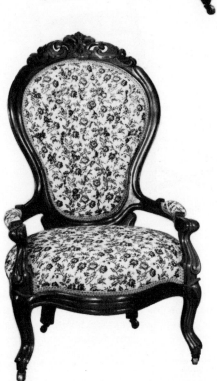

"Mr. and Mrs." armchairs in the purest Victorian spirit, forming an ensemble with the settee and dining room chairs. Recently covered with flowered tapestry. 19th century. (Séminaire de Québec.)

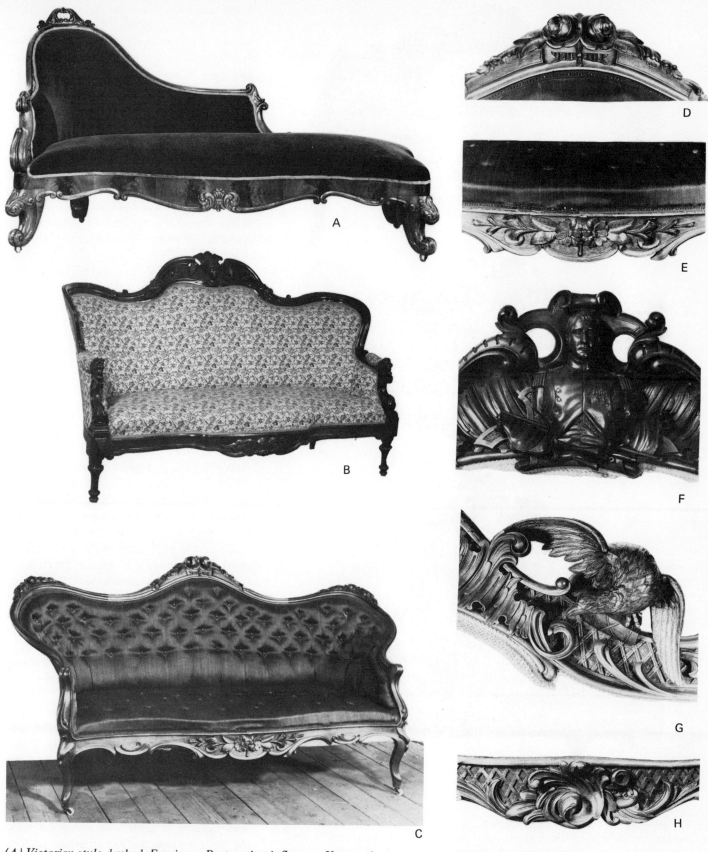

(A) Victorian-style daybed, Empire or Restoration influence. Veneered apron, massive feet on casters, heavily carved. (Séminaire de Québec.); (B) Victorian settee, back ornamented with figure of a goddess; arms carved with lion's head holding a ball in its jaws. Quebec make. Mid-19th century. (Musée de l'Hôtel-Dieu, Quebec.); (C) Victorian settee is ornamented with garlands of roses; re-covered with horsehair. Mid-19th century. (I.N.C.)

(D) Detail of the garland of roses and buckle ornamenting center of back of settee; (E) Detail of flower motif at base of settee; (F) Bust of Napoleon from sofa by Jean-Baptiste Côté on page 110; (G) Detail of eagle and acanthus leaf of sofa (see 110); (H) Acanthus leaf decorating the sofa on 110.

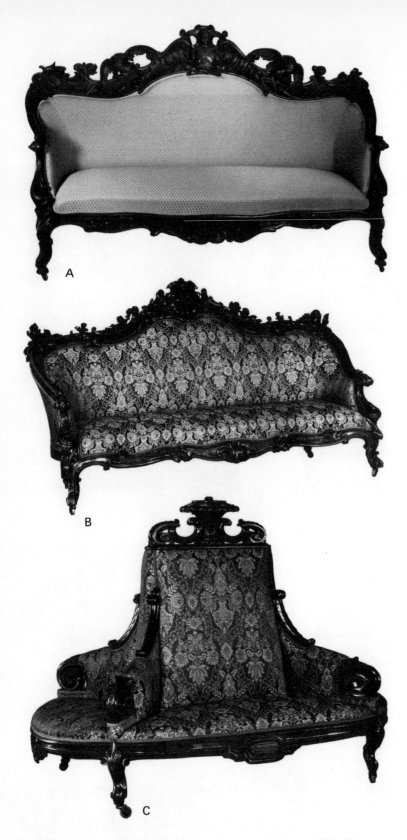

(A) Richly carved Victorian sofa, attributed to Jean-Baptiste Côté, Quebec furniture maker of the 19th century (c. 1870). (Musée de l'Hôtel-Dieu, Quebec.); (B) Armchair attributed to Vallières, Quebec furniture maker. (Séminaire de Québec.); (C) Four-seated armchair richly carved in Victorian style. (Séminaire de Québec.)

debut in 1840, brought some important changes in the armchair. Toward 1850, the use of metal springs became general. Most dwellings of prominent and wealthy people had their "Lady's and Gentleman's Chair." That group of chairs, widely distributed, had a hollowed, rounded, and upholstered back and lightly fluted stiles that are extended into armrests, but the base is curved and finely carved with reeding.

These pieces are all on casters and are generally padded. Many of them have an openwork back. The upper crosspiece as well as the front rail are heavily carved with bouquets of roses. These are the last creations with hand-carved decorations. Some artists, like Lauréat Vallières, of Saint-Romuald de Levis, who supplied the government with its Speakers' chairs for more than fifty years, continued to chisel out decorations on the wood and to create elaborate armchairs. However, he was an exception.

Rocking Chairs

According to a legend which is open to doubt, Benjamin Franklin was the first man to think of putting curved rockers on a straight open armchair. In any case, it was most certainly an American invention. But not until the beginning of the 19th century did the "Boston Rocker" appear, a style widely distributed throughout the United States and imitated in Canada after (c.) 1825. All rockers sold as belonging to the 18th century and presented as creations of French-Canadian artisans are therefore fakes.

So great was the craze for this chair among our forebears that most of the settlers possessed at least one of them, when they did not have a whole collection which they brought out on the porch on beautiful Sundays or on warm summer evenings. Today the chrome of the fifties is on the way out, thank heaven, and once again the wooden rocking chair, with its slender, attractive shape, has reappeared in many a household. The pictures of John Kennedy in his rocking chair perhaps had something to do with this revival.

In the 19th century we find a great variety of chairs called "rockers." The artisan's creative imagination varied the shapes and decorations *ad infinitum*: the double chair with three rockers, the bench with curved

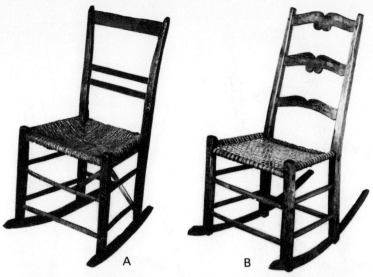

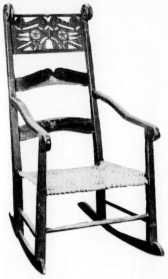

(A) Rocking chair, frequently used in the 19th century. Bottom of woven ash, three splats (one wide, two narrow); rockers with tenon and mortise joints added later to a straight chair. Mid-19th Century. (Musée des Ursulines); (B) "A la Capucine" rocker with three contoured crosspieces, open-mortise rockers and woven bamboo seat. 19th century. (I.N.C.)

Rocking chair with three crosspieces, lowered arms terminating in spiral. Open-mortise rockers. Top crosspiece decorated with openwork motifs – two ingenuous scrolls, several stars, a dome surmounted by a torch – all exuberantly decorated with chisel work (see detail). Back stiles terminate in a spiral. 19th century. (I.N.C.)

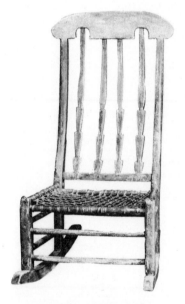

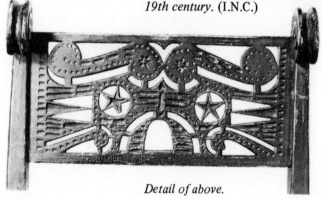

Detail of above.

Arrowback rocking chair, American inspired, topped with a horizontal crosspiece borrowed from the Boston rocker. The rockers have been changed or are of a later date, and possibly fitted on to a straight chair. Early 19th century. (I.N.C.)

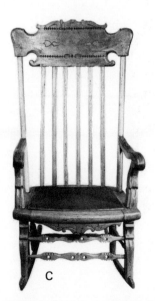

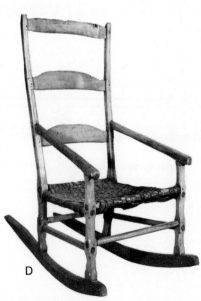

(C) The richly decorated top crosspiece (with original head) and front rungs are American inspired. Vertical grooved spindles. Late 19th century. (Private Collection.); (D) Rocking chair with chamfered stiles, back with three curved crosspieces, the first of which was mutilated and notched. Seat woven with thin strips of elmwood. Early 19th century. (I.N.C.)

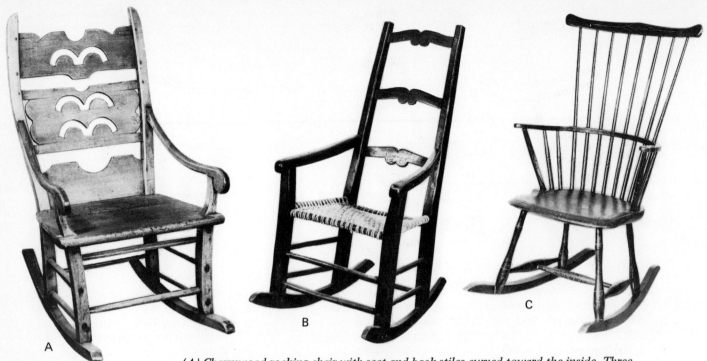

(A) Cherrywood rocking chair with seat and back stiles curved toward the inside. Three open-worked, broad, horizontal crosspieces. Arm supports extend from front stiles. 19th century. (I.N.C.); (B) Rocking chair with three cut-out horizontal crosspieces, stiles slightly chamfered. Open-mortise rockers. Rear stiles tapered toward the top. 19th century. (I.N.C.); (C) Windsor-style rocker, slender slats topped by a comb headrest, painted black. Stenciled design on the seat. Rockers attached with half mortise, open flange. Early 19th century. (M. and Mme. G.E. Gagné, Neuville.)

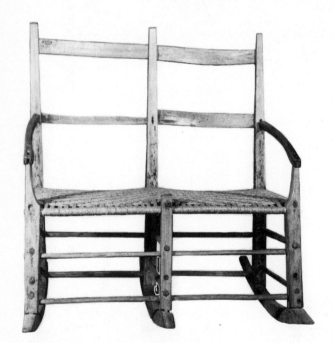

Two-seated rocker. Mid-19th century. (I.N.C.)

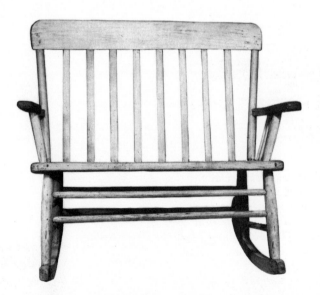

Double rocking chair, especially suited for lovers. Late 19th century. (I.N.C.)

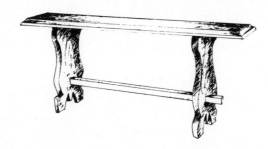

Bancelle or kitchen-table bench.

Church bench.

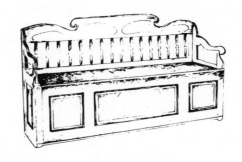

Chest bench.

A

B

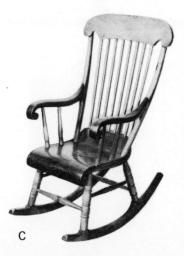

C

(A) Rocking chair, Victorian influence. Attributed to William Drum. Top crossrail with broken pediment decorated with fish. Recovered; horsehair, in fashion of the day. Mid-19th century. (Private Collection.); (B) Large rocker called "Louis Cyr," of 20th century. Quebec has a tradition of manufacturing huge rockers – in the last quarter of the 19th century, Gélinas of Trois-Rivières was known for such armchairs. (Fraternité Sacerdotale, Sainte-Pétronille, Ile d'Orléans.); (C) Type of Boston rocker with turned understructure and arms ending in spirals. Heavy seat, in shape of unrolled parchment, made from single piece of pine. Flanges cut to fit stiles in manner of ancient cradles. 19th century. (Musée du Quebec.)

rockers, and the baby's crib bear witness to their inventive genius.

The backs are generally shaped and slightly curved to give greater comfort. Decorations consist chiefly of those native designs so typical of peasant-made furniture: bleeding hearts, stars; half-moons ornament the crossrails of high backs, when the latter are not carved, as in the armchair called *à la Capucine*. A great many will show their American influence and have slats shaped like arrowheads (arrow back).

The most comfortable chairs have carved armrests supported by the front stiles and seats made of boards or woven. Chairs inspired by the "Boston Rocker" have a thick heavy seat shaped like a saddle or an unrolled parchment, curved at the front and higher at the back, from which slats rise turned and tapered. The seats are made of a single piece of wood.

The rockers may be attached in several different ways, depending upon the influences to which the artisan has been exposed: from tenon, open or closed mortises, dowels, to inserted stretchers when the legs are round. Later on, screws and bolts were added to reinforce them. We must also point out that more than one old rocking chair offered in antique shops is still a straight chair or armchair to which the settler has added rockers.

Benches

Traditional benches received special attention from merchants, and more than one shoe store or dress shop utilizes them as customers' seats. Church benches (or pews) table benches or banquettes, chest-benches, and bed-benches—called *bancs de quêteux* (beggar's-bed) represent the four principal types of this furniture.

Church pews, straight, plain, massive, and solid on legs are more and more numerous on the market. Some of these pieces in pine or cherry, dating from the 18th and the 19th centuries, have a very special charm and grace. The fretted baluster, or paneled back decorated with simple motifs such as an arrowtip, the carved and chamfered understructure and armrests inspired by Anglo-American or Empire styles—these are the principal characteristics of these handcrafted works in various sizes.

The second type of bench, whose origin undoubtedly goes back to the early days of colonization, is the straight or table bench, without a back, that is placed against the wall during the day and serves as a seat at table during meals. Some of them have a serpentine rail, simply decorated, which makes them most sought after as collectors' pieces.

The third type of bench, the chest-bench, looks like a long coffer with a back. The seat-cover opens to permit the mistress of the house to store clothing or bedding in it. This last type of bench has a romantic history which is part of French-Canadian folklore: in addition to being used for storing bed covers, with a good set of hinges it can be transformed into a bed three feet wide. This was the celebrated "beggar's bed," extremely popular in country life in the 19th century. It was usually placed in the common room, near the entrance door, always ready to receive the unexpected guest of an evening. Any number of wandering beggars, in the days when that noble brotherhood was more numerous than it is today, were given hospitality for the night on a bench of this kind. It was also used to bed one or two children, vital space being very restricted in the traditional rural household.

The lids of some of these benches were decorated with lozenges or applied moldings. The backs were shaped, or decorated with openwork or spindles, or with balusters. Some, inspired by the sleigh bed of the Empire period, had horizontally rippled or undulating backs, attractive but not very comfortable.

Certain pieces found in the country lead one to think that there were also real kneading troughs, that is, boxes of a sort, without any base, easily transportable, which were used only for kneading. They are usually put together like the hutches we know, but without a stand. They do not appear to have been in general use.

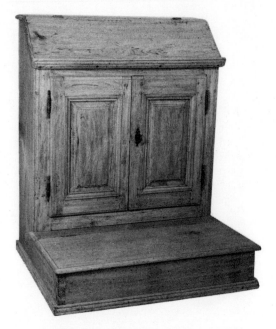

Sloping prie-dieu, *or prayer stool, with double paneled doors. Late 18th century.* (Musée de l'Hôtel-Dieu, Quebec.)

Tables

The table was an indispensable article in any house, and at the time of the French regime, death inventories everywhere mentioned square, round, and oval dining tables. Religious communities were almost the only ones to use long rectangular tables.

The top is made of broad pine planks as-

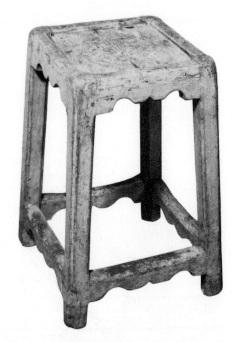

18th-century stool, with chamfered base. Contoured rail and stretchers. (Musée de l'Hôtel-Dieu, Quebec.)

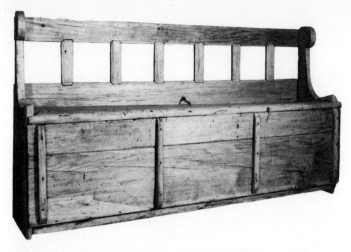

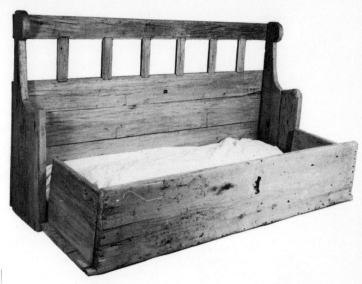

Bench bed with a straight back, ornamented with two horizontal crosspieces and six vertical splats. Back extends from the stile, and is ornamented with ears like wing chairs. Late 19th century. (Musée de l'Hôtel-Dieu, Quebec.)

Bench bed, or "beggar's bench," opened, with mattress in the bottom.

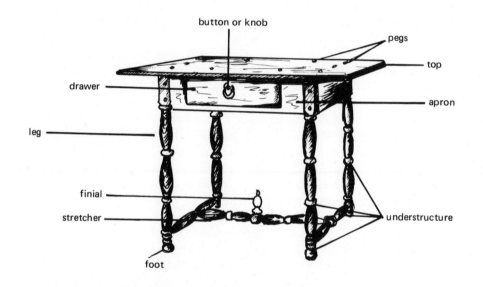

button or knob

pegs

top

drawer

apron

leg

finial

stretcher

understructure

foot

Serving table.

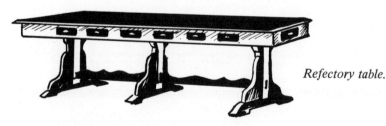

Refectory table.

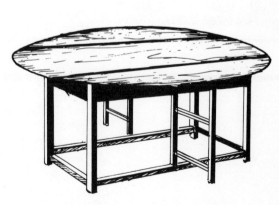

Dropleaf (or gate leg) kitchen table.

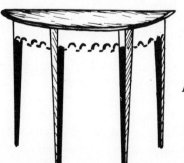

Half-moon table.

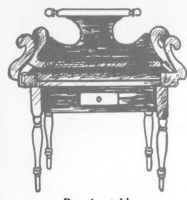

Dressing table.

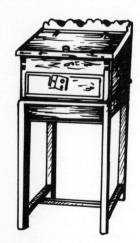

Small slant-topped desk.

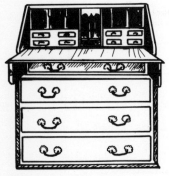

Sloped secretary desk with dropleaf.

sembled with tongue and groove joints and finished with molding. Sometimes a wood frame surrounds the edge; it prevents the surface from warping and is very useful for holding a tablecloth. This top is held in place by a series of wooden pegs set in the stiles or the apron and the tops of the legs, and this makes the whole structure solid. The stiles are often joined to connecting cubes by a tenon and mortise joint. Several specimens, especially in religious communities, have cutouts in the aprons in which to slide one or more drawers for utensils.

However, the list of tables is not limited to refectory or kitchen tables. There is also a great variety of small tables in the most surprising forms. Service tables, ladies' small dressing tables, half-moon "work tables" which are found especially in convents, pedestal or candle tables. These are some of the types which, simply decorated, are the products of rustic imagination, of which dressing tables and "wash stands" in the 19th century are brilliant examples.

Traditional kitchen tables are folding or drop leaf tables and even trestles, because space inside the house was precious and tables had to take up as little room as possible between meals. The understructure of rustic tables was chamfered, straight, at sharp angles or, now and then turned.

The oldest tables, inspired by the Louis XIII style, have a rope-molding or bead-turned base, and the connecting cubes on the stretchers are elongated vertically with the most attractive peg-tops. The legs are reinforced by H-shaped or occasionally an X-shaped stretcher, and artfully turned.

Other handcrafted tables dating from the end of the 19th century, are again drop leaf and have a chamfered understructure reinforced with a square or H-shaped stretcher a few inches from the floor.

Finally there are those huge tables of oak or walnut inspired by English Regency or Victorian styles. These tables with rectangular top, tapered legs, turned and ending in spade feet, with or without a drop leaf, are undoubtedly the most common type. Those mastodons of oak or walnut are solid and massive constructions. After 1850 a good many tables, in imitation of the Victorian style, have only three legs and resemble a tripod or pedestal, with their heavy bases ending in clusters of lion's claws. Some of them have the marble top so characteristic of Victorian tables. Then, toward 1870, entire sets of dining room furniture were put

on the market: tables, chairs, dressers with glass doors, and sideboard. Our chapter on English styles will complete the information on the tables of this period.

A variety of small tables with cabriole, curved, or straight legs, with contoured or crossbow shaped aprons were either inspired by French or English forms of the day or were simply fashioned, to judge by their rustic appearance, by some clever artisan. Most of them have a drawer but no crosspiece, whereas others, more rustic, have a chamfered understructure with an H-shaped stretcher a few inches from the floor. The most varied forms are found in this type of furniture: rectangular, square, drop leaf, half-moon....

We must point out here that in the middle of the 19th century the influence of English styles in these tables became more and more obvious. One has only to consult the preceding chapter or browse in antique shops to see this.

Rustic candlestands (gueridons), those little round tables of the 17th and 18th centuries, very popular in Quebec, are made of a panel supported by a single central shaft resting on an arched tripod. Today it is a rare piece, especially handmade ones of pine.

The "work table" is another type of table that is usually found in women's religious institutions. It is a rectangular piece with straight or shaped legs, a one-piece top upon which is attached a heavy mirror; a shelf a few inches from the floor holds the supports together. This was used for storing the needlework of ladies or nuns.

Finally, a last type that deserves particular attention is the dressing table or wash stand, as we say here. This piece of furniture is in daily domestic use and is meant to hold the basin or bowl for washing the hands or for shaving. It is made of pine, cherry or maple and is found in the kitchen or in the common room or, more often, in the bedroom of adults.

The solid (or cut out to hold the basin) top is surrounded by a protecting frame pleasantly carved or fretted, according to the creator's imagination. Below the top are one or two drawers, and the understructure can be connected by a supplementary shelf. The sides are sometimes equipped with towel-racks on the side of the top edges.

Foreign styles were to exercise a great influence on the artisan and we can affirm that most of these works, even the oldest, can be traced back to the beginning of the 19th

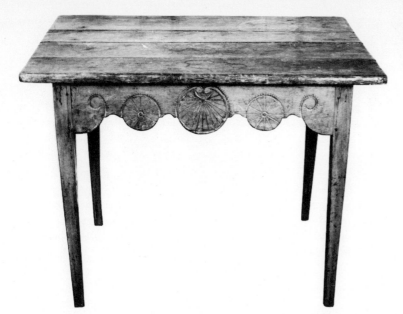

Small table with tapered legs and carved apron. Ornamented prettily (see detail above) with roundels and shell motif, in the manner of local folk art. Mid-19th century. (I.N.C.)

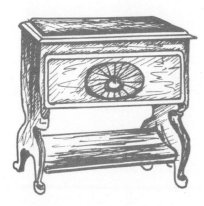

Worktable or sewing table, found frequently in religious communities.

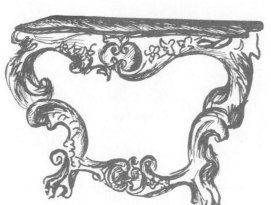

Wall console.

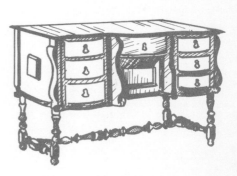

Plain desk.

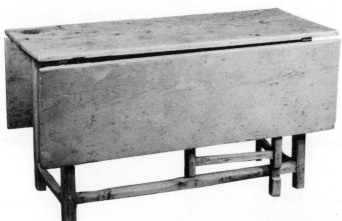 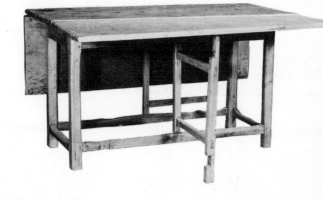

Kitchen table with dropleaf. Top of broad pine planks, legs of cherry, stretchers and gate of ash. To economize on space, table was placed against the wall at the end of meal (see right). Mid-18th century. (I.N.C.)

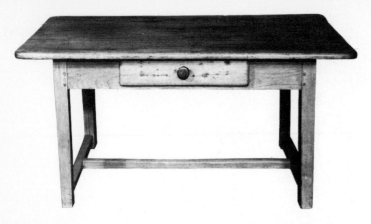

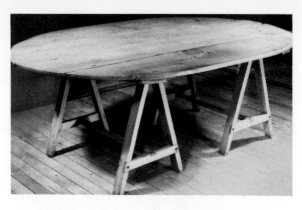

Small table with covered base, connected by an H-shaped stretcher. Apron contains a drawer; top is made of wide pine planks. Late 17th century. (I.N.C.)

Trestle table, with wide pine planks, used as kitchen table. Seats easily against wall at end of meal. (Convent of the Ursulines, Quebec.)

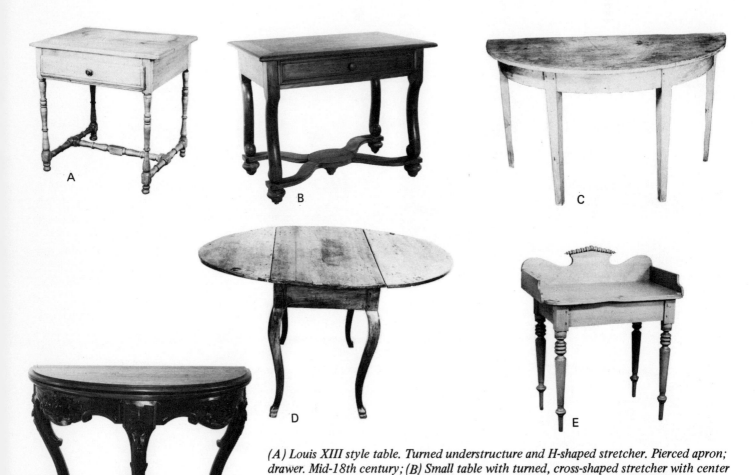

(A) Louis XIII style table. Turned understructure and H-shaped stretcher. Pierced apron; drawer. Mid-18th century; (B) Small table with turned, cross-shaped stretcher with center shaped like a gendarme's hat; legs terminate in peg tops. Apron decorated with a beautifully molded drawer. Early 19th century. (Musée de l'Hôtel-Dieu, Quebec.); (C) Half-moon table with tapered legs. Early 19th century. (I.N.C.); (D) Small dropleaf table in maple, curved legs terminating in pieds de biche *in Queen Anne style. Late 19th century. (I.N.C.); (E) Washbasin with turned legs; frame of top carved and ornamented with a finial. Victorian style. 19th century.* (Private Collection.)

Console table, Victorian style. Mid-19th century. (Séminaire de Québec.)

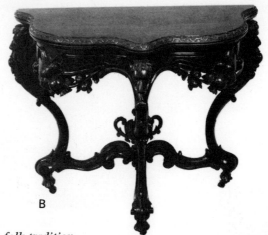

(A) Detail of apron of table at right. Bird naively carved in the folk tradition. The Drum factories in Quebec engaged the services of a certain Morel to decorate the doors of sideboards and other types of furniture with fish, birds, or animals as large as life; (B) Gaming table console, Victorian style; apron and base lavishly carved. 19th century. (Musée de l'Hotel Dieu, Quebec.)

Dining room table commonly called "eight-sided" ("à huit écarts"). Veneered; bulbous center leg supported by four cut-out console feet. Mid-19th century. (Séminaire de Québec.)

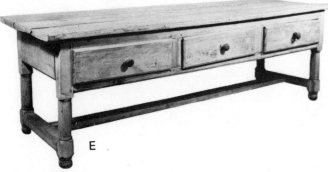

(C) Washbasin with chamfered feet, frame of top carved and scrolled. Early 19th century. (Private Collection.)*; (D) Table with cabriole legs in Regency style. Apron has a drawer ornamented with sunken panels. Legs are an extension of shaped apron. Mid-19th century.* (I.N.C.)*; (E) Kitchen table with turned base and H-shaped stretcher. Wide apron contains three drawers. Mid-18th century.* (Musée de l'Hotel Dieu, Quebec.)

century. Some of these lavabos are so elegantly carved around the rim or on the towel-racks that they may even be said to be Canadian rococo, to borrow Ramsay Traquair's phrase.

Consoles

The console is a wall table with two uprights that were placed against the wall, usually under a mirror. It was a typical piece of furniture in middle-class houses. In Quebec, it was predominantly a church piece, called a credenze, and stood against a wall near the altar to hold altar cruets, holy water basins, censers or holy vessels during the service. Most of the known ones are in the style of Louis xv, with apron and base richly carved, or else of Chippendale inspiration with claw and ball feet. Some of these tables were also made during the Victorian period; they are long and narrow, and the two uprights are spiral or bead turned.

Desks and Secretaries

Desks and secretaries were pieces of furniture limited to a very special category of persons. It was an indispensable article for the middle-class businessman or for members of the clergy. This type of furniture was therefore to be found mostly in big towns and in wealthy residences rather than in rural homes.

The oldest and, without any doubt the most richly decorated—and the most pleasing to the eye with respect to harmony and

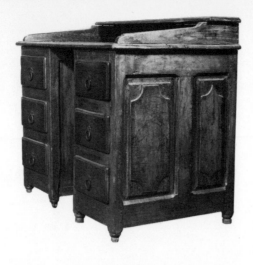

Heavy secretary. Sides ornamented with different kinds of linen folds. The six drawers are of a later date and remade, but the whole is in the Louis XIII spirit. Late 18th century. (I.N.C.)

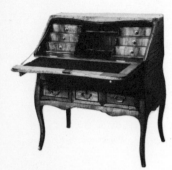

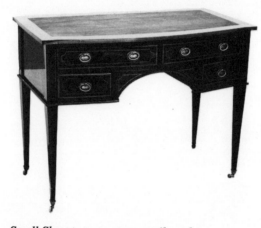

Dropleaf secretary attributed to Thomas Baillargé. Lozenges embellish the sides; legs are curved; lower crosspieces are delicately carved. Pigeonhole has six crossbow-shaped drawers. French influence is Louis XV, and Anglo-American is of the late Georgian period. Early 19th century. (Séminaire de Québec.)

Small Sheraton secretary attributed to Quebecois makers. Mid-19th century. (Séminaire de Québec.)

balance of their proportions—are those called "Mazarin," with a Louis XIII base. Mazarin, prelate and French statesman of Italian origin (1602-1661), had a remarkable influence on cabinetwork for, in addition to being a great connoisseur, he set up rich collections of works of art and encouraged artists.

These desks, with their straight or curved bordered tops, have five or six drawers, turned legs, and an H-shaped stretcher, with or without bracket in the center of the crosspiece. They are extremely rare collectors' pieces. Others, more rustic chests in pine, and dating from the 18th century, are made out of chests ornamented with diamond points or lozenges and, instead of a series of drawers placed beneath the top stopping halfway up the leg, they are closed at the base by a door.

Next we have slant-top desks, a kind of chest with a sloping lid, a little like old school desks. The box rests on a rustic table with an H-shaped stretcher or carved cabriole legs. These pieces were used for collecting tithes in and for storing registers. One of these desks, which is in the furniture section of the Quebec Museum, looks like a wardrobe with a sloped top. It was used, generally, for storing sacerdotal vestments. It was very comfortable to stand in front of this desk while fulfilling various administrative tasks such as filling out written documents.

Finally, the last type, very popular at the end of the 18th and 19th centuries, is the secretary-desk. These pieces of English influence are, in essence, commodes with drawers, topped by a drop leaf supported by two slides. Once the drop leaf is lowered, a series of pigeonholes and drawers are revealed. This pigeonhole desk also hides a secret compartment behind decorative panels. In the Victorian period these drop-leaf secretaries became regular mastodons overloaded with little columns and machine-made motifs in fashion at the time. Finally, at the beginning of this century these secretaries were transformed into the "roll top" desk, with the lid rolling on grooves.

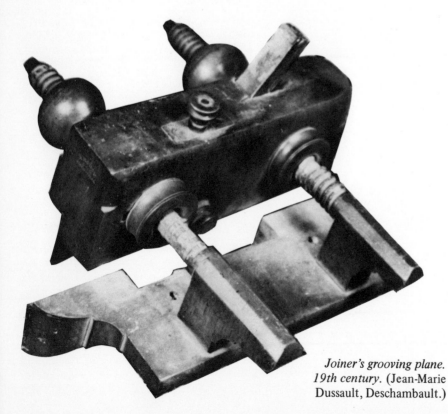

Joiner's grooving plane. 19th century. (Jean-Marie Dussault, Deschambault.)

Wooden Objects

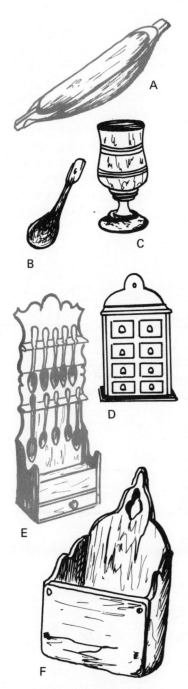

Sugar molds remained, unquestionably, the most interesting of all the molds used in Canada. The landowners who made them were clever animal sculptors, and their works are evidence of a true folk art.

ROBERT-LIONEL SÉGUIN

Wood is the material early Canadians exploited most. The clever artisan knew how to make a thousand and one useful or purely decorative objects. The settler even replaced some metal farm tools, copied from those in the mother-country, with tools made of dry, hard wood. The many wood rakes and pitchforks are testimony to this fact.

Wood also has the advantage of being easy to work. The man who had the slightest facility for handling a saw, chisel, or short adze, produced from raw materials not only furniture but also table articles (sugar molds, butter molds, candlesticks) and a whole series of other odds and ends to supply the farmer's needs. We shall give special attention to this in the chapter on spinning wheels and clocks, for wood is an integral part of those articles.

All the various woods of the Canadian forests (pine, spruce, maple, cherry, walnut) were used in a great variety of kitchen articles. These latter were either hollowed, turned, or carved from the trunk of the tree, or made with thin planks assembled with dovetailed joints bolted together or studded. Many museums in Canada possess unique turned specimens in pine wood.

Wooden salt cellars shaped like tiny egg-cups are without doubt the oldest of these pieces. In the old days, the salt cellar was not the pierced cup we use today but a little vase in the form of a chalice from which one took the pinch of salt needed for seasoning food, as is still the custom in Europe.

Since our ancestors did not always have at their disposal bowls, vases or other containers of ceramic, glass, or metal, they resorted to local materials to fill the lack. Wood—

(A) Bowl; (B) Wooden spoon for beating butter; (C) Wooden salt cellar, turned; (D) Spice box; (E) Utensils box; (F) Salt box.

(A) Wooden candlestick, turned; (B) Piece of church ornament; (C) Decorative angel; (D) Duck decoy.

very often the hardest wood—was hollowed out with adze or chisel to make a vast range of butter bowls or other bowls of different shapes that on occasion we have a chance to admire in private collections. Many of these bowls have handles carved right on the body of the piece.

It is, however, very difficult to date these objects. The way the wood was worked, the wear and tear on it, its color and weight are the only criteria that can help the amateur collector to discover the approximate age of the article that is offered for sale or that he already owns.

Still in the same genre are wooden utensils

117

of past centuries, which are eagerly sought by collectors. Certain large spoons, veritable ladles in birds-eye maple, are pieces which the alert amateur never disdains. The same may be said for those maple bread paddles or scoops.

Among other wooden tools we find in the kitchen are boxes for utensils, when the latter were not stored in the table drawer or in the corner cupboard. These are little masterpieces of carpentry with their dovetailed corners, their surfaces ornamented with simple designs carved with a knife. Some of these boxes, imitating English custom, were hung on the wall. The spoons were displayed on racks along the top and the rest of the cutlery placed in the drawer beneath. Spice cabinets with their triple or quadruple rows of drawers also hung in the kitchens of well-to-do people in the 19th century.

Matchboxes, which have the most surprising shapes, were well within reach near the kitchen stove in most houses from 1850 on. At the beginning of the 20th century, rustic wooden matchboxes were replaced by boxes of sheet metal or wrought iron.

Salt boxes also fit into this category of ordinary objects which the settler fashioned and worked over in his long evenings. These articles reflect the spirit of the rural landowner in their simplicity, their naïveté, and their ornamentation, drawing as they did from folk art motifs, animals, bleeding hearts, field flowers. These boxes used to keep the table salt dry for consumption and, like the matchbox or the spice box, they hung on the wall near the stove.

There are, of course, other utilitarian objects which the farmer carved out of wood to help the housekeeper. Pails are a typical example. The experienced amateur collector will know how to pick out the functional and historically interesting piece by referring to the methods used in making them in past centuries.

Sugar Molds

The maple sugar industry goes back to pre-colonial history, if one can trust research that has been done on the subject.[1] It appears, in fact, that the natives initiated the white colonizer into the art of gashing the tree, collecting the sap and boiling it down to that golden syrup which, to the foreigner, is synonymous with Quebec. One always finds it on our tables to be poured over such foods as those crepes our grandmothers made.

This industry has since Canada's earliest years continued to be systematically developed by our agriculturists. The beginning of spring being a slack period, each settler marked his maples on that part of his land that was covered with stands of wood and, before long, sugar and syrup were there to add to the scanty income of the farm, and above all to sweeten the entire household.

To be sure, the sugar had to be molded into a loaf. In the beginning, the local sugar-maker, like the Indian, used birch leaves or even playing cards to shape his forms; these were then torn off for the unmolding. At the end of the 18th century, the wooden mold came into gradual use throughout the country to become, in the 19th century, one of the tools that hung from the rafters in most sugar cabins.

Sugar molds decorated with the secular motif of animals.

1. Seguin, Robert-Lionel, *The Molds of Quebec*, Ottawa, Imprimeur de la Reine, 1963.

Secular motifs also include country scenes, such as a sheaf of wheat.

Bleeding heart was a common secular motif in folk art.

An example of a religious sugar mold.

Houses were also a common secular motif.

Wood sugar molds are without question the most interesting of all those used in Canada. Born of the skill of our farmers, they are still the most typical and most sought after articles of a peasant art which, for several years now, has been extinct. A number of these molds are still used by sugarmakers, and they are often inherited from father, grandfather, or an even more remote ancestor.

This is a disappearing art, for more and more square pine molds or pieces in decorated sheet metal are being used. In addition, a great many maple forests are being sacrificed, for farmers have discovered that at the price sugar and syrup are selling, it is more profitable to concentrate on farming in the spring than to put on snowshoes and run from maple grove to maple grove. That is why so many old molds are now on the market in antique shops. The demand for them is so great that in spite of the considerable quantity of original pieces, fakes are beginning to appear. The color of the wood, the patina, and the line of saw marks remain the only criteria of authenticity.

Pine, maple, cherry and ash are among the woods from which the country wood-carver cut the secular or religious motifs that shape the loafs of sugar and make them more attractive to the buyer.

Animals, vegetables, religious, and sentimental symbols are the motifs most used. If one carefully examines the molds with animal designs, one cannot help admiring the fineness of the work and admit that our ancestors were masters with their knives. They created a folk art most truly representative of the milieu. Some regions in particular, like Montmagny, la Beauce, and the Eastern Provinces, produced the most delightful specimens of this type, as a brief visit to antique shops of a local sugar hut will show. Fish, horses, birds, beavers, rabbits are undoubtedly the most common. The beaver motif is the most sought after by the collector and the most esteemed.

Among vegetables, ears of wheat and the maple leaf have been widely used as themes. A whole series of objects (locomotives, houses) are also found among the artisan's favorite forms along with the four symbols of playing cards. Religion inspired many a country carver. Bibles, missals, the crucifix, monstrances, chalices were carved of pine. And finally, initialed bleeding hearts or just plain hearts engraved with declarations of love were also part of this repertory.

Most of these molds are in one or two parts. Some, like the house or locomotive, have as many as ten thin pieces of wood assembled by wooden pegs or outside hooks.

Round butter mold.

Sliding stamp butter mold.

Square butter mold.

Vegetable motif stamps for round molds.

Commercial stamp.

Vegetable motif stamp.

A great many of them were square and unadorned. Churns and wooden pails with iron rings around them, and all old rustic pieces from sugar cabins, like those cedar flutes are collection pieces that ought to be preserved.

Butter Molds

The origin of butter molds does not go back as far in time as the molds used by sugar-makers. In the second half of the 19th century there were many social and economic changes. On the social level, the towns enjoyed a considerable development, due in great part to rural migration and population growth. These new centers opening to embryonic industrialization, also attracted the man from the country by offering him remunerative work as well as a variety of services.

And, as well, the farmer was to profit, for this was a new market for disposal of his farm products. Butter, which formerly, in a nation of farmers confined to their land, had been made primarily for home consumption, was now sold in town. To identify his product and present it in more attractive form to the customers, the dairyman did not wrap his butter in waxed paper printed with his seal as dairies do today. Instead, he molded the desired amount of butter in a round or square wooden mold consisting of a hollow circular bowl and an engraved mark puncher provided with a handle.

Several farms had a whole collection of them, from the mold for a two-pound loaf of bread to the minuscule quarter of a pound, as well as for the pound and the half-pound.

In addition to their useful function, these molds also have an esthetic function: on special occasions the housekeeper used them on the table. Of course, the farm product had to be identified, but this was done with style. The trademark was generally carved out with a knife. Simple, naive motifs depict a star, fodder plants, flowers, animals, or a family's stylized monogram. The seal decorated with a beaver or a maple leaf is the most sought after by collectors. Some of these pieces, dating from the turn of the century, are completely machine-finished.

In addition to these domestic molds, there is also a series of business trademarks in wood engraved in the name of a merchant's firm

Trademark stamp for butter mold. Late 19th century. (I.N.C.)

Wood blocks delicately carved with floral and geometric motifs were used as stencil plates to print fabrics with homemade vegetable dyes.

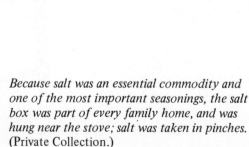

Because salt was an essential commodity and one of the most important seasonings, the salt box was part of every family home, and was hung near the stove; salt was taken in pinches. (Private Collection.)

or of a butter-dairy. The design is much more refined than those of the peasants, but these pieces are not to be found on the market.

Miscellany

Wood was the material used for a great variety of the most out of the way objects. Toys and tools were, for the most part, made of it throughout the centuries preceding ours. Later on we shall study these two items in separate chapters, since their number as well as the interest among collectors justify a more detailed description.

The artisan used wood to create all that collection of small chandeliers for the houses; even the great Easter candleholders, richly carved and turned, were fashioned by carpenter-wood-carvers out of local pine. The same may be said for all the applied decorations which, covered with gold leaf, transformed a country church into a heavenly vault. Confessionals, choir stalls, pulpits, altars, and ceilings of many churches were filled with carved creations which, more and more, because of the abandonment or alteration of these houses of worship, are found on the walls of antique shops. Most of the men who decorated these churches were genuine artists in their genre. Even in a modern setting their works add a striking note of beauty. We can better understand their care for esthetics when we realize that, in a profoundly religious society, the church is the symbol of that better world that awaits the faithful in their future life. Flowers, interlaced designs, animals, Christs surrounded by halos, angels, in short, a whole range of the most fantastic motifs are characteristic of this production.

Pails, barrels, tubs, and wooden churns encircled with iron hoops were still in use in most rural households at the end of the 19th century. The cooper, with his special set of tools, employed his skill to finish joints smoothly and make the barrel tight. Pails came in various sizes and the handles were generally a rope or a piece of wood hooked on to two ears attached to the rim. As for old churns, some were end-over-end churns; others, older, were the dasher type.

Duck decoys which the hunters of yesterday used as lures in the fall hunting season, were carved from a single block of pine or cedar, and painted to make them more realis-

tic. Those crudely carved objects have such decorative value that it is more and more difficult to find any of them on the market. In other times they were used as door stops in country houses.

Frames of mirrors or pictures are also very much in demand nowadays. The simplest frames were made of bird's-eye maple or varnished cherry and consisted of a very simple molding in which flat surfaces dominated. Others, inspired by the decorative fashions of the day, imitated the carved frames of preceding great centuries. Carvings on moldings were replaced by a layer of mastic or plaster which was pressed into a mold and which, once gilded, had a most attractive appearance. Today those moldings impressed in mastic have preserved all their freshness and are easily restored to value by gilding. The same cannot be said of plasterwork which time and temperature changes have irremediably crumbled.

Among the wide range of wooden objects which should be preserved are various chests and cornices, washboards, and curtain rods with brass ends of the Victorian era. More than one amateur collector will brighten his house with them if time and usage have not damaged them too severely.

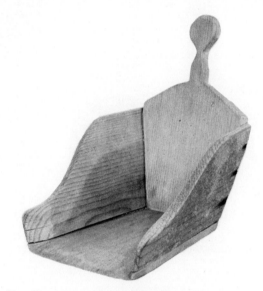

Pine dust pan, with handle and curved sides. 19th century. (Musée de l'Hôtel-Dieu, Quebec.)

Spinning Wheels

Today the spinning wheel is an obsolete and picturesque implement of the handcraft era. A relatively widespread article in the 17th and 18th centuries, in the 19th century it became a generalized reality in all rural homes. For twenty-five years this object has been so hunted down by professional scouts who cover the countryside, that it has become rare. However, New England antique dealers inherit trucks full of them to supply a clientele that specially prizes this type of spinning machine.

There were two ways of making the spinning wheel: those that were turned, which are more attractive and better finished, and the others, primitive and plain, made by farmers or artisans, directly from solid pieces of pine wood. The shape of the wood-turning or even the method of assembly can tell a good deal about the age of a piece. In any case, most of them go back to the beginning of the last century.

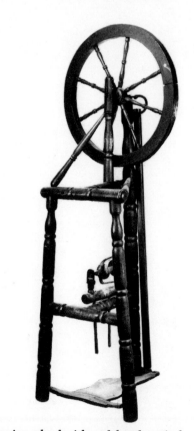

Spinning wheel with pedal and vertical structure. Rare item. Late 18th century. (I.N.C.)

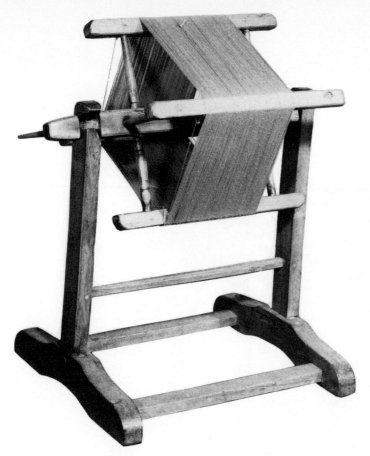

Reeling machine or winder. Mid-19th century. (I.N.C.)

Two types are available to the amateur collector: the first, a big, wide wheel which the countrywoman turned by hand; and second, and more common, a small wheel, hand-turned in the 17th and 18th centuries, but improved by the addition of a pedal in the 19th century. This is the kind we see most often in our day. The number of wheels, legs, and pedals of cast iron or wood are all details that will help in judging a piece. At one time there were large manufacturing firms in Bellechasse and Kamouraska.

Not only the spinning wheel, but a wide range of wooden tools were used in the making of wool and other fabrics. We call attention to the reels (or swifts) upon which wool was wound into skeins; the weaving-loom, the most complicated instrument of domestic labors; the carder, a small board fitted with a handle and bristling with fine steel teeth.

All these objects are worth particular attention today. The smallest are sought after for their historic and decorative value, where-

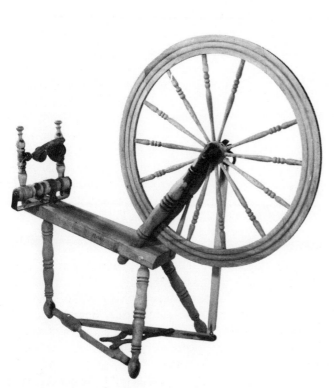

Spinning wheel has a cast-iron pedal which dates from end of 19th century. (Musée de l'Hotel-Dieu, Québec.)

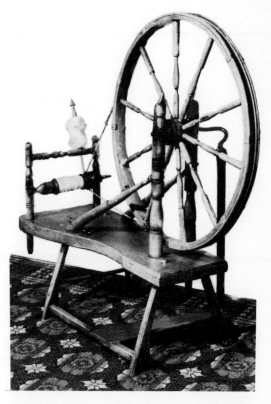

Spinning wheel with wooden pedal, early 19th century. This type of wheel was equipped with a cast-iron pedal by the end of the 19th century and the beginning of the 20th. (Musée des Ursulines, Quebec.)

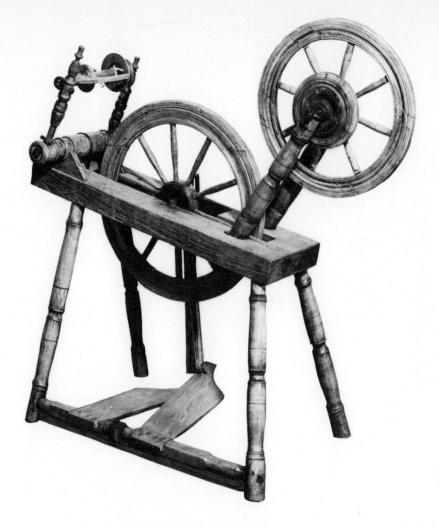

Spinning wheel with two wheels and pedal. Mid-19th century. (I.N.C.)

as the largest, like the loom, are manifestations of the artisan's ingenuity and are veritable museum pieces.

Clocks

Our ancestors had various ways of measuring time. Merely by glancing at the position of the sun, the most experienced could tell the time of day fairly accurately. At night the measuring candle that burned an inch in twenty minutes, or the sand glass no doubt came to the rescue of the pioneer. It would be interesting to know whether the chronometer lamp was used; we still find some rare samples of that lamp called "*bec de corbeau*" (crow's beak), surmounted by a graduated glass reservoir. The oil burned in a given time would lower the level in the bowl, and the lapse of time was judged by how far the level had dropped. A good many institutions and fortresses used the sundial

for greater accuracy. One can still tell time by this system in the inner court of the Quebec Seminary or even inside Fort Lennox, on the Ile aux Noix, near Saint-Jean-d'Iberville.

Then, at last, the ineluctable tick-tock of the clock, that most complex and most costly instrument, began to be heard in the common room of a number of country houses in the 17th century. Tradition has it that Mme. de la Peltrie may have had her clock when she arrived in New France. Of course, one would have to be very well off to indulge in such a luxury in those difficult times and, until the 19th century, this means of measuring time was almost uniquely reserved to middle-class households and people of prominence. The average settler had to be satisfied with Nature, the sundial, and the candle.

The face and the movement of the first clocks were, like the clock that belonged to Mme. de la Peltrie, made in France, whereas the case usually, of pine, was a local product. It was a custom that was current among the wealthy who came to settle in

America and one that persisted; many "grandfather" clocks found in Ontario and dating from the 19th century have European movements.

It was not long before watchmakers set up shop in Canada to make and repair clocks. Toward 1730, Henry Solo, whom specialists consider the first watchmaker in the land, was established in Quebec, which was then the political, economic, and religious center of the vast French colony. He was soon followed by Jean Ferment, N. Gosselin, and, in Montreal, by Dubois, Faucher, and Malo. However, of all these clockmakers of the 18th century only their names are preserved, for up to the present nothing they produced has ever been found.

Francois Valin, a man of all trades, was in turn locksmith then armorer; around the year 1750 he also took up the profession of watchmaking. In Boston, a clock signed "Valin of Quebec" has been preserved as well as an oral tradition which claims that the presbytery of Baie-Saint-Paul had once owned a large clock made by that same artisan.

After the Conquest, the clock became more and more common in middle-class and even in rural households, a fact gleaned from numerous death inventories.

Two Englishmen came to settle in Quebec and, modeling after the Chippendale style, produced "grandfather clocks" which became, in the local French of the day, "grandpère" clocks. These men were James Godefrey Hanna and James Orkney.

During the first half of the 19th century, C.S.A. Bellerose, from Trois-Rivieres, made those tall clocks with round dials and pyramidal cases. The movement was of brass. Some of them were decorated with marquetry designs.

But it was with the five brothers Twiss, natives of Connecticut, that clock and watchmaking passed from handcraft period to industrial stage. In 1821 these small manufacturers settled in Montreal where they brought out a series of grandfather clocks signed "J. B. & R. Twiss." Soon, pieces with movements of cherrywood and cases of pine were spread across all the Province of Quebec and beyond. In passing, let us mention that the wooden movement is not a criterion of age; it is a process that was to be popular in clock-making throughout the world, especially in the 19th century, but which was not as good quality as the metal movements that had preceded and were to follow it.

During the same period, Joseph Belleray

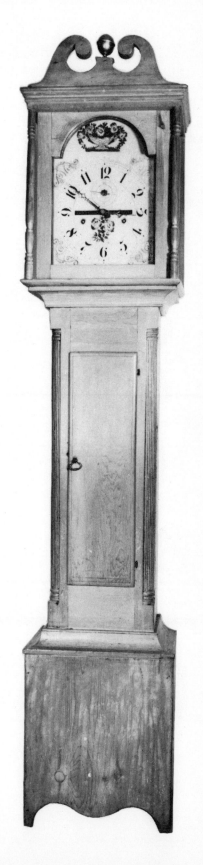

"Twiss" clock with cherrywood movement. Pine case, with its spiral pediment and fluted columns, inspired by 19th-century American styling. (M. and Mme. G.E. Gagné, Neuville.)

from Longueuil and C. J. Ardoin from Quebec, were to use practically the same forms as the brothers Twiss. It must be admitted that imitation has always been rife among artisans. Their clock cases are usually decorated with floral or geometric motifs, and some of them are even ornamented with descriptive scenes signed by famous artists such as Cornelius Krieghoff.

From 1850 on, Anglo-American imports were gradually to diminish the importance of local manufacture which, in order to keep up with foreign competitors, had to become better organized, and also reduce somewhat the quality of the cases. Veneered wood gradually supplanted the old solid pieces, veritable jewels of carpentry and cabinetmaking.

But it was mostly the American product that was to reach us and which we find the most often in the antique shops. The "Banjo" clock, with brass movement, invented in 1801 by Simon Willard, hung on the wall while at the same time resting on a console table. It was copied by numerous American manufacturers who flooded the market with them the whole of the 19th century.

There was also the "pillars and scrolls" clock patented by Eli Terry in 1841, which was mass produced and sold at popular prices in the last century as well as in the present.

Older than the grandfather clock, of which it is the logical ancestor, the clock with an outside pendulum was also very popular in the U.S.A. in the 18th and 19th centuries, but only a few old specimens are to be found in our country.

Sun dial.

Sand clock.

Calibrated candle burns an inch in 20 minutes.

Clock with outside pendulum.

Grandfather's clock.

Clock with columns and scrolls.

"Banjo" clock.

Gingerbread or spice clock (1871-1910). Most of these were manufactured by watchmakers from Connecticut and Massachusetts.

Poor man's grandfather clock, the majority made in New England at the end of the 19th century, was found in many Quebecois houses of the day.

CHAPTER 7

Ceramics

*Pottery has always been made in Canada,
at least since 1686 when an establishment
was founded at the Lairet river near
Quebec, to make bricks, tiles and
"earthenware pots." Our elders
remember the last potters, nearly
everywhere, who closed their doors
some sixty years and more ago.*

MARIUS BARBEAU, *Techniques*, 1948

Ceramics is concerned not only with the category of glazed or multicolored pottery, but with the industry in general which also produces tiles, bricks, sinks, bathtubs, grindstones, dishes of earthenware, stoneware, and china. For, as soon as plastic earth is subjected to high heat for any purpose whatsoever, it becomes ceramic. In this chapter we shall confine ourselves chiefly to handmade and manufactured pottery.

Since the beginning of time practically all peoples have made use of the plastic properties of clay. There are numerous signs of its use at the beginning of all civilizations. The Egyptians, for example, placed funeral vases and statuettes of terra-cotta near their dead. The Greeks gave their urns a pure and finished form; witness the beautiful painted mixing bowls and amphorae, those two-handled, narrow-necked jars.

American colonizers brought the art to this continent, only to discover to their surprise that another people were already making *their* own ceramics.

The American Indians had a rather archaic method of making pottery. The Iroquois, among others, took suitable soil which they washed and kneaded into a large ball; then, using their fists, they pressed a hollow in it, enlarging it more and more, thus forming pots which they used for carrying water or preserving food and which took the place of the "casseaux" or bark bag. Firing over hot coals contracted the vase, which first had been decorated with a stick, or combs, or bone awls.

Pots and pipes were the only ceramics made by the so-called primitive civilization which was scattered throughout the province before the arrival of the White Man. There are not many Amerindian pieces to be found in antique shops, but archaeological excavations at ancient Indian sites give scientists an opportunity to gather and collect the shards, and, often, to reassemble some interesting pieces.

The need of the Aborigines to be self-sufficient in order to survive was shared by the French on their arrival. Forced to produce everything they needed, the colonists were obliged to undertake every variety of occupation, and thus ceramics became a necessity to them. We shall see in the following pages how, from the beginning of colonization, Quebec was the wellspring of pottery artisans, and how pottery underwent a demonstrable evolution both esthetically and technically, from the purely utilitarian, handmade pottery of the 17th century to the ver-

Announcements in 19th-century newspapers provide an important source of information for anyone interested in ceramics. Here, an advertisement taken from the Journal de Québec, *June 17, 1874.*

satile manufactured product of the 19th century. We shall also see the influence of English Canada, and of Great Britain, an influence that is still perceptible in the terracotta objects antique dealers offer today.

Flower pot with scalloped border, in brown glaze. 19th century. (J.M. Dussault, Deschambault.)

Types of Ceramics

The paste ingredients used in ceramics vary enormously, and the composition of the clay and the material used will determine the kind of pottery that will be produced at certain temperatures, the glaze, and its degree of hardness.

Once the mixture is prepared, it is then ready for shaping. More primitive civilizations molded the pot or the object from a lump of earth which they shaped with their fingers and then fired directly in a bed of live coals. Later, the potter's wheel, operated by human hand or foot power, became current usage. It is undoubtedly the best-known method and produces the variety of multiform vases that are the result of the artisan's skill and dexterity.

In another method, slabs of earth of different thicknesses were rolled out and then cut from a pattern. The various parts of the desired object were then assembled, much the way tinsmiths do with sheet metal.

Large terra-cotta bowl, lead glaze, hand thrown. Interior dark, exterior speckled green. 18th century. (Private Collection.)

Finally, a more recent technique uses earthenware or plaster of Paris molds, thus allowing the article to be reproduced in as many copies as desired. Pots, jars, figurines, all can be fashioned in this way, according to the imagination and originality of the potter.

Once the article is fired (it is then called *biscuit*) the artist applies the glaze and the decorations. The clay-based ceramic is then coated with a mixture that has a lead base. This is the method used for the Dion pottery and certain Cap-Rouge pieces, whereas the harder pieces will take glazes that have a base of mineral salts. Some pieces, whose bases withstand heat, may be decorated with colored motifs beneath the glaze.

The ceramic, that is, the earthen article, once fired will be soft if its surface can easily be scratched, or hard if even an iron point cannot affect it. An example of soft ceramic would be ordinary flowerpots; of hard ceramic, Chinese or Sèvres porcelain.

Depending on the kind of clay used, there is a whole series of pieces labeled according

to the materials. Earthenware, stoneware and china are some of these varieties.

Clay pottery, the oldest and best known, uses clay in its natural state. It is baked at a low temperature (1,000° F.) and the biscuit takes on a rosy tint ranging from red to dark brown. Deposits of this kind are numerous in Quebec and the majority of potters of the preceding centuries turned or molded their pieces from this type of earth. The glaze on these articles, the majority of which were used in the kitchen, has a lead base, or sometimes it will be a glass compound, translucent, semi-translucent or opaque, whose coloring properties are produced by oxides or metallic sulphurs. Pieces of this sort are common but they do not withstand hard usage.

Stoneware, like semi-porcelain, is kaolin (or porcelain clay) and silica mixed with clay to make a heavier and more solid piece. Fire will partly vitrify the body, thus assuring perfect impermeability. The vitreous glaze with salt base will cover the gray or blanched biscuit. Most kitchen articles of today belong to this type of pottery.

Finally, porcelain, that great Chinese invention, was successfully produced in Europe at the beginning of the 18th century.

French-Canadian Productions: The Pioneers (Jacquet)

At the time of his voyage in 1613, Champlain was the first to call attention to the presence of rich pottery clay on the present site of Montreal. A little later, perhaps in 1686, the administrator, Champigny, officially introduced pottery into New France by announcing to his minister that a tile works was being set up on the left bank of the Lairet River not far from the St. Charles River at Québec.

Archives from the end of the 17th century show that pottery makers like Salomé produced earthenware pottery for the early settlers. One of the first potters to whom certain pieces are attributed was François Jacquet. Son of a crockery maker from Bourgoin, he first worked in Quebec for the widow Fornel. During the excavation of the Fornel house on the Place Royale, Michel Gaumond, archeologist with the Ministry for Cultural Affairs, unearthed several pieces attributed to Jacquet and which he described in a historical resume on that dwelling, published in 1965.[1] Terrines, plates, pitchers and pots came from the Jacquet workshop, which was later to become the most important one of the age (around 1750). In 1766 Jacquet

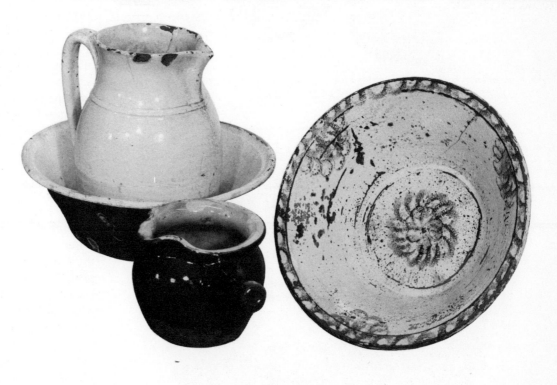

French-Canadian ceramics of the late 18th century with light yellow and brown glaze. Earthenware terrine on the right is decorated with a line of petals and flowers on the rim. (Musée de l'Hôtel-Dieu, Quebec.)

1. Gaumond, Michel, *The Fornel House* (La Maison Fornele), Quebec, Ministry of the Cultural Affairs, 1965, 38 pp.

Shallow bowl, hand thrown, probably by Francois Jacquet; discovered during the restoration of the Place Royale in Quebec. Glazed on the inside surface. (I.N.C.)

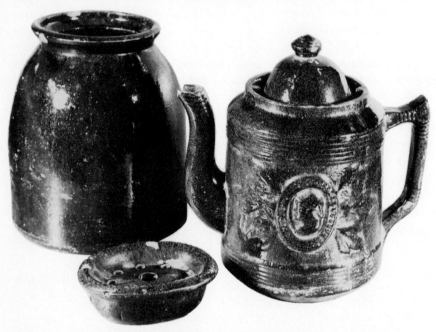

Functional soap boiler with draining rack and teapot in dark brown glazed ceramic of the Dions from Lorette. 19th century. (J.M. Dussault, Deschambault.)

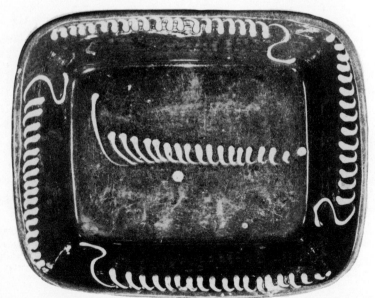

Large basin, probably made by French-Canadian potters of the 19th century. (Private Collection.)

moved to Montreal. The Vincents, Antoine Bertrand, Guillaume Duval, Nicholas Godin, Charles Le Normand, and Pierre Vasin also became famous in that art between 1750 and 1830. It is extremely difficult to find a piece of their work or to attribute it to them, for most of the time the artisan did not sign his name. The Musée de l'Hôtel-Dieu in Quebec owns some very old pieces that go back as far as that period, but are not positively identified. They are all clay, with lead glaze. The sides are amber-colored and the bottoms in tones of green, brown and yellow. Only the insides are coated with glazing.

Canadian potters used giant kilns, seven feet long by six feet wide with an opening about 15 inches high at the center; they were filled to capacity. Some of those ovens have been located by archaeological borings. This was not an easy profession in a pioneer nation. There were, of course, a number of businesses and some religious communities that sent in orders, but unless the potter spent most of his time baking brick for building houses and churches, he made a very poor living.

The Dions

After 1830, British and American influence made itself felt and was to confuse the character of rustic Canadian pottery. But hand-made pottery was not completely wiped out. Families of potters like the Maillets, la Beauce, the Merciers from l'Assomption, the Guimonds from Cap-Saint-Ignace, and others from Saint-Denis and from Pierreville were still turning out articles by hand for domestic purposes.

The most famous potters of that era are without doubt the Dions from Ancienne-Lorette, near Quebec. In the second half of the 19th century the Dions were still making plates and bowls of glazed red clay, varnished and speckled with green. Bowls, plates, dishes, pitchers, tobacco jars, and even money boxes are some of the pieces attributed to them and which are still found on the shelves of various antique shops—and at a good price.

Around 1830, manufactured pottery took over this field. Newly emigrated potters, like the Farrars from the U.S.A., the Bells of Scotland, and the Howisons of England,

captured the market. Modern methods of molding gradually supplanted handwork, and the market, formerly limited to parish clientele and to bartering, as indicated in the little announcements in the newspapers of the day, took on a wholly new dimension

The Farrars and the Potters from St. John

In an article published in *Technique* in September 1948, Marius Barbeau wrote:"The arrival of the Farrars marks an important step in the history of pottery in Canada, because of the industrial repercussions." The ethnologist was right, for, after the Farrars, a series of business enterprises specializing in ceramics settled on the Richelieu near St. John

in such numbers that by the end of the last century, the region was known as the "Staffordshire of Canada."

By 1840, and perhaps even before, the Farrars ' were established at St. John in Lower-Canada, and their pottery works, which moved frequently, were to endure until about 1925.

In that factory they made not only all kinds of useful articles, but also delicate vases and decorative pieces. The local glaze mixed with glaze imported from Trenton in the United States, gave a hard ceramic, so full of sandstone that the owners, in their publicity notices, advertised it as the "Canadian Rockingham." This term is doubtless a reference to the high, maroon glaze. Table pieces, yellow or grayish, sometimes decorated with primary blue motifs, emerged from the Farrar factories. As a rule such ar-

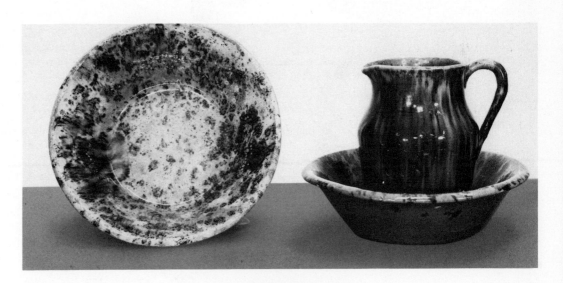

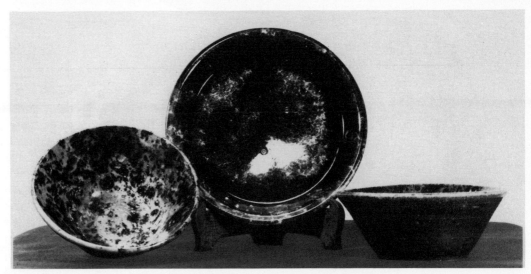

(A) Basin with pitcher, attributed to the Dions. Ceramic speckled with green and brown, lead glaze. 19th century. (Musée de l'Hôtel-Dieu, Quebec.); *(B) Two bowls and a plate attributed to the Dions of Lorette. 19th century.* (Private Collection.)

Stoneware pitcher marked E.L. Farrar, St. John, Quebec. (J.M. Dussault, Deschambault.)

Stoneware pitcher signed E.L. Farrar, decorated with a blue flower on the bulge; made at St. John-d'Iberville at the end of the 19th century. (Louis Martin, Quebec.)

Plate of white semi-porcelain or stoneware, made by the St. John Chinaware Co. Late 19th century. Stamped with trademark. (J.M. Dussault, Deschambault.)

ticles were marked "E. L. Farrar" or simply "St. John" or "Iberville, P. Q."

Another and even more important ceramic company was to open in St. John in 1873 and last until the beginning of the 20th century: the "St. John Stone Chinaware Company" was undoubtedly the most important maker of very hard white ceramic (such as is used on tables) that Canada has ever known. China services, pots and white wash-basins decorated with a protuberant handle constituted most of their production. Some were decorated with silver lines or ribbons, a process that was unique in Quebec. With a little patience one can fairly easily procure the white washbasin or kitchen sets at a more than reasonable price. One type of Rockingham (feldspar base glaze with colored and brown shadings) also came from these workshops.

Doubtless we shall never know the complete list of pottery works or ceramic factories that, following in the footsteps of the Farrars, have operated in this sector of Quebec in the course of the last century. However, we must not forget to mention a few names: John Gillespie's "Canada Stoneware Company" of 1858, which went rapidly downhill in those years of economic depression; Orrin L. Ballard, a former pottery maker of the Farrars, also went into business for a time; Bowler's "Rockingham and Yellow Ware Manufactory" and the "British Porcelain Works" were for some years after 1880 more or less fierce competitors of the "Stone Chinaware Company."

Cap-Rouge

The Province of Quebec also entered the modern era of pottery with less dash than the Saint-Jean region, but people were made quite as much aware of its presence. Between 1840 and 1850, on the rue Saint-Vallier in the city of Quebec, the brothers William and David Bell had a ceramic factory: terra-cotta pipes and drainpipes seem to have been their main products for, up to now, only a few cuspidors have been definitely attributed to them.

However, the best known and the most important pottery factory in Quebec in the 19th century was the factory of Cap-Rouge, according to the archives—especially a photo of plans—certain archaeological borings, and

the relative profusion of pieces in circulation even in our day, which are no doubt mistakenly attributed to them.

It was an Englishman, Henry Howison, who built and organized this factory in 1860. Later on, as the result of several transactions, the business passed through various hands, but the deposits of blue-gray clay left in the low-lying area of Cap-Rouge by the sea of Champlain some 10,000 years ago, were still worked. It was a clay of exceptional quality.

Most of the pieces from the Howison factory were wheel-thrown, but not entirely by hand. Bowls, dishes or jars were produced by the skillful artisan who also used a jigger template and case mold. On the other hand, small jugs, water pitchers, spittoons, teapots, and serving dishes were made in the mold. Cap-Rouge pottery was covered with two glazes: one, very common, with a lead base for bowls, dishes and jars, gave the pieces a golden or slightly greenish color; the other, more somber, and more on the brown Rockingham type, was used chiefly to glaze teapots. Several articles were beribboned with more or less wide white, brown or blue bands, according to the potter's fancy.

Teapots were decorated with biblical scenes, popular in the 19th century: "Rebecca at the well" was the one most often copied. The small jugs or water pitchers have a surface decoration of scenes of herons surrounded by aquatic plants, while the spittoons are sometimes ornamented with scallop shells on the edges, or even with fluting and oak leaves on the sides.

This factory closed its doors in 1890. That there should be such a scarcity of pieces left from an enterprise of this scale is really an enigma.

Anglo-Canadian Manufacture: Brantford

French Canadians of that time were not served at table by the works of local potters only. A great variety of ceramic articles came from Upper Canada, through the usual channels of trade in the interior of the country, and from Great Britain, the native land of more than one settler. The result of such a commerce is visible today in the antique shops where several pieces of ceramic, often attributed to local potters, come from elsewhere. (Certain pieces from the county of Waterloo, Ontario, are extraordinarily like the Dion from Lorette.)

Several potters whose pieces are sold in Quebec, and who worked in the Maritime provinces or in Ontario, have left their mark. The best known are undoubtedly the brothers Arsdale from Cornwall, Ontario; Erastus Dufoe, from Aultsville, Ontario; and especially the many potters from Brantford, Ontario. Competing companies were also to flood the market with their production; among them, "Hart Brothers and Lazier" from Belleville, or "Gray and Belts," also known under the name of "Manufacturers of Stone Rockingham and Bristol Ware."

We must linger a moment at the pottery

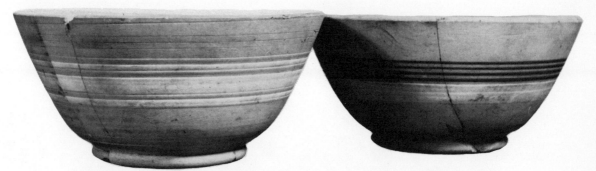

Bowls with colored bands, made at the Cap-Rouge pottery works near Quebec in the second half of the 19th century. Reconstructed from fragments of earthenware shards which were recovered during archeological excavations. Cap-Rouge, with its brown teapots decorated with "Rebecca at the Well," is almost impossible to find on the market. It is often confused with the "mottled" ceramic of the Dions from Lorette and another from Bennington, Vermont. What has become of all the production of that factory, which was so important at the end of the 19th century? Was there a steady production, or only a few samples? The search goes on. (I.N.C.)

works of Brantford in the last century. It should be noted that the pieces are generally signed by the artisan and stamped Brantford. In this, the influences of English Staffordshire are clearly felt. Dogs, large platters that could be painted and hung on the wall, as well as ceramic frames for portraits are the best known pieces. Most of the time, a deep brown glaze covers these molded or thrown objects.

English and Scottish Imports: Trademarks of Local Merchants

The fact that they were established near a great communication route of the continent permitted the French Canadians to buy, or to be depositaries of great English ceramic marks from the beginning of the British administration. Quebec and Montreal became important centers of distribution in this domain. One has only to turn to the little newspaper announcements of the day to learn of the arrivals of ships loaded with plates and dishes, often sold to merchants or to private persons in the warehouses on the port.

Many merchant-importers at that time had their own mark stamped on the bottom of pieces in the workshops of Staffordshire, Liverpool, and Scotland. This was the case with the merchants Shuter & Wilkins (c. 1830), Shuter & Glennon (c. 1845), Glennon & Bramley (c. 1850), Renaud, Prieur & Co. (c. 1860), Douglas & McNiece (c. 1860), Boxer Bros. and Co. (c. 1890), S. Alcorn (c. 1835), McCaghey, Dolbec & Co. (between 1865 and 1875); F. T. Thomas (c. 1880), François-Xavier Martel (c. 1890). Most of them had shops in Montreal, and the last four cited had shops in Quebec. A Toronto merchant, James Jackson, had a large clientele in the Province of Quebec between 1850 and 1860. The same can be said of Glover Harrison who, between 1860 and 1870, sold imported articles marked "China Hall."

Importations of Ceramics with Historic Motifs

At the end of the 18th and during the 19th century English ceramics gradually replaced local pewter and pottery dishes and was widely distributed. One has only to look in

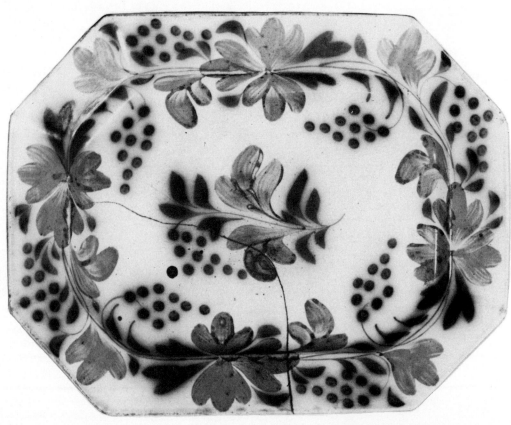

Ceramic with "huckleberry" pattern. English make, 19th century. (Private Collection.)

134

Marks of makers and
importers of ceramics.

Mark stamped on blue
ceramic pieces with historic
scenes, made by Enoch Wood
& Sons, c. 1840 in England.

Mark of the famous Saint-
Jean pottery, c. 1850, and
the later mark, used in the
late 19th century.

the cupboards of our grandmothers to discover this, which explains the enormous number of such pieces in antique shops.

Certain English ceramics have a very special interest for the Quebec collector. The historic "old blue" of Staffordshire are without any doubt the most in demand, in spite of their rarity. These sets of dishes or even the large platters bring a good price today, and lucky is the amateur collector who succeeds in getting hold of one in good condition.

Between 1790 and 1860, the Staffordshire pottery works earned a great reputation as ceramists, not only locally but throughout the world. The list of articles they produced, the range of colors used, the special processes of molding, and the hardness of their pieces, thanks to their use of different clays, made them almost unique specialists in that era.

This industry made it possible for a number of English businessmen to augment their worth. They never missed an opportunity to increase their lines. By exploiting popular sentiments, patriotism, current events, they were well able to attract buyers. A ship launching, a victory at sea, the opening of a building, a coronation or a royal visit were so many pretexts to put on the market dishes, platters, and cups commemorating this or that event or some scene.

Those businessmen who did not neglect the colonial market reproduced Canadian scenes on more than one dish. Inspired directly by engravings printed in contemporary books about Canada, especially that series of drawings by W. H. Bartlett, published in London in 1842, they reproduced scenes of the town of Quebec seen from Pointe-Levis, the Citadel, the falls of Montmorency, landscapes of Montreal, the death of Wolfe, the frigate *Shannon*. . . . All those designs are printed on a deep blue table service. Plates and dishes, water pitchers, platters signed Enoch Wood & Sons, Davenport & Co., Joseph Heath (J. H. & C.), W. Adams & Sons, Jones & Sons, John Rogers & Sons are the best known of this kind and the most in demand.

Other French- or Anglo-Canadian scenes by Bartlett were reproduced on pale blue or brown ceramics or in other colors. The English manufacturers of this type of ware were T. Godwin, Ridgway, Morely & Wear, Francis Morely & Co., Podmore Walker & Co. All of them identified their products by putting their trademark on their pieces. "The Draining of Lake Memphrémagog," the village des Cèdres, Indian scene on the St. Law-

135

C

(A) Invoice of F.T. Thomas, dated 1888. Even though the word "manufacturer" is used, all the pieces are imported from English and Scottish factories; (B) Invoice from ceramic shop of McCaghey, Dolbec & Co., 1874; (C) Invoice from the F.T. Thomas store, 1883. (All three, Paul de Granville, Quebec.)

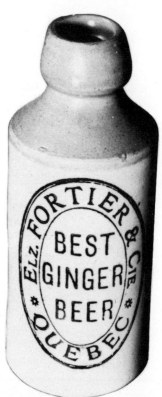

Bottle of American or English make, used by the Fortier dairy early in the 18th century. In the tradition of ceramic containers. (Jean Legros, Quebec.)

136

Piece of blue willowware with traditional pattern and motifs inspired by Chinese porcelain; made in England and widely distributed in Canada by E.F. Bodley & Co., around 1880. (Private Collection.)

Jar to hold toothbrushes, marked F.T. Thomas. Decorated with a "Quebec View": the Champlain stairs. Beavers and tracery of maple leaves near the neck. (Paul de Granville, Quebec.)

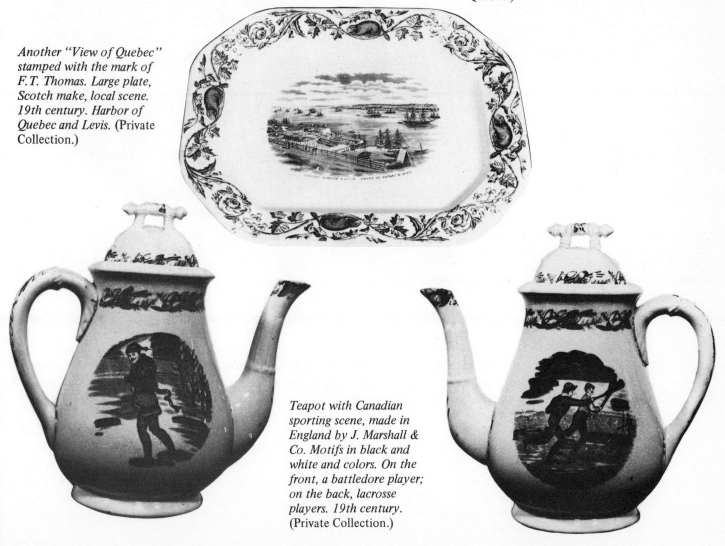

Another "View of Quebec" stamped with the mark of F.T. Thomas. Large plate, Scotch make, local scene. 19th century. Harbor of Quebec and Levis. (Private Collection.)

Teapot with Canadian sporting scene, made in England by J. Marshall & Co. Motifs in black and white and colors. On the front, a battledore player; on the back, lacrosse players. 19th century. (Private Collection.)

A Thomas platter decorated with border of beavers and maple leaves. Center scene shows the port of Quebec as seen from the citadel. Thomas's ceramics are in brown and, rarely, rosy red. 19th century.

This plate, part of the same table service, was made by E. Walley. The pattern was registered in 1856 in England. The words, "Labor omnia vincit," and "Nos institutions, notre langue, nos lois," are visible. (Private Collection.)

rence, the church of Pointe-Lévis, the bridge over the Chaudiere, Montreal, Quebec, are among the best known engravings.

At the end of the 19th and the beginning of the 20th century F. T. Thomas, a local importer (Quebec) put a variety of Scotch (Glasgow) ceramics on the market. Several of these pieces have acquired special interest for the collector, for they are decorated on their borders with beavers, maple leaves, clover, acanthus leaves, while the center de-

picts in brown or in red, scenes or monuments of Quebec identified in French and in English: the Saint-Louis gate, Wolfe's monument, etc.

Around 1860, J. Marshall & Co. launched on the local market a series of plates and bowls with Nordic sports in color or in black only. Scenes of ice-skating on the frozen lake, a game of battledore, of lacrosse—all engravings on ceramic which are now the delight of collectors.

Portneuf

Certain pieces of foreign ceramic may lead to confusion. This seems to be the case with Portneuf, which, for more than half a century, amateurs and collectors attributed to the region of that name near Quebec. Who has not admired on the shelves of dealers or in some museum the dishes, bowls, platters and soup plates with floral decoration of hyacinths, marguerites, thistles, or of unknown flowers? Other articles of the same origin even more in demand are naively decorated with birds or wild animals of the provinces. This grayish or cream-color tableware with blue, red, green motifs is, in fact, a Scotch product which perhaps does not have as much interest to the collector of French-Canadian antiques because of erroneous attribution. To pay twenty-five or fifty dollars for this imported table article is far from getting a bargain.

Plate made by the J. Marshall & Co. pottery works, England. Part of a series on Canadian sports – the skaters. 19th century. (Private Collection.)

Plate illustrating the Saint-Louis Gate, marked F.T. Thomas. Semi-porcelain. 19th century. (Private Collection.)

Blue ceramic plate with historic scene of Quebec, probably derived from illustration by R. Short, published in London in 1761. English make, 19th century. (Private Collection.)

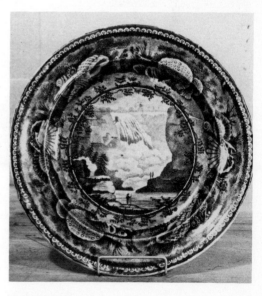

Blue plate decorated with local landscape. Made by Enoch Wood & Co., in England, around 1830. Staffordshire. (Private Collection.)

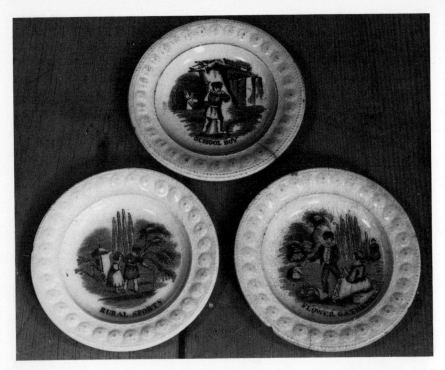

Three saucers in white ceramic, decorated with children's scenes. Used in the convent of the Ursulines of Quebec at end of 19th century. English or Scottish make. (Musée des Ursulines de Québec.)

ly decorative pieces. For example, there are those busts in white stoneware called "Parianware" or those many commemorative plates already mentioned.

Here we must warn the collector against imitations or commemorative ceramics which flourished in all historic sites, tourist areas and resorts, American or Canadian, at the beginning of the 20th century. An exposition, any great event, never failed to arouse certain industrialists to exploit this vein. A good way to tell the age of this kind of piece would be to examine the trademark carefully.

Until 1890 ceramics, table service, or bibelots were marked only by the trademark of the manufacturer or the importer. But, at the end of the 19th century, the U.S.A., wishing to safeguard its own industry, then in full expansion, took measures to protect it commercially, and to do this, placed high tariffs on articles made abroad. From this date every article had to bear the mark "made in" to distinguish its place of origin.

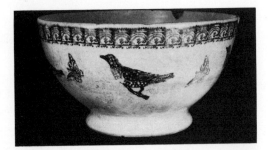

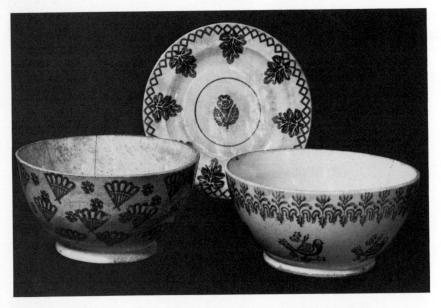

Three Portneuf pieces. Portneuf does not necessarily signify the origin, since all ceramic pieces decorated with flowers, birds, or other motifs were manufactured in Scotland and England. Many pieces are found in antique shops and most collections of French Canadiana; the value of such imported objects as examples of French-Canadian objects is much overrated.

Two Portneuf bowls. 19th century. (Private Collection.)

Several Methods of Dating Imported Pieces

England was to provide Canada with ceramics throughout all of the 19th century, not only utilitarian articles but also some uniquely

If an antique dealer tries to offer you a piece of white enameled or cracked ceramic which he claims is a hundred years old, look at the trademark. If it says "Made in England" you can be sure that the article in question was bought from the maker more recently than

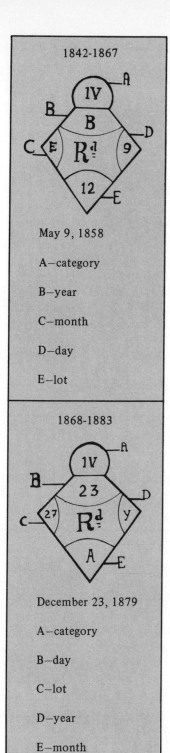

1842-1867

May 9, 1858

A—category

B—year

C—month

D—day

E—lot

1868-1883

December 23, 1879

A—category

B—day

C—lot

D—year

E—month

CODE 1842-1867
YEAR

1842—X	1846—I	1850—V	1854—J	1858—B	1862—O	1865—W
1843—H	1847—F	1851—P	1855—E	1859—M	1863—G	1866—Q
1844—C	1848—U	1852—D	1856—L	1860—Z	1864—N	1867—T
1845—A	1849—S	1853—Y	1857—K	1861—R		

MONTH

January—C	March—W	May—E	July—I	September—D	November—K
February—G	April—H	June—M	August—R	October—B	December—A

CODE 1868-1883
YEAR

1868—X	1871—A	1874—U	1876—V	1878—D	1880—J	1882—L
1869—H	1872—I	1875—S	1877—P	1879—Y	1881—E	1883—K
1870—C	1873—F					

MONTH

January—C	July—I	March—W	May—E	September—D	November—K
February—G	August—R	April—H	June—M	October—B	December—A

you have been told. Certain specialists even manage to crack the surface cracks, which then take on tones of brown, giving the pottery an old appearance. Even in this area one must be suspicious of a fake.

Another good means of checking on dates of any English import in the second half of the 19th century is to puzzle out the diamond-shaped trademark which is found on the endorsement of certain pieces, the center of which bears the mark Rd ("Registered"). That is the English trademark that allows you to date your pottery article almost to the day. Nevertheless, the registration date of a model does not necessarily correspond to the date of manufacture.

There were periods in which this system was used; the first from 1842 to 1867, and the second from 1868 to 1883. In the first, the year is indicated in facet B by a letter corresponding to a precise year, the class in A is always IV in Roman numeral (IV is symbol of all ceramic work), the month, in C, corresponding to a letter, the day in D, and the lot in E.

In the particular diagram we are using as an example, if we try to decipher it, we read: May 9, 1858, lot 12.

After 1867 there was a slight change in the distribution of the facets. Facet A always designates the pottery group, ceramic; but in B, the day is in Arabic numerals, the lot in C, the year in D, and the month in E.

For example, in referring to this picture, we read in the lozenge: December 23, 1879.

We can also certify the age of a piece by verifying the marks of the kiln. In fact, in times past ceramic articles were fired on stilts with three paws, themselves ending in three claws. If we look carefully at the underpart of certain pieces, we should notice those three triangular marks, each one having three little points.

Those, in a few words, are the principal facts concerning the ceramics used in Quebec in the course of past generations. But this is not all. We have not mentioned American, French, Dutch imports. . . . Moreover this is not an exhaustive treatise. To know more about the subject and to appreciate better all the imported terra-cotta pieces one must read the excellent study by Elisabeth Collard.[1]

1. Collard, Elisabeth, *Nineteenth Century Pottery and Porcelain in Canada*, Montreal, McGill University Press, 1967 441 pp.

CHAPTER 8

Glass

Written and archeological documents remain the foundations on which the researcher and historian can write a thesis; the archeological approach remains the sole open means in what has become one of the most important chapters of the history of craftsman's art and industrial manufacture in 19th-century Canada.

To justify my reasons for insisting on the archeological approach, allow me to point out that until now no published catalogue on Canadian glass has ever been brought to my attention for the period from 1825 to 1885, and only works for the period 1885 to 1925 have been discovered; several of the latter are without illustrations.

The archeological approach thus uses the acceptable academic method to identify the specific forms and motifs used by various glass manufacturers.

GERALD STEVENS
(Canadian Glass, c. 1825-1925)

For its myriad of shapes and colors, the delicate beauty of its transparency, for the way it catches and reflects light, and finally because of its unlimited decorative qualities, glass is a paramountly captivating substance and the most collected in all the world, especially in the United States.

All these characteristics were perceived long before our generation; one has only to visit the antique shops to see the endless number of ornamental objects or articles of current usage that, from time immemorial, man has known how to materialize out of silica, carbonates, and oxides.

For centuries men have made things which even today have a place in both kitchen and drawing room to enhance the wood of a table or brighten a window. Glass combines the useful with the pleasing: candlesticks, lamps, table services, are daily demonstration of this quality.

Because very old glass is so fragile, evidence of ancient techniques has become extremely rare, but copies abound, especially of pieces from the 15th to the 18th centuries. It is extremely difficult to determine what is a copy and what an authentic piece unless one is an expert. Even then, if the forger has used ancient techniques and the colorings of another age, it is almost impossible to detect the fraud.

In Quebec and in Anglo-Canada, the copying of beautiful pieces is rather uncommon, which is not the case in the U.S.A., especially with regard to old bottles. That is perhaps because the craze for glass is still in its infancy with us and the real lovers of early French Canadiana are few and far between.

Types of Glass According to the Materials Used

Glass may be classified in three categories: glass with a base of sodium and lime, glass called "lead", and glass with a modified sodium and lime base.

Glass with a base of sodium and lime seems to be the oldest in use for, in the glass cases of major European and American museums, we can admire pieces that go back to the Middle Ages. It is also called bottle glass and can be recognized by its greenish color shading into brown, its dull resonance, and its surprising lightness; and finally by the many impurities that appear in the body of the glass like so many spots or bubbles.

Lead-flint glass, attributed to 16th century Italy, is distinguished from the preceding glass by its clear and ringing sound when it is struck, which is without doubt the best way to test glass. One can even play a musical tune on pieces of different sonority. Flint glass is brilliant and clear and it reflects light almost perfectly; however, it does not weigh as much as sodium-lime glass made in the ancient way.

The third type is not so venerable, being at the most only one hundred years old. In fact, this modification of the old soda-lime

"Carnival" glass fruit dish in blue. American-made carnival glass articles, in many different colors, resemble the fluid shapes formed when oil goes into water. This piece is decorated with orange trees; fruit trees and animals were the usual subjects. Extremely popular in Quebec during the early 20th century. (Jean Legros, Quebec.)

Boat-shaped celery bowl. "Corinthian" motif, so-called because of its four-pointed base and its acanthus leaves reminiscent of Corinthian columns. Early 20th century. Dominion Glass. (Jean Legros, Quebec.)

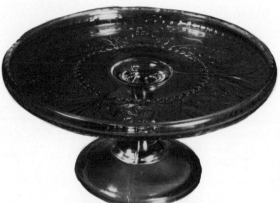

Cake plate with flowers and fruits (see detail). Made in the Maritime Provinces. Late 19th century. (Jean Legros, Quebec.)

Detail of cake plate at left.

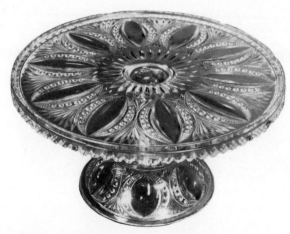

Cake plate ornamented with oval motifs and fans. Dominion Glass Co., Montreal. Early 20th century. (Jean Legros, Quebec.)

and silicon paste mixture is attributed to a Leighton of Virginia. This glass has neither the resonance of the old soda-lime nor of the one with a lead base. The sound is dull. The brightness of the metal is more obvious than in old glass, but less than in lead glass; the sheen of the lead-based glass was principally inside, whereas in the new soda-lime glass style, the luster is on the surface. Articles of this last type are usually lighter than those with a lead base.

The small amount of glass produced in Quebec before 1910 was a rudimentary composition of the first type. It is possible, however, that the second process may also have had its experts at the start of the local glass industry in the middle of the 19th century, especially in carefully finished table articles. By the 20th century (c. 1910), the third technique was in use everywhere.

An Historic Perspective on the Process of Glassmaking

There has been over the centuries little change in the methods of glassmaking, particularly until the beginning of the 20th century. The glassblower still uses the same tools, the same methods as the artisan-glass-makers of the past. The various operations are performed by a crew of men, starting with the "gatherer," who skims off the required amount of melted glass paste with

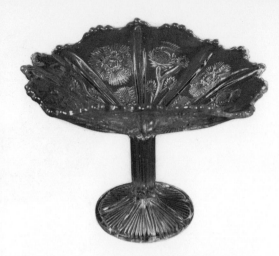

Fruit plate with motif of thistles (see detail). Attributed to Dominion Glass. Early 20th century. (Jean Legros, Quebec.)

Detail of above.

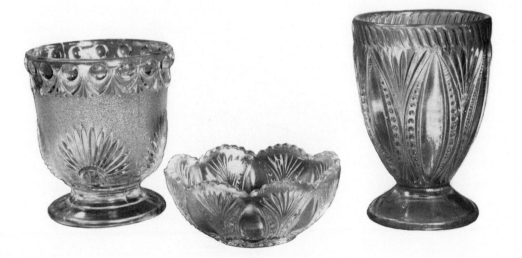

Bonbon dish and spoon holders ornamented with ovals and fans. Jefferson Glass Co., catalogue No. 21, Art: No. 208. Early 20th century. (Jean-Marie Dussault, Deschambault.)

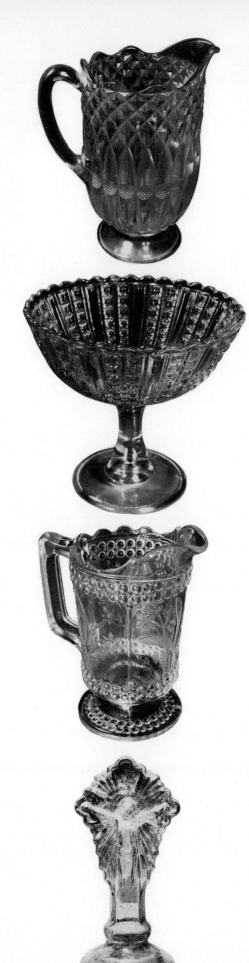

Clear-glass water pitcher, ornamented with butterfly nodes in a four-part mold. In both the catalogue of Jefferson Glass Co. (No. 204) and Dominion Glass (p. 176). 20th century. (Jean Legros, Quebec.)

Compote of clear pressed glass, made in two sections: base is plain, whereas bowl is decorated with raised bands and diamond points. Made in Maritime Provinces. Early 20th century. (Jean Legros, Quebec.)

Clear-glass water pitcher, with motifs of flowers and fruits. Made in the Maritime Provinces. Late 19th century. (Jean Legros, Quebec.)

Christ in blown glass, probably shot with mercury. Montreal. Early 19th century. (Jean-Marie Dussault, Deschambault.)

the tip of an iron blowpipe, which is a tube four feet long and an inch in diameter. The gatherer then hands over the rod and the blob of melted glass to the master blower who will give it the final form. Various kinds of tongs are used to help the craftsman shape the piece he wants from the melting mass of glass.

In the 19th century, several articles, bottles for example, were blown in earthen, wood or cast-iron molds composed of two parts. The workman blew the parison (the ball of molten glass held by an assistant) until the future bottle has filled the mold; he then cut the glass from the blowpipe and unmolded it. The bottom was reheated and a pontil (a kind of iron rod attached by a little glass or powder) was applied to it to hold the piece during subsequent operations. When the shaping was done, the pontil was withdrawn, but it always left a mark on the bottom of the bottle which the workmen often tried to buff off. The piece was then put in a compartmented oven and the heat lowered. This operation went on for between one day and one week, depending upon the thickness of the article and the use to be made of it. These operations were important, for on them depended the strength and solidity of the piece. Even in our day, this process is used in large factories.

The process of flowing tends to round and soften all the contours of the glass piece. Its edges will be clean and round. Close examination of a piece of blown glass in daylight will reveal very fine lines, like hairs, all over the surface. The mark of the pontil is also another clue. However, the fact that a piece is of blown glass is not a reliable test of its age, for, even today, more than one American or European craftsman uses this process to produce a thousand and one useful and decorative articles.

A piece is said to have been hand-blown when the craftsman, after having placed the parison in a mold, shapes it by blowing it.

The molds are in one, two, or three parts, and the piece can be made in sections, according to this process. The sections are then assembled with the aid of the blower's traditional tools. A molding or pressing piston might be used in this method of treating glass.

Molded glass has an appearance halfway between that of pressed glass and blown glass. This is not too good a test of time. It seems that this technique was preferred by the craftsmen who worked in local industries

Lampion or lantern in colored glass (blue, red) made in Montreal. Late 19th century. (Musée des Ursulines, Quebec.)

Cream pitcher in opaline glass ornamented with flowers and embossed. Scrolled base. Hexagonal cover. Burlington Glass Works. 19th century. (Jean Legros, Quebec.)

Clear glass spoon holder, with motifs of pearls and petals. Attributed to Diamond Flint Glass Co. and to Dominion Glass Co. Early 20th century. (Jean Legros, Quebec.)

during the second half of the 19th century. Here again, the process was not new, for archeological excavations in Greece and in Egypt have turned up more than one sample of glass made by this method. A good way to identify mold-blown glass is to examine the exterior motifs which will be hollow on the inside or vice versa. The ridges of the patterns are not sharp, but rounded, and we find few fine streaks in articles of this kind, as in blown glass. Finally, it should be noted that any object of free-blown glass will not have a uniform thickness.

The third major process is pressed glass. This discovery must be attributed to a Bostonian by the name of Jarves, who produced and popularized the new technique around 1827. The whole piece is poured into a mold in which shape and motifs are clearly defined. The mold offers more solidity than in the technique of mold-blown glass, because the warm paste, poured out, is then compressed by a piston. The viscosity of the melting material, difficult to work, explains why the molds must be very strong.

A piece of glass made by this technique can be rather easily authenticated, for the paste will leave seams at the joints of the mold; the articles are in addition heavy and thick, and the edges of the pressed patterns are sharp. Moreover, the external motif does not appear on the inside of the object, as happens with articles blown in a mold. Until 1910, articles pressed by hand had a lead-glass base or one of soda-lime in the old style

of making French-Canadian glass, whereas after the 1914-18 war, glass made of improved soda and lime was in general use.

How to Estimate the Value of a Piece

To detect the article of value, the amateur must proceed in a very special manner. One way to tell old glass from a recent piece is to examine the specimen by daylight rather than under electric light. However, just as with furniture, there is, quite frankly, no infallible technique for evaluating the age and the quality of a piece. Only experience, study, and the frequent handling of well-marked articles will, with time, be of great help in judging what merchants offer you.

A first glance allows for observation of the shape of the piece, its ability to reflect light, its translucence, its color, and its style, for, depending upon the era and the manufacturers, the shapes and decoration of these pieces will vary. Next, the piece must be handled to get an idea of the weight and the resonance, in order to identify the type of material used. Even the amateur, with only slight competence, will then know whether he is looking at glass with a lead base or one of soda or lime in the old style or modern. These criteria will permit him to date the piece, if he proceeds by deduction and elimination. In addition, he must decide

"Derby" hat, boot, and shoe used as toothpick and pin holders, ornamented with daisies. Probably of American make. Glass articles were imported to Canada from the end of the 19th century to the beginning of the 20th. (Jean Legros, Quebec.)

whether the luster of the glass is on the interior or on the surface, as in modified soda-lime glass.

Finally, a thorough examination of the article will help discover the process employed, and the marks that time and usage have left on it.

For the collector of French-Canadian antiques, the choice of patterns and decorative motifs is still unlimited, especially in pressed glass. Table services comprising butter dishes, sugar bowls, glasses . . . all were lavishly decorated at the end of the Victorian period. Bull's eyes, the daisy, the maple leaf, bunches of grapes, reeding, the four-leaf clover, interlaced rings, and the Canadian beaver are a few of the principal motifs that are often combined with the general ensemble of geometric lines.

In the Province of Quebec, enameling and painting on glass were not very popular in the 1880's, but the coloring of the pieces was always elegant and achieved with more or less success in local factories.

Satin or milk glasses, opaque in both cases, are more recent and are listed in the output of the end of the 19th century. It was not until the beginning of World War I that any enterprises produced cut glass of quality. However, it seems likely the St. Lawrence Glass Company was able to produce some after 1867.

Collectors of glass generally specialize in one color or one type of object such as the drinking glass, in the products of one factory, or in articles with similar patterns. A little of everything will be found in local antique shops from purely French-Canadian specimens to European importations as well as articles of Anglo-Canadian and American make.

French-Canadian Production: The Seigneurie de Vaudreuil

In the days of New France, pioneers apparently depended upon the motherland to provide them with glass, although glass had been more or less used in the 17th and 18th centuries. Windowpanes were imported, but table service and decorative objects were made from local terra-cotta or supplied by itinerant pewters, and, more rarely, by silversmiths. We must hasten to add that historical researches in this field have been far from satisfying, and that the future may hold many surprises, though the immigration laws of the colonists do not mention glassmakers.

So far, the first glass factory known to Quebec was that belonging to the Seigneurie de Vaudreuil at Como, several miles to the west of Montreal. In fact, around 1845, the Ottawa Glass Works, property of a man by the name of Desjardins, made small panes of glass, sea-green in color, and bottles of various sizes. Toward 1850, administrative difficulties obliged the owners to sell their

147

property, and the new shareholders renamed it the British-American Glass Co. For ten years, a great variety of bottles and glass containers of various shapes and sizes poured out of this factory. Then, the trained manpower and the deposits of silica at ground level quickly attracted other industrialists interested in producing glass several miles from there, at Hudson.

Montreal Glass Company

Toward 1866, new financiers were to exploit the natural wealth of this area, and for several years glass kerosene lamps, bottles, and telegraph insulation were blown in a mold or simply pressed manually in the factory known by the name of Montreal Glass Works Company. The lamps were blown in a mold; an awkwardly coiled handle was welded to the reservoir, and the latter was decorated with vertical flutings rising from a horizontal line encircling the curved base of the piece. The glass was either clear or of different light colors. It should be remarked that this type of lamp was copied by several other French-Canadian manufacturers but, following the technique of blowing in a mold, only the Burlington Glass Works Company, a society from Ontario, was to manufacture copies of it, with fewer vertical flutings.

Canada Glass Works

Again administrative difficulties—which seem to be the lot of industrialists interested in investing in this kind of economic activity—led to the sale of factories to a new group of businessmen who continued to work in Hudson, but under a new trade name: the Canada Glass Works Company. Bottles for pharmacists, telegraph insulators, accessories for kerosene lamps were still the main part of their production. Several specimens from this factory have been authenticated, among them a small, portable oil lamp.

John C. Spence

This Montrealer from the Rue Notre-Dame is considered by experts to be the very first

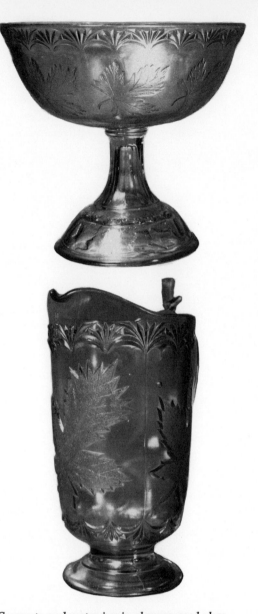

Compote and water jug in clear pressed glass, ornamented with maple leaves. Dominion Glass Co. Early 20th century. (Jean Legros, Quebec.)

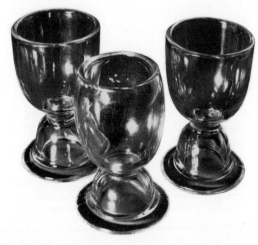

Clear glass eggcups made by Dominion Glass. Montreal. Early 20th century. (Jean Legros, Quebec.)

manufacturer to color and even paint and enamel glass in Quebec and other parts of Canada. According to an announcement that appeared in the "Canada Directory" from 1857-58, it appears that Spence specialized in church, hotel, and restaurant stained glass, railroad lanterns, colored glass articles for display in stores or in pharmacies, and cut glass. It seems that this factory, which came into being around 1855 and was to continue its production until the Confederation under the name of Canada Stained Glass & Ornamental Glass Works, was under the direction of a genuine master-glassmaker and produced numerous creations in its ateliers from simple lamp chimneys to pictorial stained glass. The soda-lime mixture or lead glass was the basic material used.

Among the principal pieces attributed to this craftsman we mention in particular the little votive lights used in our churches or on Christmas trees; these are tiny, colored jars hung on a metal tripod; deep blues, olive greens, amber yellows give these articles an unusual charm, which is greatly appreciated by true collectors.

Foster Bros. Glass Works of St. John

As early as 1857-58, the "Canada Directory" mentions a glass works at St. John. It is, of course, the factory of the two Foster brothers, Charles and Henry, who had also seen investment opportunity in Quebec. Emigrating from the U.S.A. they set up shop in 1855 and, until 1880, experienced glassblowers from New Jersey and Vaudreuil produced numerous kinds of containers, tableware, and electric insulators.

The most representative and the most easily identifiable pieces are those gourd-shaped bottles engraved in relief with the name of the firm, "Foster Brothers, St. John C. E." These specimens of glass, blown in a two-section mold held together by a hasp, are particularly heavy and massive, and their greenish-blue color makes them attractive collection pieces. It is believed that demijohns came from these workshops.

There are still many drinking glasses on clear glass stems to be found around St. Jean d'Iberville, glasses that can only be attributed to this manufacturer. The absence of lead in the material is the best criterion of authenticity. In addition, one notices on the stem

Clear drinking glasses, made in Quebec. Ornamented with portraits of historic personages. Tercentenary of Quebec. 1908. (A. Conrad Poulin, Quebec.)

Two clear glass salt cellars with twisted rose motif and pewter lid. Dominion Glass Co. Found in most French-Canadian homes at beginning of 20th century. (Jean Legros, Quebec.)

Salt cellars and pepper shaker in opaline glass, ornamented with a band around the middle and embossed with vertical grooves. Probably from the Burlington Glass Works. (Jean Legros, Quebec.)

Opaline sugar bowl and cream pitcher ornamented at the corners and on the cover with stylized acanthus leaves and hand painted in gilt. Ontario make, probably from the Burlington Glass Works Co. Popular in Quebec at end of 19th century and first quarter of 20th. (Jean Legros, Quebec.)

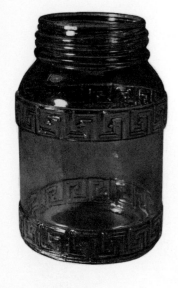

One-pint preserve jar, in clear glass pressed in a mold in three pieces. Burlington Glass Works, 1875-1909. (Jean Legros, Quebec.)

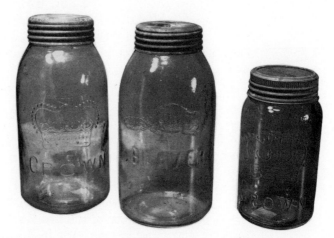

"Beaver Crown" jars, made since 1860 and continued by Dominion Glass at the beginning of the 20th century. (Jean Legros, Quebec.)

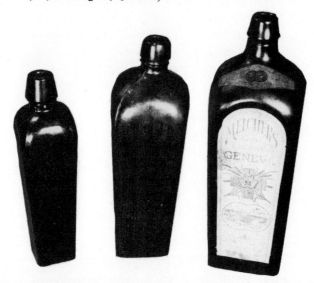

Three square bottles or "four shoulders." Forty-ounce square bottle was made by Dominion Glass at beginning of 20th century. Twenty-six and 10-ounce bottles were blown in a wooden mold. The characteristic roughnesses of the surface are easily detected. (Jean Legros, Quebec.)

a graceful, circular curve. Some have been delicately wheel-engraved with monograms, because, according to publicity notices of that day, glassware, commemorating a marriage or a social event, was the specialty of the Foster factory.

St. Lawrence Glass Co.

An important date in the history of Canada and also in the manufacture of glass in Quebec is 1867. Montreal became a center of production with the St. Lawrence Glass Co., which brought sand imported from Berkshire, Mass. This company produced various articles of clear glass with a lead base: goblets, spoon glasses, butter dishes, sugar bowls, salt and pepper shakers, oil lamps with globe. . . . Most of these articles were blown in a mold or simply pressed mechanically.

All specimens attributed to this manufacturer are doubtful. Several old descriptive catalogues or other documents, as well as archeological study of locales, are also an excellent aid to acquiring a better knowledge of the evolution of glass in Quebec. It may be that a piece discovered in a garret or in grandmother's wardrobe will some day give us more information about this factory; only the future can tell.

Excelsior Glass Co. of Saint-Jean (1878-1880) and of Montreal (1881-1885)

When the Foster brothers ran into administrative difficulties with their glass factory at St. John (Quebec) because of heavy competition from foreign markets—and perhaps also because of the more than dubious quality of the local products—it was the Yuile brothers who kept the works running, first in St. John until 1881, when the factory was moved to Montreal at the corner of rue Mignonne (in 1895 de Montigny) and rue Parthenois. This establishment changed names several times until, in 1913, a series of Canadian factories from Montreal, Toronto, Hamilton, and Wallaceburg joined together to form the Dominion Glass Co.

The pieces of Excelsior glass that were authenticated are not numerous but some may be of great interest to the amateur collector.

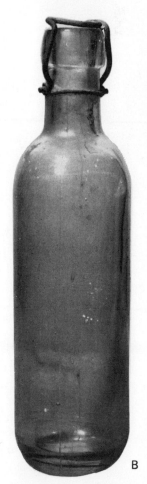

(A) Flagon from Dominion Glass. Early 20th century; (B) Soft drink bottle of Canadian make, bright blue color. Late 19th century. (Jean-Marie Dussault, Deschambault.)

There is, first, the stem glass with the beaver and maple leaf motif. This is glass blown in a mold in three sections: the bowl, ovoid in shape, three and a quarter inches high, with a maximum circumference of nine inches at the upper part. The upper half of the bowl depicts six beavers in motion, while the lower section is decorated with three large maple leaves. This work of clear glass is highly prized by collectors of French Canadiana who, as in all other chattel of the culture of the past, are always hunting for handicraft inspired by local characteristics. Certain crystal cups, rarer yet with maple leaves, have *"Saint-Jean-Baptiste, Québec, 24 juin, 1880"* engraved on the base of the foot. Another collector's piece attributed to the Yuile factory is a plain drinking tumbler of clear glass commemorating the Ottawa exposition of 1878; on it one may read the following inscription: ARD Exhibition, 1878.

North American Glass Co. (1885-1892)

A few years after its installation in Montreal, the Excelsior Company of the Yuile brothers became the "North American Glass Co." The only thing known about the production of this glass factory is that they made flagons for pharmacists, and various containers, jars, and bottles for the bottlers of Montreal.

Diamond Glass Co. of Montreal (1892-1903)

It was the Diamond Glass Company that was to continue the work of the aforementioned company on the corner of the rues de Montigny and Parthenois. The only information that has been discovered relates to the transfer of the factory to 179 rue de Lorimier in 1901. Bottles and windowpanes seem to have been the principle products of its manufacture. Here again the researcher will make use of the oral and written documents available to throw a little light on this business.

Dominion Glass Co. (1886-1898)

This 19th century factory, situated at the corner of Papineau and Lafontaine Streets in Montreal, must not be confused with the great Canadian company at the same business address from 1910 on. Because of the paucity

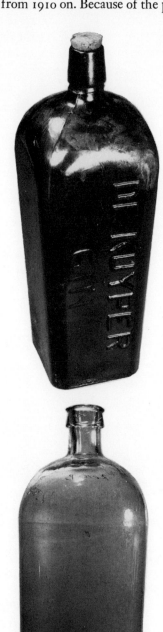

(A) Four-shouldered bottle, made in Montreal. In old bottles, the line of the mold, which can be followed on the body, is not found on the neck, which has been added later. Late 19th century. (Jean Legros, Quebec.); (B) Bright blue bottles, attributed to Como Glass of Quebec. 19th century. (Jean-Marie Dussault, Deschambault.)

of documents relating to this enterprise, we have no further information on this subject.

Diamond Flint Glass Co. of Montreal (1904-1913)

The Diamond Flint Glass Company was the immediate ancestor to Dominion Glass, which was to carry on in Canada in the 20th century. This factory seems to have specialized in bottles of all kinds, hand-pressed electric insulators such as are still found at the top of many poles in the French-Canadian countryside. Some glass paper weights blown in the shape of a ball, with floral motifs, have also been successfully authenticated.

Canadian Production

As in several other fields of business activity, Quebec in the 19th century had to rely on the production of other Canadian provinces to provide glass articles. Ontario and Nova Scotia were the only other provinces in the country to enter the Quebecois market in the last century, as certain discoveries by dealers who concentrated solely on the Quebec province indicate. And those influences are confused by the circulation, in Canada and in the United States, of basic molds among various factories.

The Ontario production of the 19th century can be regrouped around seven great companies:

1825-40: Mallorytown Glass Works, Mallorytown;

1865-95: Hamilton Glass Works, Hamilton;

1875-1909: Burlington Glass Works, Hamilton;

1881-83: Nappanee Glass House, Nappanee;

1894-1900: Toronto Glass Co., Toronto;

1897-1948: Beaver Flint Glass Co., Toronto;

1894-1913: Sydenham Glass Co.

Burlington Glass Works

The Burlington Glass Works was the most important glass factory in Canada in the 19th century. Copious documentation on its production shows that in the last quarter of the past century this factory was one of the most prolific in the variety of forms as well as in the number of works themselves.

The glassmaker-craftsmen used all techniques from simple blowing to hand pressing. And the skill of these men was proved not only by the shapes of the object, but by the knowledgeable and difficult techniques they employed in making the glass and decorating it. The glass was cut, engraved, colored, enameled, sanded, painted. Salt cellars and pepper shakers, butter dishes with molded covers ornamented with geometric motifs, kerosene lamps, bottles, inkstains, and decorative bric-a-brac in amber-green or in clear glass are the essential elements of this factory's astonishing production.

We must also draw attention to a number of articles of opaline, or "opal" glass, very popular with collectors in our day, of which a great many specimens are found in Quebec. The opal glass, commonly called "milk" glass, is translucent and is used especially in lamp shades and in globes. Many whitish molded pieces with decorations of feathers, shells, fleur-de-lis, fans, spirals, made the artisans of that region of Ontario famous.

Multicolor revolver-bottles, toothpick glasses shaped like a high hat or a "western," Easter eggs of opaline glass, blown paperweights, canes, cigar holders, balls, pipes, glass chains, lantern jars . . . these are the most characteristic pieces of Victorian glass knickknacks to come out of these workshops.

Lamps and globes of clear glass were a specialty of this house. Two types of lamps were widely distributed: the one called *Ange gardien* (Guardian Angel) and the one with an ox-eyed daisy motif. The lamp marked "Guardian Angel" is a hand lamp of clear glass, or colored glass, made specially for the house of C. H. Blinks of Montreal. A handle attached to the oil tank and a round globe give it a strange, cumbersome appearance.

In the second type, popularized by this house, the base is ornamented with a motif called "bull's-eye." Because it was so widely sold, it was copied by most glass factories at the beginning of the 20th century.

Hamilton Glass Works

Much later the Hamilton Glass Works Co.

was to launch the production of all kinds of containers blown in a two-section mold. Thick glass bottles of a very deep olive green (taken from heavy natural elements and filled with bubbles and straws) were the main articles of their production. Several of them bear the company's commercial trademark, while others are marked with the name "Pilgrim Bros. & Co., Hamilton." A few pieces molded directly came from those workshops; deep amber-yellow glass canes, blown glass balls used for decoration (or for telling fortunes), paperweights in various shapes fashionable during the Victorian era, and finally, delicate "hats" in amber glass, hats of the derby type that could be used to hold spoons or as table decorations.

Three kerosene lamps, two with bull's-eye motif, and the third a candlestick lamp. Made in Montreal by Dominion Glass. Early 20th century. (Jean-Marie Dussault, Deschambault.)

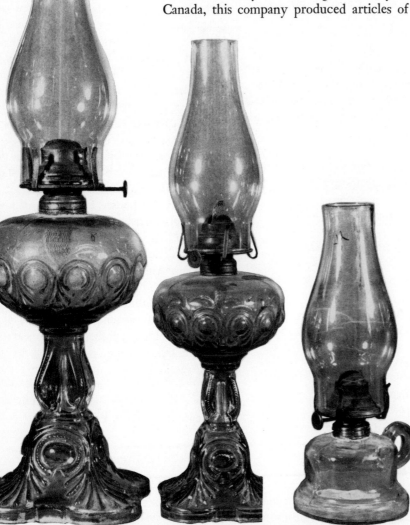

Mallorytown Glass Works Co.

The Mallorytown Glass Works Co. was situated in the area of the Thousand Islands. Considered today the oldest glass factory in Canada, this company produced articles of a light greenish-blue, made of soda and lime in the old-fashioned method. This is evident from the dull ring of the glass when struck with a hard object. This factory's entire production was free-blown without the aid of a mold. Today several authenticated pieces have been preserved as, for instance, the sugarbowl with a round base and a bell-shaped lid. The surface of some of these pieces are superimposed with a motif of flanges, others are embellished with handles on the sides. Bottles and tableware sum up the main production of this Ontarian enterprise.

Nappanee Glass House

John Herring, a businessman of American origin, was interested in, among other things, glass. Windowpanes and glass articles of all kinds were blown or molded by worker-craftsmen the proprietor himself had brought from Europe. Unfortunately, his business never flourished as Herring had anticipated and, finally, in 1883, a fire put an end to his hopes.

The Canadian heritage of the Nappanee Glass House consisted of pharmacy jars of clear glass with pressed covers, molded glass canes, and, lastly, some candlesticks of silvered glass injected with mercury of the kind German and Austrian glassblowers make. This last article was a great favorite with collectors. These pieces are ten and a half inches high. The base and the foot are ornamented with an inner layer of mercury whereas the socket that holds the candle is of clear glass.

Toronto Glass Co.

At first specializing in bottles of a light blue verging on green, the Toronto Glass Company added very little to the Canadian glass industry. Clear crystal paperweights engraved Patrick Wickham, a few links of multicolored glass are attributed to them—and that is all.

Sydenham Glass Co. (1894-1913)

The creation of the Sydenham Glass Company was due to the ingenuity and the

tenacity of a ship's captain, J. W. Taylor. Taylor had noticed deposits of quality sand at Wallaceburg. After some hesitant beginnings, the firm met with some success and, in 1913 joined Dominion Glass to become a subsidiary of that great Canadian company.

Among their products in the 19th century, we call attention to some table articles molded with shell motifs and diamond points, oil lamps decorated with an ox-eye motif, bottles, pots . . . Shells in relief on table pieces,

crystal clear or colored, have a round tip; it was only later, as the result of different methods, that sharp and pointed ends were obtained. Geometric figures, hearts, and reeding also embellished several products of this company.

This factory also produced various types of flagons in clear glass which are still almost impossible to find among Canadian production of this kind. Finally, a collection of knickknacks that included hats, crystal balls,

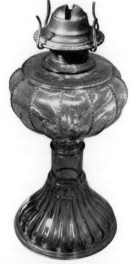

Lamp with bead and petal motif made by Jefferson Glass and Dominion Glass. Late 19th, early 20th centuries. (Jean Legros, Quebec.)

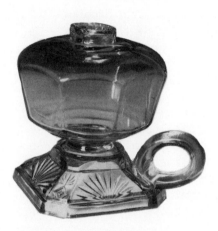

Candlestick lamp in clear glass; base ornamented with a fan or gold-nugget motif. Made in Montreal. Attributed to Dominion Glass (catalogue No. 101). Early 20th century. (Jean Legros, Quebec.)

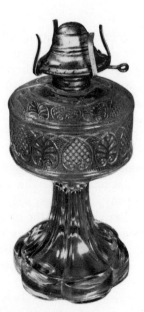

Oil lamp of clear glass decorated with palmettes. Dominion Glass Co., Montreal. 20th century. (Jean Legros, Quebec.)

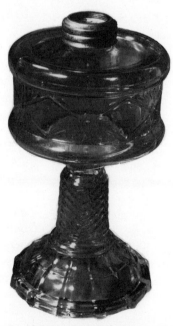

Oil lamp, bowl decorated with diamond and fans; base decorated with embossed stripes. Rare. Burlington Glass. Late 19th century. (Jean Legros, Quebec.)

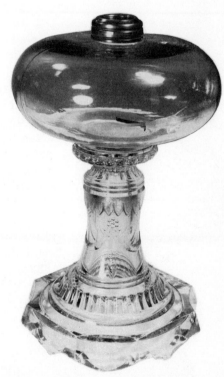

Lamp with drapery motif in clear glass, attributed to Burlington Glass. Bowl blown in a two-section mold; base pressed in a three-piece mold. Rare. Late 19th century. (Jean Legros, Quebec.)

animals, and paperweights, was characteristic of the Sydenham production. For more detailed information about the glass industry, the reader is advised to consult the works of Gerald Stevens, the Canadian specialist on that subject.[1]

Beaver Flint Glass Co.

The Beaver Flint Glass Company of Toronto has not been studied sufficiently to allow us to present, even summarily, the characteristics of its production, a situation that is not unique in the annals of glass in Canada. We shall merely mention some jam pots, decorated with a beaver and a wooden ball, and the term Beaver, as well as some laboratory test tubes and retorts. These are the only authenticated articles attributed to this enterprise. Their sealed jars in particular were widely distributed in Quebec if one can rely on the number of those articles still found today in cellars and garrets.

The Atlantic Provinces

Ontario was not the only province to spread its production of glass among the French-Canadians of the 20th century. There was also the glass industry of Nova Scotia, as certain contemporary discoveries in antique shops demonstrate. It is enough to mention here the Nova Scotia Glass Company of Trenton (1881-1920), which made its entry into the industry at Trenton, N. E., then moved to Moncton, N. B., and finally, the Lamont Glass Works (1890-1902) which, in 1898, went over to the Diamond Glass Company. Table articles and ornamental pieces sum up for the most part the production of those factories.

Some molded plates with the image of Queen Victoria, spoon glasses, derby-type hats, water jugs decorated with vines, butter dishes with bell-shaped covers, plates with checkered design are the most attractive pieces produced by craftsmen from the Atlantic provinces.

The U.S. and the Foreigner

One finds not only Anglo-Canadian or French-Canadian pieces in antique shops, but also numerous articles imported from Europe or the United States. In most cases they are recent specimens which are often mistaken for local antiques. For fuller details consult the bibliography at the back of this book. The more advanced collector who wishes to study the section of imported glass formerly used in Quebec will find it necessary to consult specialized works on this subject.

At the beginning of the 20th century, Canada attempted to be self-sufficient in glassware. Contrary to general opinion, businessmen threw themselves wholeheartedly into this realm of industrial activity, very often to their own peril, foreign competition being very strong. The 20th century marks a turn in the technical and financial fields. Imposing structures helped to develop a home market that became stronger and stronger until gradually it rivaled the imports and captured a clientele interested in products of quality. As for those fly-by-night enterprises that appeared in the 19th century in Quebec, we wonder whether in the end there was anything French-Canadian about them except their company's head office.

Conclusion

For the specialized collector or anyone who wants to know more about glass on a purely technical and bibliographical level, there is an association of Canadian collectors of glass called *Glasfax*, the majority of whose members are English-speaking.

This association is divided into districts, and reunions are held periodically at the home of one of the members.

The organization is financed by the Dominion Glass Company, and since 1967, a bulletin, the "New Letter," keeps the members informed about new publications on glass and also supplies certain information on recent studies on old glass, French-Canadian, Anglo-Canadian, or others.

For further information, write to Glasfax, C. P. 190, Montreal 101, P. Q., Canada.

The coordinator of the organization, Mr. Tom King, will explain the purpose of this association and how to become a member of it.

1. Stevens, Gerald. *Canadian Glass* (c.) 1825-1925. Toronto, The Ryerson Press, 1967.

CHAPTER 9
Lamps and Other Lighting Devices

For the past week our legislators have been working overtime. There are two meetings a day and the last one went on until two o'clock in the morning.
At those long night sessions, there is one inconvenience: there is not enough gas. In the capitol, gas is not like the sun: it does not light everybody. To provide light for Parliament, the Company has to leave the city in darkness.

THE ST. HYACINTH COURIER
(December 14, 1867)

It is undoubtedly annoying to have the electric light go off suddenly during a thunderstorm or a blizzard or even from a short-circuit. One must hunt for a flashlight, which rarely works on such occasions, then grope painfully down to the cellar, and after fumbling around in the dark, change the fuse.

These inconveniences are a thousand times less laborious than the effort our ancestors had to go to just for a little light at night: they had to clean the lamp, put in a wick that had to be trimmed regularly, fill the reservoir, take out the wick and cut it, light it, adjust the flame, wash the glass chimney.

The history of lighting methods is a most fascinating one. And it isn't necessary to go too far back in time to trace its evolution and discover how rudimentary the techniques were barely a century and a half ago.

At the beginning of French colonization, the fire in the hearth of the central room, where the family carried on its activities from rising until bedtime, was the principal source of light, especially during the long winter nights. Light was not as necessary then as it is now, for in those days a work day was based on natural light: sunrise signalled the departure for the fields and darkness put an end to all work outdoors. The hearth of the great stone fireplace gave out enough light to allow people to move about inside the common room of the house.

The Tallow Lamp Copied from Antiquity

The first lamps used in the early days of colonization were the stone or metal oil lamps just like the ones still found today among Eskimos who have not yet been too touched by civilization. A hollowed stone or a round metal dish, filled with animal fat imbedded with a wick, will give a dull, sputtering light.

The "Crow's Beak"

Our ancestors also used very rudimentary tallow lamps such as were found in classic antiquity. They are the "crow's-beak" or multiform "Betty" or cruise lamps—very rare on the Canadian antiques market, for most of them, considered old-fashioned since the appearance of the kerosene lamp or electrification, have been destroyed. One can occasionally find a single specimen in some antique shops, but that is rather unusual. One must beware of copies that are too "new."

These tallow lamps, which are filled with oil or fat, look like little shell-shaped metal dishes with one end tapered to hold a wick. In general, they are strangely like a crow's beak, which explains the name pioneers gave them.

These "crow's beaks," popular up to the middle of the 19th century, had a long curved shaft elongated by a chain attached to a hook, which made it easy to hang or fasten them on the wall. This lamp, fed by animal fat such as lard, is a good source of light. It was used especially in country houses to examine food cooking in the oven or on the hearth, and, unlike the candle, there was no danger that the fat would drip into the dishes.

The crow's beak, with a closed tank, came from the U.S.A. and from English Canada, for it was a style of lighting that was very popular. There are many similarities with the traditional crow's beak, but the dish-tank is divided in two sections and covered

157

with a tight lid to prevent overturning or any other sort of accident. This kind, commonly called the "Betty lamp," was not as generally used as the preceding type.

Bamboo rush-light holder.

Candleholder.

Piston candlestick and oil lamp.

Tinned sheet-metal (tole) candlestick.

Whale Oil Lamps

Whale oil lamps were developed at the same time as lamps that used fat. In fact, the oil of these mammals which were still numerous during the colonial period, lighted more than one ancestral dwelling. East Coast fishermen supplied the market which, in addition, sold seal oil, also not hard to obtain in those days (around 1880).

These lamps are generally of pewter, glass or iron; they are ovoid or round in shape and are mounted on a pedestal or some kind of a base. The metal disk of the burner is pierced by one or two holes through which one or two tubes are inserted. Wicks are then run through the tubes. Two tubes were used to give more light, for it had been observed that bringing two wicks close together resulted in a brighter flame. When the tubes are thin and round, that is a lamp that used whale oil for fuel; when the tube is flat, the oil or the animal fat was the combustible.

As a rule, the burner covered the tapered point of the tank and it was not until 1880 that a lamp-burner appeared which could be screwed to a metal collar. This innovation came from the Englishman, John Miles, who also perfected the burner in such a way that the oil could not leak out of the tank, the air-holes being infinitely tiny.

The float lamp was also a common article in houses of the 18th and 19th centuries, especially in the bedroom. A glass jar, half of which contained water and the other half whale oil, a burner floating on a piece of cork —it was a not uncommon lighting method. The light thus obtained was very bright. The safety of this lamp no doubt explains its success; if one forgot to put it out, once the oil was consumed the flame would die for lack of fuel; in the event of a more serious mishap, water spread with the fuel would lessen the danger of fire.

After Dr. Franklin's discovery that two wicks are better than one and the discovery of a man by the name of Argand, from Geneva, who claimed that a flat wick was more effective and not as dirty as a round one, there was more and more satisfaction

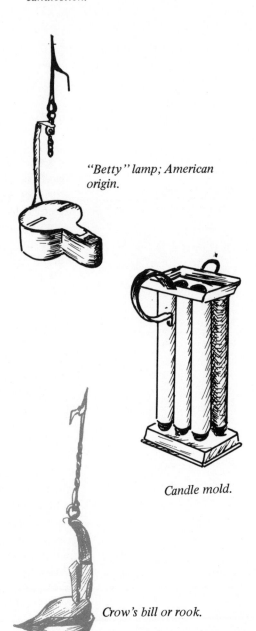

"Betty" lamp; American origin.

Candle mold.

Crow's bill or rook.

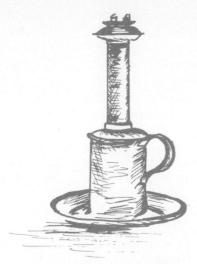

Tallow lamp of tin (tole).

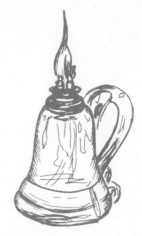

Whale oil hand lamp.

obtained from whale-oil lamps but these principles were far from being in general practice in French Canada at the beginning of the 19th century, which was when they were already being applied elsewhere.

Candle-Making Methods

While the lamp was undergoing a series of improvements, the candle was still in constant use. It was the most widespread manner of lighting among the colonists. This is understandable when it is realized that it was also the cheapest. Borrowed from the Middle Ages, the technique of candle making changed very little throughout the centuries.

In the New World mutton fat or beef fat was used. It was first boiled and strained to eliminate the fibers. This yielded a white, liquid, and opaque tallow. Two ways of making candles were brought from the homeland: the "sausage," much used in Quebec, and molding, used equally as much here, but more in English Canada.

The "sausage" consists in hanging a series of twisted cotton strings knotted on to a stick of wood. These are wicks, which must be plunged two or three times in the hot, clarified fat to be thoroughly soaked until they are stiff. After that, it is only a question of time. Soaking the strings and then letting them cool is a tedious operation. Between each dipping the fat is allowed to harden while the wood bar is stretched between the

backs of two chairs or between two supports of some kind. Finally, when the candle is thick enough to be held firmly without bending, it is untied and put away. This method was much in use, and, until not very long ago, many religious communities continued to make their candles and some tapers by this method.

The second method deserves greater attention, for it required various tools that are much sought after by dealers and amateur collectors: this is the process of molding. Molds come in sets of two, four or six tin tubes tapered toward the base and supported by a foot; the bottom of the tube is perforated by a thin hole, whereas the top is open and rimmed by a thin metal plate to which is added a curved handle. Another and more impressive type of mold is comprised of a series of separate tubes terminating in a rather wide collar; each of the tubes is inserted into a perforated board.

The technique of molding is, however, fairly simple. A wick is slipped through the lower hole in the tube which is closed by a knot. The wick must then be stretched, attached to a small stick laid across the mold, and the hot tallow paste then poured into each section. When the candles are cold, they are unmolded by cutting the lower knot, pouring a little hot water on the mold and shaking it energetically; the candles will then fall one by one onto the table. The wick and the base are quickly cleaned, and the trick is done.

The candle, which is the oldest method of lighting in use, is inconvenient in more than one way. The tallow will soften in the warmth of overheated rooms in winter and

the wax column will bend. And many a time, rodents, managing to get into the cupboard, will feast on them.

The flame may occasionally make little gutters near the part that is burning and cause the melted liquid to run. Carbon, which accumulates near the wick, or even the carbonized wick which refuses to drop, will dim the light and begin to smoke. To clean and keep the candle in condition, the pioneer had a snuffer, a pair of scissors with a little box at the end which snipped off the wick without letting it drop on the furniture or table-cloth.

Not all chandeliers in farmers' houses had six branches! The splendor of such candelabra was reserved for the rich or for the church. The greater part of the time, the simple candlestick with a single light filled domestic needs. The flat candlestick was also part of the lighting equipment in most houses; the oldest style held the candle fast on a metal point, while those dating from the middle of the 18th century have a necked holder or socket.

Candlesticks may be grouped in three categories: the flat and turned candlesticks in domestic use, footed candlesticks, and ceiling chandeliers.

The flat candleholders were the most common. Composed generally of a tube joined to a saucer or to some sort of base, they were made to hold only one candle. They are easily carried by using the handle attached to the saucer or by grasping them by the shank. Some are of metal (copper, iron, pewter), others of wood or glass. Some will have a spring in the tube which pushes the candle up as it is consumed; another type, even rarer, pinches the base of the candle, permitting the flame to burn all the fat without leaving any waste.

The second category includes all the standing candelabras one sees, especially in churches. The finest specimens of this kind are without question those large paschal candles which are seen in church choirs on holy days. Most of them are works of art carved in pine by skillful artisans. Others, smaller, in wood or silver, decorate the altar and are placed on the reredos, and are just as interesting and just as much sought after by collectors. It is almost impossible to date wooden candlesticks or to attribute them to any artist, for documents (except for factory account books) referring to unsigned works are very rare; ornamentation is the only, and often a dubious, criterion by which they can

be dated. The same need not be said of the massive silver pieces that bear the trademark of the artisan-silversmith; the catalogue of French-Canadian hallmarks will help date such works. And finally, there are all the little table candlesticks in wood and even in turned brass which abounded in the 19th century.

The third group includes all the many-branched, hanging chandeliers in wood or metal. They are true works of art and almost impossible to find, though the Quebec museum, among others, owns some fine specimens. Some of them are bleached and gilded while others are painted, especially the most recent ones. Wall brackets can also be included in this group.

Lanterns

We cannot speak of lighting without mentioning lanterns. The seeker will discover several kinds which is an indication of the skill of local tinsmiths. Those best known to the amateur collector are made of tin, and are round, with pierced motifs. Most of the ones found on the market today are copies that have been aged to make them appear older. Others are square, with four windows of the type sailors used on the ship or keepers of dungeons carried on their rounds in prisons, and which the settler used at night on his way to the barn. Much later, in the 19th century, night carriages, and, at the start of the 20th century, bicycles, were provided with elaborately wrought and very decorative metal carbide lanterns.

In contrast to Ontario, Quebec made little use of the candle with a rush wick. This very old method, found in medieval France, consisted of dipping the dried rush in animal fat, letting it harden and placing the whole thing in a kind of standing pliers specially made for this purpose. This device is occasionally offered to the amateurs by antique shops, but one may well be skeptical about its origin and authenticity.

Innovations from 1840 to 1860

After 1840, domestic lighting went through important transformations. The candlestick and the whale-oil lamp were still used, but

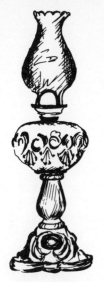

Kerosene lamp.

Tin lantern with perforations.

Bicycle lamp with carbide.

Kerosene lamp for drawing room.

Caleche or carriage lamp.

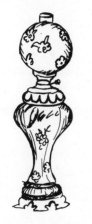

Drawing room "sinumbra" lamp (1840).

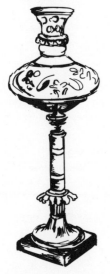

Drawing room "hurricane" lamp.

with the improvement already mentioned; however, their efficiency was not equal to new demands.

Social life was becoming more and more intense, with the arrival of Anglo-Saxon immigrants, economic progress, the steady growth of a local intellectual elite to influence the new way of life. The activities of these people impelled a constant improvement in methods of lighting. People wanted to write, to read, and to get together. The wavering candle flame or weak light of the oil lamp were no longer enough. They knew there were new techniques in Europe and they wanted to make use of them here.

Thus, from 1830 to 1860, until the appearance of the coal-oil lamp, lighting methods were to pass through a series of changes resulting from local inventions and, especially, importations.

The first of those innovations is without doubt the principle of the "astral" lamp, which was inspired by the improvements Argand had made. This lamp is a tubular wick between two vertical tubes, one of which is an open extension of the bottom and the other is connected with the tank in the shape of a ring. Air passing through the central tube creates a brighter flame than whale oil.

To offset the decline of the whale-oil industry, a rather inelegant method of lighting was perfected: the lamp with animal fat took on a new shape, very different from the one known as the crow's beak. All models using this kind of fuel provide a mechanism to reheat the lamp itself, to melt the solid fat to normal temperature. The Maltby and

Neal lamp, and the Kinnear lamp, put on the market around 1850, are good illustrations of this new type of illumination. Later there was an attempt to give this lamp more graceful lines. The "solar" lamp in particular was a success, and a number of them were to be found in drawing rooms the later half of the 19th century.

England brought the "sinumbra" lamp. It is usually a very decorative lamp with a thin, tall base, topped with a globe that was very wide at its base and narrow at the top. This dim light burned whale oil and used Argand's principle, but between 1830 and 1870 it seems to have been used particularly in the English speaking regions of the country and in the province. It is a rather rare collector's item.

Finally, another formula popular in those periods of experimentation and considered an excellent source of light was the "fluid" lamp or "Camphene lamp." This fluid, consisting of part alcohol, part turpentine, unlike other combustibles, was not very safe, for the slightest incident could set off this potential explosive. On June 12, 1846, the Theatre Saint-Louis, in Quebec, at the time crowded with spectators, was destroyed by a fire caused, as was later discovered, by the explosion of a fluid lamp. Fifty persons died in that holocaust.

This lamp looks very much like the traditional whale oil lamp in glass or in metal, with two wicks. In this type, the wick tubes extend outside as much as two inches and in opposite directions: two metal hoods connected with the tubes by a little chain act as extinguishers and prevent the carbide from

161

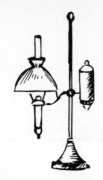

Kerosene student lamp.

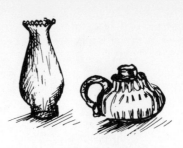

Kerosene hand lamp.

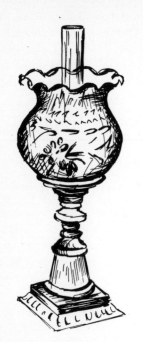

Solar lamp (1840).

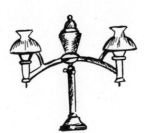

Kerosene desk lamp.

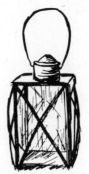

Ship's lantern or settler's lantern.

Kerosene wall lamp.

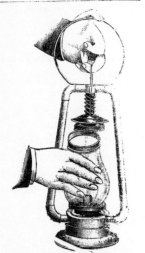

Ad for Ives lamps.

evaporating during the day. This kind of lamp was to persist until the end of the 19th century.

The Kerosene Lamp

Toward 1860, the best known lamps, and now the easiest to find on the antiques market, were to make their appearance. These lighting devices still come to the aid of the modern citizen, who is often victim of long blackouts. It is the good old "petroleum" or kerosene lamp. Only a few decades ago, before the era of rural electrification, country houses were lighted by this means; quite a few people today can remember reading the daily paper or spending a pleasant evening under the light of the flickering white flame of a glass kerosene lamp.

Its origin is obscure. It seems that France, England, and Austria all had a hand in perfecting this appliance, which predated gas and electricity by several years.

Canada had to wait for the 1860's, until the discovery of American kerosene, to make general use of this lamp. At that time, coal oil was obtained in sufficient quantities and was selling on the market at twenty-five cents a gallon. Northwest Pennsylvania and southwest Ontario became the two great supply bases for kerosene. The low cost of upkeep made it a necessary and everyday household article, which undoubtedly explains the great quantity of such lamps displayed among the bric-a-brac in antique shops.

A glass or metal font or reservoir, a burner with a narrow slit to accommodate a flattened wick, a globe—such were the principal parts of this lamp, a sample of which most of us still possess (inherited from our parents or our grandparents) to light the table for an intimate supper or when the electricity fails. There are two main kinds of kerosene lamps: standing or hanging, which in turn can be classified in three groups: the lamp for daily use, the one reserved for the parlor or the bedroom and, finally, desk (or office) lamps.

The everyday lamp was of molded glass or glass blown in a mold or simply of metal. Its make was simple, with decoration reduced to the minimum. This is the one found in multiple examples in practically all antique shops.

The second group includes all lamps on stands and slightly more elaborate, especially the well-known "hurricane" lamps. The two large china or opaline glass balls on a metal base, painted with floral or other motifs, were much in vogue during the Victorian period. In the United States, it is called the "Gone with the Wind" lamp, or even a Parlor Lamp. It was baptized "Gone with the Wind" because of its anachronistic use in the film of that name. The lamp was put on the market

Several types of oil burners appeared during the long period when the oil lamp—more particularly the kerosene lamp—was used. Most of those used in Quebec were American made.

Burner for whale-oil lamps inspired by the Argand invention. Popular in middle of 19th century.

around 1890, whereas the action in the film "Gone with the Wind" was laid around 1865. It was therefore altogether incorrect to use a lamp that had not yet been set before the public. Most of those seen in this country are of American, European, or Chinese make.

In the third group we find all the student or desk lamps, as well as all those that are portable, in various sizes and shapes.

The second large type of coal oil lamps includes all those that were fastened to the wall or hung from the ceiling. The wall lamps were merely standing lamps fitted with reflectors. The hanging lamps were more elaborate. A system of pulleys allowed the owner to lower this wall light or that ceiling light every evening as needed, light the wick, and pull them all up again. These are richly ornamented pieces in thick glass of different colors, highly prized today by shrewd collectors.

At the beginning of its phase of usefulness, the kerosene lamp was imported from the

U.S.A. and it was not until the 1870's that Canadian glass companies began to manufacture them. With the passing of the years, some of them, often extremely simple and very beautiful, have become rare specimens that attract numerous collectors.

The arrival of gas and electricity put an end to the daily use of oil lamps, which then became articles to be stored in the garret. Even during the first half of the 20th century, candles and oil were used to light some country houses. We have seen the evolution of fashions in lighting for three hundred years, from the fire on the hearth to the kerosene lamp. But that is only part of the story. Ship's lights and barn's lanterns, cart lights and carbide beacon lights at the beginning of the century deserve much greater attention. The specialized collector should own Loris Russell's magnificent volume, cited in the bibliography, for a more thorough study of the evolution of that important part of the Canadian heritage.

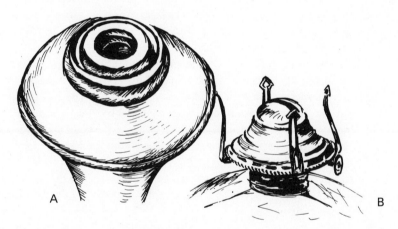

(A) Burner for "solar" lamp, c. 1840; (B) Flat wick "Queen Anne" burner. Made in U.S.A. for kerosene lamp, c. 1890.

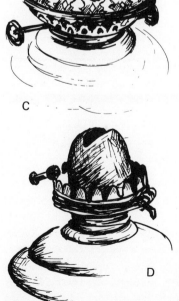

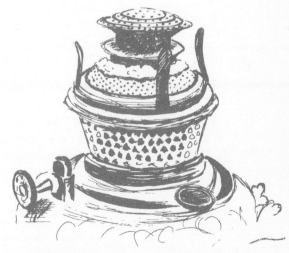

(C) Double burner with flat wick, typical of North American kerosene lamp of 1860-70; (D) Single burner with flat wick; (E) Astral lamp using Argand burners.

Burner with tubular wick from Bradley & Hubbard, an American company. Popular around 1890.

CHAPTER 10

Foundry, Forge, and Tinsmithy

Steeple cocks, ferrules for furniture,
weathervanes . . . were made in French
Canada in the 18th and 19th centuries.
In spite of the inevitable ups and downs,
in imagination as well as in skill, there
comes through that rough and malleable
matter to which the artisan gave his all,
his unpretentious earnestness, his peasant
humor, and an experience and know-how
divided equally between brain and hands.

JEAN-PAUL MORISSETTE

Importance of Base Metals in a Pioneer Society

In a society of pioneers and colonizers, non-precious metal is of prime importance. All sorts of tools, fittings for furniture and doors, weapons—in fact, most of the necessities of the material culture of a human group, require a metal part which is more or less important to retard wear and tear, to consolidate, to strengthen, to shape.

Our ancestors understood this, for, from the moment of their arrival on American soil craftsmen who were specialists in various spheres of activity opened shops to satisfy such demands.

For generations, a range of the most varied objects, from rustic ox yokes to weathervanes, were to come from those numerous local workshops. The foundry where metal was smelted to be made into a multitude of molded articles, generally of cast-iron; the forge where the metal in bars or in sheets took a more decorative or functional form under the strong fist of the smith who beat, stretched, and turned this crude iron in a spiral; the tinshop which controlled the processes of assembling and soldering sheet metal to create those magnificent and very lightweight pieces—these, in short, were the three great handicraft activities which were to produce steadily works of unquestionable charm. They are articles sought by collectors and museums or homeowners who use such creations of another age to give a special character to their contemporary dwellings.

Foundries

The forges of Saint-Maurice, near Trois-Rivières, was to be during the entire French regime—up to the 19th century—the most original experiment in the metallurgical-industrial field. From 1737 to 1883, the natural reserves of iron ore in this region were exploited to make a multitude of objects of daily use not yet completely accounted for.

Pieces of armament, chiefly cannonballs for the French armies in garrison, seem to have been an important part of the production under the administration of the Bourbons, at least if we can trust discoveries made during archeological excavations undertaken by the Minister for Cultural Affairs several years ago.

Iron stoves also were a major product of that enterprise and undoubtedly are one of the most interesting items for the collector. It is known that around 1720-1730, Canadians changed their customary method of heating. In fact, after more than one hundred years of life on American soil, they came to the conclusion that the hearth embedded in the side walls of the rural dwelling (a style copied from the mother-country) did not give enough heat to offset the severity of the Canadian winter. Even when, in cold weather, the family crowded around the fire in the common room, they were roasted on one side and frozen on the other. The greater part of the heat was caught in the immense stone chimney which gave rise to the derisive expressions "heating the weather" or "heating the outdoors," that have become part of the language.

The Evolution of Stoves

With this malfunctional hearth, one could live only when swathed in thick clothes. Early Canadians began replacing the open fire with a fire enclosed by metal, as reference to death inventories dating from

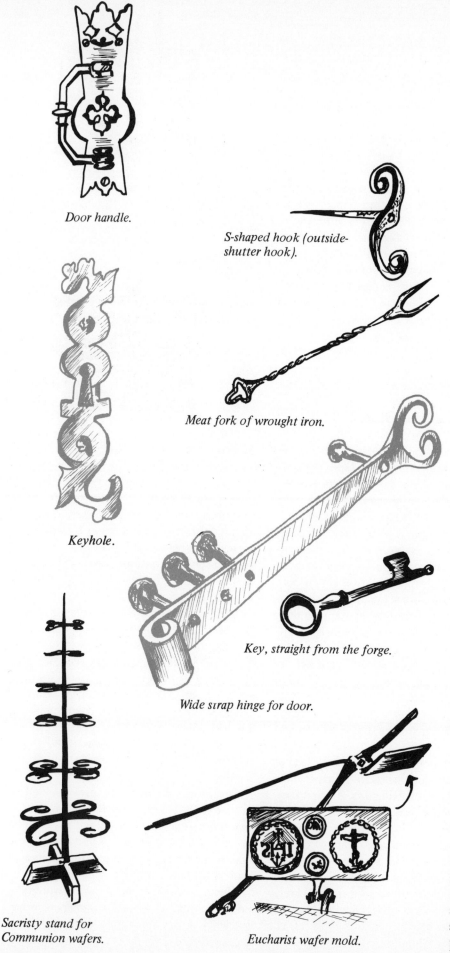

Door handle.

S-shaped hook (outside-shutter hook).

Keyhole.

Meat fork of wrought iron.

Key, straight from the forge.

Wide strap hinge for door.

Sacristy stand for Communion wafers.

Eucharist wafer mold.

the beginning of the 18th century, or possibly from the end of the 17th, show. Those first stoves were brick with a lining and door, either of sheet metal or cast iron, probably of European make. Research tells a great deal about the origins of heating methods. In any case, in the 18th century, no longer did the single flame give forth its calories: the stove, with its pipes winding through various rooms in the house, produced by radiation a comforting warmth.

Toward 1745, the first closed fire boxes, fruit of the ingenuity of the foundry craftsmen of Trois-Rivières, made their appearance on the market. These are "one-deck stoves," simple fire boxes, closed between iron plates lightly decorated and assembled in the shape of a rectangle resting on four lion's paws. "La gracque" (copied from classical Greece)—and a little before the use of that motif, lozenges—often covered the edges; the base is generally initialed FSM, meaning Forges de Saint-Maurice. (There is nothing to keep us from thinking that at the end of the 17th and the beginning of the 18th century some stoves of European make, decorated with palm trees in relief or with the scene of the Samaritan woman at Jacob's well—accompanied by Jesus—may have been in use in Quebec, as some archives state.)

But those plain iron stoves, ornamented with floral or geometric motifs, were to undergo more than one improvement, notably in the 19th century. The simple closed fire box was to be lengthened and a double door would be added to permit the insertion of a dry log of wood. After that, one or two decks were placed above the fire box, ovens that would permit the housekeeper to cook meat and cakes in sufficient quantities to feed the many mouths in the household.

Not only the Forges de Saint-Maurice but a series of varied enterprises of this kind were to produce those two- or three-tiered stoves in the 19th century and the beginning of the 20th. What had been limited to a few enterprises before the troubles of 1837 was to become more and more popular in the preconfederate period; a large number of small foundries (about 65 from 1800 to 1900) cast all kinds of articles, depending upon the needs of the population: imitation was still a factor here, as can be seen. The models of great metallurgic industries served as patterns for country smelters. There is a rather striking example of this in the two-tiered stoves stamped "Le Bijou" whose original pattern, perfected in the shop of an iron

merchant from the Portneuf area, was imitated by other iron merchants from Lotbinière and La Beauce, where only the trademark was altered. These foundries would buy a stove, make a mold from it so nearly identical that when measured each article manufactured in a different place had the same shape and the same ornamentation. Only the dimensions varied by a few milimeters.

Among the important foundries that competed with those of Trois-Rivières, mention must be made of the Batiscan Iron Works (1798-1808), the Radnor Forges of Fermont, from the Cap-de-la-Madeleine, the Fonderie de l'Islet, the Fonderie de la Beauce, and finally, the firm Bélanger from Montmagny. Those are only a few names, undoubtedly among the most important, of the 19th and the 20th centuries. A complete list of these enterprises is still to be made.

Stove with one deck or closed fire box, from the Saint-Maurice forges.

Various Cast-Iron Objects

Canadian artisan-founders also cast a great many articles for daily use. All kinds of cooking pots, kettles, doors for bread ovens were undoubtedly the most common. Those large cook pots of various shapes, so popular with early Canadians, and which today are often used for flower pots, were articles of everyday use several decades ago.

Making soap, maple syrup, dyeing wools, or sizing fabrics were some of the tasks usually done in those three-legged iron pots with handles, a little like those the American Indians made of terra-cotta. Canadian ones, however, were larger. They were set on the hot surface of a closed stove or were hung on the pothook of a hearth. In the forest at maple-sugar time, the farmer fastened them to sticks crossed saw-horse fashion and hung them over a wood fire.

Among cast-iron objects, pressing irons of various weights and sizes are always indispensable articles for collectors. Their three-footed cast-iron stands were decorated with floral motifs in relief and perforated. A handsome pierced handle allowed them to be hung on the wall. It is more than probable that many local casters produced such stands in the second half of the 19th century. Here again, it is possible that some American or Anglo-Canadian pieces, like those of H. R. Ives & Co. of Montreal, may have inspired

Stove with two cast-iron decks.

Canadian artisans, who used some of the iron objects already in circulation to make their molds. A great many pressing-iron stands offered on the antique market today are copies or fakes that can fool more than one amateur collector.

It is the same with bootjacks and door scrapers. These pieces are so popular that the counterfeiter indulges himself to the full. It would be more honest to tell the buyer how old the piece is, but it would sell for so much less. Perhaps you have seen that naked woman lying on the ground, with legs up and spread apart—that cast-iron object, used to pull off boots, is practically impossible to find on today's market, unless it is a copy.

Large cake molds or the molds some bakers used in baking consecrated wafers or *mains de pain* after certain ancient customs, are also the work of casters and deserve special attention, because more than one amateur collector is interested in them.

Quebec foundries also made a variety of odd knickknacks, from iron tongs to ornate garden fixtures, restaurant signs, and standing ash trays with jockey or animal motifs.

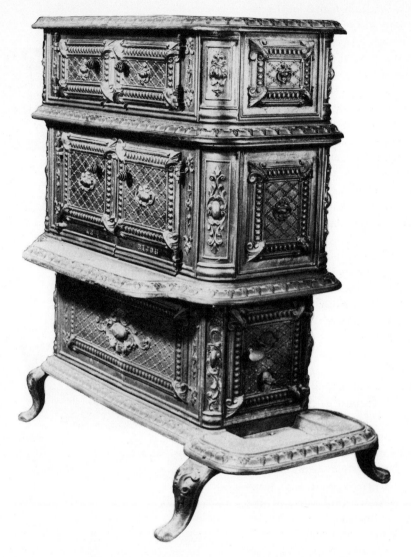

Three-deck iron stove, hallmarked "Le Bijou." Late 19th century. (I.N.C.)

Stand for pressing iron.

Wrought-iron bootjack.

Iron cake mold.

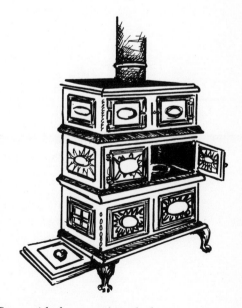

Stove with three cast-iron decks.

And finally, it should be noted that proximity to the U.S.A. and English Canada brought a great many articles made in those places to Quebec. And the farther we advance in the 19th century, the more evident this becomes, as is apparent in many houses furnished in the style of the past century or in the displays in antique shops. Elaborate cast-iron stoves of American make are a good illustration of this phenomenon.

The Smithy —

Wrought Iron, an Art That Endures

Large industrial foundries also produced iron plates, rods, blades, ingots of different shapes

and variable quality which many local artisans fashioned, using all their strength, taste, and great skill. We know from historical records that, from the time the first colonists landed, blacksmiths set up shop and promptly went to work.

The blacksmith's shop with its hearth stirred up by a huge leather bellows which an apprentice kept in motion is a landmark that has disappeared from Canadian villages. When the iron was red hot, tongs, anvil and hammer stretched, turned and thinned down the metal into ingots or bars to make all those handcrafted works that are still admired today.

There is no need to be surprised at the very keen popularity of wrought iron. Spiral-turned drawing room tables, ramps and terrace guard rails with fleur-de-lis motifs are part of the heritage of one of the most ingenious of artisan traditions.

Among the more representative pieces of this industry, keyholes, locks, door knobs, pegs and strap hinges—in fact, all the fittings of a house door or of furniture—clearly show the taste and skill of our ironmasters. Keyholes with dragon or stylized sea horse motifs or in the shape of flames are evidence of a refined art. Massive door handles with heads crowned and ornamented with four-leaf clovers are another indication of the craftsman's skill; the Burger house, at Sainte-Scholastique, is a good illustration.

Rat-tail hinges, banister hinges or bead vase hinges, old barn-door hinges, are pleasant variants of a more or less extinct art. Ancient wardrobes or cupboards of yesterday still retain those earmarks of pleasure in work well done.

Not only the decorative piece but also the useful object came from the blacksmith's shop. In the village, it was the place where almost everything was made: the smith was the repairman for everyone and anything, and to such an extent that after the socio-economical evolution many turned their shops into garages.

Most iron tools, from auger-bit to hammer, through a whole range of pincers, planes and farm tools, were to come out of the blacksmith shop. Indeed, when anyone studies artifacts of past centuries in this field they cannot fail to observe that the old tools are quite rustic and, in most cases, handmade.

Sleigh-runners and skate-blades ending in spiral curves have an elegance and a stately air of the folklore tales they have inspired.

Iron cake mold. Quebec make. 19th century. (Private Collection.)

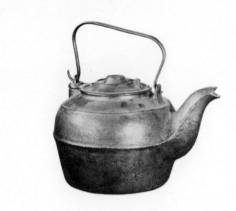

Iron kettle, no marks of any kind; cast in a local foundry. 19th century. (Private Collection.)

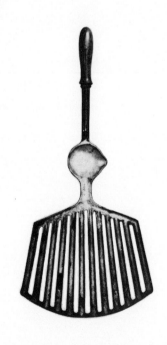

Iron meat grill. Grooves channel the juice into a bowl; sauce is saved for basting the meat. 19th century. (Musée des Ursulines.)

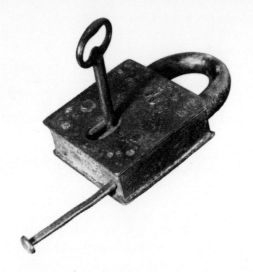

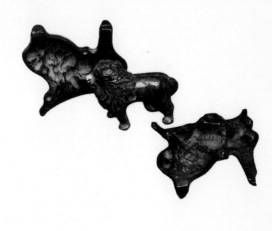

It is the same with the S-brace driven deep into bridging-joints to keep masonry walls from opening, and also the hooks on outside shutters which, to maintain symmetry, follow the same S-shape.

Those old door or window bars, cemetary gratings, and balcony railings with spear or fleur-de-lis motifs in twisted iron do not deserve to end up on a scrap-heap for export to countries lacking in basic materials to keep their minor industries alive. These are magnificent pieces, and it is easy to find a local buyer who will return them to the place of honor that is rightfully theirs.

A deep religious feeling also inspired the ironsmith, as, for that matter, all the other artisans. The most common productions among church works are bell-tower, processional, and cemetery crosses; the center of the cross is sometimes ornamented with a stylized metal crown of thorns, a spear, or a short ladder. The holy-bread *étagère*, like the one in the parish church of Saint-Benôit, county of Deux-Montagnes, with its shelves charmingly voluted, represents another facet of the ironsmith's ingenuity.

The kitchen in ancestral homes also benefited from a number of wrought-iron objects. Grills and small portable stoves (warmers), the chimney-hook, and certain utensils like the big meat fork are well-preserved relics. In sum, a number of useful tools came out of the ironmaster's shop: snuffers, iron candlesticks . . . a wide range of articles that can be found in antique shops and which clearly demonstrate the versatility of this minor art. Wrought-iron nails which are sold in the U.S.A. for twenty-five cents apiece abound on the grounds of old houses that are being torn down: most people tramp over them, knowing nothing of the labor the

craftsmen of yesterday must have expended on them.

Not only are we of today indebted to the ironsmith for his iron objects but we are also indebted to the goldsmith. Several of them, it seems, sometimes turned to working with a baser metal in order to supply the needs of a somewhat less wealthy clientele, judging by the discovery of many pieces of wrought iron stamped with a hallmark, usually kitchen utensils or those hinged molds used in making holy wafers. It is easy to date these articles by referring to the goldsmiths' guide of hallmarks. More than one delicate piece of metal work required the knowledge of such craftsmen. It is almost impossible today to attribute, or even to place in time and space, most of the pieces from ironsmith shops. The works themselves are silent, and the great quantity of specimens of wrought or hammered iron in circulation everywhere throughout the province makes the task even more difficult.

Ironwork articles are collected, of course, for their sentimental value since, when all is said and done, they are representative of another age. But they are also collected for their great beauty and in admiration of the work of those unknown men who put all their might and all their talent into such undertakings.

Tinsmithing

Tinsmithing today is generally associated with roofs of buildings, since most such professionals are slaters or tilers specializing in copper roofings that ornament the tops of

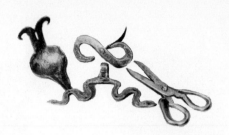

Four pieces of French-Canadian blacksmith work: wire nippers, "S" brace, strap hinge, and scissors.

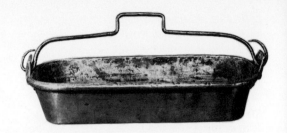

Small copper-leaf fish kettle, probably of Quebec workmanship. 19th century. (Private Collection.)

high buildings, or even in the art of making the broad ventilation pipes (airshafts) of sheet metal, equipment indispensable to any large-scale modern housing.

In times past, the role of this workman was rather different, although tin roofing and attaching gutters was to keep him busy from the 19th century on. The tinsmith of yesterday was a specialist who, aside from working with tin or plain, flat metal, by using his scissors, hammer and his soldering irons, could make practically anything.

And it must not be thought that it was an easy profession, like child's play, cutting up little pieces of cardboard to make a mask or a castle. It is one of the most subtle of arts in which, before they are soldered, the objects are fastened together in such a way that their firmness can withstand any test. The way the workman bends, edges, softens, and hammers is the result of a tradition and of long experience.

For the amateur collector, the most interesting works of this profession are church tower cocks and weathervanes, fruits of an art that vanished at the end of the 19th century. Not so very long ago, the top of the parish church tower or the commemorative chapel, or even now and then the roof over a shrine at the crossroads, was ornamented by a cross surmounted by a sheet-iron cock of one size or another.

All of these pieces are admirably simple. The shape alone seems to have been the major concern of the craftsman-tinsmith who fashioned it. The church-tower cock that dominated the village of Cap-Santé, near Quebec, and which is exhibited in the Museum of that province, is a praiseworthy example of those awkward, plain, unpretentious, but beautiful productions.

A few specimens, however, were to ignore realism so far as to cut off the crest and fiddle with the fanlike feather tail, while leaving the outline of closed wings visible in relief on the body.

Church-tower cocks today are collectors' items, so sought after and so rare that their price is never quoted as less than one hundred dollars and usually much more. Let us point out here that the craze for these native works has put a flea in the ears of fakers who have indulged to their hearts' content in counterfeiting and disguising these tinware articles, which they sell, of course, at the same price the originals would bring.

Some of these church-cocks swerved about and changed position according to the direction of the wind. Their broad tails acted as rudders. But tinsmiths (and sometimes blacksmiths) made genuine weathervanes of sheet iron mounted on a frame on which the four cardinal points were indicated by a letter or a symbol taken from the compass dial. These decorative weathervanes, heavier and sturdier than church-tower cocks, were installed on the turret of the barn, perched high up on the corner of the house or even settled on the top of a clothesline pole. Their toughness was constantly being put to test, for the cock's broad tail was a perfect target for hunters to practice their aim.

In all these specimens one must not look for perfect realism, balance, and harmony. Most of these articles are evidence of the artisan's desire to make something handsome, but experience and the artisan's limited sense of proportion made them naive, awkward compositions, though very representative of the tastes of a people. Their beauty is owed to their simplicity.

Tinsmiths also fabricated those perforated tin lanterns that were used at night out of doors or inside farm buildings. A multitude of small holes allowed the candle to cast its luminous rays on all sides while at the same time they kept the wind from putting out the flame of the wick. Here again, the great

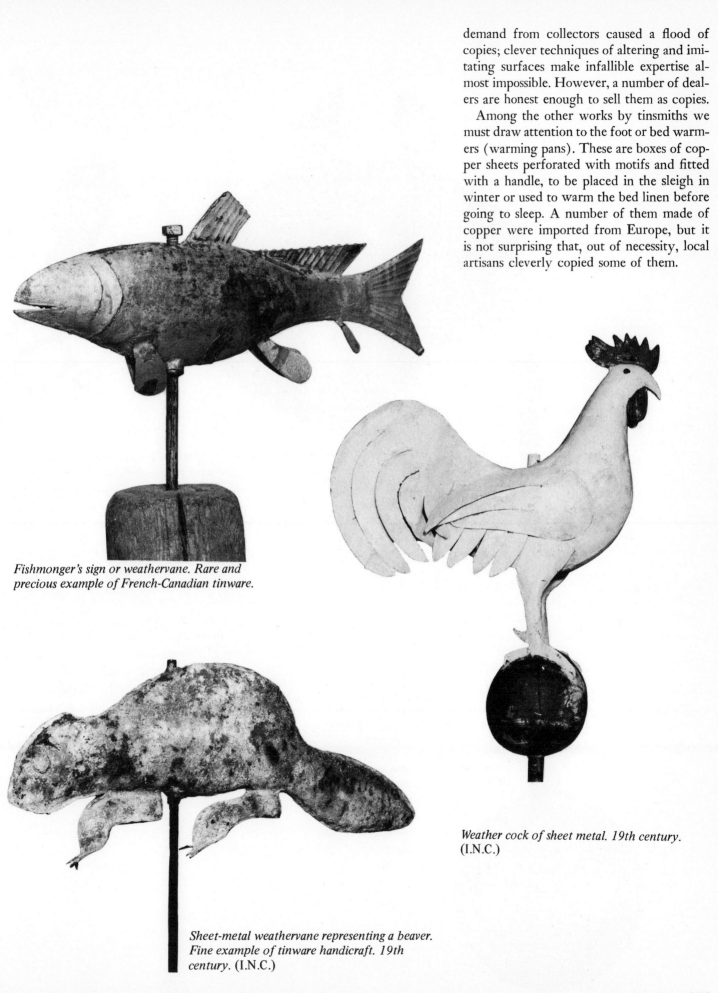

demand from collectors caused a flood of copies; clever techniques of altering and imitating surfaces make infallible expertise almost impossible. However, a number of dealers are honest enough to sell them as copies.

Among the other works by tinsmiths we must draw attention to the foot or bed warmers (warming pans). These are boxes of copper sheets perforated with motifs and fitted with a handle, to be placed in the sleigh in winter or used to warm the bed linen before going to sleep. A number of them made of copper were imported from Europe, but it is not surprising that, out of necessity, local artisans cleverly copied some of them.

Fishmonger's sign or weathervane. Rare and precious example of French-Canadian tinware.

Weather cock of sheet metal. 19th century. (I.N.C.)

Sheet-metal weathervane representing a beaver. Fine example of tinware handicraft. 19th century. (I.N.C.)

171

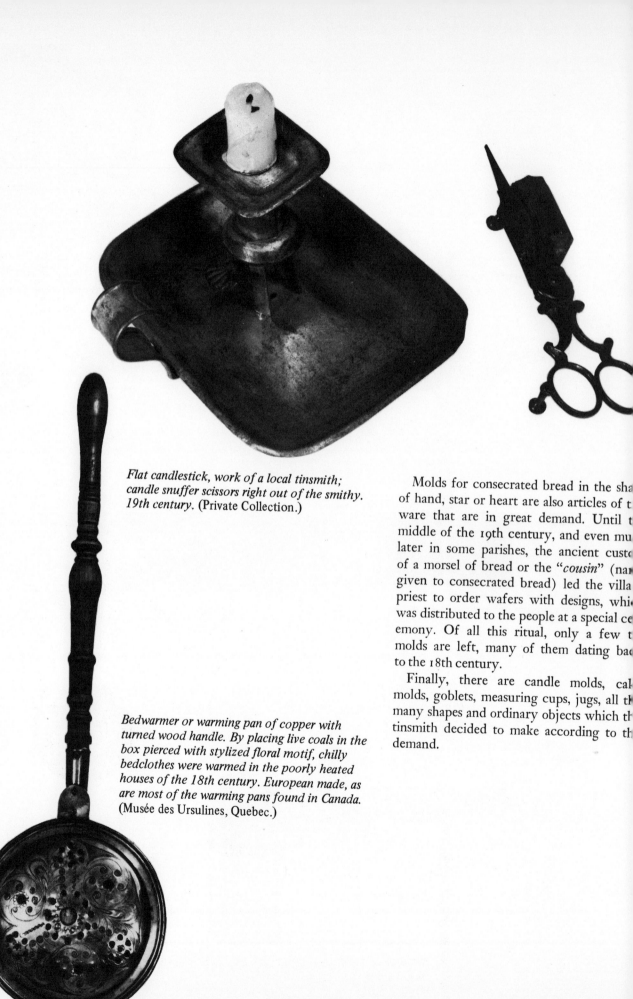

Flat candlestick, work of a local tinsmith; candle snuffer scissors right out of the smithy. 19th century. (Private Collection.)

Bedwarmer or warming pan of copper with turned wood handle. By placing live coals in the box pierced with stylized floral motif, chilly bedclothes were warmed in the poorly heated houses of the 18th century. European made, as are most of the warming pans found in Canada. (Musée des Ursulines, Quebec.)

Molds for consecrated bread in the sha of hand, star or heart are also articles of t ware that are in great demand. Until t middle of the 19th century, and even mu later in some parishes, the ancient custo of a morsel of bread or the "*cousin*" (na given to consecrated bread) led the villa priest to order wafers with designs, whi was distributed to the people at a special ce emony. Of all this ritual, only a few t molds are left, many of them dating ba to the 18th century.

Finally, there are candle molds, ca molds, goblets, measuring cups, jugs, all th many shapes and ordinary objects which th tinsmith decided to make according to th demand.

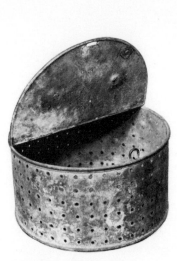

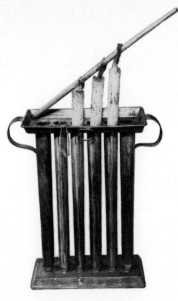

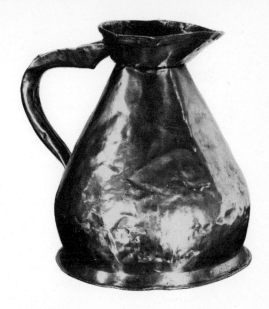

Colander, 19th-century tinware. (Private Collection.)

Sheet-metal candle mold of local make. 18th century. (Private Collection.)

Pot-bellied water pitcher, Quebec. (Private Collection.)

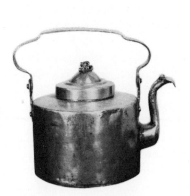

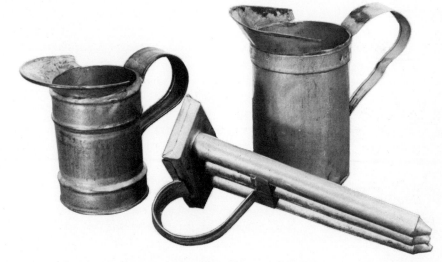

Handmade copper kettle, probably 18th-century Quebec. (Private Collection.)

Measuring cups and sheet-metal candle mold, made in Quebec. 19th century. (Private Collection.)

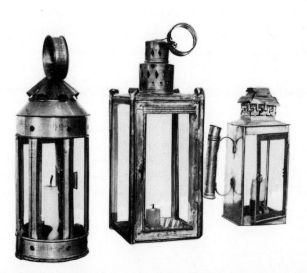

Three sheet-metal lanterns, the work of tinsmiths of the 19th century. (Musée de l'Hôtel-Dieu, Quebec.)

CHAPTER 11
Silver Plate and Pewter

In attempting to explain the value of antique jewelry, we hope to contribute to its conservation. It is through ignorance that many pieces have been sold; the harm is not great when they are acquired by museums or collectors who leave them at the disposal of the public. Unfortunately, this is not always the case.

JEAN TRUDEL, *Curator of Traditional Art, Museum of Quebec*

Every true amateur collector of Canadian antiques owes it to himself to own a piece of local silver plate, for Quebec artisans have really given their best in this genre. One has only to study museum collections or read a few serious books on this subject to develop an admiration for their taste, skill, and originality.

It is relatively easy to authenticate pieces of plate, for each artist had his own die, a trademark which makes it easy for the amateur collector to date the article, whether sacred or secular, and assign it its proper place in his collection. Those silversmiths worked primarily for the Church. Religion had a spiritual need for holy vases in silver: chalices, ciborium, monstrances had necessarily to be made of precious metals. As soon as a vestry was financially well off, censers, procession crosses, sanctuary lamps, candlesticks were made of a noble metal.

But silver was rare. Ingots of this metal were not plentiful in the colony in spite of what Europe believed at that time. French Canadians were to ease the absence of Eldorado by amassing coins. When they had saved up enough hard cash, priest and bourgeois turned their fortunes over to the craftsman who, after he had melted the pieces of precious metal, transformed them into beautiful objects which today are the pride of their owners.

It is possible at present to discover some of these old pieces in any good antique shop,

Various pieces of silver plate for barter made by Quebec silversmiths.

but at high prices, of course, for production was limited.

And here I would be negligent if I did not speak of the local silversmiths who specialized in a most particular form of worldly activity: trading silver or exchanging money with the Indians. Who has not seen in many a glass museum case, or in engravings of Indians, those trinkets in the form of a cross, or brooches worn around the neck or pinned on the chest? These metal plates and other ornaments were exchanged by trappers who gave them to our natives in return for pelts. It was a present greatly appreciated by the peoples of the forest and an excellent way for the white man to win the good will of a tribe. More than one silversmith was to go in for this kind of production. Some even made it the essential part of their output.

In plate as in furniture, decorative details are poor criteria by which to fix the date of a piece. Indeed, some motifs in the French style often reached here after such a long delay that motifs of works which, in Europe, belonged in the 16th century, appeared in Canada in the middle of the 18th century. And somewhat as in all other forms of expression, copying was characteristic of most workers in precious metals. Not that the craftsmen were lacking in inspiration or cre-

Another piece of silver plate.

174

ativity, but the demands of the priest who had seen a certain chalice in the neighboring parish and wanted one like it, had a decisive influence on form and decorative elements. The same thing happened among the middle class buyers, so that there came to be a certain monotony in the work of these professional men, except, of course, in the work of the great masters.

Techniques for Working with Precious Metals

The art of working with precious metals goes back to the farthest antiquity. Archeological excavations in Greece, in Mycenae, have brought to light pieces of rare beauty. This profession, which used gold in the beginning, soon turned to silver, a less rare and less costly metal.

The artisan first prepares the material with the aid of a great variety of tools. By hammering he thins the ingot to the thickness necessary for his work. He must then fashion this plate to obtain the desired form. With hammer and two-beaked anvil (anvil ending in points) he cuts out the pieces to be assembled and shapes the article by soldering the various parts together. Once these two operations are completed, the silversmith sets to decorating his piece: delicate carving, repoussé-work, soldering the molded pieces. Other articles will simply be molded, then chased.

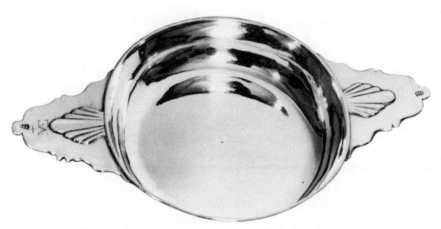

Silver porringer with two handles, stamped with a hallmark: "Varin et Delzenne," Montreal silversmiths of the 18th century. (Séminaire de Québec.)

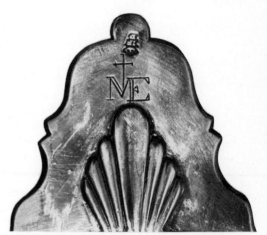

Detail of the Varin and Delzenne porringer. Hallmark is plainly visible above the mark of the Foreign Missions. (Séminaire de Québec.)

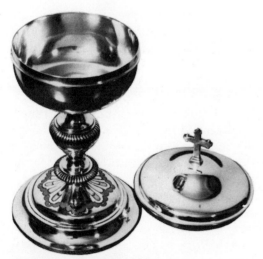

Very plain ciborium in heavy silver, signed Laurent Amyot. (Séminaire de Québec.)

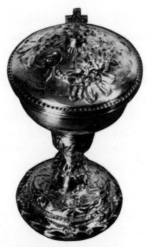

Silver ciborium by Francois Ranvoyzé. (Séminaire de Québec.)

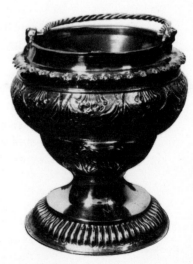

Silver holy water basin by Francois Ranvoyzé. (Séminaire de Québec.)

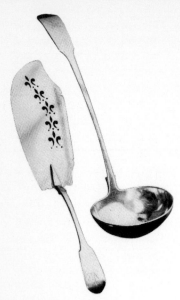

Silver ladle and cake knife with a hallmark of Francois Sasseville.
(Séminaire de Québec.)

How to Estimate the Value of a Piece of Silver

The majority of Quebec silver pieces are signed. The craftsman's hallmark is generally found on each object, but as is the case with English articles, rarely does one find the official stamp or mark of quality of the metal used.

The hallmarks of craftsmen working during the French Regime are initials and purely decorative motifs like stars or flowers. After the Conquest and up until 1880 the style was modified under English influences, which were dominated by austerity of form. The marks became simpler, the maker's initials in a cartouche being sufficient.

Around 1775, a number of silversmiths stamped their work with their monogram and a lion, quite simply to let the purchaser know that the quality of their metal was comparable to the metal used in Great Britain, for English pieces were beginning to overpower the local market.

At the beginning of the 19th century there was a concerted attempt to specify the origin of pieces, and a few more or less official marks appeared: Quebec and Montreal, the two traditional centers of silversmiths shops, had distinctive marks engraved on their silver.

And finally, around 1830, Quebec hallmarks tended to imitate those of Great Britain, with figures of Lion Passant, Lion Guardant, Lion Rampant. Some marks very characteristic of Canada were to make their appearance—as, for instance, the beaver. Several were merely a merchant's business address. Hendery & Leslie in Montreal supplied more than one salesman at the end of the 19th century.

The first step in estimating the value of a piece is to examine thoroughly the hallmark when you are sure of the quality of the metal. Once monogram and designs have been deciphered, you can refer to the guide for Canadian hallmarks by John E. Langdon (see bibliography). This reference book describes all the hallmarks of silversmiths and merchants who had their own labels, and gives dates and addresses for merchants and craftsmen.

Style is also an important criterion is discovering the authenticity of a piece; it is essential for the specialized collector to know the decorations that were in fashion during a certain era, for these, together with form and proportions are usually characteristic of a century and a nation.

Wear and time give precious articles a special patina, and in the metal of old pieces, as well as in the work done on them, there may be more than one imperfection in the raw material as well as in the execution. All these circumstances are normal for hand-crafted work.

One must also beware of forgeries. An article can be increased in value by imitating a well-known hallmark or even by welding onto a more important object the mark taken off a lesser utensil. The color of the metal, the rapidity with which the whole piece oxidizes (it must be the same all over or one should beware of it), and knowledge of that particular silversmith's production will keep the amateur collector from making too many, often costly, mistakes.

History of Silversmithing in Quebec

The first silversmiths in New France settled in the Quebec area. A little later, Montreal was to have its own craftsmen. As is understandable, the forerunners preferred to settle at first near the political, economic, and religious center of the colony: the city of Quebec.

Old records contain little information about silversmiths of the 17th century. There is little indication of how important their production was, or when the Church and wealthy bourgeois stopped importing their sumptuous plate or their holy dishes from the mother country and began using local plate.

For the 17th century, there are a few names but nothing more: Guillaume Desballes and Jean-Baptiste Villain seem to have been silversmiths in Quebec. The beginning of the 18th century was the end of a flourishing period for local precious metal work. A number of craftsmen, European trained, were inspired by French creations, though they were somewhat behind the times in style, and they took over the market in the colony.

The first of these (the Hôtel-Dieu in Montreal owns several of his works) was Jacques Pagé: forks and several spoons bear the hallmark I. P. (a number of craftsmen substituted the letter I for the letter J).

After that, a long line of young men appeared in the first half of the century of the

Seven Years' War: Jacques Gadois, François Landron, François Chambellan, Paul Lambert, Roland Paradis, Palin-Dabonville, Michel Cotton, Joseph Varin, Joseph Mailloux, Samuel Payne, and Ignace-François Delzenne. These professionals produced molded pieces like spoons, for example, or objects put together, welded, and then decorated. Most religious articles fall into this latter category.

The end of the 18th century marks the golden age of this work. Indeed, the prosperity that followed the Conquest brought a refinement and a taste for beautiful pieces, and the craftsmen's shops were the first to benefit from the success of rich fur or lumber traders.

The master of this period was, without doubt, François Ranvoyzé of Quebec, born in 1739. From 1765 on, this talented artist was to produce a whole series of secular and religious works; numerous representative pieces are in the Musée du Québec and in many parishes in the region. Ranvoyzé's works are always easy to identify, thanks to initialed hallmarks on them. It is possible that a member of his family may have entered the profession for a time, which would explain a certain confusion among the marks.

That artisan's total production is fantastic. Most of the old parishes in the Quebec area have owned one or several skillfully made creations signed by him, as, for example, the sanctuary lamp in Saint-Charles de Bellechasse or the censers in the Quebec cathedral. We must also note that Ranvoyzé produced any number of utensils or table articles: soup tureens, ladles, trays with the bottom engraved with exotic landscapes. Silver and gold were his basic metals, and everything he touched was aesthetically most attractive.

A few antique dealers who specialize in fine collections may, on occasion, put up for sale a beautiful piece signed by Ranvoyzé, but that is a rare event. The same may be said of the works of Ranvoyzé's pupil, Laurent Amyot.

After Amyot had graduated from his teacher's atelier, he went to Europe, from where he returned in 1787. Because of his foreign training, he quickly broke away from the archaic style of his predecessors, which was based on copying, and followed the new European trends of the day. Simplicity of lines, longer forms, the use of the classic decorative repertoire were bound to make him a silversmith without peer. Some of his works were little more than baubles of pure metal, stripped of any ornament. His favorite motifs were bold gadroons, the festoon of laurel leaves, and the Roman fasces.

Holy water basins, bread trays, cruets, bowls, goblets, sugar bowls, and sanctuary lamps reflected the beauty and massiveness in the style of an epoch in full swing, both economically and socially.

At the time Ranvoyzé and Amyot reached their zenith, there was nothing to prevent other craftsmen from practicing this art with commendable skill. Curtius, Delagrave, Lefebvre, Delique, and twenty others worked in the shadow of the two masters (see the list of silversmiths at the end of this chapter). The most remarkable and successful among them, between the 18th and the 19th centuries, were Michael Arnoldi, German born; Robert Cruickshank, a Scot; and the enigmatic Pierre Huguet, known as Latour. Each man was to open a shop in the Montreal area.

Latour, by profession a wigmaker from Quebec, settled in Montreal in 1781 and plunged into heavy production of decorations and barter pieces of silver of which the Indians were so fond. With his group of apprentices: Létourneau, Blanche, Marion, Gignon, Morand, Savage, and Roy, he soon became the great supplier of all the dealers and bourgeois traders in jewelry in the Northwest who had their headquarters at the foot of Mount Royal.

Numerous table pieces and ecclesiastical vessels came out of this workshop, but those creations were far from equaling the works of Amyot and Ranvoyzé either in originality or beauty of design. Their value consisted mainly in the impeccable polish and the careful treatment of the material, as Gérard Morisset so justly stresses.

The 19th century embraces both a period of fruitful handmade production and one of degeneration of that industry for being supplanted by Anglo-American imports that explored new techniques. In Quebec, the heirs of Amyot continued in the same vein as their master, often being satisfied to copy as exactly as possible the works of their workshop director. François Sasseville, Pierre Lespérance, Ambroise Lafrance, and Cyrille Duquet were to supply the townspeople and priests with silver utensils and vases tastefully carved and well wrought.

As much cannot be said of Montreal production, which was more diversified. Indeed, numerous foreign influences were to make

themselves felt and to intermingle with local traditions to give rise to something new: Salomon Marion, Paul Morand, Pierre Bohle, and Robert Hendery took over brilliantly from Pierre Huguet, who died in 1817.

During the first half of the 19th century, Marion and Morand were closer to the traditional Quebec school with its fondness for overly lavish decoration. As for Morand, he was to lean toward making very small pieces, for he belonged to that half of the 19th century in which the silver object was an article of great luxury. This was the beginning of the decline of that handicraft; silverwork was still in very great demand, but too costly for the wallets of the middle class and priests.

From 1844 to 1862, Bohle and Hendery took over the clientele of the last craftsmen, who stopped producing for lack of customers. One can still find today a fairly large number of utensils, soup ladles, trays, mugs, and taper stands signed Hendery.

A whole collection of "foreign fops," as Gérard Morisset dubbed them, some of whose works can still be found on the market, produced a variety of mediocre domestic utensils: silverware marked Cheney and Dwight, Arnoldi, Zéphirin, Grothé, Savage, and Lyman belong to this group.

Around 1840, the high cost of large items of silver was to be somewhat alleviated by the perfection of new techniques, among them plating. Thanks to advertising, the merchant silversmiths in the large cities captured almost all of the market and so dealt the final blow to the dying craft. England and the United States thereupon flooded Canada with their industrial production of mass bulk and plated silver.

A Canadian or English piece of silver is ordinarily composed of .925 part silver and .075 part copper. The same proportion applies also in France and in the United States. In other countries, the amount of copper will be higher.

Sheffield is still the leading method of silver plating. From that English village, since copied by many others, copper articles, covered by hand with thin layers of silver, spread throughout all America. Today, as a result of wear and tear, these copper articles have lost their enrichment, for the copper shows through here and there. We strongly advise against attempting to replate these articles by electroplating which would ruin them forever.

Electroplating, the second method of plating, was the final blow for local silversmithing. This technique utilizes electricity and chemical reactions to coat copper, zinc, or nickel with silver salts. There is usually an indication of the basic metal employed in making these objects: EPN—electroplate on nickel, or EPC—electroplate on copper. . . .

Almost all solid silver and plated silver at the end of the 19th century was imported from England and the U.S.A. Silverplate dealers received whole shipments of im-

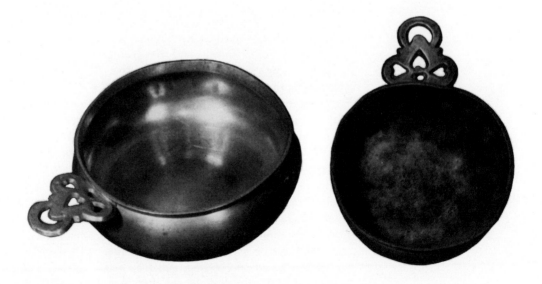

Bowl with one handle. These shallow dishes were used for liquid foods. The one on the left is in thin pewter, the one on the right is heavier and softer, a poor quality of pewter. Quebec make. 19th century. (Private Collection.)

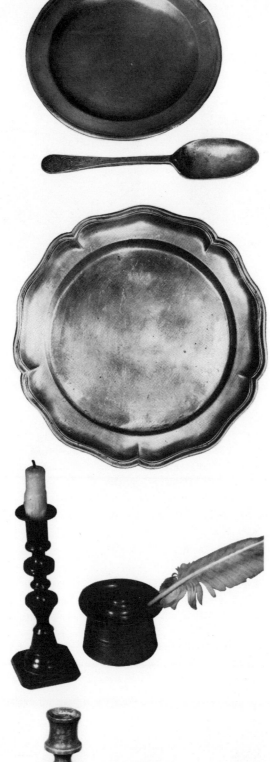

Pewter plate and spoon without craftsman's hallmark, Quebec make. In the tradition of local potters, handle of spoon is decorated with a motif. (Private Collection.)

Generally, Quebec pewters were very limited as to shape and style of the article. Spoons, plates, bowls with straight lines, plain and restrained, are typical. But some pieces, like this magnificent plate with curved border, stand out from the pieces that are available now. 19th century. (I.N.C.)

Candlestick and inkstand of poor-quality pewter, Quebec make. 19th century. (Musée des Ursulines, Quebec.)

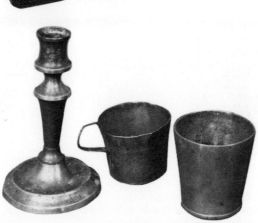

Candlestick, cup, goblet of medium-quality pewter. No identification marks, probably Quebec make. 19th century. (Private Collection.)

ported articles of solid and plated silver marked with their stamp. It is therefore difficult to trace the pieces of this period, for more than one importer was also a manufacturer. Dealers in ceramics are known to have imported baked clay from Staffordshire stamped with their name in Great Britain. The same phenomenon was repeated more often than one thinks in silverware at the end of the 19th century.

The most important among such merchants were: Louis-Philippe Boivin, David Bohle sons, Nelson Walker, Hendery & Leslie, Gendron & Cantin, Willer & Bremmer, and John Leslie. Toward 1900, the success of imports of pure metal or plated pieces in bad taste put a definite end to this craft locally, and many others were to suffer the same fate.

Pewters

Many collectors are attracted by the low-luster, silvery-gray color of pewter articles. Churchmen and laity used such vessels day in and day out, according to old inventories. The arrival of large shipments of English ceramic at the beginning of the 19th century, the need for metals at the time of the 1837 crisis, as well as military needs in two great wars, undoubtedly explain the small quantity of Quebec pewter in collections or on the market. Early Canadians sold this metal to put it to a less peaceful use.

The quality of pewter varies enormously. First-class pieces still made in contemporary workshops, and which bring enormous prices, contain 117 parts of tin to 26 of copper. Articles of lesser quality contain 100 parts of tin to 17 of antimony, while the poorest pieces have 60 parts of tin to 40 of lead. In the latter case, it is called black metal.

The melting point of pewter is, relatively, not very high. It is easily worked: one can mold it, chisel it, and beat it, to make practically anything out of it. The final polishing gives utensils such as teapots, bowls, or candlesticks a most attractive appearance. It is advisable not to clean these pieces, for with age they develop a patina that makes them valuable and popular with the collector.

A number of molds of spoons, bowls or even plates have been found in the Province of Quebec. Spoonmakers or even itinerant metal-casters were evidently among the most

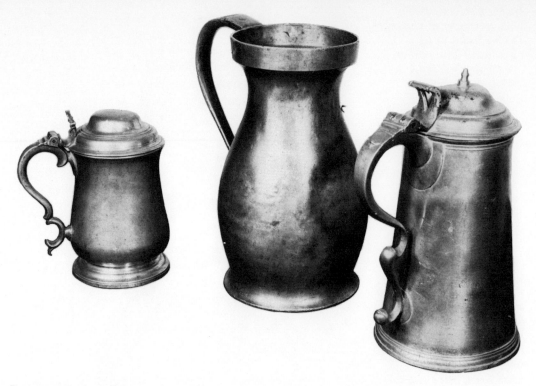

Pewter tankards with covers, and water pot, all of English make. Many pewter articles in use in the 19th century were imported from England. All are hallmarked and are easily identifiable from specialized catalogues. 19th century. (Private Collection.)

popular artisans as late as the 19th century, for more than one word-of-mouth report confirms the fact that, at the turn of the century, toward 1890, they were still running all over the country. Pewter utensils are easily damaged. Carrying all his paraphernalia in his wagon, the itinerant specialist recast and remolded dilapidated pieces in addition to repairing plates and dishes and other objects.

These itinerant potters of pewter rarely signed their pieces, if those that have survived are typical. Pewter pieces without hallmarks, plain, lightly carved, or delicately decorated with flowers were probably made in Quebec. One does find certain hallmarks

on the handles of soup spoons, such as the one engraved "T. M. Beaver Montreal," surmounted by an angel. It is attributed to Thomas Menut, who practiced the pewterer's trade from 1845 to 1871.

In 1857, one Etienne Labrecque was making spoons in Quebec, while in Upper Canada, William Heideman from Toronto and Daniel Fairman from Gananoque were working in pewter; it would not be surprising if some of their work were to be found in Quebec. Fairman was equally well known as a manufacturer of britannia ware.

However that may be, records, village monographs, and lists of trades will have to be investigated if one wants to know more

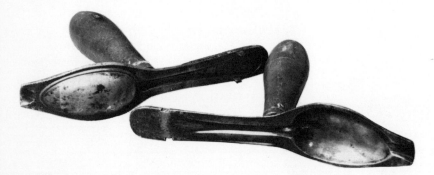

Spoon mold with wood handle; article was found in many households in the 19th century. Handles are generally decorated with geometric or floral motifs (see detail). 19th century. (Private Collection.)

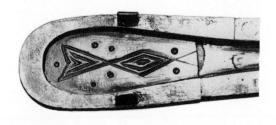

Detail of the spoon mold; triangular motif. 19th century. (Private Collection.)

about the pewter potters from this region.

Britannia is an amalgam with a high percentage of tin; with its shiny finish it looks more like silver than pewter. Its composition is variable, but usually consists of 85 parts of tin, 11 of antimony, 3 of zinc, and 1 of copper, which yields that "white metal," as it is commonly called.

In the beginning, pieces of this kind came from England. In the first half of the 19th century the firms of Nathaniel Gower & Sons, Ashberry, Broadhead & Akin as well as Vickers & Wolstenholme supplied the merchants of Lower Canada. But, from 1860, manufacturers in Quebec like Thomas Davidson & Co., from Montreal, or Octave Girard & Frères from Trois-Rivières, and Simpson, Hall, Miller & Co., of Montréal, tried—with little success—to compete with the Anglo-American market.

Plated silver and britannia are of little interest to the present-day collector, and one may wonder whether such an attitude is not justifiable.

Names of Silversmiths in Quebec before 1900

What follows is a list of silversmiths who settled in Quebec before 1900. For illustration of hallmarks and of pieces as well as authentication, the reader is referred to John E.

Pearl-bead motif decorates handles of many Quebec pewter spoons. No hallmark. 19th century. (Private Collection.)

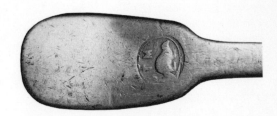

Hallmark of Thomas Menut, Montreal. Hallmark permits a quick identification once specialized catalogues are consulted. (Private Collection.)

Langdon's guide to hallmarks, and Doris and Peter Unitt's book, in which can be found a list of the marks of Quebec craftsmen and also of the dealer-silversmiths who sold articles under their own mark. This list includes local merchants who put on the market pieces of silverware stamped with their name.

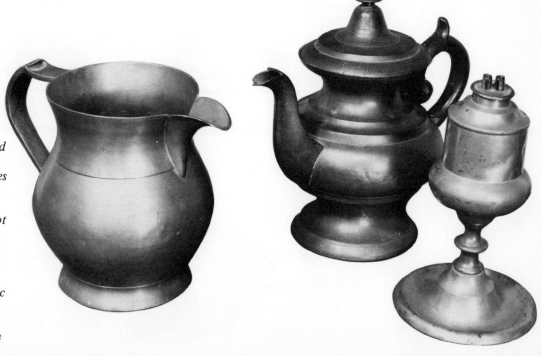

Pewter water jug, teapot, and oil lamp, American made; hallmarked. Only a few pieces were hallmarked in Quebec, partly because shop owners and itinerant potters were not numerous. The habitant was more likely to use his own spoon mold, plate mold, and other molds to make the pieces he needed for domestic uses. Many property inventories mention such molds. 19th century. (Private Collection.)

(A) Pewter potter's mold, dated 1804. (Private Collection.); (B) Religious motifs, such as this cross, were common. 19th century. (Private Collection.); (C) Top of Quebec pewter spoon, ornamented with field flower and beads of dew. 19th century. (Private Collection.); (D) Fantastic motifs on the top of a Quebec pewter spoon. 19th century. (Private Collection.); (E) Decorative motif inside a spoon mold. (Private Collection.); (F) Another decorative motif ornamenting the inside of a spoon mold. (Private Collection.); (G) Top of pewter spoon, decorated with a shell with embossed fan. 19th century. (Private Collection.); (H) Stamp of J.B. Menut. Angel with spread wings. Montreal. 19th century ; (I) Back of the spoon above, H, showing the same motif; (J) Thistle flower ornaments this pewter spoon. 19th century.

A

B

C

D

E

F

G

H

I

J

Silversmiths Before 1900

What follows is a list of silversmiths who settled in Quebec before 1900. For illustration of hallmarks and of pieces as well as authentication, the reader is referred to John E. Langdon's guide to hallmarks, and Doris and Peter Unitt's book, in which can be found a list of the marks of Quebec craftsmen and also of the dealer-silversmiths who sold articles under their own mark. This list includes local merchants who put on the market pieces of silverware stamped with their name.

Allan & Co. (1857-1900)
Amyot, Jean-Nicolas (1750-1821)
Amyot, Laurent (1764-1838)
Ardoin, C.J. (C. 1860)
Arnoldi, Charles (1779-1817)
Arnoldi, John-Peter (1734-1808)
Arnoldi, Michael (1763-1807)
Barlow, Edouard (C. 1830)
Bean, John (C. 1820)
Beaudry, Narcisse (C. 1870)
Bequay, Jean-Baptiste (C. 1800)
Bewes, Daniel (C. 1850)
Birks & Son (Henry) (1879-1971)
Blanche, René (1771-1820)
Bohle, David (C. 1790)
Bohle, David (C. 1850)
Bohle, Francis (C. 1850)
Bohle, Peter (1786-1865)
Bohle & Hendery (C. 1855)
Boivin, Louis-Philippe (1842-1856)
Boure, Narcisse (C. 1860)
Chambellan, Francois (1688-1747)
Cheney, Martin (C. 1820)
Cheney & Dwight (C. 1820)
Clements, Isaac (C. 1780)
Curtius, Simon-Charles (C. 1800)
Cruickhank, Robert (C. 1790)
Cook, T. (C. 1830)
Delagrave, Francois (C. 1820)
Delique, Charles-Francois (C. 1750)
Delisle, William-Frédéric (1820)
Delzenne, Ignace-Francois
 (1717-1790)
Desroches, Alfred (C. 1870);
Duval, Ignace (C. 1800)
Dwight, James-Adams (C. 1825)
Ellis, James (C. 1820)
Faiseret, D. (C. 1790)
Farquhar, William (1823-1930)

Flint, Samuel (C. 1820)
Fortin, Michel (1754-1812)
Gatien, M. (C. 1760)
Gill, Thomas (C. 1820)
Grothé, Christian (1795-1868)
Grothé, Z. (C. 1850)
Grunewalt, Gaspar-Frederic
 (C. 1780)
Haddington, George (C. 1830)
Halliday, L. (C. 1850)
Hanna, James (C. 1810)
Hanna, James-Godefrey (C. 1810)
Hendery, Robert (1837-1897)
Hunter, William (C. 1805)
Innes, William (C. 1850)
Irish, Charles (C. 1805)
Jackson, R. (C. 1830)
Kenzie, John (C. 1810)
Kurczym, N. P. M. (C. 1820)
Lafrance, Ambroise (1822-1918)
Lambert, Paul (1691-1749)
Landron, Jean-Francois
 (1686-1739)
Larsonneur, Francois (C. 1780)
Latour, Pierre Huguet dit
 (1771-1829)
Learmont, William (C. 1860)
Lerche, Jean-Henri (C. 1790)
Lespérance, Pierre (1819-1882)
Limberger, J.F. (C. 1870)
Lucas, Joseph (C. 1775)
Lukin, Peter (1775-1831)
Lumsden, John (C. 1790)
Mailloux, Joseph (1708-1794)
Marion, Salomon (1782-1832)
Meves, Otto (C. 1860)
Miller & Bremmer (C. 1890)
Mittleberger & Co. (C. 1810)
Morand, Paul (1775-1856)
Morin, Paul (C. 1790)

Normandeau, Joseph (C. 1800)
Oakes, John (C. 1800)
Orkney, James (C. 1810)
Pagé, Jacques (1686-1742)
Paradis, Roland (1696-1754)
Peacock, Henry (1847-1890)
Plantade, Etienne (1750-1819)
Polonceau, Henri (1766-1828)
Poulin & Co. (1890)
Powis, Thomas (C. 1780)
Preston, T.G. (C. 1820)
Ranvoyzé, Ignace-Francois
 (1739-1819)
Roy, Narcisse (1765-1819)
Sasseville, Francois (1797-1864)
Sasseville, Joseph (1776-1831)
Savage, David (C. 1850)
Savage, George (1767-1845)
Savage, George Jr. (C. 1850)
Shindler, Jonas (1760-1786)
Scott, J. (C. 1840)
Seifert, Gustavus (1831-1909)
Sharpley, R. (C. 1860)
Simplon, Hall, Miller & Co.
 (C. 1880)
Smellie, David (C. 1850)
Smellie, James (C. 1825)
Starnes, Nathaniel (1794-1851)
Stubbs, William (C. 1820)
Talender, W.M. (C. 1840)
Thompson, John (C. 1800)
Tison, Joseph (1787-1820)
Tyler, Jonathan (C. 1825)
Varin dit Latour, Jacques
 (1736-1791)
Walker, Nelson (C. 1840)
Walker, William S. (C. 1860)
Wilkes, R. (C. 1860)
Wood, John (C. 1780)

CHAPTER 12

Tools

*. . . the habitants make most of their
tools and work utensils themselves, build
their houses, their barns. . . .*

HOCQUARD
Administrator of New France

*Under the pressure of necessity, the
"habitant" performs labors that have nothing
to do with his role as a farmer. For example,
he must build and repair his house and his
buildings, make agricultural implements
as well as see that his wagons and
harness are kept in good condition.*

ROBERT-LIONEL SÉGUIN

Certain amateur collectors, though still few in number, are beginning to make a specialty of collecting tools. It is a field made all the more interesting because a great many pieces are always available in antique shops and at reasonable prices. It must be stated that the small interest in implements of the past has deprived us of a local vocabulary and knowledge of original work techniques for which they were used. Most smiths, cartwrights, and village cobblers have closed their doors; their tools, legacy of a tradition, are scattered to the four winds—when they have not simply been scrapped as rubbish. That is more or less true of an entire area of the chattel of Canada's early culture. The Ontario government has tried to make up for this disappearance of ancient techniques by organizing its famous "Upper Canada Village," where the ironmaster's smithy, the carpenter's shop, and other workrooms offer a wide range of tools displayed to public view, and where, for a moment, the trades of yesteryear live again.

The mere study of such tools or a demonstration of forgotten techniques becomes a very real and fascinating history course for any amateur collector who is interested in his own origins. Then it is that we understand the ingenuity and skill of pioneers and we come to realize that the 20th century has not invented everything, and that the first colonists also made a very considerable contribution to the evolution of North American civilization.

The tools that are left may seem crude, bulky, rustic, and aesthetically lacking if compared to manufactured ones on the market today. This is perhaps the reason why amateur collectors have shown but slight interest in them up to now. But their charm lies elsewhere, perhaps in a manifestation of ancestral ingenuity, the characteristics of a craft or of an era, or in a unique piece, the fruit of a manual trade and of human experience still in evolution. Many pieces, in addition to being crude, were made counter to the very principles that would have facilitated their use. And not until the end of the 19th century were these imbalances noticed and corrected.

It is not our intention to discuss this at length in this chapter. An entire volume would not be adequate. We shall merely show some of the work tools of the carpenter, the blacksmith, the cooper, the cartwright, and the tanner, and some handsome farm tools.

In times past, the *habitant* tried to be sufficient to himself to such an extent that one might say that many farms were autarchies. For small repair jobs or even for building, the farmer rarely called on an itinerant carpenter or one from the village. Members of the family rolled up their sleeves and pitched in to help each other on any task at hand. That is why, in inventories where a man's property is described in detail, it is not unusual to read a list of tools ranging from carpenter's plane to blacksmith's tongs. That was true for most of the first arrivals who wanted to be self-sufficient. And it is undoubtedly the explanation for the large number of old tools still available or even in use today on a good many farms.

I have often met tradesmen who made it a point of honor to let me explore their father's or grandfather's well-filled chest. Lauréat Vallières, wood-carver from Saint Romuald d'Etchemin, 83 years old, who has used tools all his life and whose father built wooden ships on the banks of the St. Lawrence, told me that when a shipwright moved his belongings, it was as impressive a commotion as many house-movings each year on the first of May.

The Importance of Wood

Canada has been blessed by nature with many varieties of fine quality wood. Hard woods were used especially in carpentry and for heating, while the softer woods were favored by tradesmen or artisans for planks and beams needed in the building and finishing details of houses. Contrary to the general notion, most rural houses in the 18th and 19th centuries used wood as building material to such an extent that most roofs of cedar shingles were ready tinder for sparks shooting out of the wide chimneys and therefore the cause of fires. Often, entire quarters of a town were destroyed, and only the stone buildings remained as survivors of the architectural forms of another age.

Not only houses but boats were made of this basic material. Building many-masted sailing vessels called forth all the skill and ingenuity of specialized workers who used tools of all kinds, and in the 19th century many shipyards flourished along the St. Lawrence River.

In that era, all work with wood was done by hand until waterpowered sawmills were established at the beginning of the 18th century. Even later, more than one *habitant* was to preserve the traditional methods and rhythms.

Axes

We cannot talk about wood without mentioning the men who cut it down, the lumberjacks. These men, who winter in the timber yards, use various types of axes. Like other tools the axe went through some transformations in the course of Canada's few centuries of history. It seems that the axes we know today are a genuine American invention.

Very old axes do not have a pounding head opposite the cutting edge, and their shape is often gracefully curved. Many of them were used in barter with the Indians. The early farmer owned more than one axe, and in addition to the axe without a hammer head, commonly called the barter or carpentry axe, there was also the hatchet or woodsman's axe shaped like a wedge, for felling trees, the "Biscayenne" axe with double blade, and the broad, square axe of which more will be said later on. After the wood

(A) Raftsman's boat-hooks, handmade. 19th century. (Jacques Héroux.); (B) Axes. 18th century. (Guy Doré.); (C) Biscayenne àx. (Jacques Héroux.); (D) Knacker's ax. 19th century. (Jacques Héroux.); (E) Huntsman's ax. 18th century. (Jacques Héroux.); (F) Huntsman's ax. 17th century. (Jacques Héroux.); (G) Huntsman's ax. 19th century. (Jacques Héroux.); (H) Traditional knacker's ax. 19th century. Made by artisan. (Guy Doré.).

was cut, it had to be brought down to the mill, to the sawmill or to the carpenter, as the case might be. The loggers had at their disposal a variety of cramp-irons and gaffs (still called "canthooks" in lumber yards) having long handles of round wood fitted with pikes and turned-down hooks with which to roll the logs.

The bark of the tree then had to be stripped off, an operation done with a series of tools shaped like a spoon or sharp shovel. The pioneer made frequent use of the plane, that sharp steel tool with two handles used principally by cartwrights and coopers.

To square off the log, one or two ropes are fastened taut to its ends. Lime, suet or blue chalk is rubbed on the rope which is then stretched like a bowstring and allowed to fall down on the round wood. In this way the woodsman draws a square so as to be able to cut out a broad beam from the felled tree. Then the hewer begins to chop every six inches on an axis perpendicular to the log. Next, taking an axe with a broad blade shaped like a halberd (flat on one surface and contoured on the other), he splits the roundness on the four marked parts. And here we must note that his axe will be flat on the left side or the right, depending upon whether he is left-handed or right-handed.

Adzes

Next, this rough piece of wood had to be smoothed off. For this the workman used the adze, a kind of iron hatchet with a long handle and curved iron the edge of which is perpendicular to the handle. The adze will vary depending upon the curve of the iron.

Planes

The colonist was not satisfied with the rough surface left by the adze. In spite of all the worries and all the dangers that hung over his head, he insisted upon a better finish for his house. And this well-executed task he accomplished with the aid of a large collection of planes, some of them imported from the mother country, but many the product of his own ingenuity. This accounts for the variety of planes found in the bottoms of old

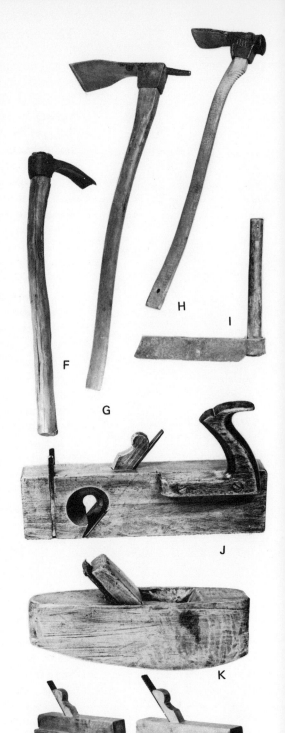

(A) Peavey; 19th century. (Jacques Héroux.); (B) Cant hook; 19th century. (Jacques Héroux.); (C) Log-carrying tool; 19th century. (Jacques Héroux.); (D) Conventional drawing-knife. (Guy Doré.); (E) Lumberman's pickaroon, made by artisan; 19th century. (Jacques Héroux.)

(F) Handmade carpenter's adze; early 19th century. (Guy Doré.); (G) Shipwright's adze; 19th century. (Guy Doré.); (H) Homemade slater's hammer, used to cut knots of wood from a board or to scoop out pieces of raw timber; 18th century. (Guy Doré.); (I) Départoir, a tool for shaping wooden shingles; 18th century. (Guy Doré.); (J) Homemade plane; 19th century. (Jacques Héroux.); (K) Cooper's curved plane; 19th century. (Jacques Héroux.); (L) Manufactured molding plane, early 19th century. (Guy Doré.)

Chisel with thick wood handle, made by artisan. 18th century. (Guy Doré.)

Shipwright's large chisel with thick wood handle, and small woodworker's chisel; 19th century. (Guy Doré.)

tool chests, shod with metal, reenforced at the corners with angle-irons, and which, more and more, are finding their way into antique shops.

The jointer or trying-plane is the most common of these tools. This is a twenty-four inch plane with a shaft akin to that of a compass-saw. It is used for smoothing surfaces that have been planed by an adze. Then there is the long-plane which does the same work, but which has more respectable dimensions, for some of them are three feet long and even more. It takes two men to work one, one pushing on the grip, the other pulling it with a rope or with side grips at one end.

The grooving plane, not so large (about 12 to 15 inches), is used in pairs to trace rabbets and tongues on thin planks and thick boards. The male part cuts out the small tongue, whereas the grooves are made by the female cutter. Even though these tools are generally found in pairs, some models can make these two moldings with one implement only. Some are even adjustable in order to regulate depth and thickness and so produce varied moldings. These are called wedge-planes.

The use of the ogee-plane, the quarter-round-molding-plane, and the rabbet plane will produce many varieties of door and corner moldings, while the molding-plane will be used to round off the beads. The catalogue of planes is impressive and numbers of these tools still have a very specific purpose.

Chisels and Hammers

To fashion the many different mortises, the professional carpenter and the *habitant* used a great many wrought-iron chisels and gouges. These implements have a blade ending in a point or a tube; the handle fits into the tube or is set into the point, and its base is always reenforced by a metal socket. Straight chisels are called mortise or heading chisels, and those that are hollowed are called gouges. Chisels and gouges vary in size, thickness and concavity. Some wood-carvers will have as many as 125 different kinds.

Old hammers are usually crude and have a flat head; the claws are much wider spread than in modern tools. The handle, as, for that matter, in other tools too, is straight. It

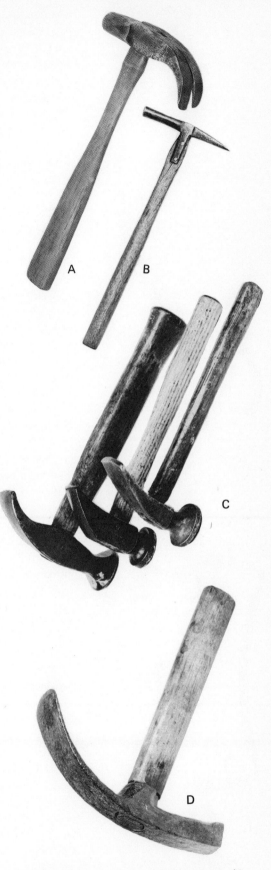

(A) Hand-made hammer of 18th century. (Guy Doré.); (B) Small watchmaker's hammer of 19th century. (Jacques Héroux.); (C) Three shoemaker's hammers of early 19th century. (Jacques Héroux.); (D) Cooper's tool of 18th century. (Guy Doré.).

Wimble, homemade. 18th century. (Guy Doré.)

Early 19th-century wimble of industrial manufacture. (Guy Doré.)

Wood wimble; Anglo-Canadian make. (Jacques Héroux.)

was not until the second half of the 19th century that the handles of these tools were given a little more curve to fit the hand better.

The wood mallet of multiple purposes was in general use, especially among carpenters who drove wood pegs with it or fashioned a mortise joint by pounding the chisel. The many pieces left give evidence that the list of the shapes and sizes of this tool is vast.

Bit-Braces

Next come all those tools for making holes in the wood. The awl and the drill penetrate the material by opening the fibers; the bit, the auger and the gimlet eat or cut into it. Certain awls are heated white-hot and driven into the wood which they groove by burning. The fraise or milling-cutter then helps to enlarge the hole; it is a tool much used by the cartwright, maker of wheels. Bits and augers come in different lengths and sizes, with screw at the beginning, flat end, etc.

The bit-and-brace of yesteryear did not have as pronounced a square as today and must have been more difficult to use. Some of those tools, at least the oldest ones, were all made of wood reinforced by metal casings and corners at strategic points.

The old squares and levels are generally of wood. The square can be wood or metal, but contrary to what one finds on the market today, it is not graduated. The air-bubble level was usually replaced by the plumb-line before the middle of the 19th century.

Tools of Indian Origin

Finally, we cannot end this account of carpenter's tools without mentioning Indian tools. It is known that the Indians used wood to carve totems, make bowls, spoons, and canoes. Lauréat Vallières, professional woodcarver, declares that, at the end of the century, he saw an Indian working on some wood and using short adzes or hand adzes of different widths, and scrapers.

Saws

Saws are also among the carpenter's impor-

Jigsaw or St.-Joseph; *19th century.* (Guy Doré.)

tant tools. Here again, variety is common, because the artisan turns out models according to his own pleasure and the purpose for which they were to be used.

The saw "*a chassis*" is mounted on a wooden frame; the blade is stretched on the edge or in the center and a wire twisted on a tourniquet connects the two uprights which act as a turnbuckle. The fret-saw is finer. The immense rip-saw with or without "chassis" (frame) for separating balks or planks; the woodsman's "godendard" with handles perpendicular to the blade; the carpenter's compass-saw (cross-cut saw) with grip as we know it today but cruder—all these were used by the artisan and by the pioneer.

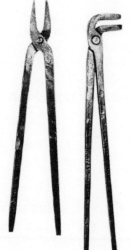

The Smithy and Its Equipment

The smith was an important man in his village. It was he who made tools, nails, pegs, hinges, who shoed horses or oxen, repaired broken wagons, put runners on sleds in winter, patched up broken farm implements, and also supplied all kinds of handles for a large variety of farm implements. There are still such wooden models hanging on the walls in workshops like Maxime Routhier's at Saint-Charles-de-Bellechasse.

In the blackness of the smithy, an immense leather bellows, worked by an apprentice or by the artisan himself, the brick-red fire, the anvils or beak-irons, the tongs, the hammers, the taps, the stock and dies, the rasps and files—those were the essentials of the smith's equipment.

Anvils weighing one hundred pounds or more are generally tapered rather than square. They are then called beak-irons. As a rule one end is pierced so that a brake-rod or some sort of a tool, like a stamper, for instance, can be placed in it in order to bend thin metal plates.

Tongs, twenty or thirty inches long, are lined up near the fire. There are all kinds, straight-nosed, hook-nosed, shaped like pliers, round, square. For the many varieties of metal forms the smith had to have suitable pliers to hold the hot iron above the flame while he hammered it firmly.

A whole series of mallets in separate groups were used to give the square bar of iron the desired shape. The lower part was pressed down on the anvil or inserted into the opening in the beak-iron for greater stability. The

The tools of a traditional blacksmith, including a variety of pincers, the jaws of which vary endlessly in form. Pieces by 19th-century artisan. (Jacques Héroux.)

Farrier's knife, with curved point for cleaning horses' hooves. Industrial make; late 19th century. (Jacques Héroux.)

Crozer – a cooper's tool used for hollowing out the chimb of barrel staves. (Guy Doré.)

Joiner's grooving-plane. Industrial manufacture; Mid-19th century. (Guy Doré.)

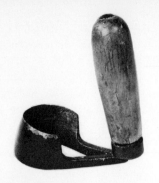

Cooper's scraper; 19th century. (Jacques Héroux.)

Cooper's curved départoir, *a tool for shaping wooden shingles. 18th century.* (Guy Doré.)

drawplates thinned down the rods to the desired size and the artisan used some of them to forge all those flat-headed nails found in old timberwork or in old furniture. The die-plates are like metal rods an inch thick, perforated by round or square holes of different sizes. The hot iron was forced through the holes, then pulled and cut. Then the head was hammered.

The smith's hammers do not have nail-claws, but instead, a pointed head to cut the molten metal or a round head to pound the grooves.

Lastly, one of the smith's important tasks was, of course, to shoe draught-horses. He had at his disposal a whole series of knives with curved points, scrapers for cleaning and cutting hooves, special pliers for pulling out nails and old pieces of iron, and a whole apparatus for holding the horse still while he was working.

It would take too long to elaborate here on all the mechanical tools that appeared at the beginning of the 19th century and which the blacksmith used to speed up his production of nails and other articles. That lies more within the province of the specialist, who can consult Eric Sloane's book *A Museum of Early American Tools.* Even though this study is concerned with the U.S.A., the same tools, with a few variations, will be found here in Canada.

The Cooper

There are tools used by other professions which also turn up in some antique shops. The cooper, for instance, worked with concave, convex, or curved planes to smooth the bulging planks of barrels, cut out of a log with a jointed chopping axe which also curved. The crozer was then used to hollow out the chimb of the staves. The staves or concave planks used in making barrels or casks, had to be mortised at their ends or crozed to receive the pieces that form the bottom. The crozer is like a curved plane with very thick saw-teeth in the rounded part. By running this tool on the edge of the staves that have been assembled and encircled with iron, the cooper will make the groove needed to receive the bottom planks and so make certain that the whole barrel is perfectly tight.

The Shoemaker

The shoemaker, who formerly used to act as a tanner, had special equipment for cleaning skins and cutting out boots or shoes. A complete collection of scraping tools, scrapers, knives, awls, and bradawls of different sizes were used in this shop. The shoemaker's bench, with its bins for nails for soles, is also a piece of furniture occasionally to be found in an antique shop.

The Cartwright

The cartwright also had his specialized set of tools for turning hubs or naves, encircling wooden wheels with metal, and for repairing all sorts of wagons. Compasses, special benches, chisels, appliances for measuring circumferences are the most typical tools in this art.

Farm Tools

And, lastly, a chapter on tools would not be complete without mention of the small work tools used on a farm, articles that abound in the Province of Quebec, for French Canadians were above all an agricultural people, at least until quite recently.

The most common implements, at any rate, those still to be found hung up on the beams in barns, are undoubtedly sickles, scythes, reapers, rakes of different sizes, flails, and shovels.

There were two types of sickles brought by the settlers and in use on farms in the 18th and 19th centuries and at the very beginning of colonization—the sharp-edged sickle and saw-toothed sickle, more popular and more efficient, according to tradition. The sickle is used particularly for cutting wheat and other grains at harvest time.

Hay was harvested with the scythe, which has a longer handle and blade. The latter, which was frequently damaged by striking stones on the top of the ground, had to be continually sharpened. The farmer therefore carried in his belt, or planted in the field, a sort of wooden case shaped like a pointed bedpost for holding the soapstone used for sharpening as well as a little water.

Soon, several thin pieces of wood three

Coffin de sol, *a container for soapstone, the stone used to sharpen a scythe or sickle. Usually, a small amount of damp turf was placed inside to keep the soapstone moist. 18th century.* (Guy Doré.)

or four inches apart were added parallel with the blade of the scythe to make the flail, which is a scyth-rake that in addition to mowing the hay will gather it into a pile if the reaper works in a circle. All these tools were the fruit of local handicraft which was to continue until the end of the 19th century and even into the 20th in some areas.

Iron or wood rakes were in continual usage. Those of wood had long teeth, and their light weight was no doubt the reason they were so popular with the farmer. Besides, he could make one himself without calling in the village carpenter, and so save a few pennies.

Forks for stacking and binding sheaves are also numerous. The early ones are of iron, but the *habitant* soon made some of wood with two or four tines, from the maple or ash trees on his land. The oldest are crude but, soon, they were cut from one plank of wood with one end divided into tines. The three or four prongs were made by placing a little wood triangle between the tines to separate them. "*Fouine,*" large pitchfork, and "*broc*" are some of the local names for pitchforks.

The hand flail was the farm implement most used for threshing wheat. Two rounded pieces of wood an inch and a half to two inches in diameter (the "beater" and the "holder") tied together by a leather noose or an iron ring—and there you have a threshing implement *par excellence.*

Finally, old shovels had handles and grips cut out of a single piece of wood, and their construction in a smithy accounts for their heaviness and solidity. The snow shovel, all wood and curved, was also in use in the 18th century.

And there you have the early tools! A fascinating task awaits the patient researcher who is interested in the techniques of the Canadian farmer of yesterday. More could be said about the making of tools and about other trades such as glaziers, cobblers, masons, which would no doubt be of valuable aid to the amateur collector who is interested. To learn more about such trades, the reader is advised to consult the bibliography at the end of this book, and in Diderot and D'Alembert's *Encyclopedie,* the volumes on architecture or on any craft trade.

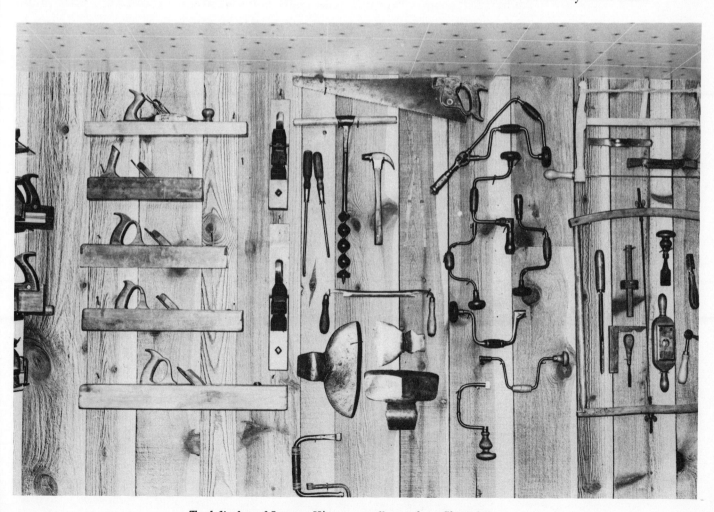

Tool display of Jacques Héroux, a collector from Shawnigan.

CHAPTER 13

Toys

The toy of primitive make remains a true piece of folk art. Wooden horses and doll's furniture are evidence of the aesthetic interests and manual skill of our rural artists. . . .

ROBERT-LIONEL SÉGUIN

Like all children on earth at different eras, the children of Canada also had their toys. Sound toys, and those which imitate the activities and utensils of adults, seem to have been among the principal products of local toymakers. It is well known that a newborn infant reacts to the tinkling of little bells or to repeated sounds, whereas the older child tries to imitate the postures of father, mother, or various people he has been able to watch at work. Who of us has not sometimes played at being a truck driver, an electrician, or a farmer?

Toys for a Newborn Baby: Rattles and Bells

Among the toys made by the early colonist, let us look first at those for early childhood, that is, up to two years. For that age, one finds toys for the bed or the cradle and toys to be played with on the floor. The most common and best known to fascinate small infants are rattles and bells. For that matter, we would have to go far back in time to discover their origins. Household lists of the 17th century mention silver rattles, undoubtedly made in Europe. But that was too luxurious for the majority, who were satisfied with a piece of string threaded with little round bells to attract the baby's attention, calm him, and make him smile now and then. In the 18th century, bone rattles were popular and, for only five pennies, one could buy this noisy toy (which was definitely imported) at the general store.

A few months later, when the baby begins to explore, he will spend his time crawling around, playing with a goblet, a broken pewter spoon, or pulling everything out of the cupboard or the wardrobe.

When he begins to be more aware of things around him, toward the age of two, the child will want objects more like real life. His talent for mimicry will make him push anything that rolls, turn wheels, or build castles or fantastic houses with building blocks. At the beginning of the 19th century children played with multicolored blocks made of cement, but around 1850, building blocks of solid wood or made of small boards glued together appeared. Animal or floral designs on paper covered five of their sides, for the hollowed-out cubes could often be fitted one into the other.

Handmade Toys and Manufactured Toys

Local toys could be divided into two broad categories: those made by hand, and the manufactured products. Most of the toys that are interesting as pieces of early Canadiana belong in the first group. In a relatively poor country, in the 18th and 19th centuries, especially among the rural people, "boughten" toys were rare. Home talents were put to use: father, brother, mother, or a neighbor patiently set to work to make something that would keep the child busy a long time.

At the end of the last century, however, industrialization began mass producing practically everything and toys were no exception. From the U.S.A. and Europe, more realistic, better proportioned, and gay-colored toys began arriving to attract the attention of parents for holidays or birthday gifts.

The devotee of antique shops can find not only indoor toys, real miniature treasures, but also homemade examples of many used for outdoor sports, most typical of Quebec.

American Indian Toys

American Indians have contributed little in this field. Reference to the chronicles of the beginning of French colonization indicates that it was the White Men who introduced toys to the child of the forest. Young Indians were pleased to receive a small bow and arrow. They also liked to play at knuckle bones, *assiette*, and jackstraws, but any systematic miniaturisation of various components of their own environment were inculcated by foreigners. Unlike other peoples of the earth, those inhabitants of Canadian forests apparently did not know the doll until the coming of the colonizer. This is rather exceptional, for anthropologists have discovered dolls in very primitive civilizations.

However, lack of playthings did not necessarily mean lack of play. Quite the contrary. In that regard, the American Indians were to contribute a great deal: hockey-stick, balloon, hide-and-seek, leather ball, the hunting of small game, were all pastimes the young natives enjoyed in the out-of-doors.

Toys Originating from Imitated Activities: Boys' Toys

Then comes the child's fascination for imitating the objects with which he is surrounded and the gestures of the human beings around him. For the little boy, in times past, the article most representative of this phase was without doubt the wooden horse, of which a number of examples are still found on the antique market. The child has always been attracted by the horse; one has only to watch the merry-go-round at a fair to see

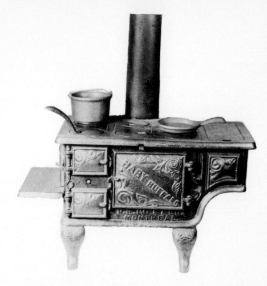

Small iron stove with accessories. Considered a toy by many, but actually used by 19th-century foundries as an example of their product. (A. Conrad Poulin, Quebec.)

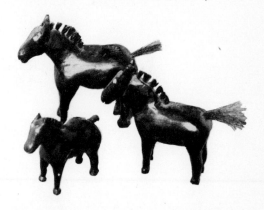

Miniature horses, carved in wood, no doubt to add to a toy farm. (Private Collection.)

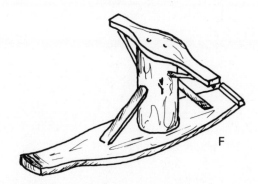

(A) Top or "turnip"; (B) Bear's-paw snowshoe; (C) Beaver's-tail snowshoe; (D) Mountaineer's snowshoe; (E) "Cod" snowshoe; (F) Seesaw; (G) Wooden ice skates; blade made from a file; (H) Snowshoe with halibut design; (I) "Chestnut" snowshoe.

193

this. This was particularly true of the child of yesterday who was constantly in the presence of the horse, the sole means of transportation then in use.

This toy may be divided into four broad categories: the horse on rollers, the rocking horse, the horse on skids, or on a swing. Most of these articles have a special charm because they are homemade. Heavy, bulky, and square at times, even out of proportion, they have nevertheless made several generations of children happy. Most of them are in bright colors and a number of them have a harness carefully painted on their frames.

As a rule, these toys are fashioned from a large log of wood, awkwardly carved into a body to which a rigid horse's head has been fastened with a transversal wooden peg. The hoofs are then directly fastened to the wheels, skids, or cradle rockers. Instead of showing a semblance of a saddle as a seat for the child, some of them had a little chair with arms and back.

The oldest of these toys are those on wheels or skids, for the rocking horse could not appear before the coming of the cradle, at the beginning of the 19th century. It goes without saying that the wooden horse was in use from the beginning of the 18th century. Not all of them were of rustic make, lacking in harmony and awkward, for the records state that on January 15, 1796, Thomas Baillargé, a wood-carver, "undertakes to fill an order for a horse on wheels for John Gragy, of Quebec." It seems that certain artists amused themselves now and then by fiddling over a toy or a puppet. Not all wooden horses were used for the child to ride on; some smaller ones were pulled by a string.

Other homemade toys especially made for little boys had to do with various rural occupations or with vehicles used as conveyances. The child who preferred games on the ground played with triangular harrows, rakes, baskets, wheelbarrows, carts, rickety old vehicles, and in the 20th century, rustic trucks always in imitation of the real ones around them. Who among us has not one time or another riffled through his father's tool chest to build, somewhat clumsily, a truck, with wheels made of spools, and painted with whatever was left of the half-dry remains of some oil paint?

Along the coast, boat toys completely filled the child's leisure hours. Copying schooners, trawlers, and all the other kinds of water transport that plied the river or the

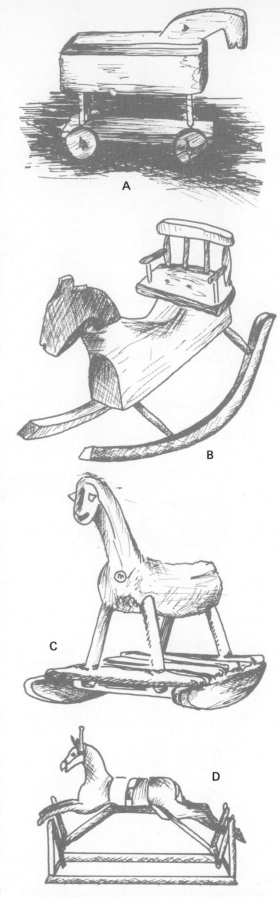

Different types of wooden horses for children include: (A) On wheels; (B) Rocking horse; (C) On skids; (D) Seesaw or swinging horse.

Wooden horse on wheels. 19th century. (Private Collection.)

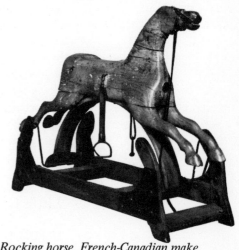

Rocking horse, French-Canadian make. Probably made by a skilled carpenter or wood-carver. Base is reinforced by metal plates. Late 19th, early 20th centuries.

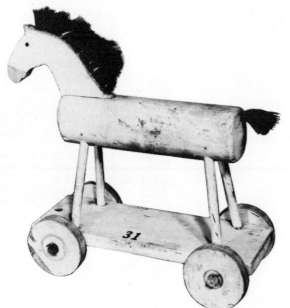

Horse on wheels. Mane and tail made from hair; rest is in pine, except for the wheels, which have been cut out of plywood and are no doubt from a later period. Late 19th century. (I.N.C.)

Fine wooden truck from early 20th century. Handmade. (I.N.C.)

Small skiff found in the Quebec area: 14 inches long, cut from a single piece of pine. 19th century. (Private Collection.)

Wooden horse with mane of real horsehair, about 24 inches high. 19th century. (I.N.C.)

bay, loaded down to the Plimsol with *pitoune* or cod, the young lads along the rivers would take advantage of the low tide to set their toy boats afloat.

Quebec, it seems did not have lead soldiers, those miniatures every child across the sea was proud to possess. There are none to be found on the local antique market. On the other hand, wooden soldiers, made in Europe or in America, stiff hussars drawn up at attention, were offered for sale at the end of the last century. An engraving by Henri Julien printed in *l'Opinion Publique* of January 8, 1880, shows a Quebec child who has just received a gift of wooden soldiers.

Little Girls' Toys: Dolls

If little boys' toys are pieces of French-Canadiana that are relatively difficult to find, it is worth making twice the effort to lay hands on little girls' toys. Antique shops in English Canada or in New England are richer in these objects. This toy is often a sign of material prosperity; and it is easy to understand that it should be the little girl's privilege in that world of success and affluence. However, one cannot say the same for Quebec.

Several types of dolls can be found among local collections. Most of them are factory made, of bisque, with eyes articulated by a lead weight. When the doll is laid horizontal, her eyes close. This type goes back at the most some fifty years, if we can rely on word-of-mouth reports dating from the beginning of the century.

Most dolls that interest the collector are from the 19th century and are of foreign make. These dolls usually wear costumes from the Victorian era, of which they are winsome emulations.

Staring glass eyes, head and limbs of porcelain or plaster, mouth open showing tiny teeth, face delicately painted, body padded, those are the main characteristics of such imported dolls. Further, they are not replicas of children or of babies, which were to come later in the 20th century, but usually semblances of people in their twenties. At the end of the last century, bisque heads and limbs that could be attached to a body of domestic make, were sold. This was of making dolls had a certain vogue in Quebec, and the different sizes made it possible for all purses to obtain one.

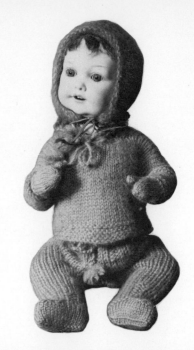

Doll with porcelain head and eyes that move. German import. Late 19th, early 20th centuries. (Jean-Marie Dussault, Deschambault.)

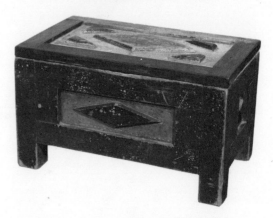

Doll's chest ornamented with lozenges. 19th century. (I.N.C.)

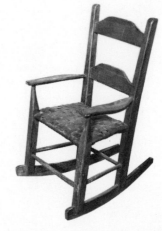

Doll's rocking chair with seat woven with thongs of elmwood. Seven inches high; back ornamented with two horizontal crosspieces; rockers attached to the leg posts by open mortises. 19th century. (I.N.C.)

Doll with papier-mâché head. Early 20th century. (I.N.C.)

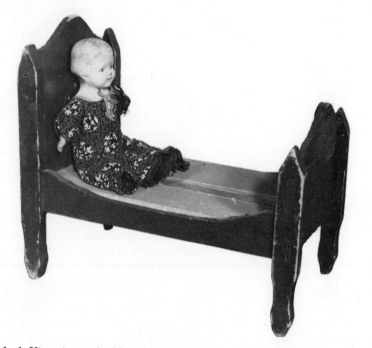

Doll's bed, Victorian style. Miniature furniture is much sought after by toy collectors. (I.N.C.)

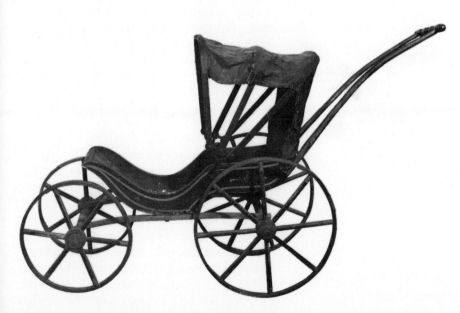

Doll carriage of the second half of the 19th century.

Miniature Furniture

Miniature furniture has great fascination and charm for the collector, for they are always pieces with more local color than imported dolls. It is still possible to discover a few pieces of dolls' furniture in Louis XIII style or of the kind in use in colonial homes. I have seen in an antique shop a doll's cupboard exactly like one that must have been in the house of the artisan who made it. The same can be said for wardrobes and beds. All that manufactured miniature furniture of cast or wrought iron of which doll's chairs and pressing-irons are among the most typical examples, must not be forgotten. These pieces, which date from the last quarter of the 19th century are of American make. They are easy to find on the market at a reasonable price.

The little girl of the Victorian era also played with pots, kettles, or more rarely, with doll carriages, mostly imported from Europe or America, as indicated by the trademark. And finally, while still on the subject of miniature articles for dolls, we must not forget the toilet articles and plates and dishes imported from England or Germany around the year 1850. Many pieces of ceramics are so delicate in shape and decoration that they deserve great attention on the part of the amateur collector for, after all, they are tiny copies of English porcelains then in use.

Manufactured Toys, Local and Foreign

At the turn of the century, American and European industries, with their assembly-line production, flooded Canada with toys—metal toys in particular. They were generally pieces cast in separate sections and assembled with long rivets. There was no internal mechanism and the child played with those toys by pulling them by a string or by simulating the way they were supposed to work.

The American-made metal trains are the most representative of these articles. The locomotive, the tender, and the passenger cars were made to look like the trains of the era. An interesting fact to note is that the passengers give the impression of moving. Starting the train operates the driving rod, attached to the axle of each car, which, in

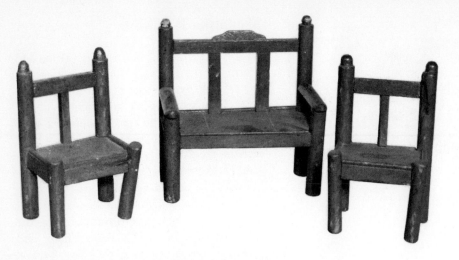

Doll's chairs and settee. Early 20th century. (I.N.C.)

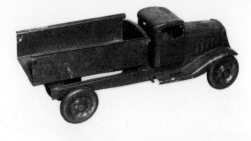

Truck with back part that lets down. Factory made. Early 20th century. (1925-30). (Private Collection.)

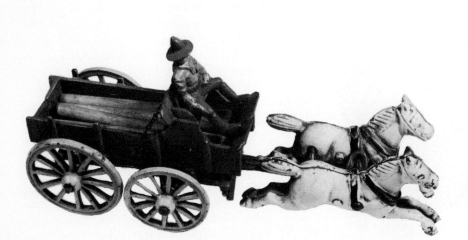

Log cart and driver with pair of horses, American manufacture. Toy is assembled from cast-iron sections. Painted in bright colors. Several toys of this kind came from Europe and U.S.A. at end of 19th century. (E. Pellerin, Trois-Rivières.)

Ceramic balls the size of baseballs, used for playing on the boulingrin *(Bowling Green), a popular activity in the Victorian period. 19th century. (Private Collection.)*

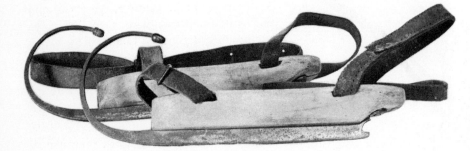

Skates of the 19th century. (Private Collection.)

its turn, activates the floor that is made of a sliding plate—and the little people, riveted to this plate, begin to wave at the car windows.

Fire engines, buses, trucks, automobiles also copied this technique, and specimens are still available on the current local antique market. Most of them are signed "Lehman's" and made in Europe.

Games of Skill

Games of skill, which must not be confused with toys, were also very popular in Quebec. Marbles of clay or blown glass, tops (turnips or spindle, depending upon whether they looked like a big turnip or whether they were made from an empty bobbin of thread), skittles of cedar or pine are the only remnants of those pastimes that were popular in Canada at the beginning of the last century. Nor must we forget to mention bowling balls, a sort of "French bowls" of

French-Canadian berlin with sides charmingly cut out. Decorated with motifs of stylized flowers; back of interior is garnished with lozenges painted to simulate quilted upholstery. Late 19th century. (I.N.C.)

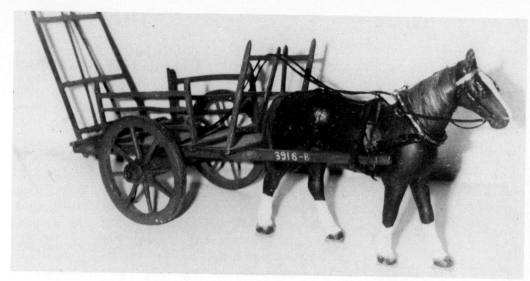

Cart, above, and single-seated berlin, below, each with harness and horse, were manufactured at the end of the 19th century. (Chateau de Ramezay, Montreal.)

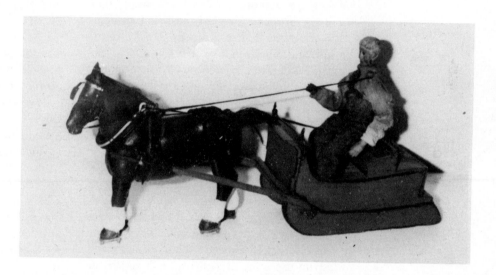

the end of the 19th century. Huge ceramic balls, ornamented with small flowers, stars, and lines, were used to test the skill of fans of this lawn game.

Snow Toys

Finally, we must say a word or two about outdoor toys that were especially popular in winter. The ice skate is undoubtedly the oldest form of amusement in cold weather, along with the snowshoe, for, as early as the 17th century, household inventories mention this article. Children's skates were not as elegant as adults' skates, whose wrought-iron blades curved up in scrolls somewhat like the high runners of certain "sleighs." They were usually made of old concave file forgings firmly attached to a wooden shoe, which was fastened to the child's boots with leather thongs.

Sleighs with iron runners were very popular during the French regime. The 19th century gave us the "*diable*" or bobsled, a plaything that required skill and, in a downhill run in the snow, compelled the driver to maintain his balance somewhat in the same way as in surfing.

Those, in brief, are some of the commodities of the past that filled the leisure hours of the young in former generations and which vestiges may still be found in local antique shops. Those handmade toys demonstrate a desire on the part of the parents of the past to amuse and entertain their children. They are tokens of love, tenderness, and interest which one can appreciate even more after reading Robert-Lionel Séguin's excellent book on *Old Quebec Toys*.[1]

1. Séguin, Robert-Lionel, *Les jouets anciens du Québec*, Lemac, 1969.

CHAPTER 14

Firearms and Sidearms

Firearms

In a pioneer society where nature is often hostile, arms become a daily necessity. For self defense as well as to hunt and feed themselves, early settlers used a great variety of guns and cutlasses. The danger from the Indians in the beginning, colonial rivalries, the need to find pelts, the basis of the economy for almost two centuries, were some of the pressures that led the first Canadians to select the best in weapons. Unlike furniture and other kinds of material goods, foreign innovations in weaponry were promptly snapped up in New France, for here a man's survival depended upon such articles. Regiments quartered on American soil and the militia had a gamut of light arms at their disposal.

Not only the importation of arms, but their improvement and manufacture were to become a salient factor in French Canada. A number of gunsmiths established themselves in the large cities in the early days of the colonization. It was their task to maintain and repair the guns of colonist, militiaman, or soldier while at the same time carrying on the trade of locksmith.

In this chapter we shall therefore attempt to study the technical evolution of guns, both military and civilian, to show the types and makes popular at the time of the French Regime, during the English Occupation, and even later, without failing to mention, as well, American contributions in the field. Not only shall we consider firearms—arquebus, gun, carbine, pistol, and revolver—but also sidearms—cutlasses, swords, and bayonets.

Technical Development of Firearms

Arquebuses and muskets were the first portable firearms Canadian pioneers used. The sole difference between each of these guns lies in the shape of the stock; in the musket it is much straighter and not as curved as in the arquebus.

Thanks to these firearms, many a pioneer was able to defend his interests. Maisonneuve and Champlain, Dollard des Ormeaux, or the man who lived on the Ile d'Orléans undoubtedly used them, for defensive and offensive weapons of this type, heavy and unwieldy, were in use here as late as 1670. Because of their weight the marksman was often obliged to lean on a gun support thrust into the ground in order to get the greatest possible precision. At the end of the 16th century the need for a lighted fuse at both ends of the gun to make sure it would fire led to the perfection, in Europe, of a new method of lighting the percussion caps.

Since stone rubbed against iron produces sparks, someone had the idea to fasten a stone between two layers of iron. This was called a hammer. In front of this stone and above the pan (a small hole containing the priming powder and placed outside the barrel), they set a grooved steel wheel-lock mounted on an axle. On being pressed, the trigger set the wheel-lock rotating rapidly and at the same time dropped the flint on it, causing friction which produced sparks that ignited the priming powder.

The first arquebuses, such as Champlain and the earliest colonists or soldiers may have used in their fights against the Indians, were without doubt of the fuse-arquebus type. They fired a volley every two minutes. The most nearly perfected of these firearms, the ones called "wheel-lock" appeared in the second quarter of the 17th century. This was apparently the type of weapon Dollard and his friends carried in the battle of Long-Sault. An able marksman could empty his gun twice a minute. Moreover, this latest improvement in portable firearms considerably reduced the number of misfires, since before this, only one shot in ten would go off.

It was also toward the middle of the 17th century that the cartridge first appeared.

Two percussion pistols;

Two flint pistols.

These three sheet-metal powder boxes were used at the end of the 19th century. The first two come from the Hamilton Powder Company of Montreal, and the third is stamped, "Sharpis, London." The box in the center – with its two hunters wearing wood snowshoes and dragging a dead caribou on a sledge over snow – was widely used. (P. de Granville, Quebec.)

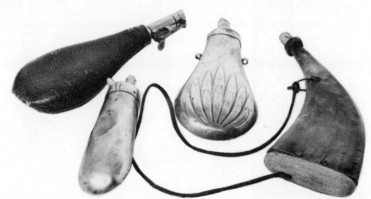

Leather shot pouch, two powder flasks for pistol, and settler's powder horn, all dating from the 19th century. Many powder horns which belonged to trappers had maps carved on them to help those adventurers find their way through the immense virgin territory of old Quebec. (Emile Pellerin, Trois-Rivières.)

Though it was not yet the convenient piece of ammunition that need only be inserted into the gun to be fired, nevertheless that invention was a notable improvement: it permitted the carrying in a paper wrapper all that was needed to fire a shot: bullet, wad, priming powder, explosive. All a man had to do was to tear open the cartridge with his teeth, pour part of the powder into the pan (that receptacle on the side into which the vent opened), and the rest of the powder into the gun. To wad the gun with a ramrod, introduce the bullet, and wad it a second time became, after a little practice, an automatic gesture for the hunter or the soldier.

In the first half of the 17th century, the straight-butt musket with much higher caliber than the arquebus was rapidly perfected. Then, in succession, appeared the pistol, a very light arquebus which is used at arm's length and which is the ancestor of the gun; the *poitrinal*, a weapon held against the chest for better aim; and finally, the blunderbuss, of more modest dimensions.

Toward 1660, those very heavy weapons were replaced by lighter and more delicate weapons called rifles, a name that has become generic for firearms that are portable. This is the type of weapon the Carignan-Salières regiment may have used with the wheel-lock arquebus.

In the rifle, the friction firing mechanism was replaced by the impact of a flint on a piece of steel. It was the advent of the flint-lock. The shape of the stone varied according to the types of guns used. Every thirty shots, the gunner had to replace the flint. Collectors thus talk about battery rifles, service rifles, or flint rifles.

Toward the end of the 17th century, in 1717, the French infantry adopted this invention, and there ensued a number of modifications or improvements which inevitably entailed a change of model. This happened in 1732, 1742, and 1754, which is the period that interests us. No doubt several rare specimens of these weapons may still be discovered here.

But all those flintlocks, which Wolfe's troops used on the Plains of Abraham in 1759, were short-range weapons and their accuracy was poor. To insert the bullet into the gun, the bullet had to be smaller in diameter than the barrel. The result was an appreciable displacement of air, entailing a loss of explosive power and inaccurate firing: two out of three times an average gunner would miss

a two-story house less than 500 feet away. A flint that wore out visibly and a gun that heated up so rapidly that the gunner had to wet it every thirty shots were some of the weaknesses of the weapon. This finally compelled hunters and military men to search for something better. The long barrels, a tube at least 44 inches long, explain the term "long carbine" given them in the U.S.A. The caliber, or diameter of the gun's bore, which had no grooves, was designed to receive large bullets. The more imposing fowling guns or shotguns of that era followed the same principles.

After 1687, the great military engineer, Vauban, improved the flintlock by adding a bayonet to it, a short blade mounted on a hollow cylinder. The cartridge case enveloped the end of the barrel without blocking it as had previously been the case. Firearm and sidearm were thus joined together in one weapon.

Until 1820, local troops and hunters were satisfied with the flintlock or battery gun, more or less long, more or less accurate and more or less practical depending upon the temperature. The arsenal of every hunter or militiaman was filled with a great variety of makes, most of them English. The most common of these weapons and also in greatest demand, was the "Brown Bess" which the conquering troops in garrison used until 1830.

The 19th century brought several transformations in the traditional firearm. They were generally improvements that revolutionized small arms: percussion priming, the rifling of the barrel, and breech-loading.

We have previously indicated the various ways of loading a gun: first a lighted fuse, then the friction of a wheel, and finally the impact of the flint against steel. Around 1820, priming with fulminate of mercury was to revolutionize the technique of firing in sporting guns. A single sharp impact was enough to detonate the primers, those brass caps shaped like a die that were kept in *amorcoirs*, flat boxes also of brass. These percussion caps are put in place by hand, on a sort of nipple that connects with the tube through the vent, and they detonate under the action of a hammer similar to the one on the old flintlock guns. The new gunlock, called percussion or piston, was to have several advantages. Dr. Alexander Forsyth is to be thanked for developing this device in England, in 1807, and Joe Manton, the greatest English gunsmith of the early 19th century, for its application.

Later, around 1840, the grooved barrel and breech-loading brought much more rapid handling and good precision in firing and really revolutionized the small arm. From then on, the paper cartridge was to combine an ovoid ball, some wadding, some powder and, in front of the latter, the fuse which set off a very long, very fine firing pin—whence the name for the first modern weapons called "needle guns." That overly long hammer

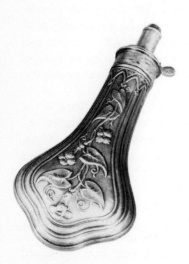

Brass powder flask decorated with flowers. English make. 19th century. (Emile Pellerin, Trois-Rivières.)

Powder barrel from the Hamilton Powder Company of Montreal. Used chiefly in the spring, to break up the ice pack on a river at logging time. Late 19th century. (P. de Granville, Quebec.)

Hunter's shot pouch, in leather. Mid-19th century. (Emile Pellerin, Trois-Rivières.)

Three powder horns. The first was used by the military in the 18th century; the second, ornamented with sawteeth near the top and brass nails at the base, is Indian; the last, and the smallest, was used for filling the vent with ignition powder. (Emile Pellerin, Trois-Rivières.)

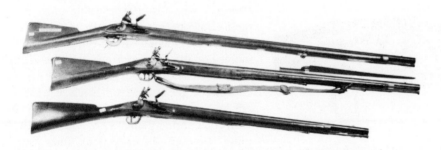

Three "Brown Bess" flintlock guns of the British army. From top to bottom: model 46, of the year 1763; model 39, c. 1795; and the "Cadette," c. 1820. (Emile Pellerin, Trois-Rivières.)

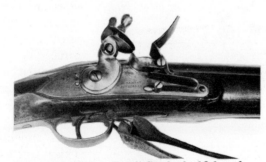

Action of "Brown Bess" flintlock, 18th and 19th centuries.

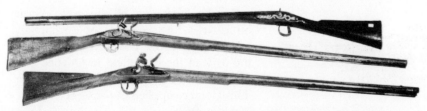

Top to bottom: 18th-century Morris gun, "Presentation" gun, flintlock trading gun.

was a passing weakness of the gun, for in 1854 a certain Mr. Morse perfected the cartridge clip with a metal cartridge case, thus introducing an important modification in the mechanism of strike and fire.

The second half of the 19th century was to bring improvements in the percussion gun and the breech-block gun, and for these large-scale changes, it was the Americans who were largely responsible. Discovery and exploitation of the West, danger from Indian tribes frustrated by unscrupulous invaders forced the pioneer to have a more rapid-fire gun—it was a matter of life and death. The repeating rifle therefore met a need. The first weapons of this kind that can be found in Quebec are rare articles, genuine museum pieces. In this category are the Colt of 1840, the Henry and Spencer of 1860 and the Winchester of 1862.

Arms Made in Quebec

Though the majority of weapons in use in Quebec were made abroad, nevertheless, according to records, several gunsmiths settled here at the beginning of the French colonization in the 17th century. Up to now, collectors and specialists in this field have been unable to attribute any pieces definitely to arms makers of New France, though there are serious doubts about some of flintlock guns with a stock made of local wood. However, it is not very likely that all the parts were made locally. The gunsmiths must have assembled barrels and locks of European make on butts carved or cut here, or they may even have repaired broken parts.

Not until the 19th century do we see one- or two-barreled guns, rarely pistols, come from any of the numerous work shops. Some weapons are marked with the name of the gunsmith or with his initials and the place where they were made. The wood of the butts, any indications as to whether it is hand-made or manufactured and the imprint of the maker are indices that should guide the collector in questioning the provenance of a weapon. Some arms makers used a stamped-in trademark. After examining the article, the collector must check to see whether the gunsmith, his mark, or his monogram are listed in Golding's volume. Otherwise, proceeding by elimination, by referring to the repertory of American and European arms, and checking to see whether such and such a mark or such and such a name is listed

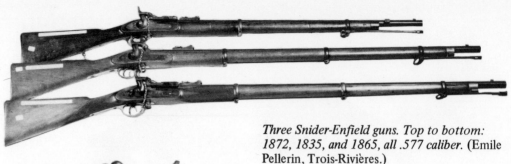

Three Snider-Enfield guns. Top to bottom: 1872, 1835, and 1865, all .577 caliber. (Emile Pellerin, Trois-Rivières.)

Action of a flintlock trading gun. This system was widely used from 1825 on. The percussion gun was leaded through the mouth of the barrel; the required amount of powder was emptied into the hollow of the hand, and was poured into the tube. Anything that could be stuffed in — dried leaves, exteriors of wasp's nests, paper — was pushed by the ramrod to the bottom of the barrel to hold in the powder and insulate it. Bullets or balls, depending upon the kind of game, were poured in. Then the ramrod was used again and put back in place under the barrel. The hammer was pulled to the stop catch, where a "cap" was placed on the vent. When the game was sighted, the hammer was moved to the second notch, and the gun was fired.

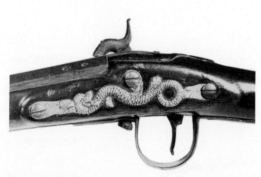

Plate with dragon motif of an 18th century Morris flintlock trade gun. (Emile Pellerin, Trois-Rivières.)

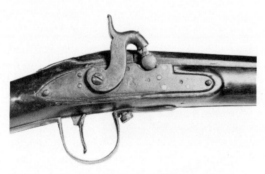

Action of a "Presentation" flintlock trading gun. (Emile Pellerin, Trois-Rivières.)

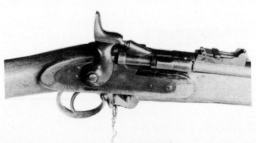

Mechanism of the Snider-Enfield.

there, one may, perhaps, succeed in discovering a new local armorer, up to this time unknown.

Even in the 19th century, many gunsmiths imported mechanisms and barrels from Europe or from the U.S.A. and assembled those pieces with genuine Canadian butt, often carefully engraving their name and their place of work on the side plate of the mechanism. The Golcher family from the U.S.A., for example, sent parts to the local armorers who made remarkable guns from them. But one must be wary of marks engraved on "Quebec" arms: not only the armorer but also the importer or the merchant, may have made many of them.

Most of the arms from such workshops are long percussion guns which the settler used for hunting game. The oldest "settlers' guns" have maple or walnut butts which run to the end of the barrel. Around 1860-70, the butt stopped at the middle of the barrel. In most cases, these local arms were engraved with floral motifs, geometric designs, and even representative scenes (landscapes, hunting scenes, animals' heads) scattered about here and there on the metal parts. The smallest parts, like the trigger, were often made with the greatest care. A few pieces were plated.

In the 19th century, the Boyd family from Montreal produced a large quantity of arms which are now pieces of French-Canadiana. This is true also of carefully made shotguns, even if a number of them may have been imported and stamped with the monogram of this maker-merchant.

At the beginning of the 20th century, Sir Charles Ross, a native of Europe, after a brief stay in the U.S.A., established near the park in the battlefield in Quebec a factory for making military and sporting guns. This factory supplied Canada's armed forces and also made more than one hunter happy, thanks to the remarkable accuracy of their weapons.

204

Armorers in Business in Quebec

Amiot, Jean (1679-1727), Quebec
Amiot, J.B.A. (1694-1749), Michillimachinac (fort Francais)
Amiot, Jean-G. (1635-1708), Quebec
Armstrong, William (C. 1882), Quebec
Barnesley, John (C. 1790), Quebec
Barthe (Bardet), Théophile (1720-1740), Montreal
Batchelor, Alexander (C. 1850), Montreal
Batchelor & Costen (C. 1850), Montreal
Beaudry, Guillaume (1657-1732), Trois-Rivières
Beaudry, Jean (1684-1755), Quebec
Beaudry, René (1707-1745), Trois-Rivières
Bédard & Bros. (C. 1850), Quebec
Bédard, François-P. (C. 1865), Quebec
Belleperche, J. (C. 1716), Quebec
Benoit, Jean (C. 1644), Quebec
Bidégaré, André (C. 1885), Quebec
Bidégaré, Félix (C. 1870), Quebec
Bienvenu, Hippolyte (C. 1850), Trois-Pistoles
Boisvert, G.S.C. (C. 1865), Sainte-Croix
Bonnet, Guillaume (1603-1709), Détroit (fort francais)
Bonneville, Alphonse (C. 1880), Montreal
Bourassa, Pierre (C. 1795), Quebec
Bourque, Joseph (C. 1870), Montreal
Bousquet, Jean (1642-1714), Montreal
Boyd, T.J. (1850 à 1900), Montreal
Boyd, T.W. (1850 à 1900), Montreal
Boyd, T.W. & Co. (1850 à 1900), Montreal
Boyd, T.W. & Son (1850 à 1900), Montreal
Boyd, F.J. (1850 à 1900), Montreal
Brehier, Jean (C. 1643), Quebec
Brodu, François (1692-1695), Quebec
Brown, Philip (C. 1800), Quebec
Bruneau, Jacques (C. 1805), Quebec

Cadieu, Jean (C. 1650), Montreal
Cahouet, Gilles (C. 1750), Quebec
Castagnet, Pierre (C. 1800)
Cavelier, Guillaume (1662-1708), Montreal
Cavelier, Jacques (1708-1743), Montreal
Cavelier, Robert (1626-1699), Montreal
Chasteau, Barthélemy (C. 1650), Port-Royal
Chauvin, Charles (C. 1715), Detroit (fort francais)
Chevalier, Joseph (1725-1793), Trois-Rivières
Cliche, Nicolas (1675-1687), Quebec
Coeur (Jolicoeur), Pierre (C. 1650), Quebec
Columbus, Isaac (C. 1820), Quebec
Cook, Patrick (C. 1885), Quebec
Cooke, George (C. 1860), Quebec
Costen, Thomas & Co. (1855-1885), Montreal
Costen, G.W. (1855-1885), Montreal
Costen, George F. (1855-1885), Montreal
Courtin, Claude (C. 1670), Quebec
David, Claude (1621-1687), Trois-Rivières
Débigaré, F. (C. 1825)
Delandaboure, Bernard (C. 1670), Quebec
De Lespinace, Jean (C. 1660), Quebec
De Rainville, Charles V. (1706-1757), Chambly
De Saintes, Etienne (C. 1665), Montreal
Doyon, Nicolas (1654-1715), Montreal
Drumont, T. (C. 1865), Saint-Denis de Kamouraska
Dulu, Charles (C. 1865), Rivière-du-Loup
Duminie, Charles (C. 1850), Montreal
Duncan, R. (C. 1880), Montreal
Dutartre, Gilles (1637-1682), Quebec
Duval, Joseph (C. 1755), Quebec
Fezeret, Claude (1660), Montreal

Fezeret, René (1642-1720), Montreal
Fisette, Joseph (C. 1870), Sherbrooke
Fréchette, Paul J. (C. 1860), Sainte-Luce
Gadois, J.B. (1641-1703), Montreal
Gadois, J.B. (1697-1751), Longueuil
Gadois, Pierre (1632-1714), Montreal
Gauvreau, Nicolas (1641-1713), Quebec
Gauvreau ou Gauvereau, Pierre (1674-1717), Quebec
Genaple, Joseph (1689-1717), Quebec
Gilbert, J.M. (1721-1779), Quebec
Gosselin, Barnaby (C. 1820), Montreal
Gosselin, Félix (C. 1845), Montreal
Great Western Lock & Gun Store (C. 1895), Montreal
Grouard, Jacques (1663-1702), Quebec
Guillory, Simon (1646-1696), Montreal
Guy, Jean (1641-1700), Montreal
Haley, François (1750), Quebec
Hall, Joseph N. (C. 1850), Montreal
Hall, Richard (C. 1850), Montreal
Hall William (C. 1850), Montreal
Harper & Smith (C. 1875), Montreal
Harper, William (C. 1875), Montreal
Hypolithe, George (1865), Montreal
Jegadeau, Louis (C. 1755), Quebec
Johnson, John (C. 1795), Quebec
Kennedy, John (C. 1850), Coaticook
Kilby, R.H. (C. 1875), Montreal
Klyne, Michael (C. 1870), Montreal
Laliberté, David (C. 1870), Quebec
Lamaison, Jean (1646), Port-Royal
Langlois, Jérome (1600-1684), Champlain
Latour, Augustin (C. 1750) Les Eboulements
Le Bouseme, Antoine (C. 1645), Montreal

(continued)

Lemieux, Zéphyrin (C. 1875),
Quebec

Lemire, Antoine (1728-1788),
Quebec

Lemire, Augustin (1737-1797),
Quebec

Lemoine, Louis (1847-1857),
Quebec

Létourneau, J.P. (C. 1800), Quebec

Loisel, Louis (1617-1691),
Montreal

Loslier, Pierre (C. 1870), Quebec

McLure, Pierre (C. 1775), Quebec

Manton, Joseph (1865-1890),
Montreal

Martin, Louis (C. 1650), Quebec

Matte, Alexis (C. 1870), Quebec

Mercier, Louis (1661-1728),
Quebec

Moffette, A. (C. 1790), Quebec

Morin, Joseph et Pierre (C. 1865),
Saint-Gervais, Bellechasse

Morin, Thomas (C. 1795), Quebec

Morneaux, François (1620-1688),
Batiscan

Morneau, Jean (C. 1670), Batiscan

McKacky (1782), Sorel

Natel, Antoine (C. 1608), Quebec

Nolin, Charles (C. 1790), Quebec

Nolin, Frédérick (C. 1870),
Berthier-en-Haut

Parent, J.-M. (1705-1755),
Terrebonne

Paillon, J.B. (C. 1870)

Paradis, Thomas (C. 1860),
Kamouraska

Parent, Joseph (C. 1860), Quebec

Parent, Pierre (C. 1850), Quebec

Parent, Jean (C. 1795), Quebec

Payan, L.J. (1722-1760),
Saint-Antoine de Chambly et
Quebec

Payne, George & Co. (C' 1895),
Montreal

Perrault, Peter (C. 1848), Quebec

Perthuis, Nicolas (C. 1690),
Pointe-aux-Trembles

Phelipeau, Charles (C. 1660),
Quebec

Pinet, Yves (C. 1698), Montreal

Piron, François (C. 1660), Montreal

Poirier, Michel (1677-1691),
Montreal

Poisson, Jean (C. 1650),
Trois-Rivières

Poitras, Antoine (C. 1865),
L'Anse-à-Giles

Praye, Nicolas (1661-1702),
Quebec

Prudhomme, Pierre (1658-1703),
Montreal

Quesnel, Olivier (1654-1719),
Montreal

Reneau (?) (C. 1790), Quebec

Rechaux, Antoine (C. 1795),
Quebec

Robert, John (C. 1865), Verchères

Robitaille, Charles (C. 1870),
Ancienne-Lorette

Sampson, R. (C. 1848), Quebec

Schmidt, E. E. (C. 1860), Montreal

Serra, Louis (C. 1805), Quebec

Shutts, Jacob (C. 1865),
Saint-Armand

Sinnett D. & Co. (1882-1890),
Montreal

Soullard, Jean (1642-1710),
Quebec

Soullard, J.B. (1678-1723), Quebec
and L'Ange-Gardien

Thibierge, Jacques (1664-1709),
Quebec

Tiblemont, Nicolas (1635-1660),
Montreal

Valin, François (C. 1750), Quebec

Vallet, René (1660), Trois-Rivières

Vallier, J.B. (C. 1790), Quebec

Valliquet, Jean (1653-1672),
Montreal

Guns Used for Barter

Among the weapons formerly in circulation in Quebec and greatly prized by amateurs, the guns used in trading with the Indians are the most sought-after. New France became a world center for supplies of furs and Quebec and Montreal were headquarters for large companies and merchants who held monopoly over territories as vast as continents.

The Indian, of course, supplied the various posts set up here and there throughout the territory to acquire precious furs—the basis of the colonial economy for almost two centuries and a half. The White Man offered in exchange products the man of the forest wanted: rum, whiskey, metal tools, glass beads, and ceramic ware, but also firearms and sidearms. For, from the first, the Indian had realized the superiority of those weapons over the bow and arrow for hunting and war-

fare, and he demanded them from the trapper, the intermediary of the big companies, who, for his part, was interested only in pelts and what they would bring him. So it happened that many merchants who owned houses in Quebec and Montreal, and who amassed colossal fortunes that are still intact today, as well as certain companies that had their headquarters in the large cities of the 18th and 19th centuries, scattered guns, liquor, and baubles widespread among the Indians, for it assured them of success in their commerce.

During the French regime it does not seem that trade arms specifically marked or initialed with the seal of numerous French or Quebec companies were used for that purpose. A few wheel-lock or flintlock guns can be found painted bright colors with a vegetable dye that belonged to some child of the forest, but there is no company or factory mark to corroborate this supposition. The

only thing one can be sure of is that those guns were certainly French. Guns from the Tulle factory (a town famous for its arms factory) and powder were sold to traders by merchant-outfitters from Montreal, but apparently without special trademarks.

This was not true of the English merchants, who identified their products very clearly. In 1783, the first Canadian-English trading company, the North-West Company, with its company headquarters in Montreal, was to mark its flintlock guns with a fox seated in the middle of a circle and facing toward the right. In addition, the side opposite the lock was usually decorated with a yellow brass plate representing a dragon fastened to the butt-stock by three screws. The arms were of English make, but stamped with the mark of the Canadian merchant.

The X. Y. Company, an offshoot of the North-West Company, also marked its barter weapons with the company seal. The Canadian-English companies' custom of marking their trading weapons no doubt inspired the ways and customs of the Hudson Bay Company. In fact, as early as 1670, after the discoveries and explorations of the two celebrated trappers, Radisson and Des Groseillers, this latter company settled in North America and, for more than two centuries, practically monopolized the fur trade in the territories of the Northwest and of the North.[1] Firearms became an important instrument of exchange in this business. A light flintlock, the hammer shaped like a gooseneck with the dragon plate motif on the side opposite the mechanism; the gun stamped with the picture of the seated fox looking toward the left in a circle half an inch in diameter and initialed HB; a bigger trigger-guard allowing one to fire with mittened hand—these are the chief characteristics of the Hudson Bay Company's trade gun. The motif of the fox, which a number of other companies were to use later on their trade guns, was first used by the Hudson Bay Company, which took it from their own well-known commercial escutcheon.

After the middle of the 19th century, this large-scale enterprise was to continue to exchange guns, which were then percussion guns and single or double barreled, with the same characteristic marks as their flintlock guns, but with, in addition, the initials HB or HBC engraved on them. A good many flintlock guns and trade guns also had their gun-lock plate improved by a percussion action.

1. Kildare Dobbs, *Les fourrures qui firent fureur (The Furs That Caused a Furor)*, adapted by Jean-Louis Morgan, McClelland & Stewart, Toronto, 1970, 128 pp.

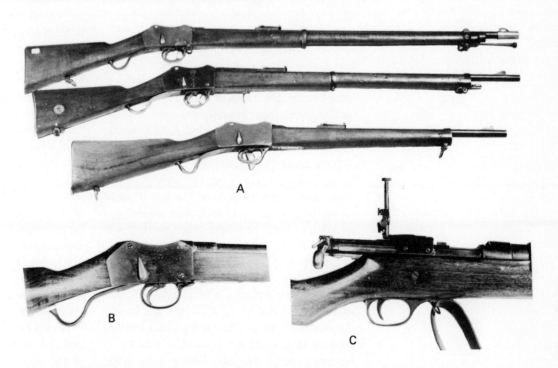

(A) Three Enfield-Martinis. From top to bottom, the 1878 model, the 1896 model, and the short Martini-Enfield-Metford of 1893, a transition weapon between the Snider and the magazine Enfield. English make. (Emile Pellerin, Trois-Rivières.)*; (B) Mechanism of the Martini-Enfield; (C) Mechanism of the Ross gun (see next page).*

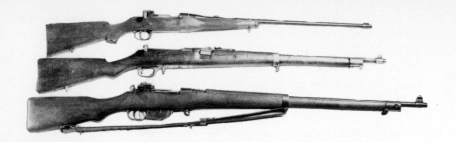

Three Ross guns. Top to bottom: the sporting model of 1910, caliber .280; the 1905 model, a .303; the 1919 model, a .303 engraved with initials H.G. – B. of M., probably the weapon of a guard at the Bank of Montreal. (Emile Pellerin, Trois-Rivières.)

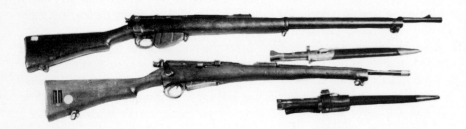

Two Lee Metfords and their bayonets. Top to bottom, the 1896 model and the 1898 model. English make. (Emile Pellerin, Trois-Rivières.)

Jacob Astor's American Fur Company, established in 1805, used the same identification marks, the fox seated in a medallion, but the initials I.A. (I for J) specified the origin of these arms. Some of those guns are still to be found in Quebec, formerly the world center of the fur trade.

Barter arms were sometimes painted red, like those manufactured by the Boyd company of Montreal at the end of the 19th century. The Indians' yearning for beauty was also shown in some of the wood carvings or engravings on the butt or even by designs representing the cross, a star, or a flower, outlined with short brass square-headed nails up to 1840 and round-headed nails toward 1850.

Some trade guns presented to chiefs or to great Indian warriors, much lighter than those usually exchanged, had a bear's paw carved on the butt or even a silver medallion on the back of the butt, representing an Indian's head wearing feathers, with bow and quiver filled with arrows. I have had an opportunity to examine one such gun at the home of Emile Pellerin, a knowledgable collector and amateur machinist of Trois-Rivières, and one can see on the lock of these guns an etching of the head of a wild boar looking toward the left, facing a hunting horn. For more information about trade guns, the reader should consult Charles E. Hanson's magnificent study, *The Northwest Gun*.

Inscriptions on Arms

In addition to the maker's insignia, there are several kinds of inscriptions that can be distinguished on the barrel, the mechanism or the butt of many firearms in use in the past. In some instances, they are letters; in others, as noted in the section on trade guns, there is a pictorial design. Old percussion guns of the Snider-Enfield type, for example, have on their butt, in a specially reserved triangle, the letters D.C. (Department of Canada) or C.M. (Canadian Militia) or even L.C. and U.C. followed by a letter and a cipher (Lower Canada and Upper Canada), the letter indicating the regiment and the cipher being the soldier's number.

Other guns, not so old—the Enfields for example—were engraved with the monogram V.R. (Victoria Regina) surmounted by a crown. One often sees a broad arrow too, which is quite simply the mark of the British Government which was used to mark government property from the middle of the 18th century. England also used this mark on various tools, implements, or arms belonging to the state. The arrow is usually surrounded by the letters B.O. (British Ordnance) or I.D. (Indian Department, instituted April 15, 1755).

Several arms, especially the Winchester carbines or the Colt or Dean & Adams revolvers of the last quarter of the 19th century, used by the Canadian Royal Constabulary, are engraved NWMP or RNWMP (North West Mounted Police, Royal North West Mounted Police, and Royal Canadian Mounted Police).

All firearms and even sidearms, bayonets, and swords in use during the English Regime by the regular troops or the local militia bear the inscription of the reigning monarch. These are clues that permit the amateur collector to date a piece quickly. On the butt of some guns from the end of the 19th century, the monogram of the Canadian government, a "c" in a circle, will appear. As for marks of French, English, American, or Canadian manufacture, one should by all means consult the descriptive catalogues that specialize in dating and authenticating arms.

In the field of guns, too, it is well to beware of fraud. More than one firearm on the market is a copy, often exact, of old pieces at prices that rival the cost of gold. There are also semi-fakes: the barrel of a broken gun is fitted to a butt in good condition; the lock is entirely fabricated or taken from an-

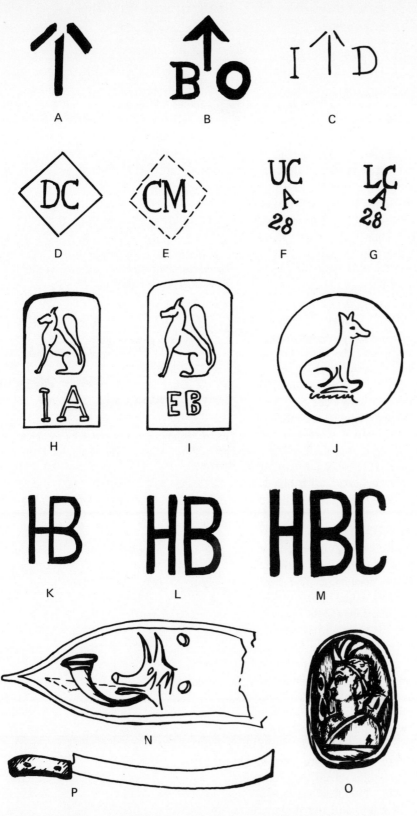

Different insignia or stamps on firearms found in the Province of Quebec: (A) Large government arrow (English or Canadian); (B) Mark of the British Ordnance; (C) Indian Department insignia, English; (D) Department of Canada; (E) Canadian Militia; (F) Upper Canada; (G) Lower Canada; (H) Insignia of Jacob Astor, fur trader, found on some trading guns; (I) Hudson Bay Company stamp, seen on their trade guns; (j) Northwest Company insignia; (K-L-M) Hudson Bay Company initials on their trade guns; (N) Plate ornamented with a wild boar's head and hunting horn, seen on trade guns; (O) Medallion, generally in silver, found on trade guns presented to Indian chiefs or to outstanding warriors; (P) Trade knife used by Quebec Indians in making birch bark canoes.

other gun. And the trick works: there is a gun that some good soul who wants an ornament for his drawing room mantelpiece will buy in some antique shop. There is also a fad for long carbines that will inspire clever craftsmen to solder two barrels end to end and so create a new gun six to seven feet long. And he who can discover the subterfuge will be very shrewd indeed.

Those who are interested in knowing more on this subject, whether specialized amateurs or collectors in embryo, should consult the wide variety of books and brochures that deal with the subject of arms. The reader will find the main publications concerning Quebecois and Canadian arms in the bibliography.

There is also in the Province of Quebec an organization, The Association of Arms Collectors of Lower Canada, which for more than ten years has published a magazine amply supplied with illustrations and engravings: *The Canadian Journal of Arms Collecting*. This is a unique source of information that one should make haste to buy, if all the numbers are still available. Firearms of the French or English Regimes, bayonets, sidearms, publications, information, announcements are among the subjects treated in this magazine, which will prove most useful to collectors, antiquarians, and specialists.

The Association of Collectors of Arms of Lower Canada comprises collectors of all types; some of them possess up to three or four hundred weapons which are often museum pieces. This club, as Emile Pellerin of Trois-Rivières (himself an avid collector of arms) has said, aims at establishing contacts between those who have common interests in preparing exhibitions, in teaching amateurs, and also, of course, in promoting exchanges between collectors.

For further information, write to the Association of Collectors of Arms of Lower Canada, C.P. 1162, Branch B, Montreal (Quebec).

Sidearms

Sidearms are offensive and defensive weapons in metal: knives, bayonets, swords, cutlasses, armor. If we want to stretch a point the flint weapons used by the Indians can be included in this group.

A collector of arms should certainly own some of the stone weapons. They are rare

articles in antique shops, but they reflect accurately the level of civilization of the early settlers. Two-sided knives, arrowheads, stone hatchets are the most typical of prehistoric armaments: but one would have to explore sites of some old Indian camps with techniques used in archeological digs to find any, for they are not on the market.

The French produced iron hatchets which replaced the tomahawk of stone or hard wood. Not only the Redskins but also the military of New France were to use these weapons in surprise raids on English settlements in the 17th and 18th centuries. Soldiers, dressed like aborigines, their faces smeared with warpaint, hurled those hatchets, originally intended for the fur trade, with extraordinary skill.

There are two major types of barter hatchets: iron tomahawks shaped like a coulter (wood chopper), and the pipe tomahawk, in which the part opposite the blade terminates in a removable pipe bowl that can be unscrewed. The handle, drilled or burned through from end to end with a red-hot iron, acts as the tube through which one inhales. A number of those tomahawks were stamped by the maker: several dots, assembled in various designs, are used as symbols. Many of these tomahawks are decorated with bleeding hearts, stars, clover leaves, and delicate geometric motifs.

Armor was undoubtedly in use in the first half of the 17th century. It is an extremely rare collector's item and difficult to attribute to any local historical personage. The steel helmet, the casque, often called *"pot-en-tête"* (head pot) or the morion (high-crested, visorless helmet) are the most widely known among the pieces of armor worn in Quebec. There is also the corselet, shaped to the chest that protects the top of the body, elongated by tassels of overlapping metal plates or chain mail from the waist to halfway down the thigh. Brassards, an assembly of mobile rings that permit a relatively limited movement of the arms, protect from sword blows. Throat and hands are also given a certain amount of protection. The first explorers, those of the 17th century, and the military who served at that time, undoubtedly wore armor, but, to our knowledge, none of it exists today.

To turn to more conventional sidearms, the bayonet of the 17th century was inserted into the gun barrel which it stoppled. Its wooden butt terminated in a plug that could be thrust into the weapon once the ammu-

Hatchets: bottom two are French barter hatchets; top hatchet was not a weapon, but a hammer to mark wood logs in the local lumberyards of the 19th century. (Emile Pellerin, Trois-Rivières.)

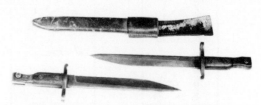

Two short bayonets with sheaths for Ross guns. Early 20th century. (Emile Pellerin, Trois-Rivières.)

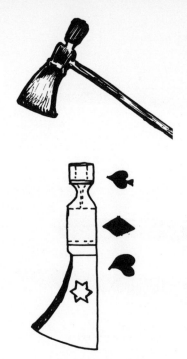

Pipe tomahawks.

nition was exhausted. This was the type of arms used by the soldiers of the Regiment de Carignan on their arrival in New France.

The bayonets on the "Brown Bess" were triangular, but the underpart of the blade was not so concave and slightly broader than the other two sides. Those on the Enfield were always triangular and long (about two feet), whereas the Ross bayonet, some fifteen inches long, had only a simple blade.

As for swords, those of the 17th century had a more pronounced cup shape guard than do fencing foils today, and the blade was flat, long, and slim. The sword with a hilt shaped like a basket—a kind of ribbon that encased the handle, in turn elongated by a broad blade tapering toward the point—was worn by noblemen in the colony of New France.

In the 18th century, the rapier (lighter than the sword or fencing foil), with its rather shallow, cup-shaped guard surmount-

ed by a protecting loop, was very popular. Short sidearms—poniards and daggers—were the same shape as the long pieces.

During the English regime, the blades of Moles and Wilkinson (English manufacturers), embellished with a basket-guard decorated with the monogram of the reigning monarch, were general among the military of the colony. They were much like those decorative arms still worn by officers of the Canadian army with their gala uniforms. A number of the sidearms worn by the Quebec militia in the 18th and 19th centuries were probably of local make. Most of them resembled a steel blade with a riveted wooden hilt, the latter separated from the blade by a plain metal crosspiece elongated by a hand guard shaped like the handle of a basket (T-shaped hilt). A number of these weapons were initialed with the same trademarks found on many army guns used by English troops in the last century.

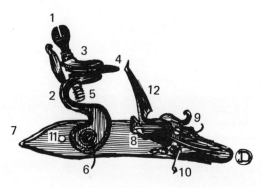

Trade hatchet.

External view of flintlock: (1 & 5) Law screws; (2) Hammer; (3) Lower flange; (4) Flint; (6) Hammer nail; (7) Complete gun plate lock; (8) Pan; (9) Screw that holds battery on lock; (10) Battery spring; (11) End of longest of two screws that fasten strap from the other side of the lock; (12) Battery.

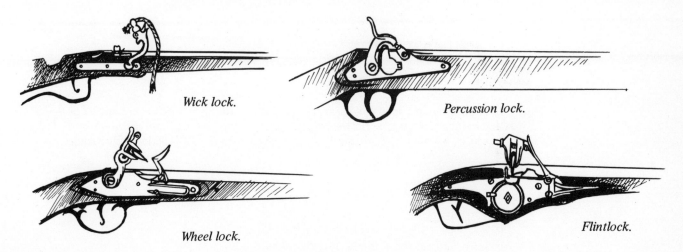

Wick lock.

Percussion lock.

Wheel lock.

Flintlock.

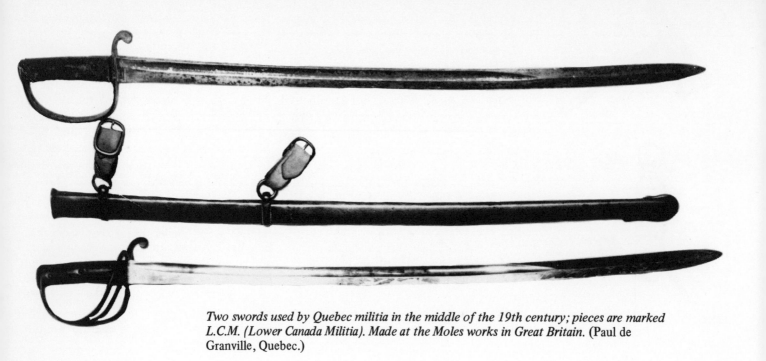

Two swords used by Quebec militia in the middle of the 19th century; pieces are marked L.C.M. (Lower Canada Militia). Made at the Moles works in Great Britain. (Paul de Granville, Quebec.)

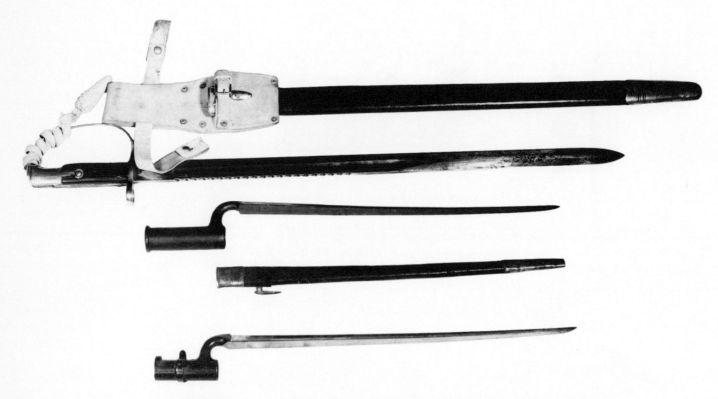

Three bayonets and their scabbards. The first is an artillery sword-bayonet used with the Martini-Henry; the second fits on the barrel of the "Brown Bess," and the third, triangular, is joined to the Snider-Enfield. 19th century. (Emile Pellerin, Trois-Rivières.)

CHAPTER 15

Papers, Books, Stamps, Money, Medals, and Buttons

Papers, Books, Stamps

One often discovers, in a garret or in some antique or second-hand shop, old manuscripts, sales catalogues, account books and invoices, "scrapbooks," transactions of some firm, fragile and yellowed newspapers, playing cards, maps, postcards, old sheets of music. Piled up in a corner of the house or hidden in some cellar bin, mildewed from dampness, all this old paper is only waiting for the next spring housecleaning to have its fate settled forever.

All those documents are interesting to a variety of specialists who seize on them in the hope of knowing more of the man of yesterday and of explaining and better understanding the man of today. Every scrap of handwritten or printed paper is testimony of an era, an event, a situation; more than having a certain sentimental value for the amateur collector, it has an undeniable scientific value.

Handwritten Documents

Papers of particular interest to the historian and the collector are old personal diaries or handwritten letters, even if the authors are not people of prominence whose names are in the Canadian Biographical Dictionary. A college student's diary, that of a country doctor, or the village curate are rare articles that a historian can use to explain mentality or social attitudes, or that an amateur will be proud to show to his friends. Moreover, it is a type of document in great demand, for it is fairly rare in Canada.

Letters, too, are important. All correspondence is an exchange of thoughts on specific matters of the day, personal reactions to life and destiny, political, philosophical, or religious opinions. Those are some of the things that revivify the people of old Quebec and tell much about their interests, their anxieties, pleasures, and aspirations.

Merchant and Industrial Catalogues

Among all that old paper in cellars or garrets, musty with mildew, one often comes upon old merchants' catalogues or fashion magazines. As it was not always possible to go to the big centers or to communicate with business houses, the general storekeeper and rural dweller of other times, annually received catalogues of the latest novelties, the kind many large department stores continue to distribute today.

These catalogues are very interesting nowadays. Some of them will be found at the homes of shopkeepers who have closed their doors, their businesses killed by too much competition from the big commercial corporations; or among all the bric-a-brac of an enterprise that failed. Catalogues dating from before 1920 are the most useful and interesting to the researcher.

Whether of lamps, glass pieces, vehicles, pottery, or furniture, such catalogues are without doubt documents that reveal much about the fashions of the times.

Account books and records of old invoices will yield information about the needs of a locality and of a social group at a given epoch, and can tell much about the incomes and tastes of certain classes of people.

Scrapbook collections of photographs of times past, clippings from the newspapers and magazines, or even of inventions patented several years ago will be of the greatest interest to engineers, historians, or collectors of old cameras.

Old Newspapers

The newspaper, that perishable article that 24 hours after it appears on the stands is worth nothing at all, becomes quite valuable with time. Collections of Quebec newspapers of the 19th century are so rare that such publications are not even found on the shelves of many university libraries. For several years now, specialists in social sciences have taken more and more interest in studies of the press. Old newspapers dating from before 1925 are documents of great sentimental, and often historic, value.

Old Maps

Geographical maps in old newspapers have always been especially popular with some collectors. These maps can even help the historian or the archaeologist to place certain structures that disappeared centuries ago or even to settle certain property litigations.

Maps of the 17th and 18th centuries deserve very special attention. Generally hand-drawn, they helped many explorers, adventurers, trappers, or scholars to trace the places they visited. Powder horns, parchment, wood, bones, thick paper are the various kinds of materials used for maps best known here. The outline of locations was engraved, carved, chiseled, painted, or even burned on the material. To have an interesting idea of these maps, some of which are veritable masterpieces of printing, one should consult *l'Atlas historique du Canada français*, by Marcel Trudel, published by *les Presses de l'université Laval* in 1961. More than one amateur collector is a buyer of rare old maps. Archivists and librarians are also on the watch for them.

Playing Cards

Quite a few amateurs collect playing cards. These are often rather elegant, in excellent taste, and command exorbitant sums from the interested enthusiast. Very old cards were handpainted and usually made in the Orient. In that case, they are museum pieces in great demand. Instead of the usual figures, some cards commemorate an event: an exposition, a coronation, etc.

Like old valentines, postal cards also have "fans" whom an antique dealer always manages to reach. Card lovers are much more numerous than one thinks. Such collectors should read the excellent book by Ado Kyron entitled *The Golden Age of the Postal Card*, published recently by André Balland. The first postcards are said to date from 1870; it was a propaganda practice that Germany used in France at that period to undermine the morale of the populace. Around 1895, at a time when the 1874 postal treaty of Berne admitted France as one of the countries of the postal union, the postcard entered its golden age. Its half rate, compared to the normal postage for the ordinary letter, resulted in its widespread use by the masses. In Quebec, at the beginning of the 20th century (and even a few years before) this custom was in general use; portraits, photographs, or sketches of public places were common themes.

Old railway tickets or tram tickets are much in demand by collectors of mechanical or electric trains. The market for all these articles relating to pioneer means of transportation is surprisingly large.

Sheets of Music

All old music sheets of the 18th and 19th centuries, both handwritten and printed, and made by local artists, are definitely collection pieces. Many intellectuals in past centuries had some knowledge of music and played an instrument; it was not unusual for these people to entertain their guests with music at frequent winter social gatherings. Thus Napoleon Legendre, that erudite gentleman from Quebec, author of a vast number of magazine articles at the end of the 19th century, was famous for the musical evenings he gave in his residence facing the old Université Laval. His own compositions, of which, unfortunately, very few remain, were often played. More than one popular piece at that time, with words and music signed by a *bon vivant* of Quebec, is today completely forgotten or has been lost. The same is true of those troops of actors who wrote their musical sketches and toured the province at the turn of the century. An old sheet of music is a manifestation of intelligence no music-lover would disdain. This has been a growing field for several years.

Old Books

If there is one object we are apt to discover in the home and that many amateurs collect, it is a book. Indeed, according to a Quebec tradition, numerous scholarly prizes were distributed annually to pupils, and in this way many literary men and women saw their works disseminated among urban and rural circles alike.

Even today, numerous homes still own some of those provincial novels, bound in red and decorated with gilt tooling. It would therefore be interesting to know what makes a Quebec book valuable, how to sell or to buy such books and, finally, what the production was in this field.

It should first be stated that a book is not sold by the pound. The large folios are therefore not necessarily the most in demand nor the most precious, but very often pamphlets of only a few pages or rare brochures are the ones that will interest the bibliophile or librarian. The binding has little importance. What is rare is not the shape, weight, or outward appearance, but the content.

The first quality demanded by the lover of old books is integrity. It goes without saying that a book in which several pages are missing loses any attraction for the collector. Next, one must note the date of the edition, which will be found on a page or two before the beginning of the text. A first edition has enormous value, especially if the volume dates from the 19th century, for it was around the year 1800 that Canadian presses first began to function. The French regime had imported manuals and books to fill its needs. Any volume published in Quebec before 1840 deserves to be labeled "incunabula," as is done in Europe for books printed in the 15th and 16th centuries.

Occasionally, books printed in France in the 17th or 18th century and artistically bound in leather are discovered in attics or libraries of old houses. Most of them are histories, biographies of saints, or apologia for Christianity. In spite of their age, these books are not as interesting, nor are they as rare as books printed in Quebec. One should not, therefore, consider these articles unique. Most of the libraries in religious communities for generations have filled their shelves with such works to nourish the minds of their flocks.

Every Canadian first edition in good condition, therefore, that was printed in at least a thousand copies in the 19th century—and even some from the 20th century, as we shall see later on—deserves special attention. If the volume is dedicated and signed by the author, this, of course, makes it rarer, and increases its value. Moreover, if you are lucky enough to come upon a numbered copy of a work printed in a limited edition of only ten or twelve copies, you have a museum piece. It is customary for an author to have a certain number of volumes printed on special paper, numbered, and dedicated to a friend or to some person of importance. Those, briefly, are a few important criteria for evaluating the rare book printed in Quebec.

Now, how can one sell these old volumes or, inversely, how to procure some with which to start or complete a collection?

The first thing to do is to get in touch with an old-book dealer. They can be found in all large cities and the Yellow Pages of the telephone book under "Book dealers, used and rare books." The dealer, who has a name and a reputation to defend as well as a professional ethic to respect, will try to give an honest estimate of the true value of books you want to sell. If you doubt his integrity, you can consult a price list of old books, like *Current Canadian Book Prices* by Robert Hamilton, published in Ottawa in 1957 and kept up to date.

Among 20th century publications printed in Quebec, history books and social studies of the milieu or of the Indians—novels, biographies and collections of poems—are the most popular. As for historical studies, the original works of Garneau, Ferland, Sulte are without doubt the most interesting and most in demand, but there is a series of regional monographs like the *Memoires sur le Canada* of the Literary and Historical Society of Quebec, published in 1838, or *l'Histoire de l'île aux Coudres*, by Alexis Mailloux, published in Montreal in 1879, which are chacteristic of this genre.

The social sciences were far from being part of the interests of Canadian intellectuals, for that branch of learning was just taking its first hesitant steps in the world at the beginning of the 20th century. And yet, in Quebec, several scholars were deeply interested in their environment: we need mention here only the *Mémorial de l'Education du Bas-Canada* by J. B. Meilleur, printed in Montreal in 1860, or Napoleon Legendre's thoughts on *Nos Ecoles*, in 1890.

The literary men of that day were interested not only in urban and rural life but also in Indian ways. And today, anything

concerning the modes and customs of the aborigines is a much sought after collector's item. The same is true also for accounts of archaeological excavations or for any 19th century publication of a scientific nature.

Biography has always been a favorite form, and the studies by Chapais at the beginning of the 20th century or Casgrain and others in the 19th, are not to be found on the market unless by chance—at a few old-book dealers, and only at high prices.

Novels and collections of poems also have their collectors. When illustrated by engravings, texts of this type are even more valuable, as, for example, Louis Hémon's book, *Maria Chapdelaine*, which, in the edition illustrated by Clarence Gagnon in 1923, now sells for $450. Any work containing sketches by Gagnon is such a rarity today that all of them have become collectors' items for the wealthy.

There are many almost contemporary publications that are also the objects of intensive research. A number of the works of the documentarian, Pierre-Georges Roy, are out of print and, because of the limited editions, as well as the originality and documentary value of many of these works, they bring surprising sums from collectors. It is more and more difficult to obtain that magnificent study, *Vieux manoirs et vielles maisons* (Old Manors and Old Houses) or *l'Ile d'Orléans*, which are two subjects fairly indicative of the nature of his work.

All works from the 19th and 20th century dealing with historical monuments have a definite value for, most of the time, the edition of those works was very limited. Texts of certain periodicals illustrated by photographs, especially if they have been slip-sheeted or tipped in, are also collectors' items.

Not only are the works of native authors printed in Quebec much sought after by collectors and librarians, but also works about Quebec written or printed abroad. We have already mentioned Louis Hémon's book, but the range of studies of all kinds that appeared as the result of a journey or of a sudden interest in Quebec is most varied. We can cite the work of Nicolas Perrot, a 17th century trapper, entitled *Sur les Moeurs, Coustumes et relligion des sauvages de l'Amerique septentrionale* ("The Customs, Costumes, and Religion of the Savages of North America"), published in Paris in 1864, by the Librairie A. Franck in a collection of unedited or rare works on America. One may also add the names of those foreign travelers whose writings have great value: Peter Kalm, Louis Franquet, Lehontan, Belmont, Bacqueville de la Potherie, and a number of others who, through their curiosity, give readers an opportunity to enter into the lives of pioneers. The exploration of the north, various techniques, the automobile, sports, all these are fields of action in which bibliophiles extend a helping hand, for the materials are scarce.

Price List of Some French-Canadian Books

These prices are correct provided the book is in good condition, that there are no torn or stained pages, and that it has not deteriorated or been mutilated.

Alonié de Lestres (Lionel Groulx) *L'appel de la race,* Montreal, 1922, 278 p.	$ 6
Garneau, F.-X., *Histoire du Canada depuis sa découverte jusqu'à nos jours,* Quebec et Montréal, 1845-1852, 4 vol.	$100
Hémon, Louis, *Maria Chapdelaine* (illustrations by Clarence Gagnon), Paris, Mornay, 1933. unbound	$450
Huston, Jean, *Le Répertoire national ou Recueil de littérature canadienne de 1734 à 1850* (Montreal 1848-50) 4 vol.	$ 85
Le Jeune, L., *Dictionnaire général du Canada,* Ottawa, 1931, 2 vol.	$ 50
Palardy, Jean, *Les meubles anciens du Canada francais,* Paris, 1963, 192 p. (French edition)	$ 70
Rouquette, L. F., *Le grand silence blanc* (illustrations by Clarence Gagnon), unbound edition	$450
Rumilly, Robert, *Histoire de la Province de Quebec,* 42 volumes	$250
Roy, Pierre G., *Vieux manoirs, vieilles maisons,* Quebec 1927	$ 50
Roy, Pierre G., *L'Ile d'Orléans,* Quebec, 1928	$ 50

Stamps

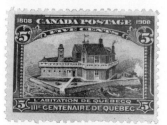

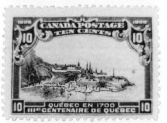

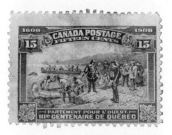

It would be impossible to tell the whole story about stamps, money, and medallions in a few paragraphs. To attempt to exhaust these subjects in only a few lines would be to demean the sciences of philately and numismatics. Nevertheless, one cannot speak of old things and of collectors without giving some sort of mention to the large and well-organized field of stamp collecting. Who has not at some time collected old stamps "for the missionaries" or for personal pleasure? It is true that we are all drawn to the exotic, but that does not mean that Canada has not produced anything original and precious in this field. An old envelope or an ancient franked postcard, discovered tucked away in some small box—the stamp could very well be a treasure for collectors.

In Canada there are three major kinds of stamps in slightly varied formats. The first group, undoubtedly the most common, is the portrait of an English monarch or of a famous Canadian statesman: Elizabeth II, George VI, Victoria, Laurier, Tupper, Macdonald. There is also the series of commemorative stamps: political events, far-flung discoveries, etc. serve as opportunities for the government to bring out a special issue of stamps. Quebec's tercentenary, in 1908, was one of these occasions immortalized in a series of stamps. And finally, in the third group, there are local scenes or landscapes, sports, fauna, and flora that inspire engravers.

There is no specific Quebec production in this genre, because the stamp did not appear until after the Confederation, and then it became Federal responsibility.

Among the most interesting and rarest Canadian stamps are the 12d black and the 2-cent green of 1868, with a picture of the young Queen Victoria, crowned; cream-laid paper was used. These stamps have a sure value of several thousand dollars in the world of well-to-do amateurs.

It goes without saying that the value of an old stamp varies enormously according to the condition it is in. A new stamp can be ten times more valuable than the obliterated stamp. Moreover, the material used, in this case, the paper, can influence the sale price, for certain stamps have been printed on different papers; or some species are rarer than others.

The most valuable stamps are printed on cream-laid paper, which is striped with vertical, horizontal, and diagonal lines. There is also vellum, commonly used in making postage stamps. This is a plain paper, without any visible mark either inside or on the surface when examined under a strong light or magnifying glass.

The third type can be recognized by its vertical and horizontal lines on the surface itself: this is striated paper. Watermarked paper retains certain internal marks that can be noticed on examining it in a strong light from behind. It is a quality woven paper marked on the inside, as one sometimes sees in some kinds of letter paper.

And then there is fine paper which looks silky and is soft to the touch and very pliable between one's fingers.

Stamps are usually perforated on the sides. Others, more rare, are smooth. The perforation is a means of evaluation, as can be ascertained in the general guide books. It has to do with a kind of measurement of the number of denticulates in the serration within a space of 20 millimeters. For example: *Perf 15* means that in the space of twenty millimeters on the side, one should find fifteen holes. There is a special instrument to help the collector verify the perforation.

For more information the reader should consult the general catalogues of Canadian stamps mentioned in the bibliography.

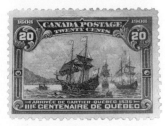

Series of Stamps commemorating Quebec's tercentenary. (Séminaire de Québec.)

Coins and Paper Money

The collector of the money of Quebec and of Canada has the benefit of a broad spectrum of pieces, since, in addition to money produced here in the country, France and England for a certain time had their own monetary species in circulation in their colonies. The French regime left a bequest of hard cash in silver and paper money. The metal pieces were struck off in different materials, but copper, nickel (alloy of copper and silver), silver, and gold are the only ones known.

Deniers, liards, and *sous* (all names for the penny) are coins of base metals: copper and nickel. The small *louis,* the *écu,* the *piastre* or dollar were coined in silver, while the big *louis,* the *pistole,* and the Portuguese *guinea* were of solid gold.

All these coins of the realm usually bore the effigy of the French monarch on one side and emblems of the royal family on the other. Paper money was without doubt a specialty of the French regime. In fact, after 1685, the Administrator Demuelle was to invent "card money" to meet the needs of the colony. There was no longer enough money to cover transactions because people were hoarding coins. Granted that the pay of officers and city officials was often delayed, cash for current exchanges was just as often lacking. Demuelle then had various sums inscribed on playing cards and set his seal to them. When the king's ship arrived, the Deputy of Finances redeemed this card money for hard cash. This practice persisted until the Conquest.

Until 1714 this money consisted of colored playing cards, decorated with hearts, spades, etc. However, after 1729, as the result of a general demand, they were plain white cards with the corner turned down or cut off depending upon an established system: the whole card was worth 24 *livres;* with a corner turned, 12 *livres;* three-quarters cut, 6 *livres;* three-quarters turned down, 3 *livres;* half a card, 30 *sols;* half-card with corner turned down, 15 *sols;* the quarter of the card, 7 *sols* and 6 *deniers.*

Numismatic amateurs can specialize also in English money which was in circulation in French Canada from 1760 to 1867 (and even later, in certain provinces). The whole English monetary system, with its pounds, shillings, etc. was exported to th colony.

Money that is specifically Canadian is very attractive to collectors, because the most precious pieces and those most in demand among the coins that circulated in Quebec and in Canada came into being with the Confederation. Consequently, the counterfeiting of certain pieces has become popular. The gold $5 piece of 1914 valued at $250 is today counterfeited by certain foreign specialists.

The value of a coin depends upon its condition. The specimen that had no scratches on it and that time has not damaged too much is certainly worth much more than the official stamped value.

The price a collector is ready to pay is often explained by a slight modification in the minting. Thus it is that in the "*cent noir,*" or "black penny" (as they say) of 1936, a simple dot under the space between the 3 and 6, between the date and the rim of the reverse side, fixes the value of this coin at $2,000.

Many merchants, like the Hudson Bay Company, also had their own barter money which was used by the Indians and colonists of the virgin territories. Those coins often have a value higher on the collectors' market than the initial value. In any event, a good guide in numismatics, which can be purchased for less than a dollar, will give more information on the actual price of interesting articles.

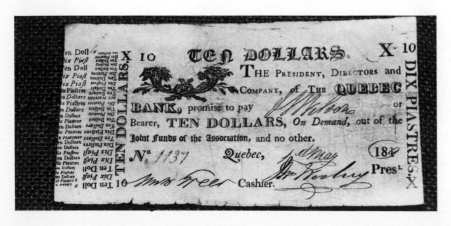

Ten-dollar bill from the Quebec Bank.
(Séminaire de Québec.)

Token used at the beginning of the 19th century by people who used the crossing at Lauzon. A number of companies, especially trading companies, issued tokens that served as a means of exchange in territories under their jurisdiction. (Séminaire de Québec.)

Card money used under the French Regime. Simple playing cards, either cut or with their corners turned down, were given a fixed value guaranteed by the signature of the Administrator or of the Governor. (Séminaire de Québec.)

List of Prices: Tokens, Coins, Paper Money, etc.

Price list of a few tokens, coins, paper money and card money that had formerly circulated in Quebec.

For fuller information on this subject it would be well to obtain Canadian guides specializing on this question. (See bibliography.)

CARD MONEY OF THE FRENCH REGIME

All of these pieces sell for between $700 and $1,500 each, if they are in good condition.

TOKENS:

Bank of Montreal, on the side (half-token) 1838-39$ 60

Bank of Montreal, on the front 25¢

Tokens for the Quebec Bridge (caleche, horse, cart, or person)each $ 25

Banque de Quebec, token from 1852 .. 75¢

Sous called "bouquets" (vegetable or floral motifs) [1837-38].
The majority 25¢

Molson Half-Token$ 10

Lauzon Crossing (see illustration)$150

PAPER MONEY

One dollar bill *Province of Canada* (1866)$ 60

Two dollar bill *Province of Canada* (1866)$ 75

Five dollar bill *Province of Canada* ..$100

One dollar bill *Dominion of Canada* from 1870 (profile of Cartier)$ 50

Two dollar bill *Dominion of Canada* (effigies of of Montcalm and Wolfe)$100

Ten dollar bill from the Banque d'Hochelaga, 1914$ 25

Five dollar bill of the Molson Bank, 1812$ 15

Five shillings note of Bank of Montreal from 1852$ 50

Ten dollar bill from la Banque nationale from 1897$ 25

One dollar bill from la Banque de Quebec from 1860$ 50

COINS

Penny piece of 1858$ 12

Penny piece of 1891 (small date)$ 15

Small penny of 1922$ 5

Small penny of 1936 (point in relief at the base of the reverse side— 4 known)Jackpot

Five silver sous from 1858 (large date) $ 45

Five silver sous from 1878 (H)[1] .. $ 18

Five silver sous of 1921$300

Five nickel sous of 1926 (6 separated)$ 22

Ten cents from 1872 (H)$ 20

Ten cents from 1875 (H)$ 35

Ten cents from 1893 (top of 3 not flattened but round)$225

25-cent piece from 1875 (H)$ 50

50-cent piece from 1888$ 20

50-cent piece from from 1890 (H) ..$100

Bank bill from the Banque Nationale. In the 19th century, banks having a charter could issue their own money; there were as many different banknotes as there were banks in operation. These are collectors' items in great demand, and are evaluated in any good Canadian numismatic guide. (Séminaire de Québec.)

1. The H is the trademark of the English Heaton Company, responsible for producing certain coins for the Crown. Valid for pieces before 1908, after which date the Canadian government produced its hard cash itself.

Medals

Old medals that were bestowed to reward an act of bravery or commemorate an important event also interest numerous collectors, which explains their presence in the showcases of many antique shops.

The battle of Chateauguay, the Fenian raids in 1870, the Red River skirmishes, also around 1870, are some of the events for which, in the reign of Queen Victoria, the participants received decorations for bravery. Among those medals, the ones most in demand are, of course, the medals awarded officers who lived through those pages of history; an officer's medal in gold, conferred for action in battle sells today for $1,000.

French and English sovereigns both had medals struck in their images to distribute to Indian chiefs. The French pieces in bronze or in silver usually portray Louis XIV, Louis

Medal from the Lieutenant Governor, struck to recompense the students who had proved outstanding in their studies. Here: medal from J.-A. Chapleau (1892). (Séminaire de Québec.)

Certain Victorian medals were struck to reward an act of bravery, or participation in an important engagement. Here: medal fashioned in 1848, with head of Victoria, commemorates the participation in the battle of Chateauguay. (Private Collection.)

Royal medals struck for disbursement to the natives. French medals are bronze or silver; British ones are bronze, silver, or plated as in Victoria's reign. Here: French medal bearing the head of Louis XIV, and an English medal from George III's reign. (Séminaire de Québec.)

xv, or another monarch. These souvenirs now sell for $25 to $100 each—and even more.

The English medals, always made in the same metals, portray a crowned head: George II, George III, George IV, and Victoria ordered large quantities of these metal portraits for which certain collectors were ready to pay more than $150. The last medals under Victoria were electroplated.

All medals struck under the French regime or after the Conquest, as well as those commemorating a coronation or the swearing in of a Governor-General, and the military medals of the Great Wars are collectors' items and are catalogued in brochures that may be procured from any good coin dealer.

Buttons

Uniform buttons also have their collectors. They are extremely important pieces and often help date an archeological site. For this purpose, certain guidebooks (mentioned in the bibliography) have been compiled.

List of Prices of Some French and Anglo-American Medals

Indian Chief Medal with head of
 Louis xiv, in silver $200
Indian Chief Medal with head of
 Louis xv, in silver $200
Indian Chief Medal with head of
 Louis xv, in bronze $ 40
Indian Chief Medal with portraits of
 George iii and Queen Charlotte $200
Indian Chief Medal under George iv . . $100
Indian Chief Medal under Victoria . . $100
 Medal commemorating the

Lieutenant-Governors of Quebec . . $ 50
Military Model commemorating the
 battle of Chateauguay $200
Military Medal to honor a soldier who
 had taken part in the battle of
 Fort Detroit . $200
Medal commemorating the
 Fenian raids of 1866 and 1870 $ 25
Medal commemorating a royal visit
 or a coronation, generally in
 bronze . each $ 2

CHAPTER 16

Works of Art

Works of Art and the Dealers

A volume on the material aspects of the culture of French Canada would be incomplete if we did not mention its artists. Many indeed are the painters, sculptors or engravers who put their whole talent at the service of the community and contributed a touch of beauty by depicting an important part of the life and soul of the people.

These men were very productive. There are, of course, masters whose works are much sought after by the shrewd collector or by museums. But there are also numerous disciples, imitators, or modest artists who gravitated around the great men and left a scattering of works, some pieces of which one can sometimes discover in a garret, in some antique shop, or even on the walls of many country houses.

The art that will be briefly discussed here includes everything that is not directly functional or utilitarian, and that has only an aesthetic or decorative goal. Furniture and other ordinary objects, even though very elaborately made are therefore excluded. We shall also avoid any critical judgment of artists but shall merely introduce local artists and consider the genre in which they excelled.

There are very few prehistoric contributions to Canadian art. Natives have left a few rock carvings and a few drawings on parchment, but that is the sum total of their expression in this field.

It was mostly native Quebecois (or of French stock), a few integrated Indians, and a certain number of Englishmen who had come to settle after the Conquest, who expressed their talents painting pictures of Canada, much altered to satisfy the tastes and demands of a very religious and bourgeois clientele. Painting, sculpture, and engraving up to the turn of the last century, are the principal forms that will interest us here.

For more than two centuries, the local painter had only two types of clients: the Church and middle-class businessman. Like the mason, the silversmith, and the sculptor, they produced on order edifying paintings for the village priest, and portraits for wealthy families. Before the 19th century the artist painted few pictures for his own pleasure.

Most of the pictures painted in French Canada before 1700 were on religious subjects and were destined for churches and convents. The clergy wanted to recreate scenes of paradise to inspire the faithful. Biblical themes or subjects taken from the history of the Church helped the poorest parishioners picture various episodes in the Book of Saints or celebrate religious services on American soil. Further, missionaries used religious paintings to catechize the Indians in their missions.

Votive painting is another area of pictorial production in French Canada. Ex-votos, ordered when a requested favor had been granted, tell interesting stories inspired by the faith of a people. Allusions to such local events were hung in church vestibules, so that all those who had heard of the miracle could tell again the story of how things had come to pass and add their own comments.

There is a certain awkwardness in these paintings, but they also have the freshness and candor characteristic of naive painting everywhere. The injured woodcutter saved from death in the cold by his dog, the sailor surviving a shipwreck are the same people who, in gratitude to a saint, offer a painting that tells the story of the tragedy in which they were actors. A phrase or a few words of explanation written on the surface of the picture tell us to whom such homage is addressed. St. Anne has received innumerable votive offerings of this kind, which can still be admired in the sanctuary at Beaupré.

The portrait is the genre that has been cultivated most consistently and most successfully. It is a valuable document on the customs and dress of ancient days for the oldest portraits date from the founding of Quebec. A score of them are known to go back as far as the 17th century. Some were posthumous, but the majority were done from life.

The posthumous portrait was popular in communities of nuns where, out of modesty and humility, they refused to pose while alive. Not until a few hours after death would

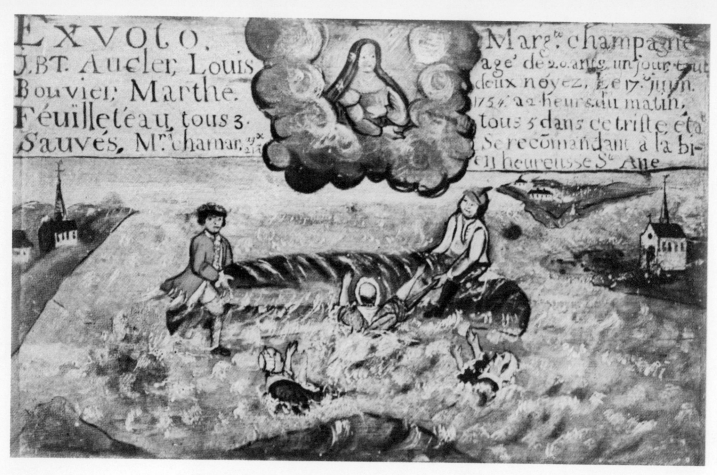

Ex-voto: The Three Shipwrecked Men from Levis; *attributed to Paul Beaucourt, 1754.*
(Sanctuary of St. Anne de Beaupré.)

the artist be allowed to paint the features of his subject from the dead woman's face. At a later date artists worked from death masks. Catherine of Saint-Augustin and Marie of the Incarnation were immortalized by Abbot Pommier who used the first method.

This genre, which was more general in the 18th century, was not as solemn as in the preceding period. It even became almost intimate, with the household accessories surrounding the subjects who were to be portrayed. François Beauçourt liked to paint his clients in the setting to which they were accustomed; as, for instance, Eustace Trottier at his card table, cards in hand and gold louis piled up before him; and Mme. Trottier, just as she is about to take tea.

From 1790 to 1870, the portrait had an unprecedented vogue. Louis Dulongpré was to harness himself to his easel and paint more than three thousand in pastel. For his part, François Baillargé was to paint more than one hundred, especially miniatures. The great names in this genre in the 18th century are Joseph Légaré, Jean-Baptiste Roy-Audy,

Antoine Plamondon, and Théophile Hamel. Their clientele, middle class to the core, had an aristocratic air; they preferred to pose in their richest clothes, adorned with beautiful jewels, and in a setting that combined red velvet draperies and Greek columns.

The landscape, or the anecdotal scene relating an episode in the life of the pioneers, was seldom depicted before the Conquest. One occasionally finds bits of landscapes or of still life on old canvasses, but that is about all.

The landscape as such was brought by English officers like Davies, Cockburn, and Smith who, in their spare time, wielded paint brush and palette in some picturesque corner of the land and also influenced several local artisans. Joseph Légaré was to lead the way with a series of landscapes in oil. After that, a host of artists were to cultivate that form. Most of the painters were self-taught, though some, especially in the 19th century, sought to improve their work by apprenticing themselves to a master, while others, rarer, completed their studies in Europe.

Fire in the St. Roche Quarter of Quebec. *Oil on canvas by Joseph Légaré: 1845.* (Musée du Québec.)

Painters of the 17th Century

The first painter to work in Quebec seems to have been Abbot Hugues Pommier who pursued his vocation in Canada from 1664 to 1680. "The Martyrization of the Jesuit Fathers among the Hurons" and two religious portraits are the only known works that can be attributed to him and which have nothing Canadian about them except their subjects.

Father Jean Pierron; Claude Chauchetière, painter of a portrait of Catherine Tekakwitha; Brother Luc (Claude François)—all of French origin, all oriented their production to the glory of the Church in New France. These artists were the source of inspiration to others; for example, for years the canvasses of Brother Luc served as models for painters working in Quebec.

Abbot Jean Guyon was the first painter of Canadian origin. Born October 5, 1659 in Quebec, raised at the Seminary, he was ordained priest by Mons. de Laval in 1683. 1687 found him a student in Paris where he died a short time after his arrival. He is known chiefly for a portrait of Mother Françoise Juchereau of Saint-Ignace and for water-colors of the local flora.

Toward the end of the 17th century, several artists initiated an art whose subjects were entirely secular. In 1683 Jean-Baptiste Franquelin painted the Château Saint-Louis; Bédard de Granville made numerous sketches of the various scenic wonders he had seen in Canada; Verrier painted a view of Louisbourg; lastly, Mother Maufils from Saint-Louis decorated the panelling in the General Hospital with landscapes.

The 18th Century

In addition to importing a large quantity of European canvases, some painters, not particularly well known, were to satisfy the local demand until 1760, that is to say, the first half of the 18th century, more or less. That they were few in number can undoubtedly be explained by competition and the clientele's preference for foreign canvases.

Michel Dessaillant from Richeterre and Paul Beaucourt, neither of them native Canadians, were to paint a number of portraits and many ex-votos. The votive canvases of the *Aimable Marthe*, in the Musée du Québec, are attributed to Beaucourt, as are the canvas of the *Trois Naufragés de Lévis*, the one of the Dorval woodcutter, and the one of Notre-Dame de Liesse. These early stammerings of local art are simple and form is secondary.

During the "Seven Years" War, Quebec pictorial production came to a halt. After the Conquest, it took another turn, with British tradition supplanting French influence which, until then, had been predominant. Several English officers and immigrants who had recently settled here painted water color with considerable skill.

The first Quebecois to make a name for himself after the Conquest was Jean-Antoine Aide-Créquy, the son of a master mason, born in Quebec in 1747. Emulation characterized the work of this priest, who officiated first at Baie-Saint-Paul, then at Ile-aux-Coudres, and finally at the Eboulements. His unsigned copies are the *Annunciation, The Vision of Angele Merici, St. Joachim*. His most remarkable work is *St. Louis Holding the Crown of Thorns*. With Aide-Créquy, who died prematurely in 1780, an era of French-Canadian painting came to an end.

End of the 18th Century and First Half of the 19th

The years after 1780 may be said to be the Golden Age of Quebec painting, a fertile period that was to last until 1850. A strong interest in portraits among men of the Church as well as among noblemen and the wealthy middle class led to an unprecedented development in this genre. François Beaucourt, François Baillargé, Louis-Chrétien de Heer, Louis Dulongpré, and William von Molt Berczy devoted their talents to painting portraits as well as a number of religious scenes.

At the end of the 18th century and the beginning of the 19th, many French ecclesiastics who were art lovers, driven from their country by the Revolution, brought their possessions to the more peaceful Canadian soil. By furnishing local artists with models and sources of inspiration these exiles launched a sort of renascence. In 1816, Abbot Philippe-Jean-Louis Desjardins shipped a collection of one hundred and twenty paintings from Paris to Quebec, which his younger brother put on public sale in the chapel of l'Hôtel-Dieu in March, 1817. Later on, several of our painters were to copy these scenes, which were scattered about in the churches of the province.

The best-known names of the epoch are J.-B. Roy-Audy, Joseph Légaré, Antoine Plamondon, and Théophile Hamel. The first two became famous for their portraits while the others were to excel in landscapes.

Roy-Audy is a direct descendant from a line of woodworkers. Born in Quebec in 1778, Cartwright, a boat-builder and sign painter, decided when he was about forty to be a "painter of portraits and history." At an early age and while still a student at the Seminary, he had taken drawing lessons from François Baillargé. Then, from 1815 till his death in 1848, he was an itinerant artist in search of customers. His admirable portraits are remarkable documents with their naive composition, realistic details of clothing, clear backgrounds, and precise brush strokes. One cannot say as much for the works copied from the canvases of the Desjardins collection.

Joseph Légaré was a self-taught artist for whom politics held a special attraction, for he openly supported Papineau and took part in the unrest of 1837. He even turned up, in February 1855, as a legal counselor. But Légaré was above all a painter and a lover of art: and he learned his profession by copying the paintings in the Desjardins collection, of which he was one of the owners. His religious paintings, landscapes, and portraits are all careful compositions. His historical canvases, inspired by poems published in newspapers, exalted the qualities of unfortunate nations like the Huron Indians, or even immortalized events such as the Saint-Roch fire in Quebec in 1845.

Antoine Plamondon (1804-1895), pupil of Joseph Légaré, is another artist who dominated that period. He lived solely for his

painting, and his clientele was considerable. Certain portraits are truly masterpieces.

Théophile Hamel (1817-1870), a student of Plamondon's from 1834 to 1840, acquired his knowledge in Paris, Rome, and the Low Countries. He was essentially a portraitist and had considerable influence on the generation of artists of the late 19th century.

Cornelius Krieghoff (1815-1872), of German origin, is known for his scenes of Canadian common life. Due to his haste in producing his art, his landscapes were almost caricatures. A number of imitators adopted his style, often shamelessly copying his works. The public's craze for art and the alarming rise in prices gave rise to a number of forgeries that were circulated on the market.

By the end of the 19th century and the beginning of the 20th, Roy-Audy, Plamondon, and Légaré had set the fashion for a number of disciples and fellow artists in the traditional vein and independently of the great world currents of this art. Antoine-Sébastien Falardeau, Ozias Leduc, Aurele de Foye Suzor-Cote, F. S. Coburn, Clarence Gagnon, and Charles Huot are other artists of that era. To know more about painting, consult J. Russell Harper's study, *Painting in Canada*.[2]

2. Harper, J. Russell, *La peinture au Canada*, Quebec, Presses de l'Université Laval, 1966.

(A) Portrait by Antoine Plamondon (1839): Madame Joseph Laurin. (Musée du Quebec.)

(B) Painting by Théophile Hamel dated 1853: Madame Renaud and Her Two Children. (Musée du Quebec.)

A

B

Oil on canvas by Cornelius Krieghoff: The Snow Storm. *1860.* (National Gallery, Ottawa.)

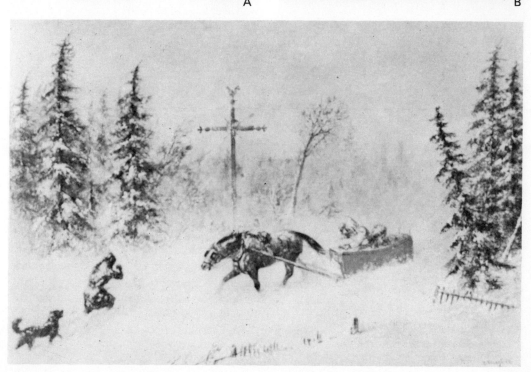

Painters and Lithographers Before 1900

Abraham, Nicolas (C. 1653)

Aide-Créquy, Jean-Antoine (1749-1780)

Alary, Siméon (C. 1870)

Alliès, Louis (C. 1780)

Arcand, Arthur (C. 1850)

Atkinson & Burton (C. 1870)

Baillargé, François (1759-1830)

Baisseau, Alfred (C. 1869)

Bartlett, William-Henry (1809-1854)

Beaucourt, François Malapart de (1740-1794)

Beaucourt, Paul (1700-1756)

Beaudoin, Antoine (C. 1871)

Beauregard (?) (C. 1770)

Bell-Smith, John (1810-1883)

Berczy, William Molt (1749-1813)

Berger, Jean (1682-C. 1710)

Blumart, Louis (C. 1840)

Boisseau, Alfred (C. 1850)

Bouchette, Joseph (1774-1841)

Bourassa, Napoléon (1827-1916)

Bourne (?) (C. 1850)

Bowman (?) (C. 1850)

Burland, Lafricain & Co. (C. 1865)

Cardenat (?) (1690)

Carlisle (Lieutenant ?) (C. 1870)

Chabert, Abbot Joseph (C. 1875)

Chapleau, Alphonse (C. 1870)

Charland, Louis (1772-1813)

Chauchetière, Claude (1645-1709)

Clifford, E.M. (C. 1880)

Cockburn, James Pattison (1778-1847)

Cooper, William (C. 1865)

Colin, C. (C. 1870)

Crehan, Charles (C. 1845)

Dauphin, Charles (C. 1870)

Demers, Friar Louis (C. 1733)

Dessaillant de Richeterre, Michel (C. 1700-1710)

Dillon, Richard (C. 1760)

Dion, Charles (C. 1860)

Dorion, Abbot Hercule (1820-1889)

Drake, John (C. 1825)

Dulongpré, Louis-Joseph (1754-1843)

Duncan, James (1806-1881)

Dynes, Joseph (1825-1897)

Dyonnet, Edmond (1859-1954)

Eaton, Wyatt (1849-1896)

Edson, Allan, (1846-1888)

Ernette, Victor (C. 1840)

Estcourt, Sir James B. Bucknall (1802-1855)

Falardeau, Antoine-Sébastien (1852-1889)

Fascio, Giuseppe (C. 1850)

Féo (?) (C. 1855)

Ferland, Albert (C. 1870)

Ferland, Alphonse (C. 1880)

Field, J.H. (C. 1844)

Field, Robert (C. 1769-1819)

Footner, Mrs & Daughter (C. 1865)

Foy, Lewis (C. 1770)

Franchère, Joseph-Charles (1866-1921)

François, Claude (Friar Luc) (1614-1685)

François, (Father) (Jean-Melchior Brekenmaker) (C. 1735-1750)

Fraser, William-Lewis (1841-1903)

Gagliardi (Family) (C. 1860)

Garneau, Elzebert (C. 1900)

Genest, Pierre (1844-1901)

Genot, Archille (1823-1879)

Gessier, N. (C. 1845)

Gibson (?) (C. 1830)

Giffard, Alexandre S. (C. 1870)

Gill, Charles (1871-1918)

Glackmeyer, Charles (C. 1830)

Guindon, Arthur (1864-1923)

Guyon, Jean (1659-1687)

Hamel, Joseph-Arthur (1845-1932)

Hamel, Narcisse (C. 1870)

Hamel, Théophile (1817-1870)

Hamilton, Henry (C. 1780)

Hammond, John (1843-1939)

Harris, Robert (1849-1919)

Hawsket, Samuel (C. 1860)

Hébert, Philippe (1850-1917)

Heaton, E. (C. 1825)

Heer, Louis-Chrétien de (C. 1750 - C. 1805)

Heldt (?) (C. 1865)

Hériot, Georges (1766-1844)

Hillyer, William (C. 1845)

Holdstock, Alfred-Worsley (1820-1901)

Holland, Samuel (1717-1801)

Huot, Charles (1885-1930)

Jacob, Thomas P. (C. 1870)

Jacobi, Otto-Reinhold (1812-1901)

James, John (C. 1830)

Julien, Henri (1852-1908)

Krieghoff, Cornelius (1815-1872)

Labourière, Abbot C.E. (1863-1893)

Lemprecht, Wilhem (C. 1860)

Lapointe, Abbot Epiphane (1822-1862)

Larocque, Zéphirin (C. 1865)

Larose, Ludger (1868-1915)

Laure, Father Pierre (1686-1738)

Laverdière, Abbot (?) (C. 1890)

Leber, Pierre (1669-1707)

Leblond (Latour), Jacques (1670-1715)

Légaré, Joseph (1795-1855)

Lefebvre, Nicolas (C. 1660 - C. 1740)

Lego, W.A. (C. 1850)

Lessard, Joseph (C. 1910)

Léveillé, Jean (C. 1870)

Levinge, Sir Richard-George-Augustus (1811-1889)

Liébert, Philippe (1732-1804)

Lockwood (?) (C. 1840)

Luc, Friar (Claude François) (1614-1685)

Mahoney, Patrick (C. 1870)

More (?) (C. 1765)

Marois (?) (C. 1890)

Massicotte, Paul-Gaston (1846-1895)

Mathers, George (C. 1845)

Maufils de Saint-Louis, Mère (1670-1702)

Meloche, F.E. (C. 1890)

Memee, Frederick (C. 1865)

Monty, L. Eustache (1873-1932)

Morin, Pierre-Louis (1811-1886)

Morris (?) (C. 1845)

Muller (Family) (C. 1865)

Murray, John (C. 1870)

Natte, (Marseille), Jean (C. 1780)

Neilson, Yvan (1865-1931)

Palmer, Samuel (C. 1841)

Pasqualoni, Vicenzo (C. 1860)

Peachey, James (C. 1785)

Petitot, Emile (1838-1917)

Pierron, Father Jean (1631-1700)

Plamondon, Antoine-Sébastien (1804-1895)

Plamondon, Ignace (1796-1835)

Pommier, Abbot Hugues (C. 1637-1686)

Quintal, Auguste, (1866-1876)

Raphaël, William (1833-1914)

Rasle, Sébastien (1657-1724)

Rho, Adolphe (1835-1905)

Richer, O.A. (C. 1870)

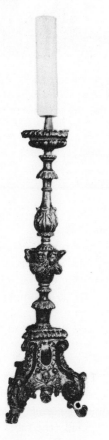

Silvered wood altar candlestick. 18th century. (Musée des Ursulines, Quebec.)

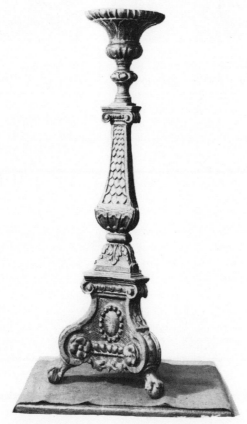

Superb carved wood candlestick decorated with rosettes, beads, acanthus leaves, and gadroons; claw and ball feet. 18th century. (Private Collection.)

Sculpture

Quebec wood-carving enjoys a worldwide reputation, and is a tradition of handicraft that is traceable back to the beginning of colonization.

The wood-carving of past times encompasses two great genres: religious and secular. From what is left today it can be deduced that 90 percent of that production was aimed at embellishing the church, decorating cemeteries, or offering thanks to God at the crossroads. Altar pieces, baldachins, rood screens, wainscoting, cornices, altars, pulpits, church-wardens' pews, baptismal fonts, candlesticks, and altar crosses are among the many accessories, pieces of furniture, ornaments and church pieces, that lend themselves admirably to the sculptor's chisel.

The secular production, which is augmented day by day through various discoveries, seems to have been limited to the decoration of ships' prows and hotel signs. History records that the maritime shipyards were a flourishing industry on the banks of the St. Lawrence in the last century, and that as a rule, sailing vessels carried a prow carved to represent a goddess, a nymph, or some other handsome personage. These figures were supposed to assure the vessel of protection. Most of those figureheads have vanished with the ships, but a few still appear today, thanks to the salvage work of deep-sea divers, and they are often surprisingly well preserved. In the 19th century, a hotel or even a store sometimes identified itself with a sculpture of some sort in a niche above the entrance or an awkwardly carved figure standing near the window, on the sidewalk. Who has not seen in old engravings that stiff wooden Indian holding a box of cigars at the door of some tobacco merchant of long ago? In the Musée du Québec there is a gigantic

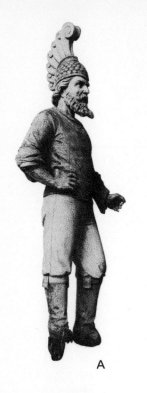

A

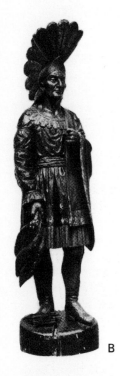

B

Store signs and figureheads on prows are the two principal forms of secular wood carving that came from the workshops of the early Quebec masters: (A) Sign of the Hotel Neptune, representing the sea god, by Louis Jobin. c. 1880. (Musée du Québec.); (B) Tobacco shop sign, an Indian figure in polychromed wood. (Musée du Québec.)

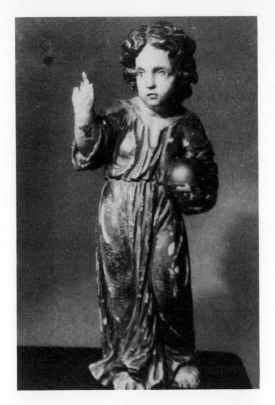

The Child Jesus with orb, in polychrome wood. Fine example of copying, for there are several pieces with this theme in Quebec. An imported statue and a few carvings served as a model for the craftsman, who frequently saw his work copied by a clever carpenter from a neighboring village at the request of the priest. 18th century. (Musée du Québec.)

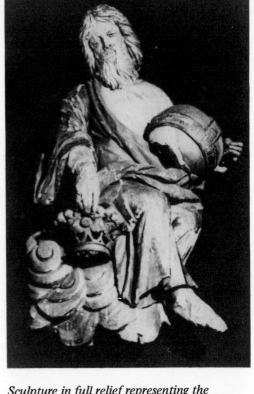

Sculpture in full relief representing the Heavenly Father; polychrome wood. Church, cemetery, and religious communities abounded in pieces of this kind, in low or high relief or modeled in the round. Occasionally, one finds today in a few antique shops the gigantic wooden statues of evangelists and saints which ornamented cemeteries and niches outside churches. (Musée du Québec.)

statue, attributed to Louis Jobin, representing Neptune. It was identified through an old photograph of the Neptune Inn in Quebec as the insignia of that hotel.

The basic material was almost always wood. In the beginning, as was done in their country of origin, the early colonists cut down oak, but this was quickly supplanted by light walnut and pine, which were easier to work and cracked less readily than hard woods.

At the end of the 19th century, many carvers gave up wood and decided to work with more maleable materials which, after being molded, were cast in bronze. Louis-Philippe Hébert (1850-1918) and Suzor-Côté (1869-1937) were to win renown following this process in so-called academic sculpture.

Most of the works were gilded, flesh-colored, or polychrome. Here it must be noted that in those museums where, often, pieces of statuary or of ornamentation are in natural wood, such works have been denuded of some of their original quality. This is ex-plained in part by a method of cleaning which many specialists and amateurs were to promulgate foolishly during the first quarter of the 20th century. It was a completely inexcusable act of vandalism.

The Ursulines of Quebec excelled in coloring and gilding, and it often cost more to gild a statue than to have it carved. The nuns used a special technique for applying gold leaf, a process with a long tradition which they had inherited. Coloring, that is, coloring of the flesh, especially the face, was done by the Sisters, but also by some of the sculptors.

In fact, polychrome, the art of applying different colors on one piece to make it more realistic, goes back to the Middle Ages and even to antiquity. Certain wood-carvers turned to this work too, although, now and then, the painter's manual skill and knowledge were preferred. Lauréat Vallières, an apprenticeship trained sculptor of the traditional school, produced statuary for more than forty churches in the Province of Que-

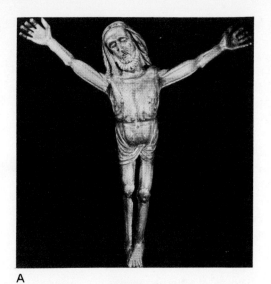

A

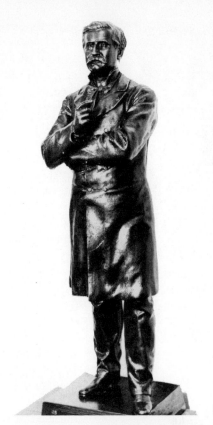

C

(A) Wooden crucifixes are in the tradition of Quebec folk art. Though the large black cross called Temperance was tremendously popular after 1860, the crucifix had its place in many households. 19th century. (Private Collection.); (B) Plaster statue of Honoré Mercier, by Philippe Herbert. Late 19th century. (Séminaire de Québec.); (C) Statuette in polychrome wood of a temperance preacher, as suggested by the black cross he holds. 19th century. (I.N.C.); (D) Ship's figurehead or store sign. Natural wood. 19th century. (Musée du Québec.)

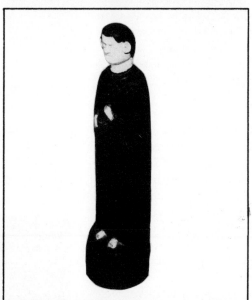

B

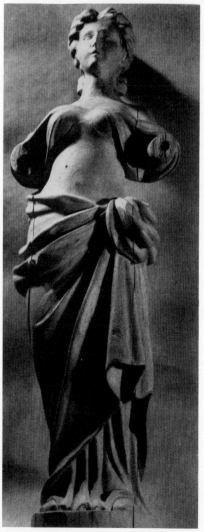

D

bec during the first half of the 20th century and always colored his works himself.

We cannot rely on the present production of the various schools of traditional wood-carving like the Bourgault school (early style) from Saint-Jean-Port-Joli to acquaint us with the subject matter of the artists in past centuries. Anecdotal scenes or pictures of daily life were rarely included in the wood-carvers' output in those days, except at the very end of the 19th century.

The subjects, for the most part, were on religious and French themes. Many ecclesiastics brought statues or engravings by well-known artists of the epoch from Europe and then gave orders to the local sculptors. Not only were foreign originals copied, but also various statues from village to village. A local curate would decide to put in a certain niche an "Infant Jesus with the Orb" he had admired in the church of a neighboring parish.

Schools and Artists

As was tradition in France, guilds and ancient corporations were united in a brotherhood and they had their patron saint. In New France, carpenter wood-carvers followed that tradition. As Marius Barbeau writes in his memoir that appeared in *Les Archives de Folklore* (vol. III, published in Montreal in 1946), the Confrèrie de Sainte-Anne (the Fraternity of St. Anne) was established on May 1, 1658, and was to survive until the end of the 19th century. Most French-Canadian carpenter wood-carvers were members of the society, which set the fashion for training apprentices who, after three to seven years of supervised practice, emerged as master carvers. In this school certain Parisian statutes, dictated by the guild mastership and put in force in 1651 and 1743, were respected. But the first really organized school of carving and carpentry was St. Joachim, near Quebec.

This latter was the outcome of the combined efforts of Administrator Talon and Msgr. de Laval to make the colony self-sufficient in the matter of decorating churches. From 1675 to 1710, a number of religious houses were decorated by Jacques Leblond (surnamed Latour), Denis Mallet, Charles Chaboillez, Samuel Genner, Michel Fauchois, and several others who served their apprenticeship in that little village on the coast of Beaupré.

The 18th century gave rise to veritable dynasties of wood-carvers. In Quebec, the Le Vasseurs and the Baillargés were leaders of schools, and a number of craftsmen became apprentices under these men. The bulk of their production consisted of chapel and church decorations.

Several names among those men who basked in the glory of the brothers Le Vasseur and the Baillargés deserve to be mentioned: Jean Valin, Gabriel Gosselin, Pierre Edmond, Antoine Jacson, Joseph Piché, and Charles Vézina were to leave reredos, a bishop's throne, candlesticks, and other ceremonial articles.

Not only Quebec, but also Montreal was swept up in the immense tide of production in the 18th century. And here three distinct phases are visible: at the beginning of the century, Charles Chaboillez was the famous sculptor in that region but, very rapidly, the Labrosses, father and son (Guillaume and Paul), became known for the quality and careful execution of their pieces and received

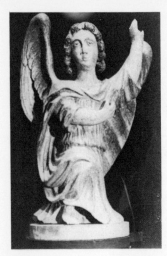

Polychrome angel, naive sculpture of 19th century. (Musée du Québec.)

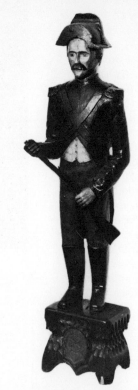

One of the first works of sculptor Philippe Hébert. Wooden soldier in uniform of Napoleonic troops. Polychrome; c. 1870. (Séminaire de Québec.)

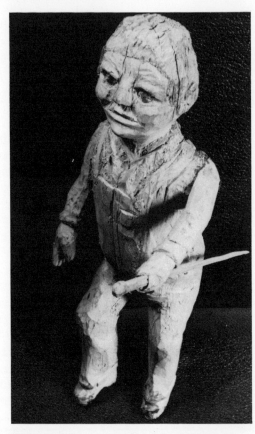

Toy carved from natural wood represents an habitant *on his way to the fields. Early 20th century.* (I.N.C.)

232

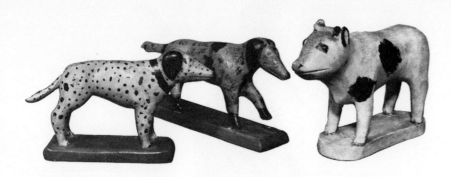

Much of Quebec's folk art appeared in toys. These two dogs and ox in polychrome wood surely amused some child. Late 19th century. (Private Collection.)

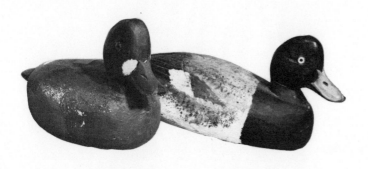

Most houses had lures or duck decoys, some of which were used as doorstops for most of the year. Most are polychrome. Many craftsmen, including Richard, Coté, Morel, Marion, the Arbours, and the Bourgaults, carved their subjects in lifelike attitudes. 19th century. (Private Collection.)

many contracts to decorate churches. At the same time a man of talent, originally from Burgundy, was to become famous and popular; working alone, Philippe Liébert (1732-1804) was to supplant all his competitors, and around 1760 most of the communities of nuns or priests in the region of Montreal were to call on his services.

Finally, the third phase of the Montreal School is the production and influence of Louis Quévillon (1749-1823). Ecclesiastics throughout the province called on that able craftsman who, with Joseph Pépin, Rene St. James (Beauvais) and Paul Rollin, produced admirable works and at the same time founded a school.

Here too several craftsmen were inspired by the Labrosses, Liébert, Quévillon: Louis Fourreur called Champagne, Paul Richard, Joseph Turcaut, Joseph Roy, François Filiau, Jean-Baptiste Féré, and several others put their skills at the service of ecclesiastical needs.

Trois-Rivières also had its school of sculpture in the 18th century and from 1715 on. In fact, Jean Jacques Leblond, originally from Brussels, was to open a workshop there only to be followed soon by Bolvin, father and son, and Jean-Baptiste Hardy, from Yamachiche.

The 19th Century

In the 19th century more than one craftsman from the region of Montreal followed in the footsteps of Quévillon. The two Davids (Louis-Basile and David-Fleury), Amable Gauthier, Louis-Thomas Berlinguet, Urbain Desrochers, and Louis-Xavier Leprohon are only a few of those well-known figures.

In Quebec, Thomas Baillargé, André Paquet, Léandre Parent, the Dions, the Berlinguets, Octave Morel, Jean-Baptiste Côté, and a galaxy of even lesser known artists down to Louis Jobin, the last on the list of traditional wood-carvers, were to fill the orders of their epoch. Sculptors of figureheads for the prows of ships are generally unknown. So far, few studies have been made in this field and it is impossible to attribute such work to any one artist. The same thing is true for store and hotel signs.

Certain rural craftsmen were also to make their mark in the course of the three centuries of sculpture. It would take too long to introduce them here, even briefly. The list will be given later on.

Plaster Molds for Connoisseurs of the Future

Before bringing this chapter to a close, we must note that by the end of the 19th century traditional sculpture, that done on furniture, had degenerated completely. Only a few artists like Lauréat Vallières, or a few sculptors of animals or genre scenes, were to continue along such veins and then only until the middle of the 20th century. The high price of pieces carved from a solid block of wood, the beauty of plaster statuary which many ecclesiastical pilgrims brought from Europe —and from Italy in particular—the craze for those more conventionally proportional and realistic cast figures were some of the influences that contributed to the demise of

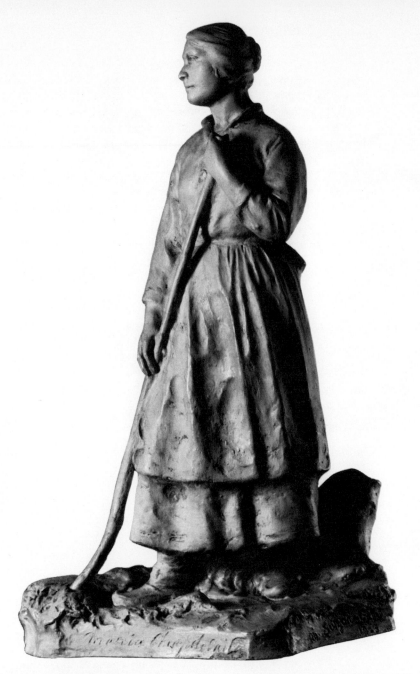

This plaster statue of Maria Chapdelaine, the symbol of Quebec to the foreigner, is signed by Suzor-Coté (1925). (Séminaire de Québec.)

Polychrome wood statue used to decorate a carriage, from the area of the Eastern Provinces. 19th century. (I.N.C.)

this art which was once so flourishing in Canada.

A number of French Canadians followed the fashion brought over by Italian artists who specialized in plaster casting, men like Baccerini, Sula, Carli, and Petrucci. These men scattered their sacred works to the four corners of the Province, while Mariotti and Movor were to prefer historic secular themes, using the same material. Joseph Richard and several other artists imitated this style.

For the collector a fact worth noting: with antique handicraft production in wood carving or in bronze becoming increasingly rare and very expensive, it would not be surprising if, several years from now, especially after a thorough study of cast work, there emerged a number of experts among artists working in plaster statuary. Such sculptors will produce collectors' pieces: cherubs, the Child Jesus, figures from the manger, crucifixes, etc. Why not, after all, when we know that the cast was made from the original carving of an artisan (or from casting a foreign piece)? This is merely a duplicate of a work of art of the period, involving practically the same method Vasarely is using now in Europe. In any case, several generations have lived with these objects, which are authentic documents of the past.

Engravings

Etchings are another manifestation of art much prized by some collectors. Several painters turned to this art form for wider distribution of pictures of typical Quebec environs. Rue Notre-Dame in Montreal, the chateau Ramezay, the Bonsecours Market, and many other places served as models for such artists as Clarence Gagnon or Herbert Raine, without question the most famous in that genre.

A number of prints are still available on the market and there is no doubt that many attics must still harbor such collectors' pieces.

Most of the works of the genre from before 1900 are attributed to three great names: Cornelius Krieghoff (around 1847), W. H. Bartlett (1842), and Nathaniel Currier, of the firm Currier & Ives (1860). Later on several local printers revived the works of these three masters in engravings of various formats.

Portrait photos, retouched and tinted, have increasing numbers of buyers among amateur collectors of memorabilia. This newly married couple was photographed in 1887; the print was enlarged and retouched around 1920. (Private Collection.)

Old photos are documents that provide information of the daily life and environment at the end of the 19th century and the beginning of the 20th. Here: a lumberman's camp in the Laurentian forest at the turn of the century. (Private Collection.)

Street scene; Hotel Quebec in foreground.

235

DEPUTES CONSERVATEURS A LA CHAMBRE DE L'ASSEMBLEE LEGISLATIVE DE QUEBEC, 1883.

1. F.-X. Paradis, Député de Napierville.
2. Joseph N. P. Marion, Député de l'Assomption.
3. Dr. V. P. Lavallée, Député de Joliette.
4. L. G. Desjardins, Député de Montmorency.
5. Elie St-Hilaire, Député de Chicoutimi et Saguenay.
6. N. Audet, Député de Dorchester.
7. Frs. S. Lesieur Désaulniers, Député de St-Maurice.
8. Joseph Robillard, Député de Berthier.
9. Léon Ledue, Député de Richelieu.

10. Sévère Dumoulin, Député de Trois Rivières.
11. Dr. Dosithé Martel, Député de Chambly.
12. Etienne Poulin, Député de Rouville.
13. Jacques Picard, Député de Richmond et Wolfe.
14. Wm. Duckett, Député de Soulanges.
15. Dr. Isidore Frégeau, Député de Stanford.
16. Hon. E. T. Pâquet, Député de Lévis.
17. Onésime Gauthier, Député de Charlevoix.
18. W. Sawyer, Député de Compton.

19. Dr. Louis Duhamel, Député du Comté d'Ottawa.
20. W. J. Pompore, Député de Pontiac.
21. Antoine Casavant, Député de Bagot.
22. Pierre Evariste LeBlanc, Député de Laval.
23. F.-X. Archambault, Député de Vaudreuil.
24. Hon. Jean Blanchet, Député de Beauce.
25. Louis Napoléon Asselin, Député de Rimouski.
26. Robert Trudel, Député de Champlain.

27. Guillaume Alp. Nantel, Député de Terrebonne.
28. Louis Trefflé Dorais, Député de Nicolet.
29. Hon. J. G. Robertson, Député de Sherbrooke.
30. L. B. Alp. Charlebois, Député de Laprairie.
31. Hon. J. S. C. Würtele, Député de Yamaska.
32. Hon. J. Alf. Mousseau, Député de Jacques-Cartier.
33. Hon. L. O. Taillon, Député de Montréal-est.
34. P. Boucher de la Bruyère, M. C. L. Rougemont.

35. Félix Carbray, Député de Québec-est.
36. Chs. Marcotte, Député de L'Islet.
37. G. H. Deschênes, Député de Témiscouata.
38. Célestin Bergevin, Député de Beauharnois.
39. Benj. Beauchamp, Député des Deux-Montagnes.
40. Edmund Spencer, Député de Missisquoi.
41. Hon. E. James Flynn, Député de Gaspé.
42. Jean-Bte. Trefflé Richard, Député de Montcalm.

Photograph of the Conservative members of the Quebec Legislative Assembly, 1883.

Sculptors, Carpenters, and Cabinetmakers Before 1900

Achard, Charles, Montreal
 (C. 1700)
Achim, André, Longueuil
 (1793-1843)
Adam, Jean, Beaumont (C. 1700)
Auclair, André, Montreal
 (1803-1865)
Baccerini & Co., Montreal
 (C. 1870)
Baillargé, Charles, Quebec
 (1826-1906)
Baillargé, Florent, Quebec,
 (1761-1812)
Baillargé, François, Quebec
 (1759-1852)
Baillargé, Jean, Quebec
 (1726-1805)
Baillargé, Thomas, Quebec
 (1791-1859)
Barbeau, Felix, Montreal (C. 1850)
Baret, Jean-Baptiste, Montreal
 (1799-1858)
Barette, Antoine, Montreal
 (C. 1820)
Beaudoin, Médard, Montreal
 (C. 1850)
Beaumont, Joseph, Montreal
 (C. 1860)
Bédard, Jacques, Quebec (C. 1700)
Bellemare, Paul, Yamachiche
 (C. 1810)
Bercier, Etienne, Beaumont
 (C. 1825)
Berlinguet, F.-X., Trois-Rivières
 (1830-1910)
Berlinguet, Louis-Thomas, Quebec,
 (1789-1863)
Berlinguet, Laurent-Flavien,
 Napierville (C. 1850)
Bernard, G., Quebec (C. 1860)
Bertrand, Benjamin, Tring Jonction
 (C. 1860)
Bertrand, Séraphin, Lacadie,
 (C. 1830)
Berthiaume, Moïse, Yamachiche,
 (1831-1905)
Bolvin, Gilles, Trois-Rivières
 (1711-1766)
Bolvin, J.-B., Trois-Rivières
 (C. 1790)
Bosqué, Edouard, Montreal
 (1774-1481)
Bourassa, Napoléon, Lacadie,
 (1827-1916)
Brien, Joseph, Varennes (C. 1800)
Brien, Urbain, Varennes (C. 1820)

Carli & Petrucci, Montreal
 (C. 1880)
Cartier, Jean-Baptiste, Yamaska,
 (C. 1780)
Catelli (?), Montreal, (C. 1870)
Chaboillez, Charles, Montreal
 (1654-1708)
Charron, Amable, L'Islet (C. 1820)
Chartrand, Vincent, Montreal
 (C. 1860)
Chaussat, A.J., Quebec (C. 1760)
Cirier, Antoine, Montreal
 (1718-1794)
Coté, Jean-Baptiste, Quebec
 (C. 1870)
Coulombe, Jean, Montreal
 (C. 1815)
Craig, Andrew, Montreal (C. 1840)
Crépeau, Basile, Quebec (C. 1760)
Curieux, Michel, Quebec (C. 1750)
Cuvelier, J.J. (platre), Trois-Rivières
 (C. 1915)
Dalpé, N., Quebec (C. 1860)
David, David-Fleury,
 Sault-au-Récollet (C. 1740)
David, Louis-Basile, Montreal et
 Quebec (C. 1800)
Demers, Jérome, Quebec
 (1774-1853)
Desnoyers, Charles, Rouville
 (1806-1902)
Desroches, Francois, Montreal
 (C. 1860)
Desrochers (Urbain Brien dit)
 (C. 1824)
Donati (?), Montreal (C. 1870)
Dorion, Hercule, Yamachiche
 (1820-1889)
Doyon, Louis, Montreal (C. 1820)
Drolet, J.B., Quebec, (C. 1860)
Drouin, Charles, Quebec (C. 1840)
Drouin, Pierre, Quebec
 (1812-1860)
Ducharme, Georges, Quebec
 (C. 1860)
Ducharme, Christophe, Montreal
 (C. 1830)
Duchesne, Pierree, Montreal
 (C. 1860)
Dugal, Francois, Terrebonne
 (C. 1840)
Dumas, Jean-Romain, Montreal
 (C. 1820)
Dupuis, Francois, Montreal
 (C. 1850)
Duvernay (?), Verchères (C. 1790)
Emond, Pierre, Quebec (1738-1808)

Enouille, Louis, Quebec (C. 1850)
Fauchois, Michel, Cap-Tourmente
 (C. 1675)
Féré, Jean-Baptiste, Lotbinière
 (C. 1795)
Filiau, Claude, Quebec (C. 1740)
Filiau, François, Montreal
 (C. 1760)
Finsterer, Daniel et Georges,
 Montreal (C. 1815)
Fournier, Claude, Montreal
 (C. 1820)
Fourreur (Champagne), Louis,
 Montreal (C. 1785)
Franchère, Joseph, Quebec
 (C. 1780)
Fréchette, Etienne, Quebec
 (C. 1745)
Gauthier, Amable, Montreal
 (C. 1820)
Gauthier, Léon, Montreal (C. 1820)
Giroux, Raphaël, Quebec
 (1804-1869)
Godin, Jean-François, Quebec
 (1700-1785)
Gosselin, Gabriel, Lle d'Orléans
 (C. 1690-1769)
Guernon, François, Montreal
 (C. 1750)
Gourdeau, Antoine, Quebec
 (C. 1820)
Guibord, Charles,
 Pointe-aux-Trembles (C. 1800)
Guibord, Pierre,
 Pointe-aux-Trembles (C. 1800)
Hangard dit Lapalice, Joseph,
 Louiseville (1817-1889)
Hardy, Jean-Baptiste, Quebec
 (C. 1770)
Hardy, Pierre, Yamachiche (C. 1750)
Hébert, Jean-Baptiste,
 Baie-du-Febvre (1779-1864)
Hébert, Philippe, Montreal,
 (1850-1917)
Héroux, Georges, Yamachiche
 (1823-1901)
Hurtubise, Joseph, Montreal (C. 1820)
Jacques, Louis, Quebec (C. 1820)
Jacquier dit Leblond, Jean, Quebec
 (C. 1690)
Jacson, Antoine, Quebec (C. 1780)
Jobin, Louis, Quebec (Beaupré)
 (C. 1890)
Jourdain (Labrosse), Guillaume,
 Quebec (C. 1690)

(continued)

Sculptors, Carpenters, and Cabinetmakers Before 1900

(continued)

Jourdain (Labrosse), Denis, Montreal (C. 1720)

Jourdain (Labrosse), Paul, Montreal (C. 1700)

Jourdain (Labrosse), P.R., Montreal (C. 1740)

Jourdain (Labrosse), Basile, Montreal (C. 1775)

Lafleur, François, Quebec, (C. 1850)

Laliberté, Alfred, Arthabaska (C. 1875)

Lambert (?), Quebec (C. 1770)

Larcheveque, J.B., Quebec (C. 1750)

Latour, Jean, Quebec (1632-1677)

Leblanc, Augustin, Yamachiche (C. 1880)

Leblond dit Latour, Jacques, Baie Saint-Paul (1670-1705)

Lemelin, Jean, Quebec (C. 1660)

Lefebvre, Pierre, Quebec (C. 1745)

Lefebvre, Paul, Quebec (C. 1860)

Lenoir, Antoine, Lachenaie (C. 1735)

Lenoir, Jean, Lachenaie (C. 1735)

Lenoir, Vincent, Montreal (C. 1700)

Leprohon, A., Montreal (C. 1820)

Levasseur, Denis-Joseph, Trois-Rivières (C. 1715)

Levasseur, Charles, Quebec (C. 1725)

Levasseur, François-Noel, Quebec (1703-1794)

Levasseur, François-Louis, Boucherville (C. 1715)

Levasseur, François, Boucherville (C. 1715)

Levasseur, J.B.A., Quebec (1717-1777)

Levasseur, Jean, Quebec (1622-1686)

Levasseur, Michel, Sorel (C. 1725)

Levasseur, Noel, Quebec (1680-1740)

Levasseur, Pierre, Quebec (1629-1686)

Levasseur, Pierre, Quebec (1661-1731)

Levasseur, Pierre, Kamouraska (1679-1737)

Levasseur, Pierre-Noel, Quebec (1690-1770)

Liébert, Philippe, Montreal (1732-1804)

Lureken, Léonard, Quebec (C. 1675)

Mailloux, Jean, Quebec (1668-1753)

Mallet, Denis, Montreal (C. 1705)

Malo, Pierre-Aimé, Montreal (1860-1924)

Mamy, (?), Montreal, (C. 1850)

Mariotti, (?), Montreal (C. 1840)

Marois, P., Quebec, (C. 1840)

Marquette, P.S., Montreal (C. 1830)

Martel, I., Quebec (C. 1840)

Martin, François, Montreal (C. 1820)

Meneclier, Louis, Montreal (C. 1830)

Mercier, Amable, Quebec (C. 1820)

Métivier, Etienne, Quebec (C. 1820)

Millette, Alexis, Yamachiche (1793-1870)

Minville, Pierre, Quebec (C. 1660)

Moisan, Pierre, Montreal (C. 1825)

Mondor, Joachin, Quebec (C. 1820)

Morel, Octave, Quebec (C. 1860)

Morin, Pierre, Quebec (C. 1750)

Nadeau, Joseph, Saint-Charles, Bell (C. 1760)

Narbonne, Louis, Saint-Rémi (C. 1840)

Noblesse, Martin, Montreal (C. 1700)

Noel, Joseph, Quebec (C. 1820)

Normand, François, Trois-Rivières (C. 1820)

Paget, Raymond, Quebec (C. 1660)

Paquet, André, Quebec (1799-1860)

Parent, Léandre, Quebec (C. 1830)

Parizeau, T.E., Quebec (C. 1850)

Patry, Louis, Quebec (C. 1850)

Pépin, François, Montreal (C. 1810)

Pépin, Jérome, Montreal (C. 1820)

Pepin, Joseph, Montreal (1770-1842)

Perrault, Chrysostome, Saint-Jean-Port-Joli (1793-1829)

Perrin, Nicolas, Saint-Eustache (C. 1810)

Perrin, Pierre, Montreal (C. 1810)

Piché, Joseph, Les Ecureuils (1790)

Poulin, T.M. Quebec (C. 1850)

Quévillon, Jean-Baptiste, Montreal (C. 1750)

Quévillon, Louis-Amable, Montreal (1749-1823)

Quévillon, Pierre, Montreal (C. 1800)

Racine, Pierre, Quebec (C. 1715)

Richard, Joseph, Quebec (C. 1850)

Robert, François-Xavier, Montreal (C. 1820)

Rochon, Antoine, Saint-Thérèse de Blainville (C. 1800)

Rollin, Paul, Montreal (C. 1820)

Rouleau, Joseph, Lachenaie (C. 1840)

Roussel, Joseph, Quebec (C. 1800)

Roy, Pierre, Quebec (C. 1840)

St-Amand, Damasse, Bécancourt, (C. 1830)

St. James (Beauvais), René, Saint-Philippe, (1785-1837)

Samson, Joseph, Quebec (C. 1820)

Séguin (Ladéroute), Montreal (C. 1780)

Séguin, Pierre, Montreal (C. 1820)

Shindler, Jean, Quebec (C. 1820)

Taphorin, Guillaume, Quebec (C. 1740)

Tattoux, Joseph, Montreal (C. 1820)

Tellier (?), Trois-Rivières (C. 1780)

Tessier (Lavigne) (?), Montreal (C. 1800)

Turcault, Joseph, Montreal (C. 1800)

Valade, François, Montreal (C. 1820)

Valin, Jean, Quebec (1691-1759)

Vallière, Romain, Quebec (C. 1840)

Vaucourt, Jacques, Quebec (C. 1740)

Vézina, Charles, Quebec (C. 1750)

Viau, Pierre, Lachenaie (C. 1820)

Viger, Denis, Saint-Denis-sur-Richelieu (C. 1790)

To complete this inventory, refer to the list of furniture makers of the 19th century which has been given in the chapter on English-inspired furniture.

CHAPTER 17

Restoration and Maintenance

However much the creations of the past were made to withstand the depredations of time and the assaults of man and nature, nevertheless the most solid, the most resistant and durable of articles must be protected and maintained. The collector who would avoid having his silver corrode, woods rot, and the glaze on ceramics crackle, must know a thousand and one secrets of maintenance and restoration that will help to preserve the charm of his possessions, their beauty, and their characteristics of another age.

We shall, therefore, consider the state of old furniture that is for sale on the market and how to put it in better condition and at the same time retain its original finish without removing the patina of age. We shall also describe the care with which it must be treated to prevent warping and cracking or coming unglued—all enemies that, in the long run, can ruin furniture forever. We shall also show the results of time on glass, ceramics and various metals, and suggest a few practical recipes for restoring them and keeping them in good condition.

The Usual Condition and Origin of Old Furniture

Do not imagine that most old furniture is discovered in the parlor of some old rustic house where several generations of meticulous housekeepers have dusted, waxed, and polished it regularly. As a rule, the oldest treasures are hidden in the attic or cellar, barn or shed of a house in the country.

Water, dampness, sudden changes of temperature, worms, all the usual enemies of wood, may not manage to destroy these pieces, once the pride of their owners, but one can imagine their condition after they have been kept for many years: dirt, dust, layer after layer of different kinds of paint running from one end of the color spectrum to the other. However, all the numerous changes, all the mutilations, must not be attributed to

nature and time alone, but in great part to man.

On many pieces of furniture, the pegs have been pulled off and replaced by rough strap-hinges or pieces of leather. Elsewhere, someone has sawed off the legs of a table that was too high, when the table itself was cut down to a size more appropriate to the needs of the room. The same acts of vandalism have been perpetrated on the wardrobes, cupboards, chairs. The *"habitant"* may have strengthened the structure by inserting a few strong nails here and there, and then used it as a workbench or a worktable. Do not be surprised to find marks of hammer blows, hatchets, inkspots, oil, even burns from a blowtorch, and traces of clumsy sawing.

All this is even truer for handcrafted furniture cut from solid blocks of light pine. Varnished pieces, in the English or American style, not as old but better preserved by country folk or careful city dwellers are as a rule not in such a pitiable condition. A few scratches, a broken molding, a leaf of veneering that has become unglued, joints that come apart, those ordinarily are the only deterioration one can notice.

Today as soon as the amateur collector has acquired a traditional piece of furniture, it is the fashion to remove the finish. Here one must be very careful, for painting was in current usage among carpenter wood-carvers, and many pieces that came out of town or village workshops were covered over with some sort of finish. Before 1800, no doubt in imitation of the veneering done in the mother country and under the influence of the Louis xiii style which was then in vogue with the general public, coloring wood was done by painting rather than by staining. Red, blue, pale green, deep blue-green, or dull orange were the principal colors favored in those days. The original paint must therefore be treated with much caution and in minute detail. It is useless to rub down a piece that has only one coat, because that is the way the craftsman who created it wanted it to be. The careful amateur collector, respectful of the original work, will be satisfied with clean-

ing the surface thoroughly to remove the dirt, but without altering its color.

It is true that the honey-gold texture of old wood that has been scraped and waxed has great charm, but above all we should try to restore the furniture as our ancestors had conceived and seen it. In this regard, the original color is the most important thing. On the surface of newly purchased furniture, there is no problem. It is only a matter of bringing it out. If, on the contrary, the piece is covered with several subsequent layers of paint, the work becomes so delicate that more than one amateur collector misses the mark in his effort to restore it. It takes the patience of an angel to handle scraper and pads soaked in paint-remover, and to learn to use the exact amount without taking off the original layer. As in restoring a painting, one must know when to stop.

Some people prefer to repaint their furniture after they have stripped it to the natural wood. One cannot, of course, find exactly the old colors on the market. The colors and the finish must therefore be copied from what is seen in museums where the authenticity of the work exhibited to the public has been respected. However, this is a highly specialized task.

Stripping

Stripping furniture should not be done blindly. There are certain rules to respect, one of which is never to use a sharp object, scraper or knife, when dealing with the grain of the wood. Otherwise, there is a risk of grooving or scarring the wood permanently and of noticeably impairing its patina. Yet, it is not an offense to use such tools cautiously when confronted with several dried and flaky layers of paint. As was said before: it is all a matter of knowing when to stop.

The informed amateur collector will arm himself with patience, for to completely cleanse an article that has been repainted ten or twenty times and restore its original color requires more than one operation. The furniture must first be thoroughly washed with alcohol or even with a mild soap. Then, depending upon whether the layer of paint is very thick or not, the scraper must be wielded dexterously and with great care. Finally, the application of some sort of a remover, such as is found on the market, com-

pletes the work. It would be better to use a brush with synthetic hairs to apply the solvent; it has a harmful effect on brushes with animal hair, which curls and becomes scraggy if immersed in a strong liquid.

The solvent is generally smeared on the surface, which is placed horizontally so that it has time to penetrate sufficiently and is not lost; then it is brushed with the same brush dipped frequently in the solvent until the layer of color is easily wiped off with a cloth or a stiff-haired brush. The operation will undoubtedly have to be repeated several times.

Old paint can be very resistant to solvent, and several applications will not soften it. It is necessary, then, to generously coat the hardened surface and wait one or even two days before this glazed finish crackles, scales, and falls off easily under the action of the brush.

The scraper, which must be handled with great care on flat surfaces, is now needed to clean the chair stretchers, as the solvent does not adhere sufficiently to the surface; and here extreme caution is imperative.

One must avoid at all costs removing paint from furniture by using a gasoline torch. It is impossible to do this work properly without burning the wood irreperably.

When the bottom paint layer is not too dark or too thick, and the wood is soft, the furniture can sometimes be washed with water and lye. This, however, is such a delicate procedure that it should be left to experts who know the exact amount of lye that can be mixed in a pail of water. Too much lye would burn the top grain of the wood whereas too little could leave smudges on the surface; such marks are indelible.

The piece to be cleaned must be taken out-of-doors, washed thoroughly all over, brushed with lye (using an even motion) over all surfaces at once to avoid drip marks, and then rinsed. If need be, the operation may be repeated. Once the furniture is dry, it is rubbed with very fine steel wool—and job is done. It is ready for polishing.

Polishing Furniture

Finishing, waxing, and polishing furniture is an important process and one that must be carefully done to restore and protect the patina. Furniture from the 17th and 18th century that was not painted with a mixture

of vegetable and mineral coloring matter as a base was rather rare: furniture from the end of the 18th century was mainly varnished with shellac or even rubbed with linseed oil.

Even if most furniture was not polished with beeswax in the past, it has become routine to use it to protect soft, porous wood, and to bring out the patina and the original color of the pieces.

But here we must exclude all those commercial paste or liquid polishes and prepare the necessary mixture ourselves, a mixture of beeswax diluted with pure oil of turpentine. To make this paste, all you have to do is to get a brick of beeswax from an apiculturist or in some hardware store and, using a vegetable grater, reduce it to flakes. Put the flakes in a glass jar with a tight lid. Next, cover the flakes with a layer of pure turpentine and allow it to soak through for twenty-four hours. As the liquid must be oily, repeat the operation until the wax is liquid. After covering the paste with oil of turpentine four or five times, the polish will then be ready to be applied. A water-soluble stain can always be used on bare wood before waxing or a little ochre can be added to the liquid to darken wood that is too light.

The wax (or encaustic) is then applied generously on the surface of the furniture with a soft paint brush, as evenly as possible to avoid streaks or an excess of wax, and it is left to dry for ten or twelve hours until the wood has absorbed as much of this mixture as it can. The excess encaustic can be removed with a brush that has short, firm bristles, by rubbing vigorously in the direction of the grain to remove the gummy residue. The wood will then have a unique glow, having absorbed the natural elements that nourish the fiber. Any surplus wax will keep indefinitely; all one has to do is to liquefy the paste with a little oil of turpentine if necessary when ready for the annual polishing.

This easy and economical method, especially suitable for rustic furniture, will soften the surfaces surprisingly and leave a delightful scent in an apartment furnished with old pieces.

The second method, even less troublesome than the preceding one, but more demanding, consists of using linseed oil which has been boiled and cooled and which is applied on completely bare wood. For this finish to be successful, the furniture must first have been stripped down to the natural grain. This technique requires rubbing with chamois-skin to lightly daub the surface a dozen times or so, leaving an interval of a day between the rubbings. It is very important to avoid oiling the furniture too much at one time. The soaked chamois must use up all its liquid as it moves back and forth over the surface and into the farthest corners.

Be careful not to use linseed oil that has become sticky. This is easily tested by poking your fingers in it; if the air has attacked the oil, your fingers will have a tendency to stick together. In this case the oil is unusable and you will have to make a new mixture.

If, unfortunately, you have used a sticky oil, a mixture of equal parts of turpentine and wood alcohol sponged on with a piece of medium steel wool and a flannel rag will remove the gummy oil.

Restoration of Cabinets

When it comes to varnished or lacquered furniture made by cabinetmakers, it is generally not necessary to scour them entirely. In fact, pieces of the Victorian, Hepplewhite, Sheraton, Regency, Empire, or French styles are usually not in such a pitiable condition as rustic furniture made by carpenters. A few scratches may appear here and there on the surface; these can be corrected with wax pencils for different textures of wood such as are sold for that purpose in iron foundries. Shoe polishes of the identical color can do the same job. After that, a good furniture polish will smooth it all out.

However, when the ravages of time are a little more obvious, it would be better to turn to a specialist, for varnishing and lacquering valuable woods is not a task easily within reach of the amateur. The restorer, with his well-tested knowledge, his vast experience, and necessary equipment, is assurance of work well done. The Yellow Pages of the telephone book will have under the listing "Cabinetmakers," such specialists. For more information, the prudent amateur should procure Le Corre's excellent book on restoring old furniture, which is mentioned in the bibliography.

Glass

Unlike wood, which has a multitude of enemies, glass is the victim of two elements

only; some atmospheric conditions will cause it to cloud and split while others will make it crack, bake, or break suddenly. Old glass also scratches very easily.

It cannot be said that Canadian glass has already been attacked by these evils, but it is better to prevent them than to discover these damages one day in the pieces in one's collection.

Sudden changes in temperature, even slight ones, can cause irreparable damage to a medium-size article. One part lighted by a warm sunbeam, the other in the shade, produces enough difference in temperature to cause old bottles or other kinds of articles to break suddenly.

Atmospheric acids which increasingly pollute the air of large cities are disintegrating stone statues, as specialists have discovered with the monuments in Venice and elsewhere. If exposed to these same conditions, glass has a tendency to flake or to cloud; in other words, the amateur collector will notice a slight cloudiness occurring on the surface or within the glass itself and that deterioration will be increased by ultraviolet rays. Detergents have a tendency to create the same problems.

Light that is too strong will discolor the pieces, and the mere piling up of bottles in a wine cellar can, with the years, blend the contents of the different bottles under the pressure of weight.

To avoid all these damages it is advisable to wash glass regularly and to set the pieces in a place sheltered from dust and excessively strong light.

To repair old glass that has become scratched or superficially clouded, the pieces can be filled with liquid to give greater solidity and then polished; a very fine abrasive will do the work, the kind a hardware dealer will be able to suggest. If, on the contrary, you have to restore a broken article, the only worthwhile glue on the market today is the one with a resin base called "epoxy." Even if this product does not bring the parts into perfect contact and even if its index of refraction is different from that of the glass, nevertheless it is at present the most finished product, and the best adhesive for this kind of restoration.

Ceramic

As a general rule, fired clay is more resistant to outside agents (even to hard knocks) than glass. To be sure, the glaze crackles, flakes, or scratches down to the bisque; the material can become spotted with use, but these are the only disadvantages of ceramic. Subsequent and numerous washings can alter the pattern superimposed on the glaze, but the piece itself will not be affected.

If, after a change in temperature, the piece flakes, it is imperative to take care of it, for dampness will penetrate the terra-cotta completely and soon the entire glaze will detach itself from the ceramic. From that moment on, avoid wetting the article if you do not want to destroy it forever. The flaked glazing can be repaired by using paint or an impermeable liquid plastic. The more conspicuous crevices can be filled with "plastic wood," or tile cement; then the whole thing should be lightly polished, painted, and covered with an impermeable substance that gives a shiny finish.

When ceramic is broken, any glue that is resistant to water will give an excellent result. In the use of clinches specialists in restoration have another way of putting fragments together.

When an amateur collector discovers a broken ceramic piece and the article has great sentimental or historical value, all the fragments at hand can be glued together, the missing pieces in the puzzle replaced by filling the gaps with a rapidly drying cement of the same type dentists use to make buccal impressions. Paint and enamel can then even out the finish.

Nevertheless, a damaged piece is always damaged. In examining ceramic, the would-be purchaser must be very critical of detail and very meticulous. That the object you are planning to purchase should be in perfect condition is a reasonable demand. And finally, we must point out that, like glass, ceramic containers must not have holes drilled in them to make lamps, or any other article of interior decoration, out of them. To the true collector, that is sheer vandalism.

Metals

Even the hardest and heaviest substances are subject to the assaults of Nature and accidents that crack, break, twist, and erode them. It is not unusual, in fact, to discover a magnificent cast-iron stove, made in the 19th century, and ornamented with biblical

scenes, but cracked in more than one place. In spite of their reputation of being so solid that nothing can harm them, most metal objects cannot hold out against time.

All metals, with the exception of gold and platinum, become tarnished or corroded, the principal oxidizing agent being the sulphur in the surrounding atmosphere. Some museums have succeeded in mitigating this scourge, caused by the pollution of large cities, by putting their pieces in sealed glass cases. Individual collectors certainly cannot afford such equipment, and most of the copper, pewter, or silver articles in collections continually suffer this kind of airborne assault obliging the owner to rub the pieces regularly with some chemical product to preserve their original finish.

Iron

Iron oxidizes and corrodes. Not only does the metal become dull, but its surface becomes rough, flakes, and even loses in bulk, becoming, with time, something having little resemblance to the ordinary bar metal. When archeologists discover in some layer of the ground a relic of a civilization in iron, steel, or cast iron they treat it electrochemically, a fairly effectual method of halting corrosion and even of thoroughly cleaning the piece they have unearthed. The amateur collector, not having recourse to such methods, will have to depend on more accessible means.

Rust can be recoved easily from an old iron piece by rubbing it with steel wool dipped now and then in kerosene. If some spots still persist, the item must be immersed in kerosene for one or two hours and then dried by wiping it thoroughly. After that, the amateur restorer will apply a thin layer of oil and wait several days before wiping it off completely.

Another good way to clean the surface of rusted iron is the method given us by Jacques Dufresne, restorer at the Inventory of Works of Art, which consists in letting the article soak in a water bath to which has been added citric acid (1 gallon of water to 6 ounces of citric acid, which can be procured from a pharmacy).

Once the article has been cleaned, it is wiped all over with a thin film of lubricating oil, which has the advantage of being a rust preventive and loosener, the kind used for maintaining household appliances and firearms. This sort of monthly care will prevent any subsequent oxidation, for the metal will be impervious to the air around it. The object can also be painted if this does not change its original appearance too much; but this should be done only as a last resort.

Tinplate articles in sheet metal are almost irreparable when oxidation has been allowed to take place over a long period. Rust can be arrested by oiling the metal well.

For cast-iron stoves, the method of cleaning iron is the same but, instead of applying a little oil at the end (to avoid further oxidation), stove-black, specially made for this purpose, will make the stove look like new without any risk of rubbing off on the hands of people who are in the habit of "looking with their fingers."

When iron objects that were once kitchenware are put to domestic use anew by the modern housekeeper, after being treated with steel wool and kerosene, they must be thoroughly washed, dried well, and coated with a thin layer of salad oil. It is important to wipe them well after each washing, for there is danger of rust attacking them again.

Copper

Articles in molded copper or in copper sheet metal are in general use in Canada. Pieces molded before 1840 show a fine line on each side; they are taken from two-part molds. After that date, the single mold does not show any edges.

The most important copper articles, and those most popular nowadays with amateur collectors, are those famous beds that go back to the Victorian era and the beginning of the 20th century. Some of them look like veritable trumpets so turned and convoluted is their brass tubing. In most cases, these are iron covered with a thin sheet of brass, and this covering is the thing that interests us particularly.

When the bed or any object made of brass is not too tarnished, most of the commercial cleaners on the market will give excellent results. On the other hand, if the layer of oxidation is thicker and, in addition, the last owners felt it advisable to cover the metal with a layer of transparent lacquer to retard the action of the air, it will take an abrasive to get rid of the tarnish. Soap pads like S.O.S.

used with an ordinary brass cleaner will quickly remove the layer of oxidation. There is a very effective product on the market that can simplify the work in many cases: it is *Dursol*. There is also another that has silicon carbide in it which is used in garages to polish the valves of automobile engines. Europeans recommend a powder, Bull's liquid metal polish, which they thin down with water or alcohol; it is a very potent product and very expensive. Or else, one could simply use a mixture of citric acid and water in the proportion of 8 ounces to 1 gallon of water.

Silver Plate

Old pieces of gold or silver plate have a color and a soft luster not found in modern plate. Oxidation does not spare this precious metal and a good way to prevent it is to use silver dishes and utensils frequently. Otherwise, if you want to preserve them in a glass case with all the patina which was acquired from former usage and handling, the only cleaning method that gives excellent results entails using a good silver polish of the kind sold in hardware shops or at jewelers and goldsmiths. However, one must beware of cleaners that work through chemical reaction, those said to have ultra-rapid action. The reaction is so strong that even delicate chasings that, with time, have taken on a matte finish resembling pewter, a beauty most sought by collectors, will become shiny again. Silverplate must never be machine-polished, for often all the patina, the heritage of years and usage, may be lost.

If polishing with commercial cleaners takes too long, the more heavily oxidized silver pieces can be plunged into a weak acid solution with a base of lemon juice or a weak alkaline solution made with bicarbonate of soda; this mixture must be boiled before using. It is very important to wrap these articles in aluminum foil before dipping them. This is an amazing chemical process for, after two hours in a bath in these solutions, the silver comes out clean, ready to be polished with a cloth lightly dipped in a commercial cleaner. But, be careful not to use this method on electroplated pieces or on pewter.

Another recipe advises filling an aluminum container with water, adding three tablespoonsful of washing powder, and immersing the articles which are stained or which need to be polished. Then bring the solution to a boil and stir with an aluminum skimmer. As soon as the articles are clean, remove them, rinse them in hot water, and polish with a chamois skin. To keep them clean and shiny longer, a commercial powder or cream product will complete the work. If these pieces are not used every day, it would be wise to store them in little black or blue soft flannel bags. Oxidation can be delayed by wrapping the articles in dark tissue paper. A mixture of 30 parts formic acid to 70 parts water, heated to just below boiling point, will also give surprising results. Be sure to keep a watchful eye on the piece, for deoxidation is almost instantaneous.

Pewter

Pewter is also subject to deterioration caused by chemical reactions to atmospheric conditions. The acidity of foodstuffs, alkalines, salts gradually alter the appearance of this metal. If the piece has not been cleaned for a long time, oxidation will cover it with a dull dark brown, almost black, film. What can be done to restore its more conventional color? Here we must point out that many collectors prefer their pewter in a "mature" state: blackened, battered, scratched, all of which give the surface a desirable patina.

Plates, dishes, utensils, candlesticks can easily be restored to their rich dull-gray color. A little scouring powder of the kind found in all kitchen cupboards, mixed with a half a cup or so of kerosene and applied to the surface with a soft rag will restore the blackest pieces to their natural condition. Another good method is to beat up the white of an egg and add to it one or two teaspoonsful of concentrated liquid chlorine bleach; spread the mixture over the object to be cleaned, let it dry, remove it with a soft rag soaked in vaseline, then very carefully wipe the piece.

It is important not to rub these articles with steel wool or even very fine emery paper. To do so would sacrifice the patina to the original color of the article, and it is the patina that often makes a piece of pewter valuable.

For ordinary maintenance, silver polish or even a soft wad of cotton drenched in oil will do very well. The European market has

Bull pewter polish that cleans old articles without abrading the patina.

Bronze

The best technique for removing the thick greenish layer from bronze is still electrolysis. Or, the whole piece can be boiled in some receptacle or other; the oxidation will fall off in pieces. Do not rub with sandpaper or steel wool. Many amateurs prefer old bronzes with their patina and their oxidation, which are criteria of age and of beauty.

Gildings and Frames

Most collectors who decorate a room in their apartment or in their house in the style of another era prefer pictures and mirrors to have frames that match or fit in with it. Old frames are therefore much sought after, but they are too often offered at exorbitant prices.

Most old frames have elaborate moldings, enhanced by a pattern of decorative details in a plastic material such as mastic or plaster; all this is covered with plaster of Paris and finished with thin gold leaf which gives them a special brilliance and richness. The ones with printed shells or wreaths of flowers on sale in antique shops or the shops of gilders go back to the Victorian era (1840-1910).

Very often these frames have not withstood the weight of years, and frequent knocks have broken off some section of the applied decorative motifs. In that case, one must be skillful enough to restore by eye, using a plastic material like non-oily mastic, plastic wood, or any other material, to put the missing patterns together.

If you do not have the small broken-off pieces that you could re-attach with glass or wood glue, rebuild the pattern with the modeling paste children use in their games. Take impressions of the motif on some other part of the frame. Then pour some plaster of Paris into this mold. When this is firm, unmold it and glue it to the desired spot which you have marked on the wood beforehand. Then let it dry for a week to allow the whole thing to harden in place. Flat surfaces or small breaks can be repaired with gesso or

with a porous mastic to allow for faster drying. Any new addition to the decoration must be burnished and varnished.

The amateur collector then has two choices: to cover the object with liquid gold powder or with gold leaf. In the first case, the operation is within reach of everyone; it is a matter of painting the entire molding of the frame with a fine brush, using the most suitable gilding; the market has dozens of kinds for sale. Certain gilded waxes ("Treasure Jewels") may also be used. These are applied with the fingers and then polished with a soft rag.

If, on the other hand, you should choose gold leaf, that is quite a different process and more delicate. First, a layer of varnish, mixed with a little oil, must be applied. When the varnish is tacky, say after twelve or fifteen hours, the surface is ready for the gold leaf. The leaf must then be cut with a silver table knife to the desired size. To work well, the thin leaf must lie on the chamois. Next you must take a silky camel's hair brush, rub its hairs to produce static electricity and gently pick up the gold leaf which, from then on, will adhere easily to the hairs and can be applied to the surface to be covered. After repeating this operation until the work is finished, the whole thing is allowed to dry for a week.

Next, wipe the surplus gold off the brush and your work is done. If the new surface is too bright, this brilliance can be softened with use of an umber varnish or a varnish stain slightly thinned with a bit of turpentine.

To restore brilliance to old gildings without disturbing the patina, mix two tablespoonfuls of concentrated chlorine bleach with two egg whites. After dusting the frame, the surface must be painted with the above mixture, using a soft brush; then, before it is allowed to dry, wipe, as you go along, with a fine piece of linen.

Wicker, Cane, Bamboo

The end of the 19th century and the beginning of the 20th launched the fashion for rattan or cane tables and chairs. Every year, at housecleaning time, homeowners never know how to restore the original sheen to such pieces of furniture. First, they must be brushed with a fairly soft brush to remove the dust. Then, if one wants to renew and freshen them, use of the following prepara-

tion will give surprising results: into two pints of hot water, put two tablespoonfuls of linseed oil and two tablespoonfuls of turpentine. The furniture is then wiped with a natural sponge dipped in this mixture. For this process to be effective, the bowl holding the hot solution must be placed in a tub of boiling water; the mixture must stay hot during the cleaning. Be careful not to put this mixture directly on the fire, for there is danger of explosion. This operation must be carried out in the open air. Once the solution is applied, let it dry.

For wicker furniture which is just slightly soiled, the following method will prove sufficient: dissolve three tablespoons of black soap in four pints of boiling water, dip a sponge in it, soap, rinse, wipe, and let dry in full sunlight, which will have the added effect of tightening the wood.

These are a few recipes which we hope will prove useful to many an amateur collector. However, when a piece has an historic value and there is a large scale repair or restoration job to be done, it is always better to call in an experienced specialist. You gain in the long run, for the repaired object may then be exhibited proudly without any danger of seeing it go to pièces at the slightest touch.

For further information on this subject, amateur antiquarians and restorers may be interested in consulting the "bible" in this field: H. S. Plenderleith's book, *La conservation des antiquités et des oeuvres d'art*, published in Paris by Eyrolles in 1966.

CHAPTER 18

Outlook for Research on French Canadiana

Conclusion

There is a great wealth of material on the subject of French-Canadian material culture to be studied, but few researchers have devoted much time to it. Little has been done with regard to authenticating and evaluating pieces. Prices of articles are fixed according to the seller's will; and often the criteria of age, rareness, or state of preservation are barely respected. An inventory of fakes and of ways to detect them, as well as a list of pieces still available on the market, is still to be made. Nevertheless, there is an ever-growing interest in the antiques of French Canada, as witnessed by the more than one hundred and twenty-five local museums which display their showcases to interested collectors.

As for furniture, in spite of the excellent study of Jean Palardy, who is a pioneer in this field, there are still many areas to be clarified. Most French-Canadian pieces originated in French regional furniture and any further study must take into account the variations observed outside of the French capital. Local types should be divided according to economic or migratory areas when that is possible: the many different places where craftsmen-cabinetmakers were subjected to special influences, but where they also made individual forms and methods popular. France has done this, and a regional study has revealed many modifications in the capital's ways of doing things. A research on furniture of Quebec, Montreal, Trois-Rivières in the 18th and 19th century still needs to be done.

The English contributions to French Canada and the inspiration which the Georgian, Regency, and Victorian styles exercised on industrial manufacturers and craftsmen is still a subject to be exhausted, and there are many documents to examine and study. This applies also to American influence, too.

In the area of ceramics, Elisabeth Collard's study has explained the importance of importing English wares to Canada. However, one finds many old Quebec-made pieces in antique shops and it is often difficult to assess the influence of Canadian craftsmen on this form.

As for handcrafted pottery, the ninety potters at present known to have been in the Province of Quebec (before 1900), are only the beginning of a longer list which is still to be completed. Canada has a pottery tradition that goes back to the very beginning of early settlements on the banks of the St. Lawrence. To study village monographs that were written, especially by priests, in the 19th and 20th centuries, is to discover a treasure of unprecedented information about certain artisans.

Glassmaking, in spite of its minor importance, in Quebec, dates back to before the middle of the 19th century. Gerald Stevens's inventory is a work of inestimable value.

Foundaries, ironworks, and tinworks are also included in this group. Casting has always been used in making closed stoves, pots, and a variety of heat-resistant objects for daily use, many of which were richly decorated and signed.

The makers of pewter and the itinerant or sedentary spoonmakers were undoubtedly artisans greatly in demand and a few molds have been discovered and certain pieces attributed to a well-known craftsman, but most of the pieces in collections, and which bear a trademark, are of American make. Langdon's study on French-Canadian silverware is important but not definitive.

As for lighting, there is a fairly exhaustive study on the evolution of lighting techniques by Loris Russell.

In the matter of tools, firearms and sidearms, this is virgin ground with little to show French-Canadian contribution or how much came from French and Anglo-American sources.

Still, there is no doubt that French Canada has many authentic treasures for the serious collector.

Bibliography

We have confined ourselves to volumes consulted in this work, purposely omitting magazines, newspaper articles, and catalogues that would have lengthened each section out of all proportion. Further information of interest to the more specialized collector will be found in the books marked by an asterisk.

General Works

Barbeau, Marius, *Maitres-artisans de chez nous,* Montréal, 1942.

Black, Howard, R. Jr., *The Collectors Guide to Valuable Antiques,* New York, Grosset & Dunlap, 1970.

Diderot, Denis, *Encyclopédie ou Dictionnaire raisonné des sciences, des arts et des métiers,* 17 vol., Paris, Briasson, 1751-1765.

Dobbs, Kildare, *The Great Fur Opera,* Toronto, McClelland & Stewart, 1970.

Fauteux, J.N., *Essai sur l'industrie au Canada sous le Régime francais,* 2 vol., Québec, 1959.

Frégault, Guy, *La civilisation en Nouvelle-France, Montréal, 1944.*

Gross, Leslie, *Housewives' Guide to Antiques,* New York, Cornerstone Library, 1959.

Minhinnick, Jeanne, *At Home in Upper Canada,* Toronto, Clarke, Irwin & Co. Ltd., 1970.

Morgan, Jean-Louis, *Les fourrures qui firent fureur* (french adaptation of *The Great Fur Opera*), Toronto, McClelland & Stewart, 1970.

Rouveyre, E., *Analyse et compréhension des oeuvres et objects d'art,* Paris, Eugène Roy, 1924.

Roy, Antoine, *Les lettres, les sciences et les arts au Canada sous le Régime francais,* Paris, 1930.

Séquin, Robert-Lionel, *La civilisation traditionnelle de l'habitant au XVII^e et au XVIII^e siècle,* Ottawa, Fides, 1967.

*Stevens, Gerald, *In a Canadian Attic,* Toronto, Ryerson Press, 1963.

The Complete Encyclopaedia of Antiques, New York, Hawthorn Books, Inc., 1968.

Trudel, Marcel, *Initiation à la Nouvelle-France,* Toronto, Holt, Reinhardt & Winston, 1968.

Furniture

Barbeau, Marius, *J'ai vu Québec,* Québec, Garneau, 1957.

——————, *Maitres artisans de chez nous,* Montréal, Le Zodiaque, 1942.

Bjerkoe, Ethell H., *The Cabinetmakers of America,* New York, Garden City, 1957.

Boisson, J., *L'industrie du meuble,* Paris, Dunod, 1949.

Boulanger, Gisèle, *L'art de reconnaitre les meubles régionaux,* Paris, Hachette, 1963.

——————, *L'art de reconnaitre les styles,* Paris, Hachette, 1960.

Comstock, Helen, *American Furniture,* New York, Viking Press, 1962.

Downs, Joseph, *American Furniture,* New York, 1952.

Drepperd, Carl W., *Handbook of Antique Chairs,* New York, Doubleday & Co., 1948.

Gauthier, Joseph Stany, *La connaissance des meubles régionaux francais,* Paris, Charles Moreau, 1952.

Havard, H., *Dictionnaire de l'ameublement et de la decoration depuis le XIII^e siècle jusqu'à nos jours,* 4 vol., Paris, Quantin, 1890.

Janneau, Guillaume, *Dictionnaire des styles,* Paris, Larousse, 1966.

——————, *Les Meubles,* 3 vol., Paris, Flammarion (in a series, *Les arts décoratifs*).

——————, *Les sièges,* 2 vol., Paris, Flammarion (in a series, *Les arts décoratifs*).

Jourdain, M., and Rose, F., *English Furniture: The Georgian Period, 1750-1830,* London, 1933.

Joy, E.T., *English Furniture,* Batsford, London, 1962.

Le XVII^e siècle francais, Paris, Hachette, 1956 (in a series, *Connaissance des arts*).

Le XVIII^e siècle francais, Paris, Hachette, 1956 (in a series, *Connaissance des arts*).

Maumene, Albert, *Les beaux meubles régionaux des provinces de France,* Paris, Charles Moreau, 1952.

Ormsbee, Thomas H., *Field Guide to Early American Furniture,* Boston, 1951.

*Palardy, Jean, *Les meubles anciens du Canada Francais,* Paris, A.M.G., 1963.

Rogers, John C., *English Furniture,* London, 1950.

Ryder, Huia G., *Antique Furniture by New Brunswick Craftsmen,* Toronto, Ryerson Press, 1965.

Stewart, Don R., *Guide to Pre-Confederation Furniture of English Canada,* Ontario, Longmans, 1967.

Symonds, Robert W., *Furniture Making of 17th and 18th Century England,* London, 1955.

Verlet, Pierre, *Les meubles francais du XVIII^e siècle,* 1—Menuiserie; 2—Ebénisterie, Paris, P.U.F., 1956 (in a series, *L'oeil du connaisseur*).

Viaux, Jacqueline, *Le meuble en France,* Paris, P.U.F., 1962.

Ward-Jackson, Peter, *English Furniture Designs of the Eighteenth Century,* London, Her

Majesty's Stationery Office, 1958.

Yarwood, *The English Home,* London, Batsford, 1964.

Clocks

Drepperd, Carl W., *American Clocks and Clockmakers,* Boston, 1958.

Nutting, Wallace, *The Clock Book,* Garden City, 1935.

*Palmer, *The Book of American Clocks,* New York, 1950.

Ceramics

Barbeau, Marius, "Potiers Canadiens" in *Technique,* September 1948, pp. 425-431.

Bemrose, Geoffrey, *Nineteenth Century English Pottery and Porcelain,* London, Faber & Faber.

*Collard, Elisabeth, *Nineteenth Century Pottery and Porcelain in Canada,* Montreal, McGill University Press, 1967.

Dixon, J.L., *English Porcelain of the Eighteenth Century,* London, Faber & Faber.

Fontaine, Georges, *La céramique francaise,* Paris, P.U.F., 1965.

Gaumond, Michel, *La poterie de Cap-Rouge,* Québec, Ministere des Affaires culturelles, 1971.

Greber, E., *Traité de Céramique,* Paris, Sfelt, 1950.

Honey, W.B., *French Porcelain of the 18th Century,* London, Faber & Faber.

——————, *Wedgwood Ware,* London, Faber & Faber, 1946.

Lafrenière, Michel, and Gagnon, Francois, *A la découverte du passé: Fouilles à la Place Royale,* Québec, Ministere des Affaires culturelles 1971.

Lambart, Helen H., *The Rivers of the Potters,* Ottawa, National Museum of Canada, 1970.

——————, *Two Centuries of Ceramics in Richelieu Valley,* Ottawa, National Museum of Canada, 1970.

Lane, Arthur, *French Faïence,* London, Faber & Faber, 1946.

Glass

Bird, Douglas and Marion, and Corke, Charles, *A Century of Antique Canadian Glass Fruit Jars,* London, Ont., Douglas Bird, 1970.

Haynes, E. Barrington, *Glass,* London, Penguin Books, 1948.

Lee, Ruth Webb, *Handbook of Early American Pressed Glass Patterns,* Northboro, Mass.

Maclaren, G., *Nova Scotia Glass,* Halifax, N.S. Museum, 1968.

McKearin, George S. and Helen, *American Glass,* New York, Crown Publishers, 1941.

Revi, A.C., *American Pressed Glass and Figure Bottles,* New York & Toronto, Thomas Nelson & Sons, 1964.

*Spence, Hilda and Kelvin, *A Guide to Early Canadian Glass,* Longmans Canada Ltd., 1966.

*Stevens, Gerald, *Early Canadian Glass,* Toronto, Ryerson Press, 1961.

——————,*Canadian Glass (c. 1825-1925),* Toronto, Ryerson Press, 1967.

Unitt, Doris and Peter, *Treasury of Canadian Glass,* Peterborough, Clock House, 1970.

Vienneau, Azor, *The Bottle Collector,* Halifax, Petheric Press, 1968.

Silver

*Barbeau, Marius, "Deux cents ans d'orfèvrerie chez nous," *Memoire S.R.C.,* vol. 33, sec. 1, 1939, pp. 183-191.

Boivin, Jean, *Les orfèvres francais et leurs poincons,* Paris, 1925.

Ensko, Stephen G.C., *American Silversmiths and their Marks,* New York, 1948.

Francois Ranvoyzé, orfèvre, 1719-1839, Québec, Musée du Québec, 1968.

Havard, Henry, *L'orfèvrerie,* Paris, Delagrave, 1892.

Jackson, Sir Charles, *English Goldsmiths and their Marks,* London, 1921.

Lanel, Luc, *L'orfèvrerie,* Paris, P.U.F., 1949.

Langdon, John E., *Canadian Silversmiths and their Marks, 1667-1867,* Vermont, 1960.

——————, *Canadian Silversmiths, 1700-1900,* Toronto, 1966.

——————, *Guide to Marks on Early Canadian Silver,* Toronto, Ryerson Press, 1968.

Traquair, Ramsay, *The Old Silver of Quebec,* Toronto, MacMillan, 1940.

Pewter

Colterell, H.H., *Old Pewter, its Makers and Marks,* London, Batsford, 1963.

Jacobs, Carl, *Guide to American Pewter,* New York, The McBride Co., 1957.

Kovel, Ralph M., and Terry, H.A., *A Directory of American Silver, Pewter, and Silver Plate,* New York, Crown Publishers, 1968.

Forge Foundry and Tinsmithy

Morissette, Jean-Paul, and Picher, Claude, *Galerie Nationale du Canada,* Quebec.

Subes, Raymond, *La ferronnerie d'art,* Paris, Flammarion (in a series, *Les arts décoratifs*).

Tessier, Mgr. Albert, *Les forges du Saint-Maurice, 1729-1883,* Trois-Rivières, Editions du Bien public, 1952.

Lamps and Lighting Equipment

Allemagne, Henri-René d', *Histoire du luminaire depuis l'époque romaine jusqu'au XIXᵉ siècle,* Paris, A. Picard, 1891.

Janneau, Guillaume, *Le luminaire,* Paris, Flammarion (in a series, *Les arts décoratifs*).

*Russell, Loris, S.A., *Heritage of Light: Lamp and Lighting in Early Canadian Homes,* Toronto, University of Toronto Press, 1968.

Twinng, Leroy L., *Flickring Flames: A History of Domestic Lighting Through the Ages,* Rutland, Vermont, Charles E. Tuttle Co., 1958.

Toys

Allemagne, Henri-René d', *Histoire des jouets,* Paris, Hachette, 1922.

Doyon, Madeleine, *Jeux, jouets et divertissements de la Beauce* (Les archives de folklore), Québec, U.L., vol. 3, 1948, pp. 159-211.

Earle, Alice Morse, *Childlife in Colonial Days,* New York, McClelland & Stewart, Ltd., 1930.

Fournier, Edouard, *Histoire des jouets et des jeux d'enfants,* Paris, Dentu, 1889.

Rabecq-Millard, M.-M., *Histoire du jouet,* Paris, Hachette, 1962.

*Séguin, Robert-Lionel, *Les jouets anciens du Québec,* Ottawa, Leméac, 1969.

Tools

Benoit, Fernand, *Histoire de l'outillage rural et artisanal,* Paris, 1947.

Oakley, K.P., *Man, the Tool-Maker,* Chicago, University of Chicago Press, 1957.

Séguin, Robert-Lionel, *L'équipement de la ferme canadienne aux XVII^e et XVIII^e siècles,* Montréal, Ducharme, 1959.

*Sloane, Eric, *A Museum of Early American Tools,* New York, Funk & Wagnalls, 1964.

Firearms

Blackmore, Howard L., *British Military Firearms, 1650-1850,* London, Jenkins, 1962.

Canby, Courtland, *Histoire de l'armement,* Lausanne, Rencontre, 1963.

Carey, A. Merwyn, *English, Irish and Scottish Firearms Makers,* New York, 1954.

Darling, Anthony D., *Red Coat and Brown Bess,* Ottawa, Museum Restoration Service, 64 p.

Foulkes, Charles, *Arms and Armament,* London, 1947.

*Goodings, S. James, *The Canadian Gunsmith 1608-1900,* Oshawa, Ont., 1962.

Hamilton, Edward P., *The French Army in America,* Museum Restoration Service, Ottawa, 1967.

Hanson, Charles E. Jr., *The Northwest Gun,* Lincoln, Nebraska, N.S.H.S.P., 1955.

Hicks, James E., *French Military Weapons, 1713-1938,* Connecticut, Flayderman, 1964.

Mallet, Allain Manesson, *Les trauvaux de Mars ou l'Art de la guerre,* vol. 3, La Haye, 1696.

Peterson, Harold L., *Arms and Armour in Colonial America 1526-1783,* Harrisburg, Pa., 1936.

Phillips, Roger, and Knap, Jerome J., *Sir Charles Ross and his Rifle,* Museum Restoration Service, Ottawa.

Purdon, Charles J., *The Snider Enfield,* Ottawa, Museum Restoration Service, 1963.

Stanley, George F.G., *Canada's Soldier: The Military History of an Unmilitary People,* Toronto, MacMillan, 1960.

Stevens, Frederick J., *Bayonets, an Illustrated History and Reference Guide,* London, Arms and Armour Press, 1968.

The Military Arms of Canada, Ottawa, Museum Restoration Service.

Webster, Donald B., *American Socket Bayonets, 1715-1873,* Ottawa, 1964.

Books and Old Papers

*Beaulieu, André, and Hamelin, Jean, *Les journaux du Québec de 1764 à 1964,* Québec-Paris, P.U.L. et Collin, 1967 (Les Cahiers de l'Institut d'Histoire, no. 6, 1965).

Dionne, Narcisse-Eutrope, *Québec et la Nouvelle-France,* 2 vol., Québec, 1906.

Gagnon, Pilléas, *Essai de bibliographie canadienne,* 2 vol., Québec, 1895-1913.

*Hamilton, R.H., *Canadian Books Prices Current,* Toronto, McClelland & Stewart, 3 vol. (1-1957, 2-1960, 3-1964).

Sabin, Joseph, *Bibliotheca Americana,* 29 vol., New York, 1868-1963.

Simonneau, Gérald, ed., *Catalogue des livres canadiens en librarie,* Canadian Books in Print Committee, 1970.

Tremaine, Marie, *A Bibliography of Canadian Imprints, 1751-1800,* Toronto, University of Toronto Press, 1952.

Stamps

Bileski, K., *Plate Block Catalogue,* Winnipeg, 1969.

Harris, H.E., *Stamps of the United States, United Nations and British North America,* Toronto, Ryerson Press, 1968.

Holmes, L.S., *Holmes Specialized Philatelic Catalogue of Canada and British North America,* Toronto, Ryerson Press, 1968.

Lyman's British North American Postage Stamp Retail Catalogue, Toronto, 1970.

Scott's Standard Postage Stamp Catalogue 1971, 2 vol., New York, Scott Publishing Co., 1970.

Money

Breton, P.N., *Illustrated History of Coins and Tokens Relating to Canada,* Montreal, 1894.

*Charlton, J.E., *Standard Catalogue of Canadian Coins, Tokens and Paper Money,* Port Carling, Ont., Charlton Publications, 1970.

————, and Forbes, Jack, *Guide et liste de valeur-prime,* S.E., 1970.

————, and Willey, Robert P., *Standard Guide to Canadian Decimal Coins,* Racine, Wisconsin, Pitman Pub. Co., 1965.

Zoell, Hans, *Major Coin Varieties,* Regina, 1964.

Medals

Purves, Alec A., *Collecting Medals and Decorations,* London, B.A. Seaby Ltd., 1968.

Buttons

Emilio, Luis Fenellosa, *The Emilio Collection*

of Military Buttons, Salem, Essex Institute, 1911.

WORKS OF ART

Painting

Barbeau, Marius, *Cornelius Krieghoff,* Toronto, MacMillan, 1934.

Bellerive, G., *Artistes-peintres canadiens-francais: les anciens,* 2 vol., Québec, Garneau, 1925-1926.

Chauvin, J., *Ateliers: études sur vingt-deux peintres et sculpteurs canadiens,* Montréal, Carrier, 1928.

Falardeau, E., *Artistes et artisans du Canada,* 4 vol., Montréal, Ducharme, 1940-1943.

*Harper, J. Russell, *La peinture au Canada, des origines à nos jours,* Québec, P.U.L., 1966.

Morisset, G., *Coup d'oeil sur les arts en Nouvelle-France,* Québec, 1941.

_____, *La peinture traditionnelle au Canada,* Ottawa, Le Cercle du livre de France, 1960.

*_____, *Peintres et tableaux,* Québec; Les éditions du Chevalet, 1936-1937.

Musée du Québec, *Peinture traditionnelle du Québec,* Québec, Ministère des Affaires culturelles, 1967.

Sculpture

Barbeau, Marius, *J'ai vu Québec,* Québec, 1957.

Falardeau, Emile, *Artistes et artisans du Canada,* 4 vol., Montréal, Ducharme, 1940-1943.

Hubbard, R.H., *An Anthology of Canadian Art,* Toronto, 1960.

Musée du Québec, *Sculpture traditionnelle du Québec,* Québec, Ministère des Affaires culturelles, 1957.

*Traquair, Ramsay, *The Old Architecture of Quebec,* Toronto, 1947.

Vaillancourt, Emile, *Une maitrise d'art au Canada, 1800-1823,* Montréal, 1920.

Engraving

Gundy, H. Pearson, *Early Printers and Printing in the Canadas,* Toronto, 1957.

Restoration and Maintenance

Freeman, Larry, *How to Restore Antiques,* New York, Century House, 1960.

*Le Corre, Robert L., *Comment restaurer les meubles antiques,* Montréal, Editions du Renouveau Pédagogique, 1970.

Ormsbee, Thomas H., *Care and Repair of Antiques,* New York, 1949.

*Plenderleith, H.S., *La conservation des antiquités et des oeuvres d'art,* Paris, Eyrolles, 1966.

The Conservation of Cultural Property, New York, UNESCO, 1968.

Thompson, G., *Recent Advances in Conservation,* London, Butterworths, 1963.

Yates, R.F., *How to Restore China, Bric-à-Brac and Small Antiques,* New York, 1953.

Value of the Article

Rheims, Maurice, *La vie étrange des objects,* Paris, Plon, 1959.

*Unitt, Doris and Peter, *Unitt's Canadian Price Guide,* Peterborough, Clock House, 1970 (Book I: 1969).

Yates, Raymond, *Antiques Collector's Manual Price Guide and Data Book,* New York, 1952.

Index

FRENCH CANADA

1534 Jacques Cartier plants cross on Gaspé Peninsula

1663 Royal Government established in New France

1763 Quebec becomes British province

1791 Representative government established; Quebec named Lower Canada

1846 Quebec joins Ontario to form Canada East

1867 Quebec becomes province in Dominion of Canada

PORTN

St.-Alban

Deschamb

Shawinigan Falls

Batiscan

St.-Maurice

Cap-de-la-Madeleine

TROIS RIVIÈRES

Yamachiche

Pierreville

L'Assomption

St.-Louis

St.-Benoît

MONTREAL

Richelieu River

Hull

OTTAWA

Ste.-Scholastique

Longueuil

Como

Dorval

Vaudreuil

St.-Jean

Iberville

O N T A R I O

ILE AUX NOIX
(Fort Lennox)

Lake Memphremagog

St. Lawrence River